SATIRE ON STONE

Joseph Keppler (1838–94) ca. 1880.

SATIRE ON STONE

The Political Cartoons of Joseph Keppler

Richard Samuel West

University of Illinois Press
Urbana and Chicago

The author and the publisher gratefully wish to acknowledge the generous grant-in-aid from the Swann Foundation for Caricature and Cartoon, which paid for the color illustrations in this book.

This book is printed on acid-free paper.

Library of Congress Cataloging-in-Publication Data

West, Richard Samuel.
 Satire on stone.

 Bibliography: p.
 1. United States—Politics and government—1865–1900—Caricatures and cartoons. 2. Political satire, American—History—19th century. 3. Keppler, Joseph Ferdinand, b. 1838. 4. Lithography—19th century—United States. 5. Chromolithography—United States—History—19th century. I. Title.
E661.W46 1988 320.973′0207 87–19212
ISBN 0-252-01497-9 (alk. paper)

In loving memory
of my father and friend,
S. I. West,
for what he gave me

Contents

Foreword

AS AN AMERICAN political cartoonist, I feel toward Joseph Keppler as you might feel toward some famous great-great-uncle of yours: Proud to be called by the same name, aware of (and humbled by) the general outlines of his legend, but also . . . removed.

Keppler does not have a daily influence on contemporary cartoonists in any way that we are aware of. Rather, his name is engraved above the altar along with Nast and Gillray and Daumier. Heirs like myself to their pen and ink worship at that alter from time to time. But it is just too heavy a burden to carry the majesty of a Keppler to the drawing board every morning. His gaze over our shoulders is too intimidating.

My readers and I, however, take for granted a mutual understanding of the vocabulary of cartoons, from elephants and donkeys to voice bubbles and cap-tions. That vocabulary was built, bit by bit, over the short history of political cartooning by artists who needed to press new devices and perspectives into action in order to get on with the business of making a point. Upon Thomas Nast's steel framework, Joseph Keppler hung a multicolored, dramatic vision of the great range of expression political cartooning could contain.

It has always seemed to me a paradox that in many creative fields the earliest pioneers flexed their medium as their followers would seldom dare. For those first pathfinders, the dimensions of the wilderness were not yet clear, the territory was uncharted, and so there were no main roads from which to fear diverging. Their whole energy was directed at exploration.

Generations later, ironically, it becomes harder to veer off into the forest, simply because the well-traveled paths have proven true and safe. That they are also

predictable and unexciting is judged a lesser evil than the fear of getting lost in the quicksand. No comic strip today is half as adverturesome as *Little Nemo* was in 1905, no comedian as inventive as Chaplin.

Watching Keppler explore this virgin frontier is invigorating. This is political expression at its free-ranging best. Keppler employs Roman history, biblical tradition, classic literature, comic theater. Today's political cartoonist is out on a limb making reference to Dickens or Twain. If I did a cartoon comparing American imperialism to the fall of the Roman Empire, brows would furrow in confusion from Bangor to San Diego. Keppler ranges even more widely and, in a less literate society, with poetry, fluency, and grace. His work captures the art form before it grew self-conscious or aware of its limitations. It mirrors the sense of possibility that America itself felt (and especially its immigrants) toward its future.

Baudelaire said of Daumier that removing the caption from one of his drawings leaves a work of art standing by itself. In the same way, Keppler's are linked firmly with the classical draughtsmen from whom he learned that beautiful, fluid line. When my generation grew up, editorial cartooning had already taken a distinct route from fine art. It had laden itself down with visual baggage and hieroglyphs and gone off to perform in its own corner of the art world. Its carpetbag of symbols seldom reached outside its circle of listeners. Cartoon art still has that singular "look" about it, and when we approach it as readers, we adopt a certain stance toward it before we ever even see what it says.

Joseph Keppler's readers were less sure of what was coming next. Exhibiting an actor's sense of pacing and flair, Keppler opened the curtains of his stage to an audience not yet savvy to the cartoonist's dramatic devices. And he played that crowd for all it was worth. Color, lighting, costumes! Elephants, presidents, paupers! Apocalypse, redemption, a cast of thousands! His colorful bazaars in the pages of *Puck* must have hit his readers full-force between the eyes. Never before, nor probably since, has the art of political cartooning enjoyed so luscious and pregnant a moment.

The world is different now, perhaps for the better. Political cartooning occupies a more appropriate place amid the swirl of opinion in the popular press. My cartoons are tossed into the hopper of public debate, and there digested with columnists, TV commentators, and doorknob election propaganda. I would be hard-pressed to argue that the cartoonist *should* still wield the sole power to persuade masses of uninformed voters, as indeed Keppler had in those early days.

But this book has come along to celebrate that moment in time when this art form was at its grandiose, garrulous, and festive peak. And to celebrate the genius of greatest visual showman the young art would produce—Joseph Keppler.

Jim Borgman

A Note on the Illustrations

The cartoons in this book have been arranged roughly in chronological order. The black and white figures are numbered to reflect their sequence in the book. Those few dozen cartoons that don't appear chronologically have been moved to group them with like cartoons. Each cartoon, however, is accompanied by its date of publication, so the reader should not be mislead.

The color figures are grouped into a single section following chapter 4 and lettered sequentially. The requirements of printing technology have made it impossible to place the color plates where they should fall under ideal circumstances, but we trust the reader will not have trouble locating them.

Some of the cartoons have creases down their centers, obscuring part of the artwork. This is because these cartoons were photographed from bound volumes of the magazines in which they originally appeared. In all such cases, attempts were made to locate unbound cartoon prints, but without success.

—RSW

ONE

The Brilliant Thread

IN 1893, the shores of Lake Michigan in the city of Chicago served as the site for the global event of the year—the World's Columbian Exposition. The exposition's ostensive purpose was to mark the four-hundredth anniversary of Columbus's explorations of the New World. But its real purpose was to showcase four centuries of American technologic innovations. Although many foreign nations were represented, the exhibitions of the United States dominated the fair. All other countries were relegated to the role of spear carriers for this powerful new colossus.

The fair buildings stood as testaments to American industry. The gargantuan 1.3-million-square-foot Manufactures and Liberal Arts building dominated the shoreline. Surrounding it were sister buildings devoted to agriculture, machinery, electricity, mines, transportation, and horticulture. This fair sent the world the message that the United States was in the vanguard of the industrial revolution. Every type of machine, from the beautifully simple automatic sprinkler to the latest in sophisticated mining equipment, could be found in Chicago in 1893.[1]

When the fair commissioners wanted to showcase advances in the color printing field, they did what seemed to be on the face of it a strange thing. They turned to America's premier satire magazine, *Puck*, then in its sixteenth year of publication. Founded in 1877, *Puck* had become a financial success by 1880 and a national power by 1884. Read religiously by tens of thousands, feared and denigrated by those who felt its wrath, *Puck* was one of America's most popular and influential magazines. But *Puck* had been chosen to participate in the fair for none of these reasons. Rather, it had been chosen because of its beautiful chromolithographic cartoons.

As *Puck* explained to its readers in October of 1892: "*Puck* is going to be

at Chicago in 1893. . . . [There] *Puck* will be found every day of the great exhibition, and [there] he can be seen in every stage of his work of bringing out the weekly paper that bears his name. . . . Probably no other paper could have undertaken to give the object lesson in printing which *Puck* is going to show the world at the World's Fair. . . ."[2]

Before the founding of *Puck*, American readers knew only the black and white world of the steel engraving and the woodcut. The chromolithograph had become a popular wall decoration, courtesy of firms such as Prang and Currier and Ives, but their products were offered to the public as broadsides, or prints. They were featured only rarely in magazines because they took so long to create and were expensive to print.

Puck made chromolithographs its primary attraction. Each weekly issue featured three of them. *Puck*'s success sparked an explosion of color in the American media. Soon magazines, and then newspapers, across the country began using color, from eye-catching front covers to vibrant comic sections. Today's rapid technologic advances, which make even the fantastic seem commonplace, make it difficult to appreciate *Puck*'s chromolithographic achievement and its impact on the visual sensibilities of nineteenth-century America. But *Puck* had been, in fact, the leader in a movement that transformed the tastes of a nation.

The nation, for its part, flocked to Chicago in 1893 to experience the celebration of the century. It came in unimaginable numbers. On any given day, thousands, tens of thousands, hundreds of thousands, packed themselves into the two-mile stretch of Lake Michigan shoreline.[3] They crammed through the gates, clogging the narrow walkways of the international midway plaisance. They queued into an endless line to ride the huge, original Ferris wheel. They jammed into the stockyard displays to see prize animals from foreign lands. And they wedged into the Puck Building, not only to see the beautiful art of lithography being performed right before their eyes, but also to catch a glimpse of the flamboyant owner and cartoonist in charge.

He was easy to pick out from the crowd. Joseph Ferdinand Keppler stood six feet tall. His thick, wavy, mostly grey hair framed handsome facial features—a strong nose and deep, elegant eyes. His moustache and imperial marked him as a European transplant. While at work, he dressed casually, usually undoing his vest, loosening his collar, and rolling up his sleeves. In appropriate season, he could be seen more characteristically in a top hat, cape, calf-high boots, and gloves.[4] To many, Keppler looked more like an actor than a businessman. In fact, much of the first fifteen years of his adulthood had been spent on the stage. And although, in 1893, he had been away from the footlights for nearly two decades, the characteristics of a performer, the theatrical impulse, had never left him. That

impulse ran deeper than the serendipitous choosing of an occupation. Theatricality was central to Keppler's character, and central, he believed, to the character of his people, the Germans.

Puck staff member, cartoonist W. A. Rogers, was afforded a unique view into Keppler's philosophical outlook when he happened to mention to him that he had read the colorful 1857 historical novel *Ekkehard* by Joseph Victor von Scheffel.[5] The novel, based loosely on the life of the tenth-century Swiss monk, Ekkehard I, is a story of unrequited love, the loss of hope, and, ultimately, redemption through a rejection of conventional and artificial restraints in favor of a free, natural, and practical approach to life. Keppler told Rogers, "Nobody in America has before said to me that he has ever heard of *Ekkehard*. It is good that you should know that wonderful book. It is the German spirit!" Keppler insisted, "One cannot understand the poetry of our ancient people if he does not know *Ekkehard*."[6]

Some time later, the two cartoonists spent a Sunday afternoon together in Schutzen Park on the New Jersey Palisades. There, Rogers witnessed respected German-American bankers and businessmen parading around in yellow vests and sky-blue coats, with wreaths of oak leaves and flowers on their heads. They seemed to Rogers "absolutely unconscious of anything but the physical joy of living—[with] Manhattan only two miles away." Upon witnessing this carefree display, Rogers came to understand why his colleague "drew men with purple coats and green trousers, and why he liked and lived the exaggerated romanticism of *Ekkehard*."[7]

Keppler's theatrical tendency is woven like a brilliant thread through the scenes of his life, binding them into a whole and coloring them in the liveliest hues. Keppler's outlook was simple. He viewed politics as theater, art as theater, life as theater.

In Chicago in 1893, Keppler faced a dizzying theatrical opportunity: performing before twenty-seven million people.[8] At first Keppler relished showing off to the world his beloved *Puck* in all its lithographic glory. But this wondrous public display, instead of being Keppler's shining moment, became a nightmare. Ultimately, even the consummate entertainer was not up to the part. The performance Keppler gave in Chicago proved to be his final curtain call.

Keppler's interest in the arts had a humble beginning. He was born on February 1, 1838, to Johann (a distant descendant of the astronomer and mathematician who shared his name) and Josepha Keppler in the Lichtental district of Vienna. There, the family operated a *konditorei*, or pastry shop. Keppler first experienced the satisfactions of artistic creation helping his father decorate the sweet confec-

tions that came from the konditorei oven. The Vienna of Keppler's youth was both the arts capital of Europe and seat of political power for the Austrian Empire. Johann Keppler, while educating his son in the manual arts, also imbued young Joseph with the political sentiments of nineteen-century liberalism. He railed against royalty and the self-serving hypocrisy of those in power.[9]

In 1848, Vienna found itself at the center of a revolutionary cyclone then tearing through Europe. Johann Keppler sided with the revolutionaries. When the Austrian army crushed the Viennese insurrection in October, Johann was forced to flee to the United States.[10] He bequeathed to his ten-year-old son a skilled hand and a liberal temperament, the seeds of Keppler's later success.

Because his father took with him sons Franz and Johann, Jr., Joseph Keppler became the eldest male in the Keppler household, which now included Keppler's mother, his younger brothers Karl and Rudolf, and his infant sister Aloysia. When his mother had trouble maintaining the bakery business, young Joseph was switched from the district elementary school to the *hauptschule des waisenhauses*, a school for orphans and the children of the financially troubled.[11]

In 1851, Keppler's budding artistic abilities earned him entrance into the *K.K. Elementar-Zeichnungs-und Modellir-Schule* (Elementary Drawing and Modeling School) in Vienna. There he successfully completed two semesters' study in freehand drawing. This led to his admittance to the esteemed *K. K. Akademie der Bildenden Kunste* (Academy of Fine Arts) in 1852, where he took courses in painting preparation. Because the academy was supported by state funds, qualified students like Keppler were admitted tuition-free.[12]

Keppler entered the institution just after it had gone through a period of transition in its curriculum. After decades of neoclassicist teaching that emphasized treatment of the human form in the tradition of the Greeks and Romans, the academy now embraced pictorial naturalism. This emerging school of painting rejected neoclassicism's artificiality in favor of an honest view of the world as it was. It took its inspiration from everyday life.[13] Keppler's emersion at the academy in this way of looking at the world reenforced his disdainful feelings toward pretention and pomp and helps explain his later reverence for *Ekkehard*'s celebration of nature.

The academy's new direction was undoubtedly due to the commanding influence of academy professor Peter Johann Nepomuk Geiger.[14] In the 1850s, Geiger was known throughout Europe. Favored by kings and commissioned by governments, Geiger drew on the glorious and the treacherous events of European history to establish as his forte historical illustration and narrative art. He impressed on his students the importance of the fundamentals—human anatomy and composi-

tion. Geiger's best work was vital, evocative, and beautifully designed, making history come to life. Two decades later, Geiger's influence was evident in Keppler's work: careful composition, an eye for detail, a preference for accurate portraiture over exaggerated caricature, and the predilection to employ analogous historical dramas to make a point.

It has been said an artist never completely forsakes elements of earliest influences. This is absolutely true in the case of Keppler and Geiger. The most graphic example of Geiger's hold on Keppler was demonstrated in the women Keppler drew. The same Teutonic women who populate Geiger's historical illustrations reappear in near-identical form twenty years later in Keppler's political cartoons (fig. 1). Keppler would never forget Geiger's importance in his artistic training. In later years when asked about his teachers, Keppler never mentioned anyone but Geiger.[15]

Keppler successfully completed Geiger's course of study in historical painting in 1855. Unfortunately, his prestigious diploma didn't guarantee work, so the seventeen-year-old Keppler indulged his wanderlust and, in the company of a photographer, set out for Italy. They made their way southwest, village by village, the photographer plying his infant trade and Keppler plying his to help that infant trade along, which is to say, he retouched tintypes. When the two reached the Tyrol in southwestern Austria, the photographer decided to veer southeast toward Budapest. Keppler continued south.[16]

He reached Italy nearly penniless. His days were spent seeking work, any odd jobs a painter could do. His nights were spent in fields and groves. For a short while he stayed at a monastery, earning the gratitude of the monks there by repairing and restoring their precious, aging oil paintings.[17]

After some time, he came upon a traveling theatrical company, which engaged him to design and paint its scenery. While Keppler's academy training under Geiger had taught him discipline and technique, it was to be his work in the theater that would shape his unique artistic vision. That vision, which later found full expression in *Puck*, involved imagining the blank drawing page as a stage.

In 1893, Keppler's colleague H. C. Bunner explained how Keppler viewed the cartoon. He saw it as a "picture parable" with "the actors of the fable.... so drawn as to display their characters in their lineaments." Moreover, these "actors" were drawn in such a way to suggest "action, and not merely . . . position. . . . "[18] In his cartoons, Keppler created the illusion of having selected a single frame of action from an unfolding drama. This two-dimensional stage, like its three-dimensional inspiration, used scenery and composition, as well as words and suggested movements, to evoke moods. Late in life, Keppler himself remarked

"whatever taste or ability I may have in the way of color and composition is due in a great measure to the theater with its arrangements of groups and its decorative and scenic effects."[19]

After a while, the actors with whom Keppler traveled recognized that their scene painter had a touch of the thespian in him as well. They tried him in one of their shows, and he proved to be a natural. Keppler had found his calling. Within a short time, he became the company's lead actor. In the late 1850s and early 1860s, he led a peripatetic existence traveling throughout Austria as a member of various beer hall troupes, slowly gaining greater and greater recognition as an actor, singer, and comedian.[20]

In the nine years since his graduation, Keppler could claim a variety of exotic accomplishments, but little in the way of security. Back in Vienna in 1864, he had reason to hope all that would change. Keppler had fallen in love with a twenty-three-year-old Viennese actress, Minna Rubens.[21] They married, and after honeymooning in Venice, took up residence in the city of their birth. Keppler's search for employment turned up a plum. He signed a two-and-a-half year contract with the *K.K. Private Theater in der Josefstadt.*

After almost a decade on the road and living out of a suitcase, Keppler now looked forward to steady employment at a good salary: 700 marks a year, plus 2 marks for each performance. Over the next five months, theater director Johann Hoffman cast Keppler in all five *Josefstadt* productions, including a musical entitled *Das Goldatenfind,* in which he gave Keppler the lead. The *Josefstadt* closed out the season early, in April, to make some much needed repairs. It turned out that the theater's finances were also in need of some shoring up. In July, when another Vienna theater director assumed the *Josefstadt*'s debts and its operation, Keppler's contract was not continued.[22]

The summer of 1865 found the Kepplers on the road. Late in the season, both Kepplers signed one-year contracts with the K. K. National Theater in Innsbruck. By this time, Keppler was a recognized star, known throughout Austria as an actor and singer capable of handling dramatic, comedic, and operatic roles. The theater notices plastered about the towns he performed in trumpeted his name in large type. When he gave a special performance at a German playhouse in Bolzano, Italy, in January of 1866, "J. Keppler" received top billing, even above the name of the production. "Frau Keppler" was awarded several bit parts (fig. 4).[23]

In between stage engagements, Keppler painted portraits, listing himself in the Vienna city directory as a painter to drum up business. Apparently, in 1864 or 1865, he returned to the academy to take a course in landscape painting, for which he had a lifelong affection.[24] Also during this period, he contributed car-

toons to the fledgling Vienna humor magazine *Kikeriki!* (Cock-a-doodle-doo!).

From 1863 through 1867, Keppler drew nearly thirty comic, political, and social cartoons for the magazine, the majority of which appeared during the summers of 1864 and 1865. Were it only for the artwork, many of these crudely executed woodcuts would be impossible to identify had Keppler not initialed them. However, their themes mark them unmistakably as Keppler creations, concerning themselves with political and social matters that would occupy Keppler's attention for the rest of his life (figs. 2 and 3). A few decried state censorship and the harsh hand of the Austrian police. Others chronicled the latest takedowns in the political wrestling match between Prussian chancellor Otto von Bismarck and France's Napoleon III. Still others illustrated events and personalities of the Vienna theater world.[25] As a leading Austrian actor and comic, Keppler surely regarded his *Kikeriki!* work as a pastime. Nevertheless, in these cartoons, Keppler expressed his comic impulse graphically for the first time. He learned he could do something with his academy training other than paint portraits.

After their year in Innsbruck, the Kepplers decided to raise a family. Vienna once more beckoned them home. In 1867, Keppler's joy over the arrival of twins was tempered by the sobering financial challenge posed by a growing family. One child died at birth or soon after, however, and the other lived for only a few months.[26] The deaths no doubt left Joseph and Minna disconsolate.

By coincidence at about the same time, Keppler received a letter from his father in America. Twenty years before, Johann Keppler had landed in New Orleans with his two sons and traveled to Minnesota. There a smallpox epidemic ended the lives of both Keppler boys. Eventually, the elder Keppler settled in the little town of New Frankfort in southern Missouri. In the intervening years, he had become one of the town's leading figures as druggist and proprietor of a general store.[27] Typhus was then rampant throughout the countryside. Too many were sick, and too few knew how to treat the infection. Johann Keppler saw this as an opportunity for his aimless son. He urged Keppler to come to America and become a doctor. To Keppler, the thought of a new beginning had irresistible appeal. In late 1867, the twenty-nine-year-old actor and artist, in the company of his wife and brother-in-law Harry, boarded a ship bound for America.[28]

The trio landed in New Orleans and immediately set out for New Frankfort. There, they found Keppler's father, and a tearful reunion, with introductions all around, followed. After a short time, Joseph, Minna, and Harry left for St. Louis, where Keppler planned to enroll in medical school.

In the 1860s, St. Louis was a common destination for ambitious German immigrants. Back home, the machinations of the autocratic Bismarck were edging

the whole of central Europe toward war. This unstable political climate sent thousands of German liberals and intellectuals first to America and then to its most burgeoning city, St. Louis. The influx of fifty thousand Germans swelled St. Louis's population rolls and catapulted the city to the status of fourth largest in America, behind only New York, Brooklyn, and Philadelphia. The country's new railroad lines snaked in and out of St. Louis, connecting it to all major points. Its crowded docks exported the wealth of America's midwest to the world and imported some of the finest goods that new wealth could buy. St. Louis, the geographic heart of the nation, had become in many aspects its commercial and communications heart as well. Several quixotic midwesterners were even lobbying for the removal of the nation's capital to the city of the future on the banks of the Mississippi.[29]

The German community rapidly swallowed up the oldest part of St. Louis, staking its claim to a dozen blocks defined by a busy arcing waterfront. There one could find a German city within a city, with its businesses and pleasures: breweries and publishing houses, beer gardens and German theaters. The more timid immigrant could live a life there largely untouched by American influences.

Many Germans, however, had grander aspirations. And several would fulfill them. Thirty-eight-year-old Carl Schurz, German revolutionary, American Republican, had come to St. Louis just a few months before Keppler to co-edit the St. Louis *Westliche Post*, a leader in the growing number of German press publications in the United States.[30] Twenty-year-old Joseph Pulitzer was one of Schurz's young reporters. Both would move into politics, Schurz on a national level as senator, and Pulitzer on a state level as a legislator. Schurz had even greater political honors awaiting him. Pulitzer would soon discover the newspaper page to be his most effective forum.[31]

This was the vital, up-and-coming community the Kepplers found in St. Louis. Soon after his arrival, either because of soul-searching or preclusive admission requirements, Keppler abandoned his medical aspirations. Instead he became involved in the St. Louis German theater, giving a *gastspeil*, or guest performance, for a twenty-four-night run. Then he, and presumably Minna, joined a traveling theatrical company that took him back to New Orleans and to New York.[32]

Upon his return to St. Louis, he became the manager of the Apollo Theater, a struggling German playhouse. Years later, Keppler contended that when he accepted the position he had had no idea how struggling the theater was. He threw himself into the manager's job, arranging for performances, painting scenery, surveying the books, and undoubtedly acting. But after six or seven weeks, when he realized that he might never be able to pay himself for all his earnest efforts, he quit. Next, he pieced together a living appearing infrequently on stage (fig. 5), painting an occasional portrait, doing some advertising art, and drawing

caricatures to decorate the walls of Bessehl's Saloon, a favored local beer hall. He also tried selling caricatures to St. Louis English- and German-language publications, without luck.[33]

While Keppler could hardly claim a career for himself as either an actor or an artist, he could proudly claim a growing circle of friends. Chief among them were Joseph Pulitzer and Udo Brachvogel. Keppler was amused by the argumentative and excitable young Pulitzer. When their conversations had reached a natural conclusion, Keppler would resort to his standard joke: that he had little left to do but go home and draw Pulitzer's nose. Mercantile librarian Udo Brachvogel proved to be a more thoughtful and supportive companion, later contributing essays to Keppler's publishing efforts. Brachvogel's friendship meant so much to Keppler that he named his son after him. Keppler rendezvoused with them and others at the Planter's House or the Southern Hotel to smoke an after-dinner cigar and enjoy a bottle of champagne. If they were in the mood for a dose of aggressive philosophical inquiry, they rallied with their fellow Germans at Fritz Roeslin's bookstore.[34]

Their drinking, smoking, and camaraderie usually began early in the evening and sometimes did not break up until late into the night. Their conversations roamed over many subjects: the homeland, politics in Europe and the United States, theater, and the press. Many of these German expatriates had fled their homeland to escape the repressive backlash of the failed revolution of 1848; others, more recently, to separate themselves from the intellectually untenable climate created by the rise of Bismarck and the German state. Regardless of when they'd left, both groups shared a violent distaste for royalism, the class system, and the more sordid aspects of politics, with its power seekers and dealers.

Keppler could not argue as effectively as some of his articulate and sharp companions, but he felt as strongly as they did. He was, at thirty, a fully formed cynic, ready to believe the worst about anyone in power or anyone who aspired to it. Rather than reasoned argument, Keppler's exhibitionist tendencies directed his critical energies toward satire. Inevitably, one of the Germans, raised on a hearty satiric dose of *Fleigende Blatter* in Berlin, *Lustige Blatter* in Munich, or, in Keppler's case, *Kikeriki!* in Vienna, would comment on the lack of such a comic paper in the United States. Several unfunny monthlies published in New York caused hardly a ripple on the waters of politics or society. And if a weekly did appear, it would fold from lack of funds just as people began to look for it on the newsstands. One scholar from the period examined this morbid phenomenon and concluded that Americans simply weren't interested in a weekly dose of satire, handed out like so much medicine.[35]

The subject intrigued Keppler. At the time, roughly one out of twenty publications in America was published in German. St. Louis was a center for foreign-

language press activities, serving as a spawning ground for more than a dozen dailies, weeklies, and monthlies published expressly for the German-American.[36] Keppler wondered if he could establish in America a German-language satire magazine like the successful journals of Europe. In the next three years, he would devote all his energies to that task, first with *Die Vehme* and then with *Puck*.

When Heinrich Binder made Joseph Keppler's acquaintance, Binder was the publisher and editor of the St. Louis *Abendzeitung,* one of that city's four German-American dailies. This Viennese refugee of the failed 1848 revolution had earned the respect of his St. Louis colleagues in his stints as an associate editor on the Democratic *Abend-Anzeiger* and on the Republican *Westliche Post.* Professional respect, however, did not pay printer's bills. In an effort to save his struggling daily, he joined with another St. Louis journalist and reincarnated his paper as *Die Neue Welt.* But the daily German-language press in St. Louis was as much a cruel world as a new one, and this venture struggled too. Tired of working so hard for so little, Binder began thinking that the less well-served field of weekly journalism might hold more hope for success.[37]

Enter Keppler, unemployed actor with pronounced drawing ability and sharp satiric bent. In the summer of 1869, Binder sold his interest in *Die Neue Welt* and used those modest funds to bankroll a partnership with Keppler. On August 28, 1869, they brought out the first issue of *Die Vehme, Illustrirtes Wochenblatt fur Scherz und Ernest* (The Star Chamber: An Illustrated Weekly Paper in Fun and Earnest) (fig. 7).[38] Binder and Keppler took their mission seriously, if the title they chose is any indication: The Star Chamber, was the name given to a fifteenth-century court in England that came to epitomize swift and harsh retribution. The hooded figure on the cover echoed this ominous tone. *Vehme*'s black-cloaked executioner threatened, with his sharpened pen, to puncture the stuffed shirts and social sycophants begging for mercy at his feet.

As it turned out, few had to worry about *Die Vehme*'s dark mien. The eight-page weekly was more cheerful than charring, its character set by the gentle humor and graceful line of Keppler's cartoons that dominated the magazine. Keppler drew several full-page cartoons and one double-page cartoon for every issue.

Die Vehme was one of the first periodicals in the United States produced entirely on lithographic presses.[39] The other illustrated periodicals of the period were stereotyped, a process that required all pen and ink art work to be made into woodcuts or steel engravings in order to be printed. *Die Vehme*'s cartoons were printed directly from impressions of Keppler's originals. Such a printing method cut out a middleman, the engraver, whose skill determined the faithfulness of the

finished product. To a caricaturist, the benefits of such an innovation were obvious.

The artist who finds the tool or medium that enhances his or her message is fortunate indeed. Such was Keppler's good fortune when he discovered lithography. No other medium could so express Keppler's ebullient theatrical flourishes. Its soft lines and tones and inherently graceful quality conveyed Keppler's exaggerated romantic outlook perfectly.

Ironically, in *Die Vehme*'s early days, Keppler didn't use the drawing tool that most successfully exploits lithography's liberating qualities, the lithocrayon. Instead, probably out of habit, he used a pen. This unfortunate choice highlighted the quirks and amateurishness of his early likenesses and compositions. After a few months, however, he began using the lithocrayon exclusively and, except for his tenure at Frank Leslie's Publishing House, would never return to pen and ink.

Die Vehme, despite its innovative printing method, was not the most polished of efforts. It wasn't unusual, for example, to find pages of the magazine bound in upside down or backward. At its most prosperous, it claimed a circulation of 2,500.[40] This figure, while respectable by German-language press standards of the period, was not enough to make the magazine a financial success. On August 20, 1870, as it approached its first birthday, *Die Vehme* hung up its magisterial robes.

Soon after, Binder secured financial help from a fresh source, and *Die Vehme* reappeared as *Frank und Frei*. This new incarnation, however, was even less prosperous than its predecessor and folded after two months.[41] Binder, burned twice, returned to daily journalism. Keppler once more looked for work.

Keppler's St. Louis friends remembered him during this period as "a half-starved Bohemian".[42] In his desperate search for employment, he even returned to pastry baking. In later, more prosperous days, Keppler recounted the frustration and humiliation of that time. "I had finished a watercolor picture of which I felt tremendously proud. It was my masterpiece—the portrait of a rich lady—and I had figured on getting a nice piece of change for it. You can imagine my feelings when the lady told me the picture didn't look a bit like her. I spat on it and rubbed the palm of my hand over the face before she had a chance to protest. Then I said to her: 'Madam, you do not wish a portrait which doesn't resemble you,' and I threw it in a scrap heap."[43]

At this professional low ebb, Keppler was dealt a cruel personal blow. Minna died of tuberculosis on December 16, 1870.[44] Unemployed, insecure, and alone, Keppler fell into a deep despondency. In his despair, he painted a delicate tempera that was not so much an homage to his lost love as it was a testament to his sorrows (fig. 6). It featured vignettes of Keppler courting his wife and mourning at her bier around the central image of himself, grief-stricken, stumbling down

an arbor path. His verse inscription speaks of having experienced life's highs and lows, now with but "bitter pain within." To his own question, "How will I approach the evening of my life?" he answered, "I am one of those who die along the way."[45] Fortunately, within a few months, Keppler's sharpest grief passed. As the winter of 1871 covered St. Louis with a blanket of snow, Keppler became involved in the creation of another magazine.

On March 18, 1871 the first issue of *Puck* appeared.[46] Its nameplate sported, in contrast with *Die Vehme*'s haunting representative, a playful cherub, Keppler's version of Shakespeare's merry wanderer of the night. He was clothed in a top hat and tails, and nothing more. In one hand he held a lithocrayon; in the other, a glass of champagne (fig. 9). Twenty-seven-year-old Friedrich Herold,[47] another German transplant and fugitive from the rigors of daily journalism, was editor. Keppler's brother-in-law Harry Rubens was made business manager. Keppler, as illustrator, was the chief attraction and his work, as in *Die Vehme*, dominated the magazine. A survey of his cartoons from both publications shows Keppler to be opinionated, independent-minded, and wide-ranging in vision.

No subject was too large or too small to merit Keppler's attention. His selection of topics during this period had about it an adolescent naiveté and bravado, at once silly and charming. He did not hesitate to mix the parochial with the worldly. One week he might cartoon the dangers of falling bricks at a construction site near his studio, and the next celebrate the end of the Franco-Prussian War. He seemed to take his editorial cues from the concerns and conversations of the street—whatever the topic of discussion at Fritz Roeslin's bookstore or the Lindell Park beer garden was grist for Keppler's cartoons.

Keppler's broad interests led him to draw a good number of satirical cartoons on the doings and fads of daily living. He lampooned such things as the fertile habits of married Germans and the absurd design of ladies' bustles, a fashion that afforded cartoonists much merriment for the entire latter half of the nineteenth century. He drew many commemorative cartoons, usually detailing local events such as the St. Louis Agricultural and Mechanical Association Fair or the German community's 1871 Peace Accord celebration.[48] Politics completed the entertaining mix of subjects. In *Die Vehme* and *Puck* can be found all of the issues and concerns that occupied Keppler's attention a decade later on the national stage.

During Keppler's St. Louis period, Europe was in turmoil (fig. 8) and Count Bismarck was largely the cause of it all. Keppler had ambivalent feelings about Bismarck. The count's militaristic imposition of his policies on Prussia, combined with his reputation for political doubledealing and his military triumph over

Austria in the 1866 Seven Week War, deeply offended Keppler as a liberal and as a Viennese.[49] But the same man created a strong North German Confederation with a constitution that included a bicameral parliament, the lower house of which was elected by the people. Such a bold democratic stroke, no matter how suspect at first, had powerful appeal to Keppler and his fellow anti-royalists.

Even though Keppler read and talked about Bismarck's maneuverings daily, he usually pictured the count merely as a character in the European drama, refraining from expressing opinions about him or his actions.[50] Eventually Germanic pride asserted itself when, in 1870, Bismarck goaded Napoleon III into war. Intellectually, the staff of *Die Vehme* could not approve of Bismarck's wanton aggression, but emotionally they could not deny the appeal of the concept of a unified Germany, especially if it came at the expense of the supercilious Napoleon and his proud-to-the-point-of-grating countrymen. Keppler's comments on Bismarck continued to be guarded, but he relished subjecting the incompetent Napoleon to frequent ridicule, indulging in attacks on his short stature and notorious vanity.[51]

When war broke out between the two countries in July, Keppler devoted most of the cartoons in *Die Vehme*'s last five issues to commentary on the war. His most prophetic cartoon appeared in the last issue. "France Unshackled" showed Germania with her foot on "L'Empire" weeks before America knew of the September 1 capture of Napoleon at Sudan.[52]

The contents of *Puck*'s first issue demonstrated the extent to which German affairs occupied the thoughts of the German immigrant. Begun shortly after the Franco-Prussian War officially ended, *Puck* placed its opening message among advertising to devote its first editorial to the newly established state of peace in Europe.[53] Keppler celebrated the peace accord with an anti-French jab simply entitled "Peace," which pictured a German cat with a French mouse in his mouth. In "The Escutcheon of the New German Empire" (fig. 9), Bismarck dominates a coat of arms that features Napoleon in a cage.[54]

In the weeks that followed, Keppler continued his anti-French campaign, drawing two cartoons inspired by the work of Wilhelm Busch that chronicled the Frenchman's inept and comical efforts to cope with his wounded pride. The aftermath of the peace accord, however, was anything but comical. Keppler watched the rise of communism in France with dismay. When violence and bloodshed resulted, Keppler censured the French for their tragic excesses (fig. 10).[55]

Following Bismarck's triumph over France and his announcement of the formation of the German Empire, Keppler finally gave in to Bismarck's magnetic appeal and drew a celebratory cartoon in line with the sentiments of most German

immigrants. In a cartoon in June of 1871, he portrayed the newly appointed German chancellor in a heroic pose at the helm of the ship "Germania." He captioned the cartoon "The Champion Pilot of the Age" (fig. 11).[56]

After Bismarck and Napoleon, the personality Keppler chose to caricature most often was the pope. Pope Pius IX embodied, for Keppler, the worst of European society: divine right and reactionism. These "evils," combined with the pope's power, truly frightened Keppler. Having been raised in the Catholic Church, Keppler brought to his anti-papacy campaigns a fervor that only a lapsed Catholic could muster. He portrayed the pope not as God's elect but rather as a petty, tyrannical mortal, who led a church that strangled its members in a grip of dogma and greed.

In 1869, the Vatican Council issued the Doctrine of Papal Infallibility, which confirmed the pope's declaration that it was "an error to believe that the Roman Pontiff can and ought to reconcile himself to, and agree with, progress, liberalism, and contemporary civilization." Keppler responded with a council of his own— thirty leading enemies of the Catholic Church—from Luther and Calvin to Jefferson and Garibaldi, all helping to topple the pope from his papal throne. In "Clear the Track: This Train Can't Be Stopped" (fig. 12), Keppler drew the locomotive of "science," "progress," and "the future" barrelling toward a rickety papal cart brandishing the Ecumenical Council banner.[57]

The hero of the day was Johann Döllinger, a Roman Catholic priest who spurned the 1869 Doctrine and was excommunicated. In *Puck*, Keppler featured him in a few cartoons, including a sympathetically drawn double-spread cartoon portrait.[58]

Keppler, although a stranger to the American political process, wasted no time exercising his new-found privilege to criticize those who governed. President U. S. Grant presented an easy target. Unlike those who had lived through the Civil War, Keppler knew of none of the heartache, anguish, and, for the North, ultimate exhilaration associated with those years. Consequently, Keppler would never understand the special hold Grant had on the American psyche. After Lincoln's death, Grant became the embodiment of the bittersweet virtues that triumphed at Appomattox. This sacred role served Grant to the end of his life, blinding even some of the most clear-headed to his political weaknesses and mistakes. Not so Keppler. He became Grant's most astute and persistent critic. In Europe, Keppler had witnessed how easily self-aggrandizing politicians and militarists could destroy the stable and happy lives of average citizens. The naïve Grant was the perfect pawn for scheming powerbrokers. Keppler would spend a significant amount of energy trying to alert others to this threat.

In the early 1870s, Keppler was not obsessed with what would later become an anti-Grant crusade, but he was nevertheless one of the president's most vocal opponents even then. A cornerstone of Grant's domestic policy was the purchase of an island in the Caribbean for colonization by former slaves. Keppler mined this subject for all its comic possibilities, devoting several cartoons to the travails of the San Domingo Commission, which, in carrying out its charge to explore the island, encountered mosquitos, alligators, and heat the likes of which the pampered legislators had never experienced.[59]

Keppler also had an opinion on the political matter of purchasing countries. In "An Economical Administration," Uncle Sam, already burdened with economic woes, says, "The only consolation I have got is the promise made by my steward Ulysses to retrench expenses and inaugurate the most stringent economy." Grant meanwhile covetously eyes a St. Thomas parrot, a San Domingo white elephant, and a Cuba boa constrictor.[60]

Keppler was not alone in his criticism of the president. Many liberal Republican intellectuals had trouble with the thought of a second Grant term. A split in the Republican party loomed more and more likely a year before the nominating conventions were to meet. Keppler decried the impending split, although his sympathies clearly lay with the so-named Liberal faction.[61]

One of the leaders of the Liberal Republicans was St. Louis's own Carl Schurz. Keppler heralded the community's most famous citizen by contrasting the "Triumphal Entrance of U. S. Grant in St. Louis," which showed the president being greeted by one man, with the "Reception of Carl Schurz in St. Louis," which showed the senator being welcomed by a throng of cheering supporters. In the same issue, he drew a double-spread cartoon portrait of Schurz poised and ready to flick a Lilliputian Grant into oblivion (fig. 13).[62]

When Horace Greeley, publisher of the anti-Grant *New York Tribune*, looked to be the Liberal Republican candidate, Keppler drew him weighing the might of his pen against the glory of Grant's sword. The next week Keppler cartooned Greeley's trip to Memphis to meet with Jefferson Davis. The caption: "A Late and a Future President Meet Each Other." As the election year neared, Keppler stepped up his criticism of Grant, picturing him as an opportunist bent on retaining the White House and, in a somewhat confused analogy, as a fish in a sea of corruption.[63]

The big political story of the year was happening in New York, where *Harper's Weekly* cartoonist Thomas Nast and the *New York Times* were taking on the corrupt, all-powerful Tweed Ring that ran the city. In September, Keppler wistfully pictured the ring with bags packed, marching out of office. The caption

read, "Farewell, a Long Farewell to All Our Greatness." A month later, in "The Fate Which They Deserve" (fig. 14), Keppler drew one of his most gruesome cartoons, relieved only by its comic caricatures. It showed the members of the Tweed ring strung up on hangman's posts and crucifixes, left to the wild dogs and buzzards.[64]

In late October, Keppler drew a cartoon that may well have inspired Nast's famous work "The Tammany Tiger Loose" (fig. 16), which was published three weeks later. In "Who Will Conquer[?]" (fig. 15), Keppler showed Lady Justice grappling with the Tammany Tiger ("Corruption") in a coliseum. While Keppler's treatment compares poorly to Nast's later artful and dramatic rendering of the same idea, the similarities between the two works are difficult to ignore.[65]

St. Louis was not without its political wrongdoings as well. Keppler had his own little Tammany rings in a financial scandal involving officers of the Northern Missouri and Pacific railroad. He celebrated the earnest local prosecutors and delighted in imagining the culprits in hell's inferno.[66]

Keppler's St. Louis cartoons are of interest primarily because they foreshadow so much of his later, more mature work. Not that these cartoons, judged by themselves, are lacking in merit. Keppler was undeniably one of the most skilled artists engaged in cartooning during the period. And his natural sense of fun is evident in many of the pieces. But much of his St. Louis work lacks power. This is due in some cases to awkward composition, in others, to convoluted or weak concepts, in still others, to a lack of passion for his subject matter. Because he favored cleverness over commentary, many of his opinions, although evident, were stated mildly. This would change in the years ahead, as he followed current events for professional as well as personal reasons. In St. Louis, Keppler proved to have a natural talent for cartooning. As his interest and political opinions deepened and matured, he transformed that natural talent into mastery.

Puck's launch in March of 1871 had done much to buoy Keppler's wilted spirit. By late spring, his life with Minna had become a sad memory. Now Keppler looked to the future, because once more he was in love. One of the St. Louis drinking establishments he had come to frequent was Theodore Pfau's *Flora-Garten*. There he had met Pfau's nineteen-year-old daughter, Pauline. On June 28, 1871, they were married in a civil ceremony. Five weeks later, on August 3, undoubtedly to placate Pauline's parents, they repeated their vows in front of a minister of the gospel.[67] By that time, young Mrs. Keppler was pregnant. Unfortunately, this happy news was overshadowed by the death, on August 11, of *Puck* editor Herold.[68] His passing cast doubt on the magazine's future.

For several months, *Puck* had no official editor. Keppler turned to Brockvogel and other writers in his circle to help continue his struggling magazine. In October, Rubens enlisted H. Kullmer as co-publisher. The next month he relinquished the position to Kullmer entirely, saying good-bye to his brother-in-law and heading for Chicago to study law. For a while, Keppler apparently shouldered sole financial responsibility for the magazine.[69]

Puck was beset with a variety of petty problems. Unscrupulous agents failed to deliver copies of the magazine as promised. Pipes broke in the press room, delaying publication. A staff member was called to jury duty, postponing the magazine's appearance yet again. These headaches, on top of the larger financial problems, proved so draining that when Keppler found a purchaser for *Puck* in November, he withdrew entirely from the magazine.[70]

Puck's new owner and editor was Louis Willich,[71] a German-American journalist and poet, as well-known in the St. Louis German community, it seems, for his remarkable girth as for his intellect. Willich hired two artists, Fritz Welcker and C. C. Zeus, to replace Keppler. Welcker was talented, especially as a caricaturist, and Zeus, while an inferior graduate of the F.O.C. Darley school of feather-line illustration, added another dimension to *Puck*'s graphic offerings.

The new *Puck*, however, paled in comparison to its predecessor. Willich contracted the editorial and graphic content of the magazine into eight pages, giving over the remaining six to advertising. He abandoned Keppler's delicate and subtle (perhaps too subtle) nameplate for a coarse, amateurish one drawn by Welcker. And in an effort to save money, he began printing *Puck* on a cheaper grade of paper.

But Willich was no piker. He had grand plans for the magazine. Because he was nearly as facile a writer in English as he was in German, he had purchased *Puck* with the idea of producing an English-language version of the magazine as well. Undoubtedly many non-Germans had expressed admiration for Keppler's cartoons, which probably explains why he captioned them in English and German. But before Willich's ownership, the captions were the only thing in the magazine in English.

Initially, the launch of *Puck*'s "English-speaking brother" was set for the new year, but Willich, finding that date to be too ambitious, had to defer the project. In the meantime, Willich lured Keppler out of his short-lived retirement by offering him the vice-presidency of the Puck Publishing Company and a share of the profits. With Keppler fortifying *Puck* artistically, Willich reinstated his plans to introduce an English-language version, this time on March 16, *Puck*'s first birthday.[72]

Reflecting on the magazine's first year, Willich wrote: "*Puck* [has] felt sometimes like the poor actor . . . who must, although he has nothing to eat at home, play the bon vivant. Nevertheless [*Puck*] intends . . . to celebrate his birthday in the coming week full of hope, faith, and humor."[73] The image was apt. He could just as well have been referring to his impoverished but ever sociable artist, Keppler.

Despite trying circumstances, Willich and Keppler launched the English *Puck* with hope, faith, and humor on March 23. The tardiness of the launch, one week later than planned, was now a depressingly chronic characteristic of the feeble publishing firm. To distinguish the English Puck from his German brother, Keppler Americanized the impish mascot that had become identified with the German *Puck* (fig. 18). He clothed him in a beaverskin top hat and, for the more delicate American sensibilities, red, white, and blue-striped undershorts.

The dress was different, but the weekly's politics remained the same. In April, Keppler placed *Puck* at the head of "The Grand (Not Grant) March to the Cincinnati Convention," where the Liberal Republicans planned to nominate Greeley. The following week, in contrast, he drew "The Grant Guard Marching to Philadelphia," which showed Grant at the head of a procession of post office, custom house, and internal revenue employees bowed in slavelike submission to their master.[74]

In May, Keppler portrayed Greeley as a farmer toiling in a field full of the weeds of "nepotism" amd "corruption." In provocative contrast to the pro-Greeley cartoons Keppler had done in the last year, in this cartoon Keppler allowed that Greeley was "not quite the choice [of the German-Americans]." But he goes on to exhort, "we ought to help the old man to get hold of this glorious farm and prevent . . . the present lessee . . . from ruining it, which is sure to happen if we Grant him another lease for four years."[75]

In "Ulyses [*sic*], the Moor of Galena," Keppler cast Grant as Othello in Desdemona/Corruption's embrace. Desdemona says, "The heavens forbid but that our loves and comforts should increase." Greeley, whom Keppler oddly casts as the treacherous Iago, swears, "O, you arc well tuned now. But I'll set down the pegs that make this music."[76]

Election year interest in politics undoubtedly helped the dual editions' fortunes. By late spring, the combined circulation of both magazines reached five thousand, a soaring improvement over the German *Puck*'s 1871 average circulation of one-fifth that number.[77] But the logistics and responsibilities involved in producing dual editions proved more than Willich could handle. In the last weeks of spring, *Puck* began to sputter. Two Saturdays in June came and went without

Puck's appearance. Willich was struggling to hold it all together. Keppler knew it and took steps to protect himself from *Puck*'s imminent collapse.

He made two important moves. The first was to bring his work to the attention of publisher Frank Leslie in New York. In late June, Keppler sent him an illustration of the 1872 Sangerfest celebration (fig. 20), that year held in St. Louis, and invited him to use it in his *Illustrated Newspaper*, one of the leading news magazines of the day. Leslie did just that in his July 6 issue, giving over a full page to the first contribution to *Leslie's Illustrated Newspaper* by St. Louis artist "Jas. [*sic*] Keppler."[78]

The second move, in July, was signing on with a new St. Louis weekly, *Unser Blatt* (Our Newspaper), launched July 20. Each issue of this German-American literary and social magazine featured a distinctive nameplate and several pieces of artwork by Keppler. Many of his contributions were scenic illustrations of such places as Pike's Peak, Colorado, or sketches of St. Louis locales such as Lindell Park. But the *Unser Blatt* management encouraged him to do some political cartoons as well.[79]

Continuing his anti-Grant assaults in *Unser Blatt*, Keppler drew "A Dream— The Awakening" (fig. 19) in August. This cartoon showed Grant dreaming of himself enthroned and being treated to gifts by a crowd of kneeling supplicants. He is, however, only a moment away from being rudely disturbed. Schurz and friends stand posed around his bed with brooms in hand ready to awaken him.[80]

Two weeks later, Keppler caricatured "The German Press of St. Louis." He drew his friend Pulitzer, who had the year before bought into the *Westliche Post* partnership, with lasso in hand, presumably laying in wait for the big story. And he pictured his beloved Puck, pathetically enough, drinking beer, kicking up his heels, and holding a fistful of unwanted stock notes labeled "$25 only."[81] The characterization was accurate. *Puck*'s continuing financial troubles forced Willich to skip publication of two more issues in August. The *Puck* of August 24 proved to be the last.

Puck's demise prompted Keppler to make a momentous decision. The birth, on April 4, of his and Pauline's first child, a boy, fortified his determination to lift his small family out of the hardscrabble existence he had come to know so well. When Frank Leslie accepted his Sangerfest cartoon, Keppler began weighing his chances of success in the publishing center of the United States. Then, *Puck* folded. In September, Keppler decided to move to New York City.

In his first few months there he primarily did commercial work, although he continued to contribute an occasional cartoon through the mails to *Unser Blatt*. One of his last pieces for that weekly was a slam at German-born political car-

toonist Thomas Nast. In "Isn't That Nasty?" (fig. 21), Keppler took Nast to task for criticizing Carl Schurz, whom Nast suggested should go back to his homeland if he had problems with American leaders such as Grant. The cartoon is boldly drawn, and the caricature of Nast particularly fine.[82]

In October 1872, Keppler had reason to have Nast on his mind. Nast was America's greatest political cartoonist, celebrated in the United States and abroad, feted at the White House, lauded in the press, and in 1872, at the very height of his power. Keppler had reason to have Nast on his mind, because he had made it his professional goal to become Nast's chief rival.

Figures 1–21

1. Keppler in school. Academy of Fine Arts Professor Peter Johann Nepomuk Geiger awakened Keppler's artistic appreciation of human anatomy. His influence on Keppler is particularly evident in the way in which Keppler drew women. The illustration is from Geiger's historical panorama, *Memorabilien aus der Europäischen Geschichte* (*Daybook of European History*), with text by Joseph von Bülow, (New York: von Bülow, 1860). The inset is from an 1881 Keppler cartoon. (The German Society of Pennsylvania and author's collection; *Puck*, July 27, 1881)

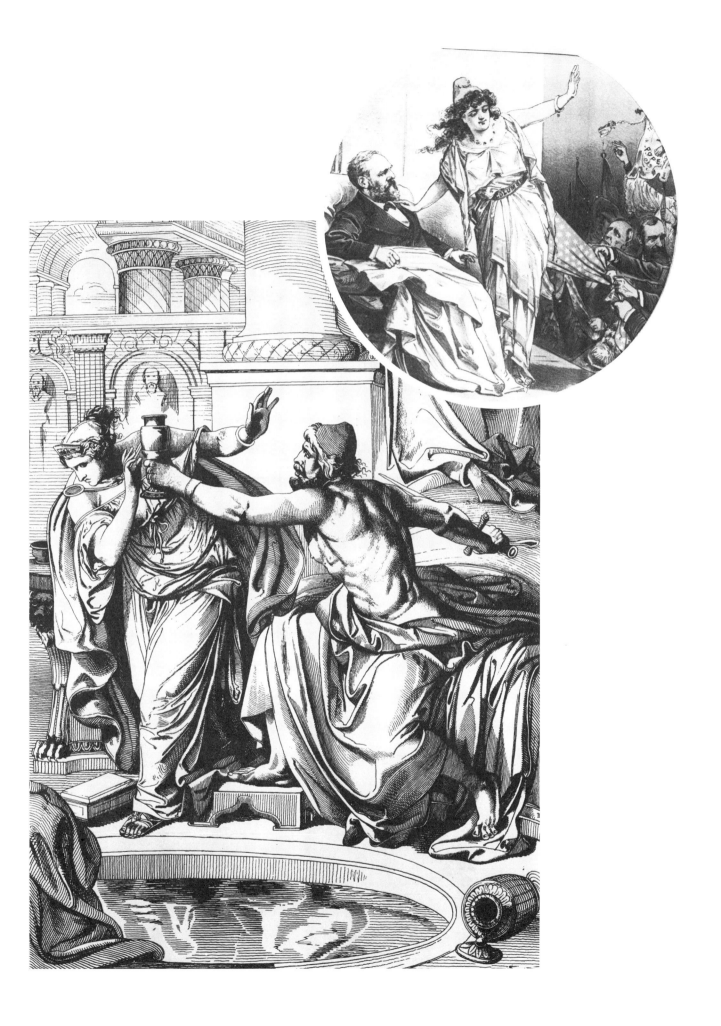

2. *Kikeriki!*, a Vienna humor magazine founded in 1861, published about thirty woodcuts by Keppler from December 1863 to October 1867. Accompanying the caption "Debts Equal Arrest," Keppler drew Vienna's debtors' prison. The headline reads: "All Houses Complain About the Lack of Tenants—Except This One." (University of Massachusetts at Amherst; *Kikeriki!*, Nov. 10, 1864)

Erscheint jeden Donnerstag
und kostet loco Wien vierteljährig 60 fr.
Für die Provinz:
mit portofreier Zusendung 80 fr.
Einzelne Blätter kosten
5 fr.

Vierter Jahrgang.

Redaktion: Mariahilf, Getreidemarkt 3.
Administration
wohin die Abonnements zu richten sind und
wo Inserate angenommen werden
Stadt, Wollzeile Nr. 30.
Zuschriften werden nur frankirt angenommen.

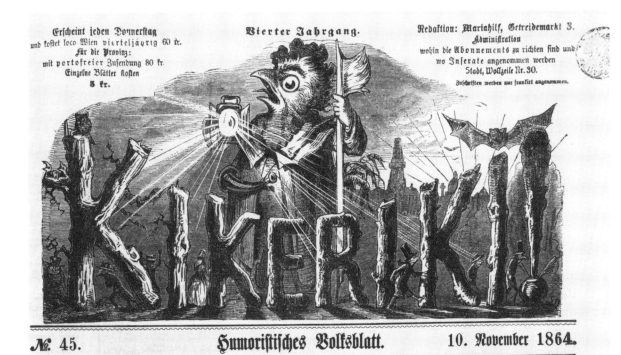

№ 45. Humoristisches Volksblatt. 10. November 1864.

Alle Häuser haben zu klagen über Mangel an Partheien — nur nicht der:

Schulden = Arrest.

3. The Austro-Prussian War of 1866. Keppler damned Prussian Chancellor Bismarck's arrogance and Austria's bravado during this seven-week conflict, which consolidated Bismarck's power and humiliated the Austrian people. Under the title, "It Had to Come to This," Keppler's black caption reads: "This is the result, that's what you got/ from your deadly saber strokes/ How hard it is, you must admit/ to shake each other's hand again." (University of Massachusetts at Amherst; *Kikeriki!*, Aug. 2, 1866)

4. Keppler the actor. In January 1866, Keppler took a brief leave from the Innsbruck K. K. National Theater to stage a comedy benefit just across the border in a German playhouse, the Bozen (or Bolzano) Theater, in Bolzano, Italy. Notice his headliner status. During his last few years in Austria, he invariably received top billing. Frau Keppler joined him on stage in this production, playing several roles in the third play "The Final Journey." (New-York Historical Society)

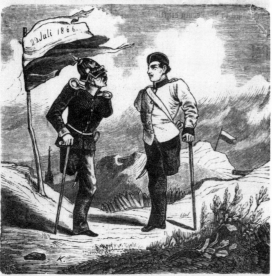

So mußte es kommen.

Das ist nun die Folge, das habt Ihr jetzt
Von Euren tödtlichen Streichen,
Wie schwierig ist's, gesteht es nur,
Die Hände sich wieder zu reichen?

Theater in Bozen.

Samstag, den 13. Januar 1866.

Benefize des Komikers

J. Keppler.

Zum Erstenmale:

Buch III. Capitel I.

Lustspiel in 1 Akt, frei nach dem Französischen von A. Bahn.
(Leiter der Vorstellung Herr Stefan.)

Personen:

Edmund von Mailly	Herr Arnau.
Lucile, seine Gattin	Fräulein Viola.
Eduard Dumont	Herr Stefan.

Hierauf zum ersten Male:

Eine verfolgte Unschuld

Posse in 1 Akt von Anton Langer.

Personen:

Lorenz Maier, Privatier	J. Keppler.
Isidor Maier, sein Neffe	Herr Arnau.
Helene Maier, seine Gattin	Fräul. Rudolf.
Peter, ein Diener	Herr Lung.

Die Handlung spielt in Maiers Zimmer.

Zum Schluß zum ersten Male:

Die letzte Fahrt oder: Ein alter Postillon.

Ländliches Gemälde mit Gesang in 1 Akt von J. Grün.

Personen:

Graf Felsberg	Herr Arnau.	Röschen	Frau Keppler.
Ehrmann, sein Sekretair	Herr Glück.	Peterl	
Schleichmann, Verwalter	Herr Weidenkeller.	Hansel seine Kinder	
Blasius, Ortswächter	Herr Graubner.	Toni	
Peter Felling, ein ehemaliger Postillon	J. Keppler.	Franz Eichner, ein junger Bauer	Herr Lung.
Mathias, sein Sohn, Pächter	Herr Stefan.	Mirzl, eine Bäuerin	Fräul. Schiller.
Suse, sein Weib	Fräul. Welz.	Die Handlung spielt am Morgen und endet Abends.	

☞ Zwischen dem I. und II. Akt, ferner II. und III. Akt wird Signor:

Antonio Bonato di Bassano,

Concertist auf dem von ihm selbst erfundenen Harmonium folgende Piecen executiren:

I. Gran Sinfonia nell'Emma d'Antiochia, capel M°. Mercadante. II. Trovatore Miserere, capel M°. Verdi.
III. Duetto Norma, capel M°. Bellini.

Verehrungswürdige!

Indem der Gefertigte keine Kosten gescheut und durch sorgfältige Wahl der Stücke den geehrten Gönnern einen recht vergnügten Abend zu verschaffen bemüht war, hofft selber vertrauungsvoll auf einen zahlreichen Zuspruch. Dero ergebenster

J. Keppler, privil. G'spaßmacher.

Preise der Plätze:

Sperrsitz 42 fr. — Logen und Parterre 32 fr. — Gallerie 15 fr.
Garnison vom Feldwebel abwärts: Parterre 20 fr. — Gallerie 10 fr.

Kassa-Eröffnung ½6 Uhr. — Anfang ½7 Uhr. — Ende nach 9 Uhr.

Z. N. St. G. Druck von G. Ferrari vorm. Eberle.

5. The many faces of Joseph Keppler. The broadside reads: "The Comic Actor and Mimic Joseph Keppler in His Remarkable Character Performance." At one time or another, Keppler (featured without make-up in the center) played all of the characters in the surrounding ovals. Keppler drew this self-promotion around 1869, when he was in desperate need of work. (New-York Historical Society)

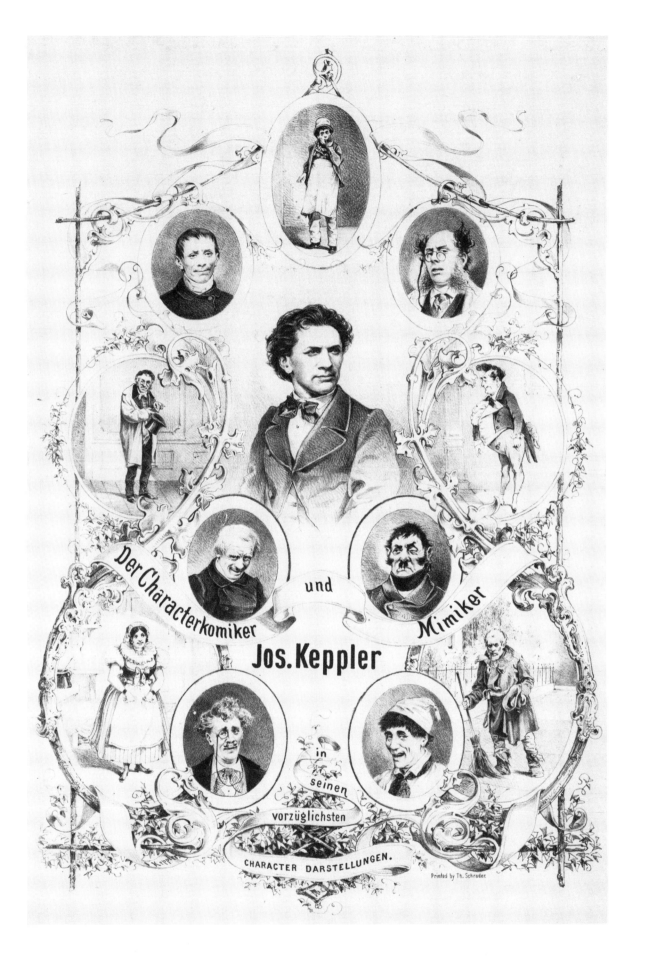

Der Characterkomiker und Mimiker

Jos. Keppler

in seinen vorzüglichsten

CHARACTER DARSTELLUNGEN.

Printed by Th. Schrader.

6. Keppler's tribute to his first marriage. This tempera painting was finished December 31, 1870, two weeks after Keppler's first wife, Minna, died of tuberculosis in their St. Louis home. The strained and awkward verses accompanying the vignettes do not speak well of Keppler's abilities as a poet: "I have walked many paths/And have taken some bitter steps/ And ever my heart, in fright and longing, asks/How will I approach the evening of my life?/So have I been in richly decorated halls/And when hope let all its blossoms fall/Reality also drooped for me/Now I quietly carry the bitter pain within/I am one of those who die along the way." (Draper and Sarah Hill collection)

"Aus meinem Leben"

So bin ich schon so manchen Weg gegangen —
So hab ich manchen bitteren Schritt gethan
Und immer fragt das Herz in Angst u. Bangen
Wie werd ich mich des Lebens Abend nahen?
So war ich schon in reichgeschmückten Hallen

Hab manchen Berg u.
manches That gesehen

Und liefs die Hoffnung
einmal Blüthen fallen

Liefs Wirklichkeit sie mich auch welken sehen
Und still trag ich in mir den Schmerz den herben
Ich bin von denen die am Wege sterben!

Zum Benefize d.

Wien.

31. Dec. 1870.

Souvenir
louis

7. **Die Vehme.** Keppler founded this comic weekly with newspaper veteran Heinrich Binder on August 28, 1869. It lasted for one year. Initially eight pages long, *Die Vehme* grew to fourteen pages per issue, counting advertising. Although no price is printed on the cover, *Die Vehme* cost 10 cents. (New York Public Library; *Die Vehme* Oct. 2, 1869)

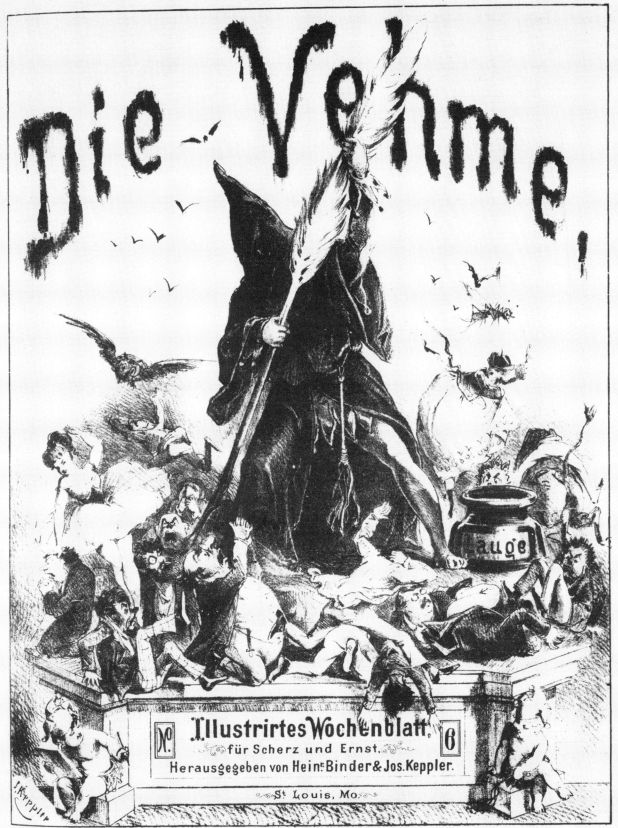

Die Vehme,

Illustrirtes Wochenblatt,
für Scherz und Ernst.
Herausgegeben von Hein: Binder & Jos. Keppler.
N⁰. 6
St. Louis, Mo.

Steam Lith. Press of R. P. Studley & Co.

8. "Different Dreams in Hotel Europe." In this playful cartoon, Keppler pictured the wistful hopes of four European leaders. Napoleon, in exile in England, dreams of the execution of French politicians Jules Favre, Adolphe Thiers, and Émile Ollivier. Thiers, France's new president, dreams of starting a dynasty. Franz Josef dreams of the submission of the unruly elements within his Austro-Hungarian empire. Bismarck, meanwhile, dreams of Josef's Austria under his control. (Author's collection; *Puck* [St. Louis], Sept. 2, 1871)

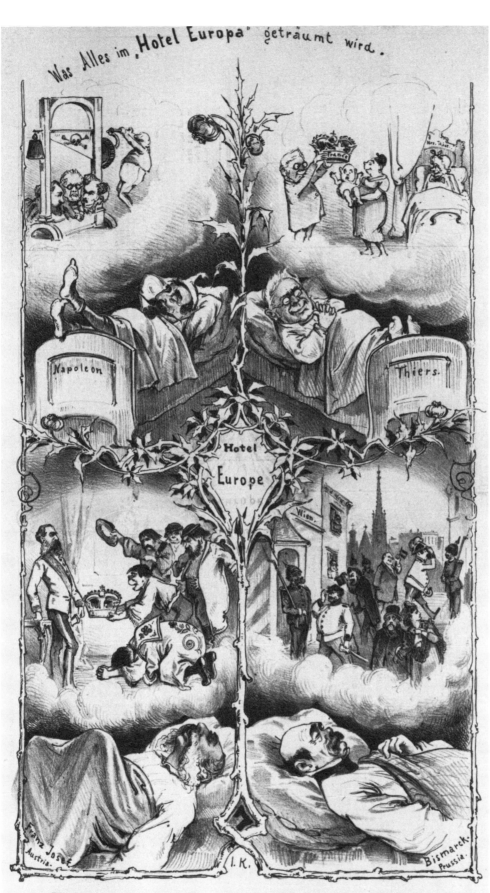

Different dreams in Hotel Europe.

9. The St. Louis *Puck* was Keppler's second entry in the comic weekly field. Unlike *Die Vehme*'s unchanging front cover, *Puck*'s half-page nameplate allowed for a different cover each week. Usually it sported a Keppler cartoon; occasionally, a poem. This cover cartoon, "Escutcheon of the New German Empire," celebrates the de facto end of the 1870 Franco-Prussian War, when Chancellor Bismarck's German troops captured Napoleon III at Sedan in northeast France. (Author's collection; *Puck* [St. Louis], March 25, 1871)

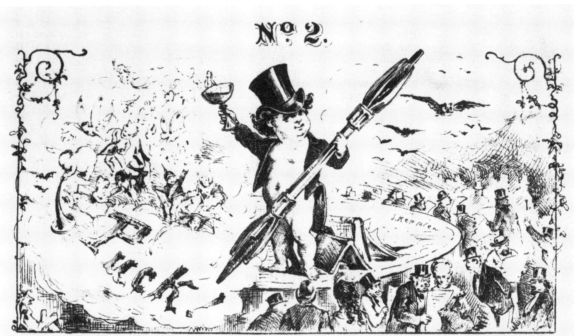

Redigirt von E. HEROLD Illustrirt von J. KEPPLER. Geschäftsführer H. RUBENS.

Escútcheon of the new German empire.

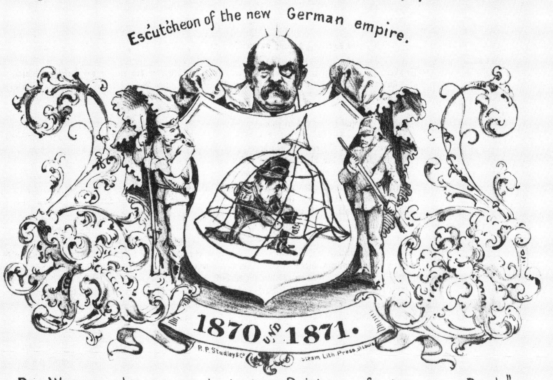

1870 und 1871.

Das Wappen des neuen deutschen Reiches, erfunden vom „Puck".

10. "Intoxicated with Blood." Despite Napoleon's surrender, Paris republicans refused to submit to the German army. The Germans lay siege to the city for four months. After the French National Assembly, sitting at Versailles, accepted the terms of the Franco-Prussian peace treaty, and the Paris leaders still refused to capitulate, French forces besieged Paris. In the final desperate days of their resistance, the Paris republicans, known as "Communards," burned some of the city's finest buildings and executed provisional government sympathizers. In the cartoon, Keppler's skeleton of death wears the cap of the French Communard. After Keppler drew this cartoon, word came from Paris of even greater violence. When the city finally fell to Assembly forces, tens of thousands of Paris revolutionaries were put to death. (Author's collection; *Puck* [St. Louis], June 3, 1871)

Intoxicated with Blood.

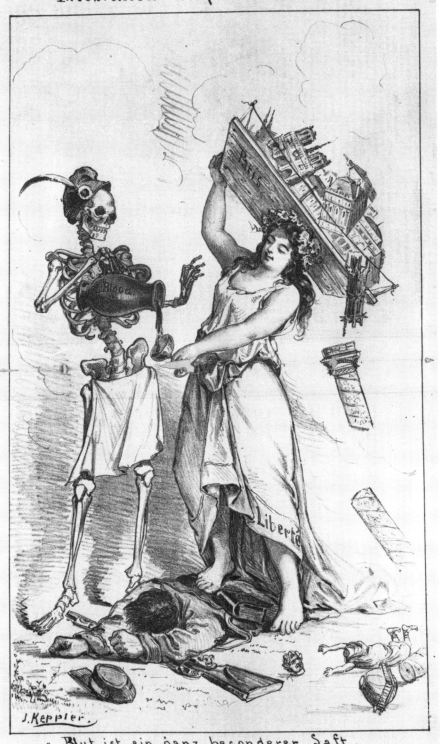

„ Blut ist ein ganz besonderer Saft.

11. "The Champion Pilot of the Age." Following the close of the Franco-Prussian War, civil strife threatened to destroy the French nation. In contrast, Germany, under the strong and visionary leadership of Chancellor Bismarck, had never been more united. With the defeat of the French and the unification of Germany, Keppler's previously ambivalent feelings toward Bismarck were overcome by national pride. (Author's collection; *Puck* [St. Louis], June 10, 1871)

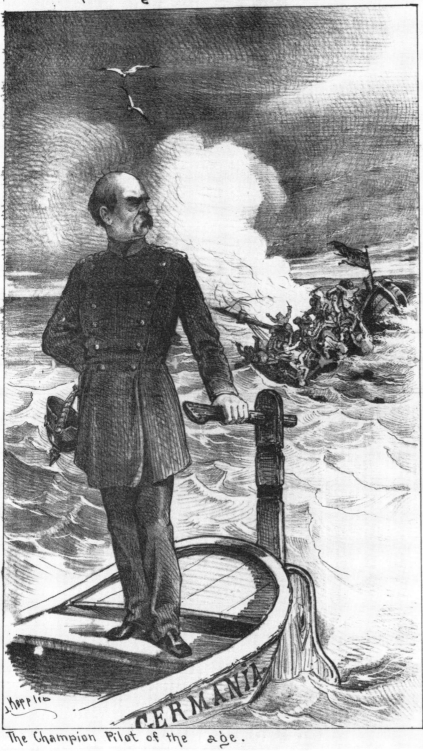

The Champion Pilot of the age.

12. "Clear the Track: This Train Can't Be Stopped." Keppler had been raised a Catholic, but was won over by the democratic, anti-clerical spirit of the mid-nineteenth century. This cartoon was prompted by the Ecumenical Council's support for Pope Pius IX's Doctrine of Papal Infallibility, which asserted that he did not have "to reconcile himself to, and agree with, progress, liberalism, and contemporary civilization." (New York Public Library; *Die Vehme*, April 9, 1870)

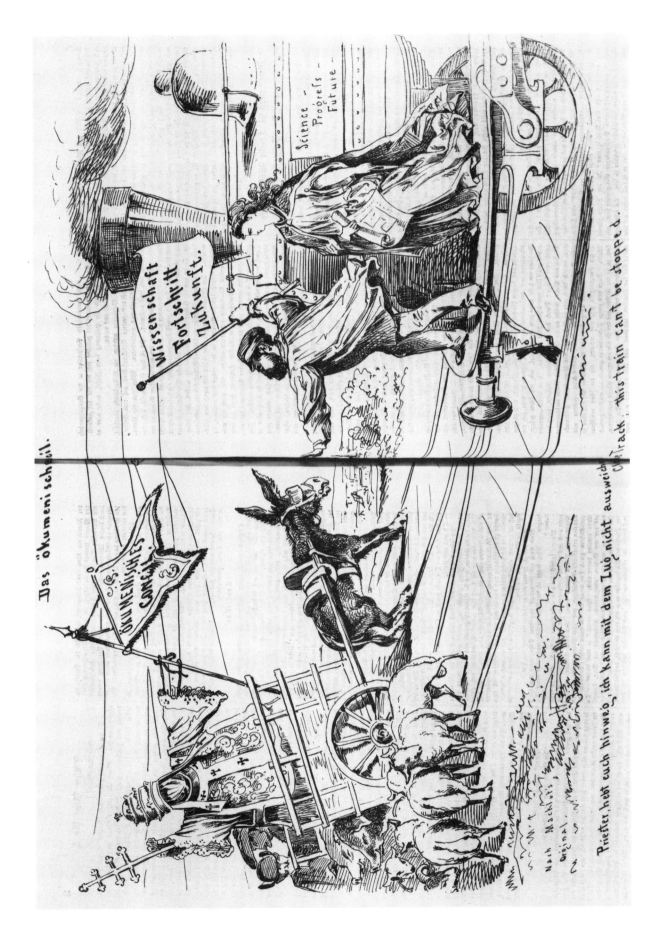

13. "Our Western Men." Germanic pride and loyalty to his new home of St. Louis prompted Keppler to draw this flattering portrait of Carl Schurz, the most prominent German-American immigrant. Although Keppler never really got to know Schurz personally, he nearly always supported the Republican reformer in his political cartoons, for which Schurz was grateful. (New York Public Library; *Puck* [St. Louis], May 13, 1871)

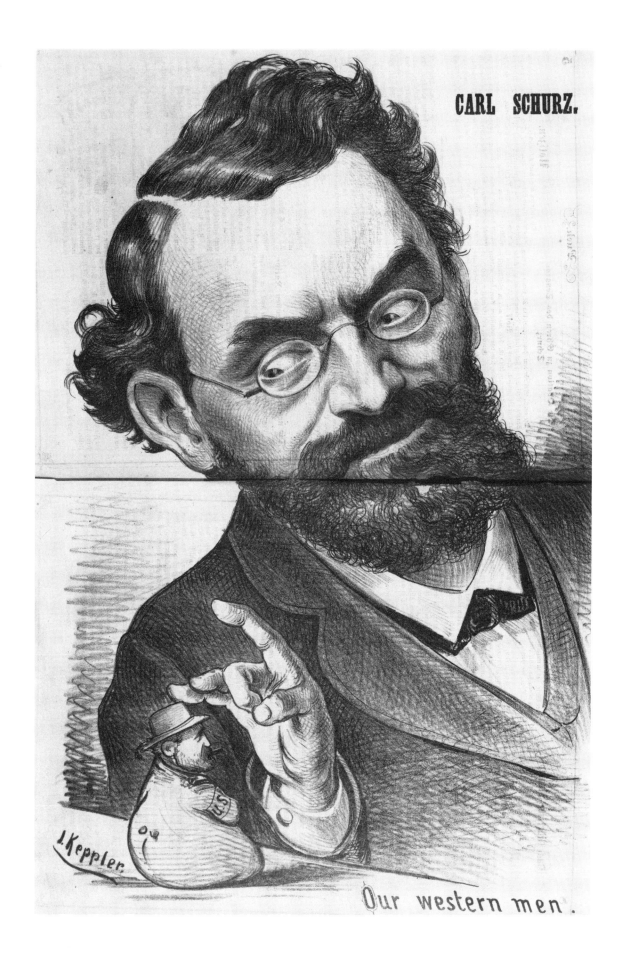

CARL SCHURZ.

J. Keppler.

Our western men.

14. "The Fate Which They Deserve." In 1871, the corrupt Tweed Ring of New York City was fighting for its political life. In response to a cartoon that appeared in the New York comic weekly *Wild Oats*, which showed Tweed and his cronies in jail, Keppler drew what he thought was a more appropriate punishment. (New York Public Library; *Puck* [St. Louis], Oct. 8, 1871)

THE FATE WHICH THEY DESERVE.

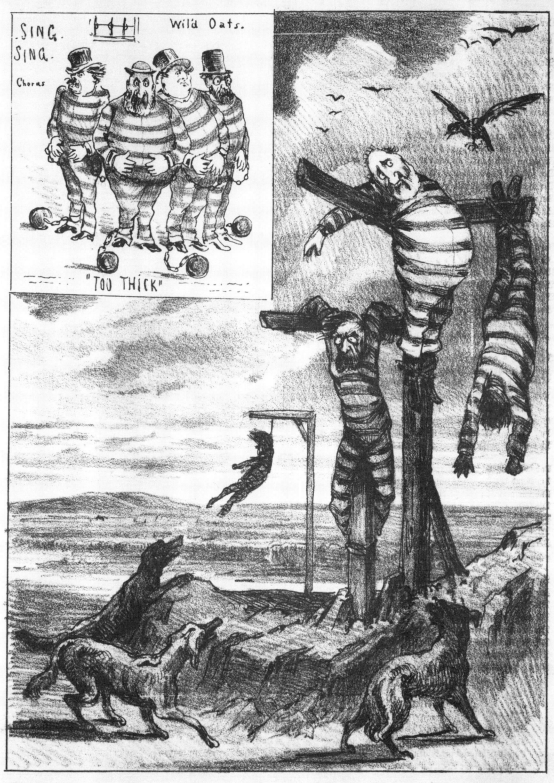

Was mit den Tammany Gaunern geschähe, wenn Puck ihr Richter wäre.

15. **"Who Will Conquer [?]"** As New Yorkers prepared to go to the polls to decide the fate of the Tweed Ring, Keppler drew the states as spectators to this struggle for reform. The tiger, a symbol popularized by Thomas Nast, represented Tammany Hall, the political organization run by Tweed. (New York Public Library; *Puck* [St. Louis], Oct. 22, 1871)

Wer wird siegen?

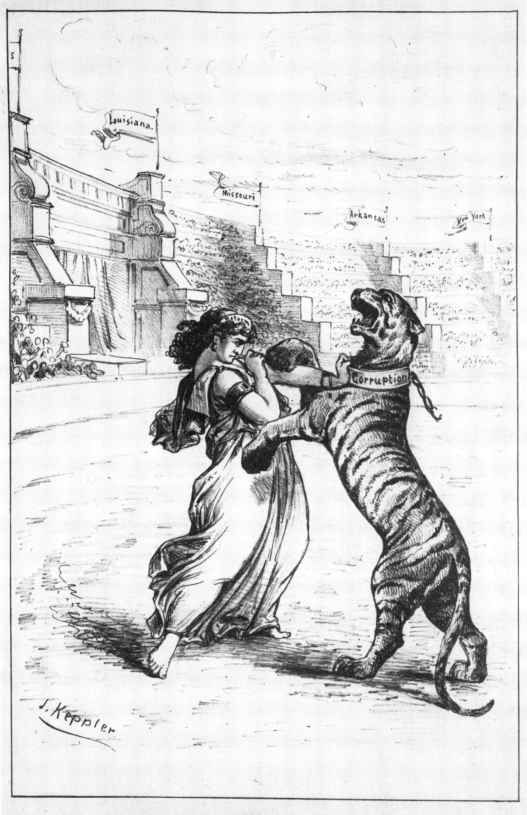

J. Keppler

Who will conquer.

16. "The Tammany Tiger Loose." Three weeks after Keppler's "Who Will Conquer [?]", *Harper's Weekly* cartoonist Thomas Nast drew this striking cartoon, the climax to his year-long campaign against the Tweed Ring. The similarities between the two cartoons are obvious, but Keppler has never been cited for having anticipated, and perhaps inspired, Nast's great work. (Author's collection, *Harper's Weekly*, Nov. 15, 1871)

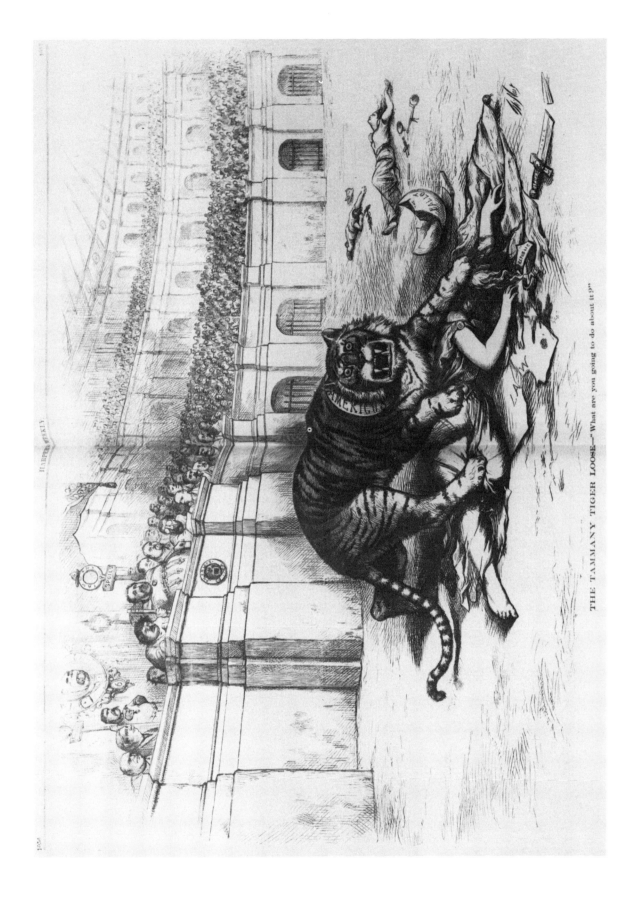

THE TAMMANY TIGER LOOSE—"What are you going to do about it?"

17. "The 15th Amendment Illustrated." When Keppler arrived in America, he supported women's suffrage, as this cartoon demonstrates. Four months earlier, in *Die Vehme*'s New Year's cartoon, he wished for, among other things, "suffrage" and "equal rights." But his feelings on this matter soon changed, possibly due to the increasingly radical pronouncements of feminist leaders Susan B. Anthony and Victoria Woodhull. In his June 3, 1871, *Puck* cartoon "The Two Factions of the Woman's Suffrage Party," Keppler belittled the female suffragist, characterizing her as either a "sweet talker" or a "demander." The following month, in *Puck*'s 1871 Fourth of July cartoon ("Hail Columbia," July 8, 1871), Keppler came out for "soft-minded women." Forever after, he freely ridiculed the female suffrage movement and its leaders. (New York Public Library; *Die Vehme*, April 2, 1870)

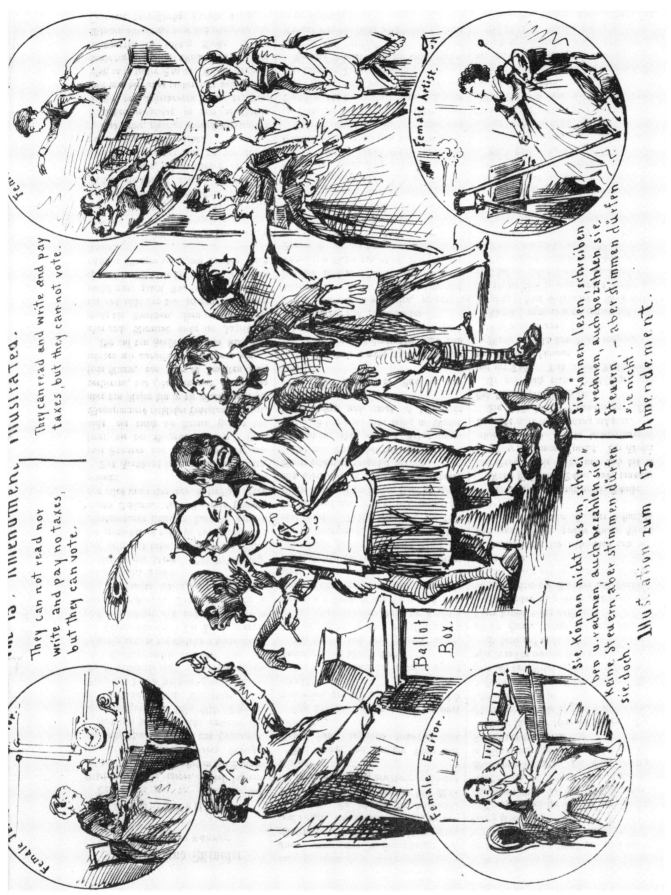

18. The English St. Louis *Puck*. *Puck*'s new owner ambitiously launched an English-language edition of the magazine on March 22, 1872. It lasted twenty issues. (Missouri Historical Society, *Puck* [St. Louis], March 22, 1872)

Howard and Boyle's Restaurant, No. 3 North Fifth street. v. 2.

NO 2 **PUCK** 2ᵀᴱᴿ JAHRGANG

A. McLEAN STEAM LITH. ST. LOUIS, MD.

PUB. BY THE PUCK PUBLISHING CO. L. WILLICH. EDITOR.

BAPTIZING PUCK.

19. "A Dream—The Awakening." The sleeping Grant dreams of himself enthroned, receiving tribute-bearing office holders, who say to him, "Your majesty, we're coming to pay our respect." But members of his own party, the Liberal Republican faction led by Charles Sumner, B. Gratz Brown, and Carl Schurz, have a different idea. They hover over the sleeping Grant and say, "We're coming to cleanse the White House." (Missouri Historical Society; *Unser Blatt*, Aug. 3, 1872)

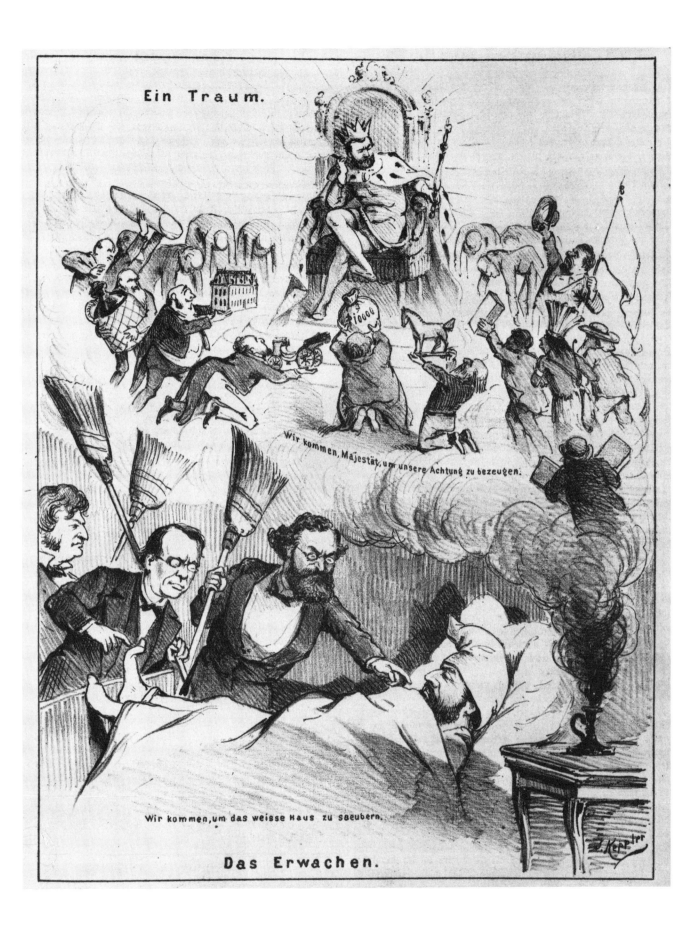

Ein Traum.

Wir kommen, Majestät, um unsere Achtung zu bezeugen.

Wir kommen, um das weisse Haus zu saeubern.

Das Erwachen.

20. **"St. Louis Sangerfest."** This illustration of the famous German-American annual festival was Keppler's first work published in *Frank Leslie's Illustrated Newspaper*. He joined Frank Leslie's staff five months later, in November 1872. (Author's collection; *Frank Leslie's Illustrated Newspaper*, July 6, 1872)

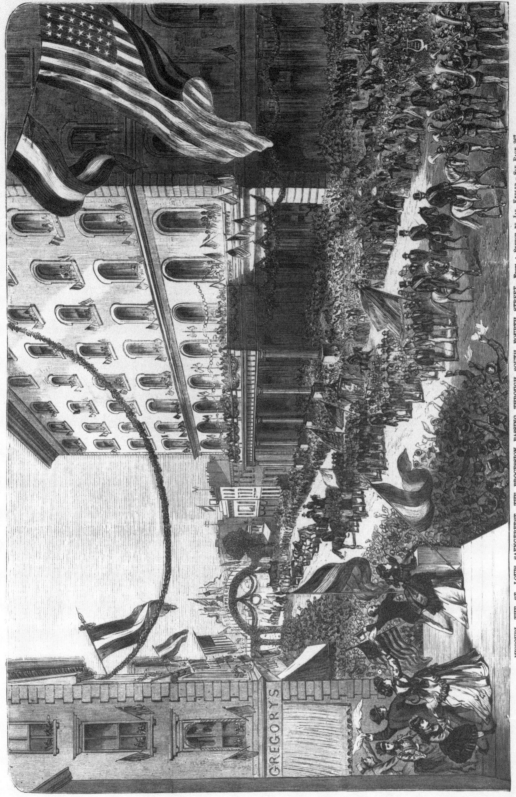

MISSOURI.—THE ST. LOUIS SAENGERFEST.—THE PROCESSION PASSING THROUGH SOUTH FOURTH STREET.—FROM A SKETCH BY JAS. KEPLER.—SEE PAGE 267.

21. "Isn't That Nasty?" *Harper's Weekly* cartoonist Thomas Nast is depicted here by Keppler as an early hurler of the taunt "love it or leave it." Carl Schurz's impeccable credentials as a reformer protect him from Nast's mud-slinging. President Grant is in the background paying for the services of Nast's employer, whom Keppler pictures as a lady of the evening. (Missouri Historical Society; *Unser Blatt*, Oct. 26, 1872)

Isn't that Nasty?

T W O

"A Stir in the Roost"

DURING THE 1872 presidential campaign, Thomas Nast had chewed up the national scenery. The country's leading cartoonist was perfecting the art of fighting from an offensive stance. In the pages of *Harper's Weekly* he went after Grant's opponent, Horace Greeley, with savage abandon, portraying him as an ineffectual know-it-all, an appeaser of the racist white South, and an opportunist willing to deal with anyone in order to further himself. The assault was telling and helped Grant to a landslide victory. Some even said it contributed to Greeley's untimely death just one month after the election.[1]

Harper's Weekly's chief competition was *Frank Leslie's Illustrated Newspaper*. In supporting Greeley, the *Newspaper* was at a distinct disadvantage. Grant's stewardship had convinced many that he was incapable of anything beyond partisanship and knavery, but still he was the man on horseback to millions of Americans. *Frank Leslie's Illustrated Newspaper*, with all its cartoons and editorials, could do little to alter that image. Nast's idolatrous advocacy of Grant's leadership only made *Leslie's* task of discreditation that much more difficult.

Leslie had anticipated the Nast threat in the fall of 1871 by importing cartoonist Matt Morgan from England. Morgan had made a name for himself in London through his short-lived but spirited satire magazine, *Tomahawk*. Leslie had high hopes for Morgan, as evidenced by the princely salary he offered him: $10,000 a year.[2] During the campaign, Morgan put up a valiant fight, matching Nast salvo for salvo, but he simply wasn't as deft a critic or as skilled an artist as his Republican competitor.

Keppler's portfolio compared favorably with that of Leslie's prize cartoonist. Morgan produced more focused and straightforward cartoons, but Keppler was

the better artist and caricaturist. In November 1872, Leslie hired Keppler to work alongside Morgan. There was more than enough work to go around. Keppler's duties, for $30 a week, consisted of drawing political cartoons for Leslie's two humorous monthlies, the *Budget of Fun* and the *Jolly Joker* and occasionally spelling Morgan on the *Illustrated Newspaper*.[3]

In 1872, New York City, which then consisted only of Manhattan island, had a population of nearly 1 million, 150,000 of whom were German immigrants.[4] About a third of the island was heavily developed, from the Battery into the Thirties. Above the Thirties for twenty or so more blocks were a scattering of grand homes and a few hotels and apartment buildings among modest one- and two-story frame homes. The rest of Manhattan was country crossroads' communities, farm houses and shanties, rolling hills, fields, and marshes.

The city of the 1870s is remembered for its squat brick and frame buildings, tightly packed one after another on narrow streets. The introduction of the elevator in 1870 helped send the city skyward, with structures as tall as ten stories. Many of the city's grandest buildings would be constructed in the coming twenty-five years. In 1872, most of New York was drab and undistinguished looking.[5]

New York's lack of visual appeal didn't make living there any less expensive. Upon coming to New York, Keppler found that he couldn't afford to buy or rent a home in the city's residential district. So he looked northward and soon found a house in Inwood, the northernmost community on Manhattan. There, on a little country lane, which residents christened Bolton Road, he settled with his wife and son.[6]

Even in the 1870s, transportation in America's largest city was a headache. People traveled by horse car, carriage, and elevated railroad. None of the els climbed past Central Park, and the horse cars were used only in the clogged residential and business districts. To get into the city each day, Keppler had to ride by carriage for more than an hour.

Each morning, he traveled down Broadway, New York's widest avenue. The theater and opera district, known as the Rialto, stretched for one mile from 42nd Street down to Madison Square at 24th. Keppler became an avid theater-goer, and even performed at the Terrace Garden, one of New York's German playhouses, in August 1873.[7] But by this time acting was largely a part of Keppler's past. Now he focused his energies on the publishing district further south. One of that sector's most imposing buildings was at 537 Pearl Street, the home of Frank Leslie's Publishing House.

Leslie had built his publishing empire of twelve periodicals in less than twenty years. He had been born in England and christened Henry Carter, but when he began his career as an engraver he took the pseudonym Frank Leslie. In 1854, six years after his arrival in the United States, he introduced his first magazine, *Frank Leslie's Ladies Gazette of Fashion*. The magazine that was to assure his financial success and make him a household name, *Frank Leslie's Illustrated Newspaper*, was launched two years later on December 15, 1855. *Leslie's Newspaper* was not the first of its kind, but it was the first to exploit timely reporting of sensational events. By dividing work on a large woodblock among many men, Leslie was able to produce in a night what would take one engraver two weeks to accomplish. After a rocky start, the *Newspaper*'s circulation soared to more than one hundred thousand.

The House of Harper introduced its illustrated newspaper, *Harper's Weekly*, in 1857. During the Civil War, *Harper's Weekly*, out-Leslied *Leslie's Newspaper*, bringing into America's drawing rooms descriptions and scenes of battle within days of their occurrence. Both weeklies profited from the public's insatiable appetite for war news, but when the conflict ended, *Harper's Weekly* was the undisputed circulation leader. By the time Keppler joined Leslie's, the *Newspaper* was a distant, although steady, second-place finisher in the illustrated weekly race.[8]

With Morgan taking a breather following the election, Leslie wasted no time in putting his new artist to work cartooning the doings of the Grant administration and the Republican party. First on the docket was the Crédit Mobilier scandal, which had come to light during the 1872 campaign and was still, in early 1873, very much an issue. The scandal involved a group of Union Pacific Railroad stockholders who set up a construction company, to which they then awarded millions of dollars worth of contracts. Afraid that Congress would find out about this sleight of hand, the stockholders sold or assigned stock in the company to several key congressmen at its par value, even though the stock was worth twice that. James G. Blaine and James A. Garfield were two of the many politicians who found themselves owning stock in the company when the scandal broke. The congressmen proclaimed their innocence.[9]

Keppler summed up Democratic opinion in his February 1873 cartoon, "Injured Innocents" (fig. 22). It showed little congressional boys protesting to Uncle Sam that they hadn't eaten the Crédit Mobilier cake. Uncle Sam replies, "Very fine excuses but still my cake is gone, and look, you rascals, there are crumbs on all your fingers."[10] A congressional investigation ensued, but none of the congressmen involved was ever charged. Keppler, however, never forgot the scandal and never forgave Blaine and Garfield for their involvement in it.

Another national issue was civil service reform, growing as a concern primarily because of Grant's blatantly partisan and nepotistic handling of government jobs. In "A Difference in Taste" (fig. 23), Keppler drew *Harper's Weekly* editor and reformer G. W. Curtis sculpting a statue to civil service reform. Grant, meanwhile, is scrawling the names of family and friends he appointed to jobs on its base.[11]

The six cartoons that Keppler drew for the *Newspaper* from February through May 1873 were more spirited and polished than any of the cartoons Morgan had drawn in the preceding year and a half. But, alas, they failed to impress his boss. Leslie was a man of strong convictions—one of those being that he knew what made a good cartoon. Subtlety and grace of line did not impress him. He preferred the cartoonist who carved up his victims with a battle-ax. Keppler did not have the disposition for that kind of heavy labor. For the last half of 1873 and for most of 1874, Leslie exiled Keppler's work to the less prestigious but more spritely pages of the *Budget of Fun* and the *Jolly Joker*.

In the *Budget*'s pages (no copies of the *Jolly Joker* having survived), sundry subjects occupied Keppler's attention. He ridiculed Grant for his indecision over going to war with Spain to liberate and acquire Cuba. When Congress voted itself a pay raise, Keppler portrayed the representatives, in "The Washington Pig-sty," as pigs feeding at the Treasury trough. In "Prudery and the Fine Arts" (fig. 24), Keppler skewered both those who would censor nudity in art and those who derived puerile pleasure from it. He even drew a macabre and hilarious two-page cartoon lampooning the then unconventional practice of cremation (fig. 25).[12]

His liveliest contributions to the *Budget* came when he chronicled a bizarre trial that took place over many months in 1874 and 1875. It involved the flamboyant and charismatic Brooklyn preacher, Henry Ward Beecher, and the charge that he had taken liberties with the affections of the wife of his friend and parishioner, Theodore Tilton. As far as Keppler was concerned, this sordid carnival of accusations, betrayals, and lies provided the perfect opportunity for exposing religious sanctimony and hypocrisy. Keppler was on to Beecher even in St. Louis. There, for *Die Vehme*, he had drawn the wayward preacher being lured by the recently excommunicated French cleric Père Hyacinthe from the "accommodation train" of American Protestantism, "with sleeping car attached," into another train, heading for hell, in which the devil is seated.[13]

In the *Budget*, Keppler took up where that cartoon had left off. He was relentless. In November 1874, he drew "The Brooklyn Plymouth Minstrel Troupe" (fig. 26), which caricatured the players in the trial as members of a musical ensemble ready to entertain. In vaudevillian fashion, he has Beecher asking the question, "Why am our statements like a piece of soap?", to which Tilton replies, "'Cause

there's a heap of Lie somewhere in 'em." This wry analogy became Keppler's biggest hit while with the House of Leslie. The demand for it was such that Leslie reprinted and sold it as a broadside.[14]

In April of 1875, Keppler posited that the "appropriate hat for Mr. Beecher [was] not a cardinal's, but a fool's-cap" (fig. 27). Playing on the fools-cap pun, he pictured Beecher wearing a cap made from the amorous letters he had sent Mrs. Tilton.[15]

In his May cartoon, "The Great Brooklyn Spelling Match," Keppler cast Lady Justice in the role of schoolmarm conducting a spelling bee. She asks Beecher to spell "innocence," Tilton to spell "proof," and Mrs. Tilton to spell "confession." All fail.[16] When the trial ended, the jury couldn't agree on a verdict. Later Beecher's church elders cleared him of charges of improprieties, but Keppler remained a skeptic.

The climax of his 1875 campaign against Beecher came with a classic cartoon that showed Beecher with outstretched hands protesting the offer of a court official who holds a Bible. The caption reads: "The Only Thing He Won't Kiss" (fig. 28).[17]

Keppler's zest in exposing the hypocrisies of those involved in the Brooklyn trial is not surprising. More, however, may have been at play here than just Keppler's delight over Beecher's public embarrassment. Surely, he reveled in the Beecher trial because of its obvious parallels to another celebrated love triangle that had recently been in the news—one involving Leslie himself.

In addition to Leslie, that love triangle included E. G. Squier, the managing editor of *Leslie's Illustrated Newspaper*, and his wife Miriam Squier, editor of *Leslie's Lady's Magazine*.[18] It seems that Leslie and Mrs. Squier had fallen in love. In 1872, Leslie divorced his wife of many years and then encouraged Mrs. Squier to divorce her husband, suing him on the hypocritical grounds of E. G. Squier's unfaithfulness. Keppler's colleague, Matt Morgan, became a crucial witness in the Squier divorce trial. He claimed that he had accompanied Squier to a brothel, where one of the prostitutes had declared that she had slept with Squier on several previous occasions.

After the Squier divorce was granted, Leslie and the former Mrs. Squier were married. Mr. Squier suffered a nervous breakdown and spent his final days in an asylum. Although the story filled the New York newspapers, Keppler was in no position to draw cartoons satirizing a serio-comic public play that starred his employer. But, by savagely commenting on the Beecher trial, Keppler was able to let his audience draw its own mischievous conclusions.

Leslie, instead of censuring Keppler for his sly work, rewarded him. The month of Keppler's "Minstrel Troupe" triumph marked the return of his work to

the pages of the *Illustrated Newspaper*. Although Morgan's work continued to appear occasionally in Leslie publications, Keppler became Leslie's chief cartoonist.

The major political question of 1874 and 1875 was whether Grant would seek a third term. The idea appalled the Democrats, who, besides having sound reservations about Grant's ability to govern, feared he'd be unbeatable. Even many Republicans loathed the idea of perpetuating Grant's inept rule. The charge that Keppler made most often in his anti-third-term campaign was that of "emperorism," a fear many Americans shared. Only five American presidents before Grant had served a full two terms, and none had aspired to more than that. Grant was different. He liked the prestige and power the presidency bestowed, and he simply didn't know what he would do with himself after he left office. A third term had a natural appeal to him.[19]

Indulging in some wishful thinking in November of 1874, Keppler drew "The Last Straw." It pictured Grant, astride the Republican camel, trying on a hat labeled "third term." The motion proves too vigorous though, and Grant's shown losing his balance.[20]

In "Trying It On," Keppler drew Grant feeling right at home in royal garb. When King Kalakaua of the Hawaiian Islands came for a visit, Keppler pictured the king decorating Grant in ceremonial tattoos (fig. 29). To Grant's dismay, however, the royal tattoos catalog the misdeeds and blunders of his administration.[21]

In late 1875, Congress passed an anti-third-term resolution by an overwhelming margin. Keppler depicted it as a bombshell scattering the third-term advocates. To Keppler's relief, the resolution put an end to Grant's third-term aspirations—at least in 1876.[22]

By the time of the resolution, revelations in the press had exposed the Grant administration as the most corrupt in American history. As a prime example, earlier in 1875, Benjamin Bristow, Grant's secretary of the treasury, had uncovered a monumental scandal in which the federal government had been defrauded of millions of dollars in liquor tax revenues. Grant seemed sincere in his support for Bristow's investigation—until it began to point to some of his own political appointees and aides, most notably to Orville Babcock, his personal secretary.[23]

In "Latest Phase of the Great Whiskey Trials," Keppler twitted Grant about his dilemma, using Grant's own words: "Let no guilty man escape. But see to it that no innocent man be implicated." To this, he added the popular interpretation: "save Babcock." As his secretary's role in the scandal became more evident, Grant grew increasingly protective. At first Keppler pictured Grant simply shielding

Babcock from Justice, but then he came to see them as conspirators and drew them as Siamese twins.[24]

As revelation after revelation rocked Washington, Grant's complicity seemed an inevitable conclusion. In "A Flutter in High Life" (fig. 30), Keppler cast Grant in the role of a common criminal. As policeman Uncle Sam knocks at the door, Grant exhorts his cronies, "Hide your swag quickly."[25]

Babcock was brought to trial and eventually acquitted, but the affair forced his resignation. Bristow, despite his noble work, was asked to leave as well.

In New York State, Governor Samuel Tilden was doing a little crusading of his own for justice. He played a major role in breaking what became known as the Canal Ring, a group of businessmen who had made millions from the state of New York by submitting fraudulent bills of repair on the Erie Canal. Because of this good work, Keppler suggested Tilden for the presidency in an April 1875 cartoon (fig. 31). The next year the Democrats followed his advice, nominating Tilden to run against Republican Rutherford B. Hayes of Ohio. *Leslie's Illustrated Newspaper*, while lauding both parties for choosing respectable men, had no intention of forgiving the Republican party for the excesses of the Grant administration. The Democratic ticket received the *Newspaper*'s support.

In "The Centennial Race" (fig. 33), Keppler showed Hayes's Republican wagon stuck in the mud of "universal corruption" and "national degradation," while Tilden's wagon heads off to Washington. Uncle Sam, viewing Hayes's predicament, says, "I shall not require your services anyhow, as I am about to make a four-years' contract with my honest namesake over yonder." Keppler made the same point the following month in "No Change Could Be for the Worse." This cartoon showed Uncle Sam choosing between Hayes and all of the ugly things Republicanism represented during the Grant years, and Tilden, who stood for reform and a fresh start.[27]

Months before the publication of that cartoon—his last for the *Illustrated Newspaper*—Keppler had begun planning a fresh start of his own. He had decided to form a partnership with a printer named Adolph Schwarzmann.[28] Keppler had met Schwarzmann, who was then Leslie's print shop foreman, when he began working for the *Illustrated Newspaper*. What they had in common led them to become immediate friends. They were fellow emigrants of the same age, politically liberal, more comfortable speaking German than English.

The characteristics they didn't share helped them become perfect business partners. While Schwarzmann was convivial, even "jolly" in the estimation of one co-worker, he was a far more private person than Keppler, one who preferred solitary pursuits, such as his later passion for boating, over large social gatherings.

In a group, Keppler was the center of attention, while Schwarzmann was one of the audience. Perhaps because Schwarzmann felt less of a need than Keppler to please, he was also the more hardheaded of the two. Prudence guided his decision making, and planning for the future was his watchword. A bachelor when Keppler met him, he postponed marrying and raising a family until he became a financial success. In partnership, Schwarzmann's head tempered the unbusinesslike impulses of Keppler's heart, while Keppler's *joie de vivre* infected Schwarzmann's business aims with a spiritedness they would never otherwise have known. Perhaps they sensed this. Certainly, their complementary talents contributed greatly to their eventual strong reliance on one another, girded by mutually held feelings of deep respect and trust.

Born in Konigsburg, Germany, Schwarzmann had come to America in 1858 with nothing more than a working knowledge of the printer's craft. His first several years in the United States were rough. Failing to find work as a printer, he tried several other occupations, without success. Eventually he landed a job in the printing offices of Leslie's Publishing House. He was a hard and conscientious worker and soon caught Leslie's eye. Impressed by Schwarzmann's diligence, Leslie began promoting the printer into positions of increasing authority. Slowly, with every promotion, the frugal Schwarzmann put away money. By 1875, he had amassed a substantial sum, enough to buy his independence from *Leslie's* and part ownership in the *New-Yorker Musik-Zeitung*.

The *Muzik-Zeitung* was a weekly devoted to the New York music and opera scene. At the time Schwarzmann bought into it, the ten-year-old publication, which called itself the only American professional magazine published in German, had reached its all-time-high circulation figure of 2,416.[29] Schwarzmann's departure from Leslie's had made him his own man, but he aspired to more than that. He wanted to be rich. He knew that the *Muzik-Zeitung* was no great prize; its real value lay in its publishing facilities. What Schwarzmann needed was a star by which to guide his ready and waiting wagon. By 1876, Schwarzmann had come to view Keppler as that star. Like Binder, Herold, and Willich before him, he was convinced that Keppler's talent could attract national attention if only it was given the proper forum.

Keppler, meanwhile, had become Leslie's star performer. He drew the cover of nearly every issue of the *Newspaper*, as well as two or three full-page cartoons a month for Leslie's humor magazines. But the honor of the position carried a price. It was as if Keppler had made a Faustian deal with Leslie: in exchange for greater prominence, Keppler would give Leslie the type of cartoons he favored. Little else can explain the lecture-like tone and unimaginitive compositions of Keppler's 1875–76 work.

Still, for Keppler, the fruits of submission were not all bitter. As the head of a family of four (a daughter, Irma, had been born on December 27, 1874), he sorely needed the $50 a week he was now being paid.[30] Ultimately, though, security meant less to Keppler than creative independence. When his friend Schwarzmann suggested they team up to establish a German-American humor magazine, Keppler was ready to risk all for a more personal and satisfying success.

The partners agreed to christen the new magazine *Puck* in honor of Keppler's failed but valiant St. Louis effort. In May, Keppler took out a copyright on the *Puck* name and image. The following month, in order to simplify future financial agreements, Schwarzmann bought out his *Musik-Zeitung* partner. Soon after, he began partitioning off space in the *Musik-Zeitung*'s office at 13 North William Street for *Puck*'s future use. The basement became *Puck*'s printing office; the third floor, quarters for the editorial and art staffs (fig. 65a).[31]

The salaried position of editor went to thirty-two-year-old Leopold Schenck.[32] This stout, learned German had arrived in America in 1868. His university education earned him quick and steady employment on several German-American newspapers, including the *Westliche Post* in St. Louis, where he may have made Keppler's acquaintance. By the time Keppler and Schwarzmann called on his talents, he was known in the German community as a powerful writer of brilliant attainments.

Throughout August, Schwarzmann and Schenck labored to assemble the first *Puck*. After working hours, Keppler walked the few blocks from Leslie's to the North William Street address to draw the cartoons and advertisements. The new magazine's nameplate featured Keppler's St. Louis Puck, somewhat matured, riding a shooting star across the sky, with a lithocrayon and flogging whip in his hands. In the shower of light that followed the star was the magazine's name, *Puck*. The cherub Puck appeared again in the cover cartoon. Keppler drew him on a stage, handing out subscriptions to both delighted and appalled audience members. The cartoon was titled, "Puck's First Debut" (fig. 34).[33] Perhaps they adopted this redundancy to make clear that they wanted this *Puck* to be regarded as a fresh start.

At about this time, according to one possibly apocryphal account, Keppler was overcome with doubts about the new venture and decided to put his fate in his employer's hands. As the story goes, Keppler went to Leslie and said if Leslie would give him a $5 raise, he would stay. If Leslie refused, he would go. Leslie, contemptuous of Keppler's and Schwarzmann's plans, dismissed the request and, with a snort, told the cartoonist that his *Puck* would not last six months.[34]

Whether or not this story is true, Keppler's fate was cast by late August. On the 28th of that month, he signed an agreement of co-partnership with

Schwarzmann that outlined their financial and professional responsibilities to each other.[35] Each would contribute $1,000 to form *Puck*'s initial working capital (the evidence suggests that Keppler never raised more than $500) and split all profits 50–50. Schwarzmann would direct operations and publish the weekly as economically as possible. Keppler would turn over his copyright on the name and figure of *Puck* to the partnership. He would also provide the cartoons.

Following his experience with Leslie's dictatorial ways, Keppler included a clause guaranteeing his freedom of expression. It read: "[Keppler's] illustrations [are] not to be subject to the direction, censure, or control of his co-laborers or partner except so far as may be necessary to avoid differences between their [the cartoons'] tendency and the literary tendency of the paper and to exclude libelous matter."

The nervous Keppler also insisted on one more clause: a guarantee of income. Schwarzmann, after all, had his printing establishment and the *Musik-Zeitung* to fall back on if *Puck*'s days proved lean. In order to keep bread on Keppler's table, Schwarzmann agreed to pay him $40 a week above his 50 percent share of the profits, whatever they might be.

On September 23, 1876, *Puck, Illustrirtes Humoristisches-Wochenblatt!* appeared on newstands throughout New York. Keppler, Schwarzmann, and Schenck held their breath.

The timing of *Puck*'s launch was questionable at best. The nation was in the midst of a depression, the result of the financial panic of 1873, and the economy showed few signs of recovery. Nevertheless, German-Americans took to *Puck* from the start and made it an immediate success. Circulation climbed to ten thousand early in its run and then doubled to twenty thousand within a few years, where it remained for nearly two decades.[36] Perhaps the fact that most German-Americans had fond memories of the humor magazines of Europe helped *Puck* overcome the sluggish economy. Where *Puck* was published may have been just as significant a factor. While the magazine found an audience in German communities throughout the country, most of its subscribers and newsstand buyers lived in New York City. And as large as the St. Louis German community was, the New York German community was three times the size. In gross mathematical terms, this larger market tripled *Puck*'s chances for success.

Then, of course, there was the staff of the German *Puck*. Schwarzmann's conscientiousness and industriousness served the small publishing company well. One employee remembered, "There were few offices [in New York] where the system [of operation] was so thorough and so good. For this Adolph Schwarzmann, the publisher, was responsible."[37] Schenck also must be credited

with contributing to *Puck*'s success. His erudition, experience, and circle of literate friends helped him meet the daunting weekly challenge of filling ten closely printed pages with poetry and prose. But ultimately, it was Keppler's surprising creations that made *Puck* unique. After more than a decade of cartoon work in lesser spheres, Keppler was ready for the challenge *Puck* presented.

Like his St. Louis cartoons, Keppler's *Puck* cartoons were lithographed. But unlike his St. Louis cartoons, these new creations were dressed up with some color. By 1876, color had been introduced into a number of cartoon magazines in Europe, but it was largely absent from the American media. Keppler acted boldly when he committed himself to investing the time and money necessary to make color a weekly publishing option. Years passed before that commitment yielded any real artistic or financial gain.

In the magazine's early days, the tinting process was primitive. A color was added by sending the cartoon through the presses twice, once to print the black plate and once to apply an orange or green tint to the entire page. Sometimes, *Puck*'s lithographer sectioned off the color inkwell, creating bands of tints instead of just one hue. Still, the color looked laid on and rarely had anything to do with a cartoon's action or subject matter.[38]

Next, in an effort to achieve more natural coloration, Keppler experimented with multiplate lithography. The plate he drew with the black lithocrayon became the source of the other plates. This was done by transferring the black image onto a block of wood and then cutting away the elements of the image that weren't to appear in color. For some cartoons, he employed two or three color plates. This elaborate process was only moderately successful. In some of the cartoons, the woodgrain of the color plate was intrusively obvious. In others, poor registration marred the effect. Still, coloration made Keppler's cartoons more provocative than they would have been in black and white, and it made *Puck* more eye-catching than ever.[39]

The magazine's success went to the owners' heads. After only a few months of publishing the German *Puck*, Keppler and Schwarzmann decided to produce an English-language edition of their fledgling magazine as well.[40] The move was more than risky; it was reckless. Dozens of men before them had attempted to establish an American magazine of satire, and all had failed.

In 1876, Europe could boast of many hearty satiric weeklies. The French *Le Charivari* was more than forty years old, the English *Punch* was thirty-five, and even the repressive German government suffered *Kladderdasch* and *Fleigende Blatter*, both several years past their silver anniversaries. In the United States, several monthlies, such as *Budget of Fun* and *Yankee Notions*, managed to keep going year after year, but they were neither popular nor profitable. Influence and money

lay in the arena of weekly publishing. And in that arena, during a thirty-five-year period, more than three dozen satiric weeklies had vied for the favor of a demanding American audience, and none had received it. What was the explanation for this inhospitable behavior?

For one thing, Americans in the mid-nineteenth-century were wildly nationalistic. Their contempt for other cultures took an ancestral bent and made them loathe all things English. Yet at the same time, Americans seemed to lack the creativity or boldness to break out of the English cultural orbit. Despite brave efforts by Poe, Hawthorne, and Melville, most popular American literature mimicked its English counterpart. American musicians and artists studied in Europe and rarely broke with European conventions.

Those who started American humor magazines exemplified this contradiction. The dozens of humor magazines founded in America following *Punch*'s debut in 1841 seemed to be contestants in a *Punch* look-alike pageant.[41] Without exception, every weekly American humor magazine before *Puck* blindly adopted *Punch*'s format and, while attacking Great Britain and the English in their pages, never managed to free themselves from the weighty bonds of slavish imitation. The magazines seemed to stake their ground in their text, where they were almost defiantly less refined than *Punch*. Unfortunately, this "original American content" was predicated on the assumption that the pun and dialect writing were the highest forms of humor. Unlike the writers, the cartoonists made no attempts to be different. Their work, although hopelessly amateurish compared with the work of Tenniel and other *Punch* artists, duplicated the English emphasis on allegory over commentary and portraiture over caricature.

Thomas Nast, in *Harper's Weekly*, did much to change American notions of what a cartoon could be. He took inspiration not from the *Punch* school of cartooning, but from the work of Gustave Doré, the Franco-German illustrator. Doré's somber and detailed illustrative technique served Nast well in the patriotic cartoons that he drew during the Civil War. When Nast began engaging in more partisan commentary, he melded deadly caricature into his heavily worked set pieces. In contrast to the English style, the art was bold, the artist's opinions unrestrained. For Nast, allegory was an instrument for commentary, not an end in itself. He used portraiture only when caricature didn't serve the overall purpose of the cartoon. The brazenness and power of Nast's work startled Americans used to the pablum served up by the English imitators. By the late 1860s, Nast had single-handedly established the art of American political cartooning, showing in the process that it need not be based on anything English to be successful.

Nast's achievement was made possible by an even more significant development in the character of American reading matter—the advent of copious illustra-

tions. *Frank Leslie's Illustrated Newspaper* ushered in the era of illustrated journalism. The enthusiastic response to the *Newspaper* showed that Americans were fascinated by pictures. Nast's large Civil War tableaux and Reconstruction cartoons were successful in part because they tapped into that fascination.

Despite Nast's trailblazing and obvious success, doltish businessmen continued to create pale imitations of *Punch* containing pale imitations of Tenniel well into the 1870s. The number-one award for thick-headedness goes to *Punchinello*, whose creators were so stuporous that they couldn't even come up with a name that didn't echo its English model. Its owners took the English formula to its extreme, shying away from controversy at every opportunity and publishing one forgettable cartoon after another. *Punchinello* lasted nine months.[42]

Although dozens of humor magazines had come and gone in the thirty-five years before 1876, for all intents and purposes, only one *type* had come before—an imitation of *Punch*. It had just been created dozens and dozens of times. The English-language *Puck* would prove to be different. It would be modeled after the German-language *Puck*, which in turn had been inspired by the achievements of Leslie and Nast. Leslie showed Keppler that Americans had an insatiable appetite for the visual. Nast showed Keppler that bigger and bolder could mean better. *Puck*, although several inches smaller than *Harper's Weekly* or *Budget of Fun*, was considerably larger than any previous weekly humor magazine. And because Keppler was the star of this venture, the cartoons would hold center stage, occupying the front and back covers as well as the two center pages.

But would this be enough? Given that humor is perhaps the most idiomatic art of all, producing the English-language version would not be a matter of simply translating material in the German edition into English. How could two German immigrants who didn't speak English fluently even hope to manage an operation that depended so much on subjective judgment? Moreover, the German *Puck* was profitable, but not a money machine. How could they hope to sustain the expense of publishing in a field that had left dozens of native Americans in financial ruin before them? There are no ready answers to these questions. In the final analysis, their decision did not make sense.

Keppler and Schwarzmann, of course, were not oblivious to the risks. They realized, for example, that the English-language edition would only succeed if its editorial content was "distinctly American" in flavor. So they began searching for an American to edit it. The person they chose was Virginia-born, New York-bred Sydney Rosenfeld.[43] They had met Rosenfeld when all three had worked at *Leslie's*. He undoubtedly impressed the two Germans as a young man of considerable ability. He impressed many people that way.

In 1876, Rosenfeld was a mere twenty-one years old, but he was already a

literary veteran of seven years. He had begun writing boys' stories at fourteen. While still a minor, he worked for the New York *Sun, Frank Leslie's Illustrated Newspaper,* and several small literary and drama magazines, one of which he founded. He produced his first play at eighteen and went on to translate and adapt several German plays for American audiences. While Rosenfeld's literary talents and skill as a German translator made him a logical candidate for the editorship of the English-language *Puck,* his reverence for the German theater undoubtedly endeared him to Keppler and ultimately made him the leading candidate for the job. When he was offered the editorship, he accepted immediately.

March 14 was set as the debut date of the English-language *Puck.* To distinguish the English edition from its German brother, Keppler drew an elegant new nameplate. It featured the erstwhile Puck with lithocrayon and portfolio in hand, welcoming readers into a world of thought, wit, fancy, and mirth. He was featured again in the premier issue's cover cartoon. Keppler thumbed his nose at those who doubted the ultimate success of the English-language *Puck* in "A Stir in the Roost—What, Another Chicken?" (fig. 37). It featured Puck springing forth from an open eggshell as other players in the New York journalism barnyard looked on. Thomas Nast appears unimpressed. James Gordon Bennett of the New York *Herald* looks aghast. And old boss Frank Leslie regards the whole affair in stern silence. His recently released employee pictured him surrounded by four of his brood, secured to him by string leashes.[44]

In *Puck*'s opening statement, Rosenfeld wrote, in the guise of the magazine's mascot, "I have a mission to fulfill. . . . But like almost everybody else I can't exactly tell what that mission is until I have found out definitely myself." *Puck* promised to be good-natured but also hoped to address a "harvest of things that may sink deep into the soul . . . often enough to prove that I have not come merely as a flippant plaything to amuse you in your idle moments. . . . "[45]

New Yorkers probably didn't know what to make of *Puck.* It was undeniably unusual. Keppler's cartoons could be thanked for that. And it had its comic moments. The magazine's typeset pages were an entertaining mix of light poetry, comic essays, and serial fiction. But people simply weren't buying the publication.[46] In fact, for many months, *Puck* seemed likely to confirm the opinion of skeptics and go the way of its predecessors.

A circular announcing *Puck*'s first issue had been sent to periodicals and potential advertisers on March 1.[47] To the chagrin of Schwarzmann in particular, the response was disappointing. Even though subscribers, not advertisers, sustained publications in the nineteenth century, lack of advertiser interest was always a bad omen. Seven firms, most already patrons of the German *Puck,* had purchased two pages' worth of advertising space in the first issue. *Puck*'s sliding

fortunes in the succeeding months were mirrored in its declining advertising. The original seven slowly began cutting back on the size of their ads. Some dropped out entirely. No new advertisers appeared. By September, excluding internal promotions, advertisements occupied just a single column.

Rosenfeld, for his part, was doing everything he could to make *Puck* work. He wrote a good deal of the material himself. He also assembled a staff of young American contributors of varying talents. A few, such as Bret Harte, were famous, but most were unknowns. His most important move was selecting as his associate editor his friend and contemporary H. C. Bunner;[48] important because Bunner, not Rosenfeld, was to be the third star in the luminous constellation eventually responsible for making *Puck* shine.

Contributor Brander Matthews recounted his meeting with Bunner in 1877. After encountering Rosenfeld at street level, they toiled up the three flights of stairs to *Puck*'s editorial and art offices. Along the way, Matthews complimented Rosenfeld on several pieces that had appeared in *Puck*. Rosenfeld generously identified each one as Bunner's creation. Upon reaching the third floor loft, Matthews recalls, "I had the pleasure of shaking hands with the writer of the various articles I had admired. He was beardless and slim, and, in spite of his glasses, he impressed me as being very young indeed. He had ardor, vivacity, and self-possession, and it did not take me long to discover that his comrades held him in very high esteem. As for myself, I liked him at first glance; and that afternoon a friendship was founded which endured as long as his life."[49]

Bunner, born in Oswego, New York, and raised in New York City, had prepared for Columbia University but couldn't afford to enroll. Instead, he sharpened his skills through freelance writing. He met Rosenfeld when both were contributors to the magazine *Arcadian*. Later, when Rosenfeld was trying to establish a drama magazine, Bunner dropped by his office and donated his time and talent. Now these two twenty-one-year-olds were at the helm of a magazine that, if successful, could make history.

In 1877, however, the magazine was making neither history nor money, and this created tension among the staff. Rosenfeld, anxious about *Puck*'s sorry state, charged Schwarzmann with not giving him enough money for quality contributions. In Schwarzmann's defense, he was reluctant to funnel hard-earned German *Puck* money back into one of his own properties that showed no signs of impending success. Still, that's exactly what he found himself doing as the year wore on and *Puck*'s fortunes failed to improve.

In December, Bunner wrote to Matthews about "a business row that has not yet subsided and I fear is going to get nastier still." It did. Four months later, Bunner told Matthews the news: "Syd [Rosenfeld] has told Schwarzmann to get

out his own qualified paper—S[chwarzmann] has offered me the editorship—alternative: bouncing the whole American crew in favor of the first ready journalist who will take the job cheap and dutchily."[50]

Rosenfeld did quit, and Schwarzmann did offer the editor's chair to Bunner, but not without a condition: he would first have to pass through a six-month trial "managing editorship" before he could have the editor's position permanently. Bunner had little choice but to accept. He knew Schwarzmann wasn't an easy boss, but he also knew that Rosenfeld's excitable nature had contributed to the explosive atmosphere at the *Puck* office. Ultimately, the editorship, in whatever form, was an opportunity he couldn't pass up.

Bunner's appointment did little to change the magazine's poor showing at the newsstands. A gains and loss account for the first half of 1878 reveals that the company turned a profit of $8,716.95. Notably, the German *Puck* contributed twice as much money to profits as it cost to print. The English *Puck*, in contrast, contributed only about 20 percent more to profits than it cost to print—a figure that had validity only on paper because Schwarzmann did not charge salaries against the English *Puck* revenues. Had he done so, he would have had no financial justification for keeping the English *Puck* going.[51]

On several occasions, Schwarzmann threatened to close *Puck* down. But Bunner, who was throwing himself into the magazine heart and soul, routinely writing half of each issue himself, would plead with Schwarzmann to give the English *Puck* just a little more time. In the face of such commitment, Schwarzmann would grimace, shake his head, and let Bunner have his way. The proprietors, as Keppler and Schwarzmann called themselves, later came to appreciate how fortunate they were to have listened to their dedicated editor. Bunner was awarded the full editorship in October 1878.[52]

Keppler was surely an anxious participant in all the office spats, but he deferred to Schwarzmann on matters of the magazine's management. His job was to guide *Puck* artistically. And in that capacity he had his hands full. During these early years, Keppler produced a voluminous amount of work. He drew *Puck*'s three cartoons a week, an occasional illustrated supplement, several advertisements for its back pages (figs. 35 and 36), and portraits for the *New-Yorker Musik-Zeitung*. For the first month or so of the dual language editions, he drew a different cover cartoon for each edition to make them easy to distinguish from one another, but this was soon judged too onerous. He also worked on long-term projects, such as the one hundred illustrations that went into *Puck*'s 1878 *Volks-Kalender*. And as if this weren't enough, because money was in short supply, *Puck* announced the opening in October of 1877 of a "General Designing Office"

under Keppler's "personal" direction that was capable of "furnishing all kinds of illustrations, in the most perfect style, on short notice, and at reasonable rates."[53] What three men were responsible for in later years on *Puck*, Keppler during 1877 and 1878 handled alone.

Figures 22–37

22. "Injured Innocents." When the Crédit Mobilier scandal broke in 1872, prominent congressional leaders, such as James G. Blaine and James Garfield, were caught holding stock in a company that had recently been granted special privileges by Congress. The congressmen claimed they had not purchased the stock; it had simply been assigned to them by the foxy company directors. Keppler found their explanation disingenuous. (Author's collection; *Frank Leslie's Illustrated Newspaper*, Feb. 1, 1873)

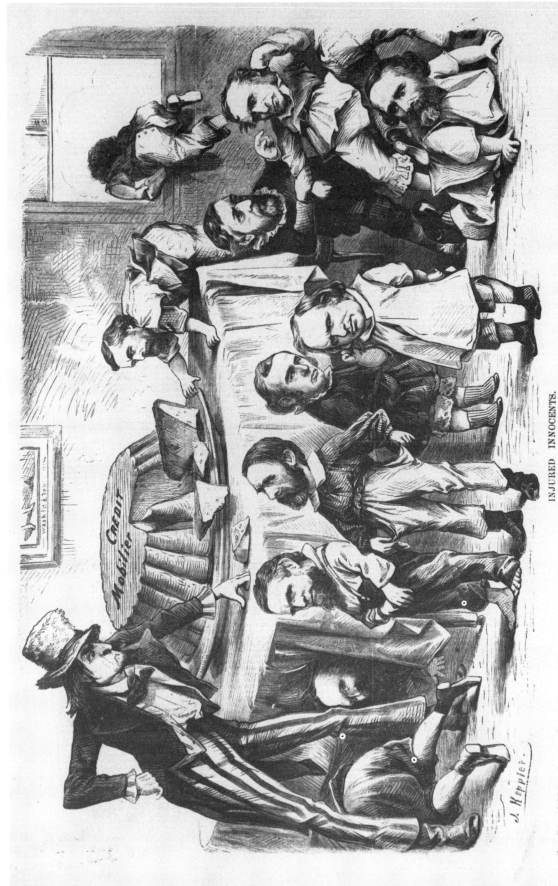

J. Keppler.

INJURED INNOCENTS.

First Boy—"I didn't touch it, sir; I only smelt it." Second Boy—"I just took a little piece, sir, but I put it back again whole." Third Boy—"I just had a very small piece, sir; but I found it had a bad smell about it, and I didn't keep it." Fourth Boy—"I did have a piece, sir; but then I bought it, for a penny, of that other boy, who said it was all right, and that you wouldn't mind it." Uncle Sam—"Very fine excuses; but still my cake is gone; and look, you rascals, there are crumbs on all your fingers!"

23. "A Difference in Taste." *Harper's Weekly* editor G. W. Curtis was both a member of Grant's party and a leader of the infant civil service reform movement. As long as Grant remained in office, Keppler was saying, Curtis's hopes of creating a lasting monument to reform would be futile. Less a tribute to Curtis, this cartoon is more a gleeful depiction of his predicament. (Author's collection; *Frank Leslie's Illustrated Newspaper*, May 3, 1873)

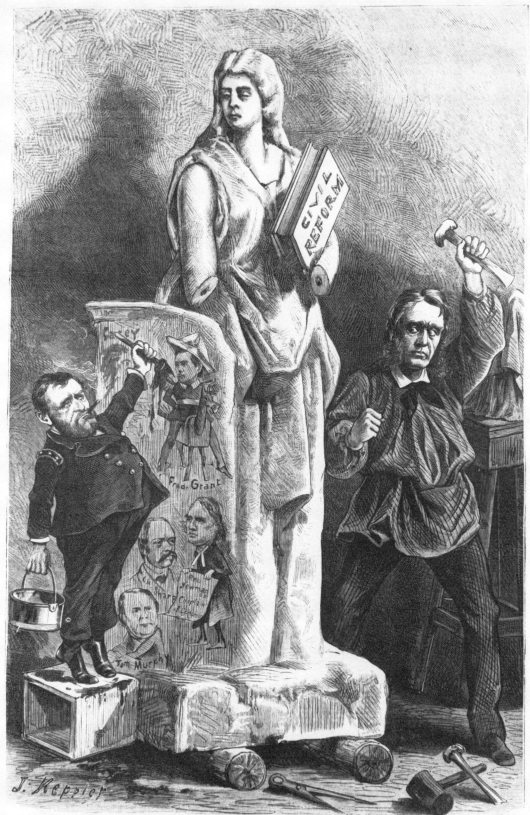

A DIFFERENCE IN TASTE ABOUT CIVIL SERVICE REFORM.

G. W. C——s.—"Here have I been laboring for years upon this cherished model of Civil Service Reform, and now this fellow defaces it with his vile figures. I'll work no more."

U. S. G.—"I've got my own idea of fixing this thing, no matter what that dreamy chap may say or think of it."

FRANK LESLIE'S ILLUSTRATED NEWSPAPER

24. "Prudery and the Fine Arts." Keppler despised self-righteousness, especially when it was applied to the pleasures and pastimes of others. This is the first of a number of cartoons he would draw on the subjects of public morality, censorship, and blue laws. (Library of Congress; *Frank Leslie's Budget of Fun*, Oct. 1873)

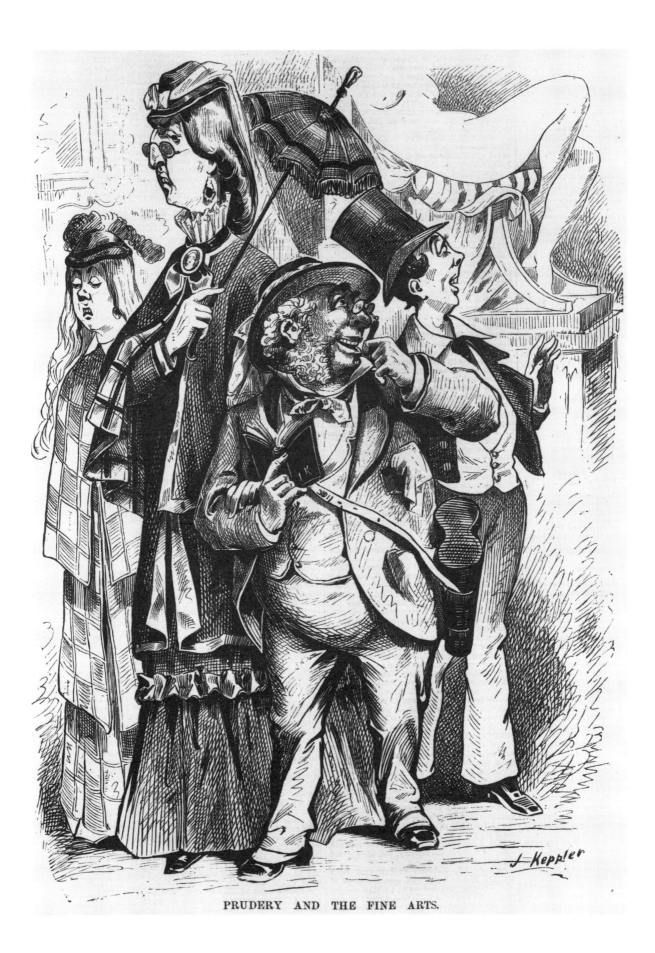

PRUDERY AND THE FINE ARTS.

25. **"The Humors of Cremation."** This daring cartoon, the only double-spread Keppler drew for the *Budget of Fun*, was the first of his "vignette cartoons"—one cartoon composed of many on the same subject—that later became a *Puck* mainstay. (Library of Congress; *Frank Leslie's Budget of Fun*, June 1874)

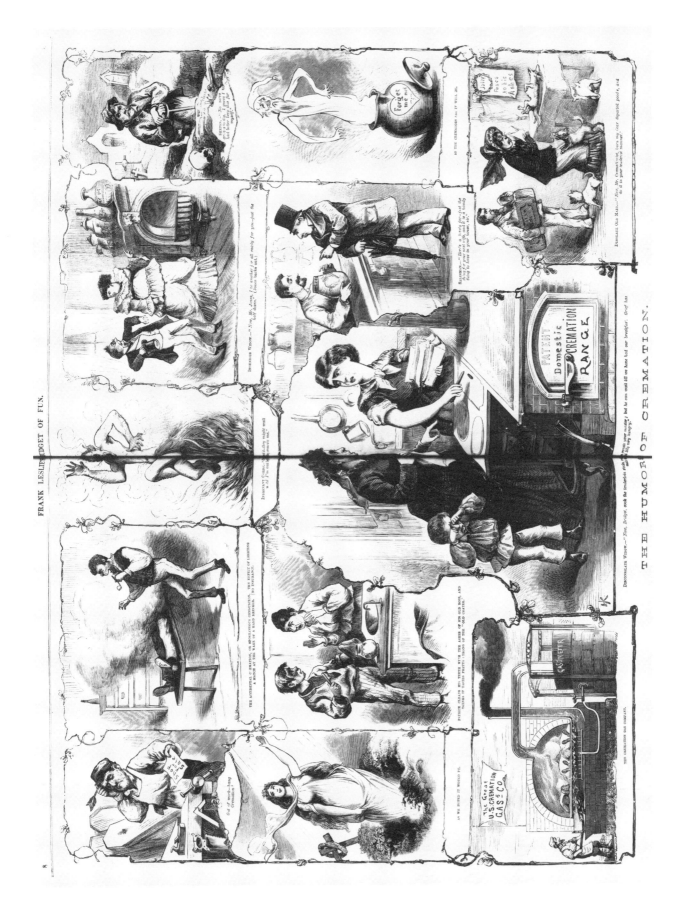

THE HUMOR OF CREMATION.

26. "The Brooklyn Plymouth Minstrel Troupe." In 1874, Brooklyn preacher Henry Ward Beecher was sued for civil damages by one of his parishioners, Theodore Tilton, for alienating the affections of Tilton's wife. The trial, which dragged on for months, was marked by so much conflicting testimony, murky motives, and outright lies that Keppler was prompted to draw the principals in the drama as members of a stage act, complete with comic delivery and bad jokes. From left to right, Theodore Tilton, standing, obscuring two other performers; Counsellor Morris, the trial judge; Elizabeth Cady Stanton, suffragette and friend of Beecher's sister, Harriet; Frank Moulton, a friend of Beecher and Tilton who attempted to arbitrate between the two parties; suffragette Susan B. Anthony, Beecher antagonist, who had had an affair with Tilton; Benjamin Butler, Beecher's legal adviser; Beecher; and Elizabeth Tilton. (Library of Congress; *Frank Leslie's Budget of Fun*, Nov. 1874)

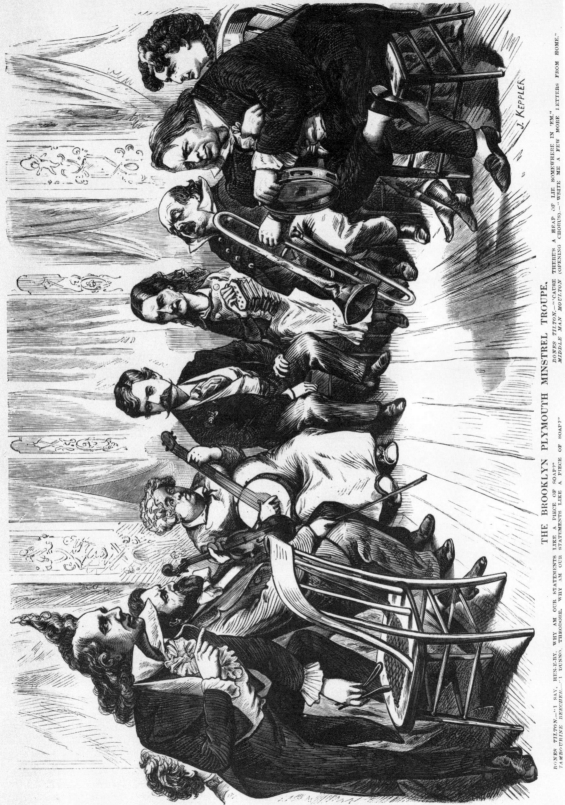

J. KEPPLER

THE BROOKLYN PLYMOUTH MINSTREL TROUPE.

BONES TILTON.—"I SAY, HEN-E-RY, WHY AM OUR STATEMENTS LIKE A PIECE OF SOAP?" BONES TILTON.—"CAUSE THERE'S A HEAP OF LIE SOMEWHERE IN 'EM."
TAMBOURINE BEECHER.—"I DUNNO, THEODORE. WHY AM OUR STATEMENTS LIKE A PIECE OF SOAP?" MIDDLE MAN MOULTON (OPENING CHORUS).—"WRITE ME A FEW MORE LETTERS FROM HOME."

27. "An Appropriate Hat for Mr. Beecher." Trial principals ring bells on the beleaguered Beecher's "fool's-cap," drawing attention to his indiscretions. (Library of Congress; *Frank Leslie's Budget of Fun*, April 1875)

FRANK LESLIE'S
BUDGET OF FUN

Entered according to the Act of Congress, in the year 1875, by FRANK LESLIE, in the office of the Librarian of Congress, at Washington.

EIGHTEENTH YEAR.　　　　　　　NEW YORK, APRIL, 1875.　　　　　　　No. 205.

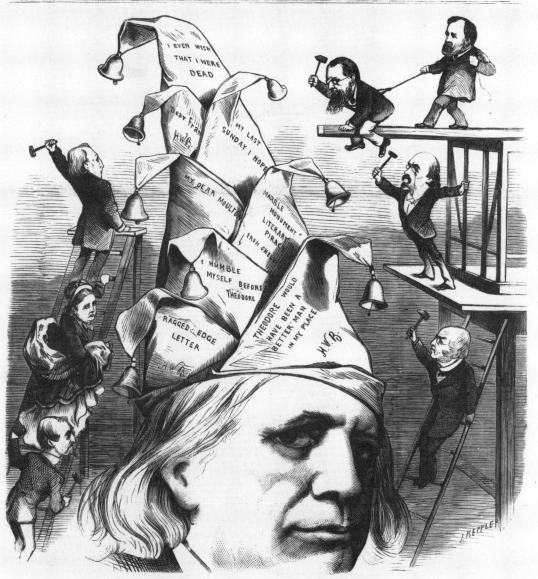

AN APPROPRIATE HAT FOR MR. BEECHER.

NOT A CARDINAL'S—BUT A FOOL'S-CAP.

28. "The Only Thing He Won't Kiss." By the end of the Beecher trial, the reverend was revealed to possess considerable seductive powers. But the jury failed to reach a verdict, so the charges against him were dropped. Keppler remained convinced of Beecher's guilt and continued to ridicule him for years after the controversy had died away. (Library of Congress; *Frank Leslie's Budget of Fun*, June 1875)

Entered according to the Act of Congress, in the year 1875, by FRANK LESLIE, in the office of the Librarian of Congress, at Washington.

No. 207.—EIGHTEENTH YEAR. NEW YORK, JUNE, 1875. PRICE FIFTEEN CENTS.

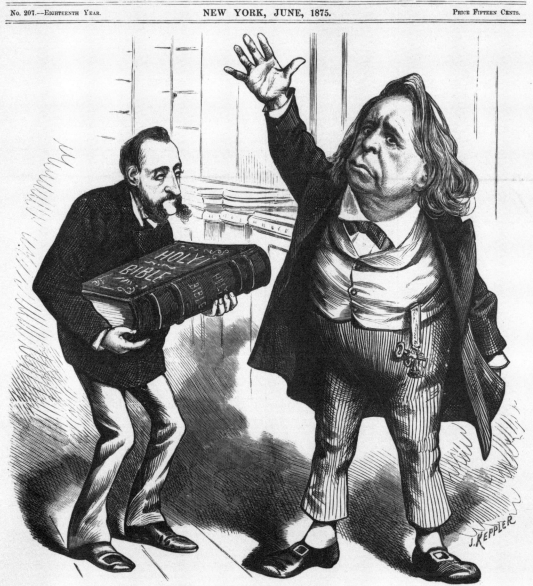

THE ONLY THING HE WON'T KISS.

29. "The Royal Tattoo." Visiting Hawaiian chieftain Kalakaua I draws his inspiration from Grant administration mistakes and missteps to induct his host into Hawaiian royalty. The dogs to the right are a reference to two bulldogs Grant reportedly received as a gift from a man who in turn was awarded a ministry post. The story was later revealed to be a hoax, but Morgan and Keppler believed it. (Library of Congress; *Frank Leslie's Budget of Fun*, Feb. 1875)

FRANK LESLIE'S

BUDGET OF FUN

Entered according to the Act of Congress, in the year 1875, by FRANK LESLIE, in the office of the Librarian of Congress, at Washington.

SEVENTEENTH YEAR. NEW YORK, FEBRUARY, 1875. No. 203.

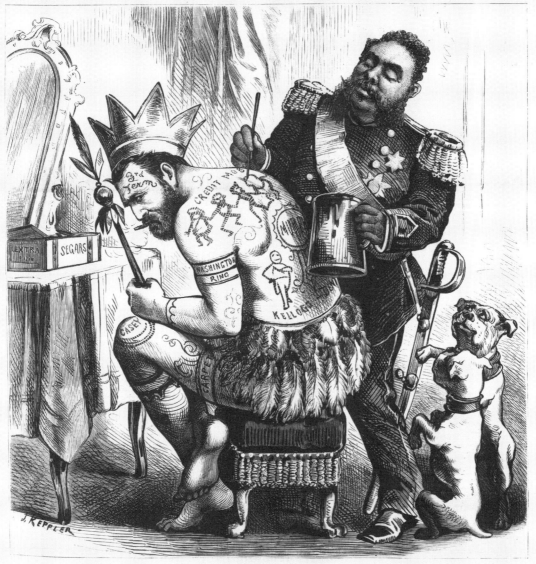

THE ROYAL TATTOO.

KING KALAKAUA.—"KEEP STILL, GENERAL, THIS IS DELICATE WORK, AND THERE'S HARDLY ROOM TO GET IT ALL IN. YOUR PEOPLE WOULDN'T HAVE YOU FOR AN EMPEROR, BUT I'LL MAKE A KING OF YOU, AFTER OUR FASHION."

30. **"A Flutter in High Life."** By 1876, the country was just beginning to comprehend the magnitude and multiplicity of the Grant administration scandals. Keppler saw Grant as the conniving king of crooks. (Author's collection; *Frank Leslie's Illustrated Newspaper,* April 1, 1876)

FRANK LESLIE'S
ILLUSTRATED
NEWSPAPER

Entered according to the Act of Congress, in the year 1876, by Frank Leslie, in the Office of the Librarian of Congress, at Washington.

No. 1,070—Vol. XLII.] NEW YORK, APRIL 1, 1876. [Price, with Supplement, 10 Cents.

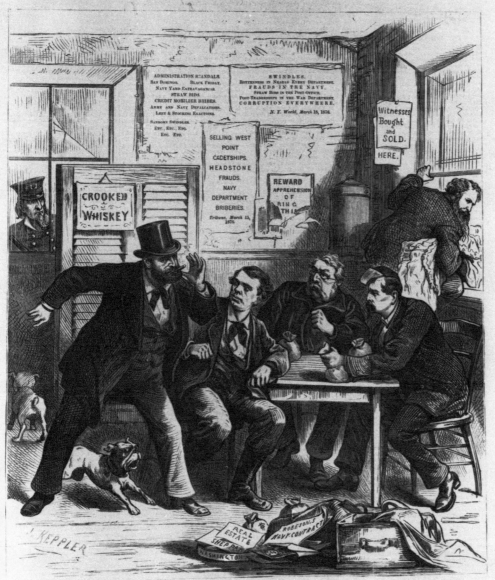

A FLUTTER IN HIGH LIFE.

CHIEF OF THE GANG TO HIS PALS—"Hi, my jolly coves! Hide your swag quickly! The cops are on us!! This lay is played out, and we must keep shady for a while!"

31. "The Governor After the Canal Rats." After learning that the state had been paying fraudulent bills of repair on the Erie Canal, New York Governor Samuel J. Tilden vowed to prosecute the guilty contractors and pass legislation to prevent such abuses in the future. His firm response to the scandal moved Keppler to advocate him for president. (Author's collection; *Frank Leslie's Illustrated Newspaper*, April 17, 1875)

FRANK LESLIE'S
ILLUSTRATED
NEWSPAPER

Entered according to the Act of Congress, in the year 1875, by Frank Leslie, in the Office of the Librarian of Congress, at Washington.

No. 1,020—Vol. XL.] NEW YORK, APRIL 17, 1875. [Price 10 Cents.

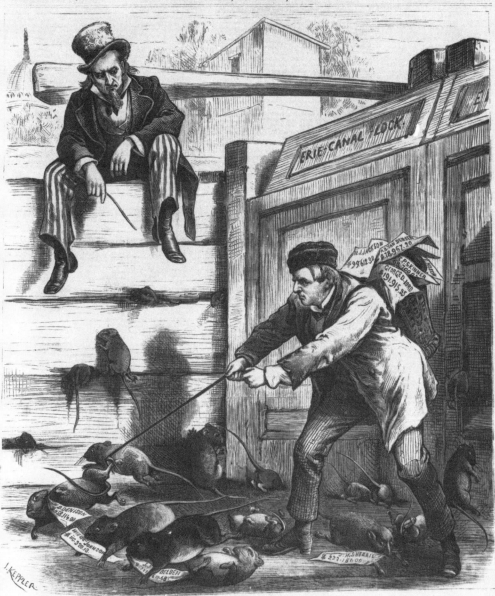

THE GOVERNOR AFTER THE CANAL RATS.

SAMUEL J. T.—"*If I can only succeed in driving out these rats, I shall save the taxpayers of New York State two million dollars a year.*"
UNCLE SAM—"*Well, Samuel, if you can do that much for a single State, the taxpayers of all the United States will agree that you are just the man for us at Washington, where there are more Ring rats and heavier taxes.*"

32. "Take Any Shape but That!" When Ohio Governor William Allen embraced a state Democratic platform that advocated paper money and inflation, pundits suggested that he did so to improve his presidential chances. Keppler believed that the U.S. would be ruining its fiscal reputation if it printed paper money that wasn't fully redeemable in gold. This cartoon is notable because its simple design and visual humor contrasts sharply with most of Keppler's other *Illustrated Newspaper* cartoons from this period. (Author's collection; *Frank Leslie's Illustrated Newspaper*, July 17, 1875)

FRANK LESLIE'S
ILLUSTRATED
NEWSPAPER

Entered according to the Act of Congress, in the year 1875, by Frank Leslie, in the Office of the Librarian of Congress, at Washington.

No. 1,033.—Vol. XL.] **NEW YORK, JULY 17, 1875.** [PRICE 10 CENTS.

The Rag Money Platform adopted by the Ohio Democrats at their State Convention in Columbus, June 17th, announced their belief in currency inflation. Now, Inflation, in its logical result, is Repudiation, and the mere suggestion of that would be insulting to honest Americans of all parties.

"If," says the New York *Tribune* (Ind.), "Governor Allen of Ohio labors under the impression with which he is credited, that his acceptance of a renomination on an inflation platform is likely to better his chances for the Presidency, he is liable to escape from the delusion before a long time elapses."

The Troy *Press* (Dem.) tells him : "It is by no means certain that he wants to be President, but if he does, his acceptance of a renomination under present circumstances has greatly injured, if not destroyed, his chances. THE GREAT MASS OF THE VOTERS OF THE UNION WILL NOT FAVOR AN INFLATION CANDIDATE. That is a pretty well determined fact, and therefore Governor Allen must be regarded as having counted himself out of the race. DALLIANCE WITH INFLATION WILL PROVE FATAL TO THE PRESIDENTIAL PROSPECTS OF EVERY ASPIRANT, whether he be Democrat or Radical, and hence it is quite unlikely that Ohio will furnish the next Chief Magistrate of the United States."

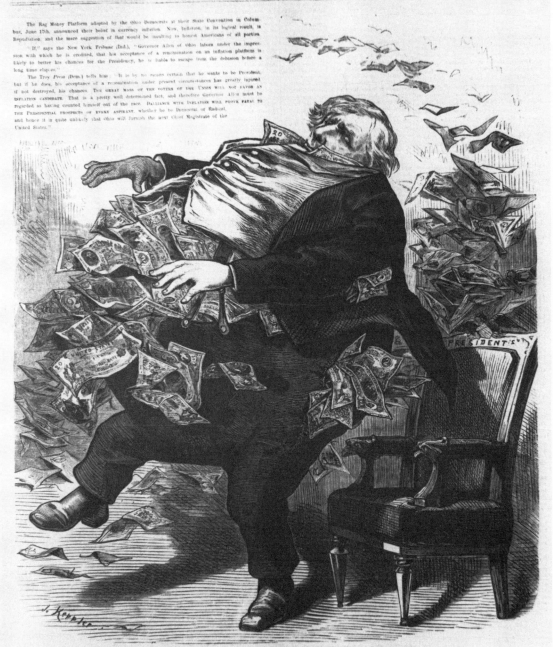

"TAKE ANY SHAPE BUT THAT!"

INFLATION ASPIRANT FOR THE PRESIDENCY—"*I shall have to bring myself down considerably before I can get into that chair.*"

33. **"The Centennial Race."** Republican presidential candidate Rutherford B. Hayes was forced to carry bad goods he inherited from the Grant administration over a rough road in order to reach the White House. In contrast, Democratic candidate Samuel Tilden's path was unobstructed, or so Keppler believed. (Author's collection; *Frank Leslie's Illustrated Newspaper*, Sept. 16, 1876)

FRANK LESLIE'S
ILLUSTRATED
NEWSPAPER

Entered according to the Act of Congress, in the year 1876, by Frank Leslie, in the Office of the Librarian of Congress, at Washington.

No. 1,094—Vol. XLIII.] NEW YORK, SEPTEMBER 16, 1876. [Price, 10 Cents. $4.00 Yearly.

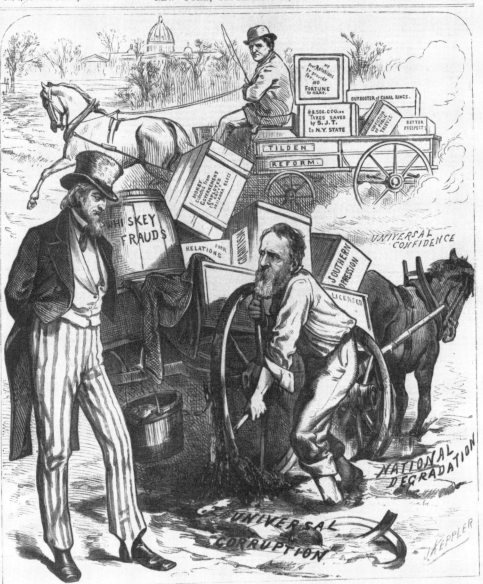

THE CENTENNIAL RACE.

Uncle Sam.—"Friend Hayes, you have undertaken a hard job! Your wheels are so deep in the mire that you can't possibly draw them out again whole. Your vile load, however, is such a nuisance, that you had better let cart and contents sink out of sight in the mud, where the men deserve to be who got it into that scrape before you took it in charge. I shall not require your services anyhow, as I am about to make a four-years' contract with my honest namesake over yonder."

34. The German Puck arrives. Ex-actor Keppler chose a stage for Puck's New York debut. The caption reads: "Who Brings Much Will Bring Something for All." Keppler's two-year-old daughter Irma modeled for this incarnation of Shakespeare's merry wanderer. In the upper right box of the theater sit Puck's colleagues, the mascots of the notable comic papers of Europe. *Puck* first appeared on Wednesday, September 27, 1876. The vicissitudes of publishing being what they were, Schwarzmann chose not to date the issues with anything more specific than the month and year until June 1877. (Author's collection; *Puck, Illustrirtes Humoristisches-Wochenblatt!* Sept. [27], 1876)

No. 1. September 1876. 1. Jahrg.

Entered according to Act of Congress, in the year 1876, by KEPPLER & SCHWARZMANN, in the Office of the Librarian of Congress, at Washington, D. C.

Illustrirt von Joseph Keppler. Redigirt von L. Schenck. Unter der technischen Leitung von A. Schwarzmann.

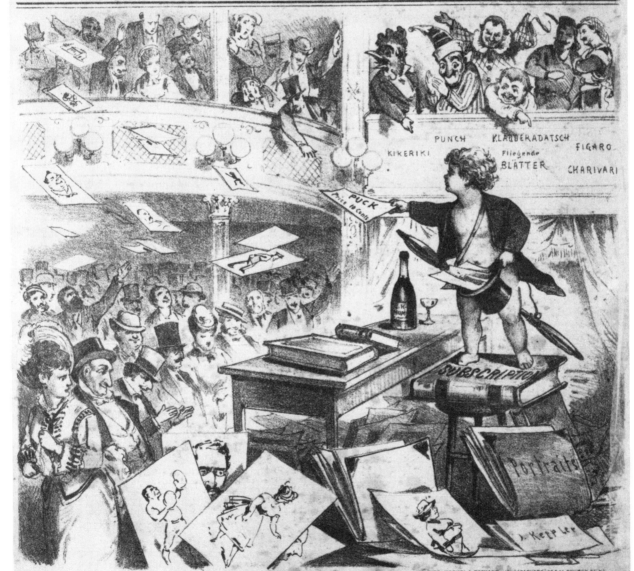

Wer Vieles bringt wird Manchem Etwas bringen.

PUCK'S FIRST DEBUT.

35. *Puck*'s advertisements. *Puck* was the first magazine in America to regularly publish illustrated advertisements (all drawn by Keppler). These two pages are from the German *Puck* of November 8, 1876. The weekly was ahead of its time. After the experiment had run for several months, advertisers apparently concluded that using pictures to sell their products was a waste of space. *Puck*'s advertising pages reverted to the traditional calling-card classified design. It would be about another twelve years before businessmen came to appreciate the eye-catching value of illustrated advertisements. (Author's collection: *Puck, Illustrirtes Humoristisches-Wochenblatt!* Nov. [8], 1876)

36. The famous Traveler's Insurance umbrella protected none other than Keppler himself in this 1877 *Puck* advertisement. Keppler frequently drew himself into his cartoons, but this is the only advertisement in which he appeared. (Author's collection; *Puck*, May [9] 1877)

37. **"A Stir in the Roost."** The first number of the English-language *Puck* appeared March 14, 1877. Inhabitants of New York's journalism barnyard include, from left to right: Whitelaw Reid, *Tribune*, Benjamin Wood, *Daily News*, George Jones, *Times*, James Gordon Bennett, Jr., *Herald*, Charles Dana, *Sun*, and William Cullen Bryant, *Evening Post*. With their backs to the viewer, from left to right, are Frank Leslie with his family of publications, the editor of the *New York Daily Graphic*, and cartoonist Nast, representing *Harper's Weekly*. Roosting behind Puck are the editors of Frank Leslie's comic monthlies, *Budget of Fun* and *Jolly Joker*. Note, in the nameplate, Keppler's subtle homage to Carl Schurz. The limestone slab behind Puck bears his portrait. The contents of the English-language *Puck* were entirely different from the German edition except for Keppler's centerspread and back cover cartoon. In April, the two editions began sporting the same cover cartoon as well, although their nameplates always remained different. (Author's collection; *Puck*, March [14], 1877)

NEW YORK, MARCH 1877.

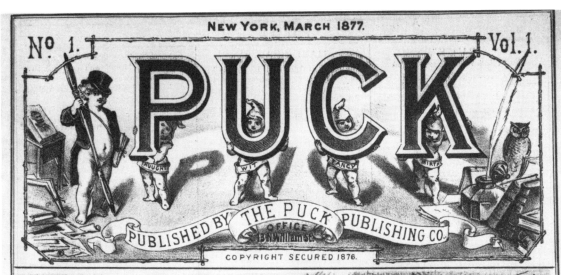

No. 1. Vol. 1.

PUCK

PUBLISHED BY THE PUCK PUBLISHING CO.
OFFICE 13 N. William St.

COPYRIGHT SECURED 1876.

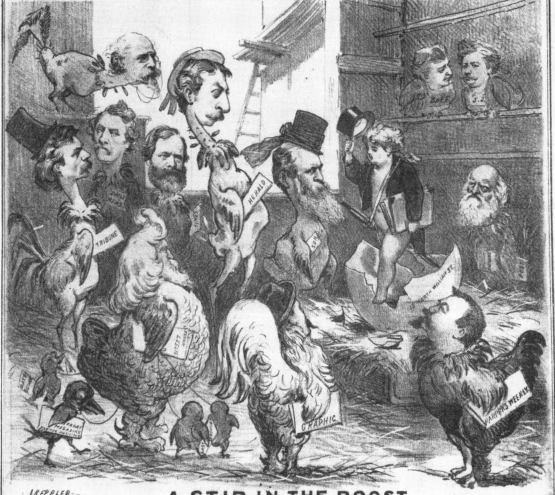

A STIR IN THE ROOST.
"What! Another Chicken?"

THREE

"Going for It"

WITH THE ADVENT of the German *Puck*, Keppler once more had a forum largely free of restrictions. A survey of Keppler's cartoons from *Puck*'s earliest days shows him reveling in that freedom, artistically and politically. In several *Puck* cartoons, Keppler mimicked the French school of caricature, drawing the heads of his cartoon subjects many times their proportional size. In others, he portrayed his subjects as animals and as inanimate objects. The large caricatures, except for registration problems, tended to work. The animal and inanimate portrayals were weaker and seemed forced.[1] But this was all part of learning his own artistic limits. As he gained confidence, he abandoned such alien devices.

At the same time that Keppler was indulging artistic urges, he was also cutting loose from some of his old political moorings. While he had felt entirely comfortable at Leslie's debunking Grant, he felt less comfortable adopting Democratic party dogma without reservation as Leslie had. In the hotbed of creativity at 13 North William Street, Keppler's previous staunch support for Tilden wilted. In October, he illustrated his new political stance. In that cartoon, he pictured a headless candidate in the White House thumbing his nose at the other candidate, also headless, standing dejectedly outside. Keppler kindly supplied their heads at the bottom of the page and invited the reader thusly: "Yous pays your money and yous makes your choice."[2] In this cartoon and others like it, Keppler announced *Puck*'s independence. Unlike its two political cartoon competitors, *Harper's Weekly* and *Leslie's Illustrated Newspaper*, *Puck*, at least at its outset, would not be an apologist for any party or politician.

If Keppler had any preference for one candidate over the other, he probably preferred Hayes to Tilden. Tilden's wealth made Keppler suspicious. After the

dust from the 1876 campaign settled, Keppler began suggesting that Tilden was untrustworthy. In fact, Tilden didn't receive good press in *Puck* until his death in 1886, when the magazine was obliged by custom to publish a generous memorial cartoon.[3] Hayes, on the other hand, always seemed to have Keppler and *Puck* on his side during the battle-filled four years that he was president, even during his administration's shaky early days.

Hayes had gotten off to a shaky start because the 1876 election had yielded no true winner. At first, Tilden appeared to have won because he had more popular votes than Hayes. But the electoral votes of four states were in doubt, leaving neither Tilden nor Hayes with the necessary majority of 185. Tilden needed just one of those contested electoral votes to win; Hayes needed them all. Keppler believed Tilden had won (fig. 38), but he chose not to press the point in his cartoons, emphasizing instead the intrigue and confusion surrounding the controversy.[4]

Just days before the presidential inauguration was scheduled to take place, a special electoral commission declared Hayes the winner. Democrats cried foul and urged Tilden to press his claim on the office, but the Democratic candidate prudently chose self-sacrifice over chaos. Keppler, far from disappointed, drew *Puck* and the Republican victors dancing together to a chorus of "Hurrah, they've counted us in!" (fig. 39).[5] Considering Keppler's implied-at-best support for Hayes during the preceding six months, this is a curious cartoon. It was probably prompted by Keppler's overweaning desire to see *Puck* become a part of the American mainstream. In the magazine's early days, Keppler strove to be agreeable. This led him to emphasize wit over satire, analogy over commentary, and a good-spirited impartiality over partisanship. Perhaps he was also tired of the strident political cartoons he had been called on to do at *Leslie's*. Whatever the reason, this desire to be agreeable soon faded. Within a few years, Keppler was drawing uncompromisingly severe political cartoons.

Keppler soon realized the problem with such well-meaning cartoons: they were eminently forgettable. As *Puck*'s fortunes stagnated, Keppler learned that to entertain his audience, he had to get their attention first. And the best way to get the attention of an American audience was to do something outrageous. During the sorry summer months of 1877, Keppler was served with the perfect opportunity to be outrageous.

Mormon leader Brigham Young died in August, and Keppler decided to do a memorial cartoon. Because hatred and suspicion of Mormons ran high in the East, Keppler knew he could get away with something other than the run-of-the-mill memorial. A common anti-Mormon satirical image of the day was a bed large enough to accommodate that religion's practice of polygamy. Keppler used

this image, filling the bed with twelve grieving women, six on each side of a vacant spot in the middle. He captioned it: "In Memoriam Brigham Young. And the place which knew him once shall know him no more" (fig. 40). The cartoon was an immediate hit. The issue in which it appeared sold out quickly. Schwarzmann then reprinted the cartoon as a broadside, selling it separately for almost two years.[6]

Keppler had touched a responsive chord. In the next few years, religion would provide him with his best material. At the time the machinations of party politics held only modest allure for him. But religion, with all its attending spectacle and dogma, presented him with enough cartoon fodder to fill a year's worth of *Puck*s. He needed to look no further in this area than to his old friend, Henry Ward Beecher.

In the same issue as the "In Memoriam" cartoon, Keppler drew Beecher, with suitcase and umbrella in hand, rushing from the arms of beseeching young women. The caption reads: "HWB sees by the *Herald* that Brigham Young leaves no successor, and promptly strikes for Salt Lake, leaving Brooklyn disconsolate." Keppler leveled less gratuitous charges at the reverend as well. In one cartoon, he drew an obese Beecher with pictures of various delicacies and a "$20,000 salary" label on his immense stomach. Two servants offer Beecher "lecture receipts" and "$ pickings" on platters. Under the title "Beecher's Theory and Practice" (fig. 41), Keppler quotes Beecher as saying, "The man who can't live on bread and water is not fit to live!"[7]

Keppler soon found another religious leader almost as plump for plucking as Beecher. T. Dewitt Talmage, pastor of the Central Presbyterian Church in Brooklyn, while not having Beecher's checkered past, had a propensity for showmanship and sensationalism that was just as offensive to Keppler (figs. 42, 43). To protect his parishioners, Talmage frequently "investigated" the evils of contemporary society firsthand. Then he would report his findings to his congregation in purple sermons full of titillating details, delivered in an inimitable gymnastic manner. Keppler usually pictured Talmage, in mid-harangue, as two sets of flailing arms and legs, with a gigantic tongue at their center. Nothing Talmage did was above suspicion. When his church burnt down in 1879 and parishioners rallied to rebuild it, Keppler viewed the new tabernacle as Talmage's monument to himself, further evidence of his unchristian-like arrogance.[8]

Not far down on Keppler's hit list was the Catholic Church. He didn't pay much attention to the church in *Puck*'s pages until his old nemesis Pope Pius IX was on his death bed in November of 1877. Upon that solemn occasion, Keppler showed no mercy, picturing Pius cringing in front of death itself with all his pronouncements of infallibility going for naught (fig. 44). Keppler treated the

subsequent search for a new pope with equal scorn. In "Going for It" (fig. 45), he cartooned bishops frantically vying for the papal crown, which he pictured perched atop a greased pole.[9]

When a new pope was chosen, taking Pope Leo XIII as his name, Keppler drew his portrait for the edification of *Puck*'s readers. Predictably, it wasn't flattering. Called "A Physiognomical Study," it depicted Pope Leo as the sum of his parts: his vestments are, on close scrutiny, actually the world Catholic press, his collar is a stone wall labeled "the Vatican," his chin and lower lip are sacks of money, and his nose is the rear view of a squatting church officiate. His forehead, a map of the world, is topped by a cap of propaganda (fig. 46).[10]

Keppler also gave considerable attention to the plight of New York Jews, who were banned from popular mountain and seashore resorts. He considered the bannings offensive, and he ridiculed the bigotry that prompted such un-American behavior.[11] But he was not above using the incidents to caricature the Jew unsympathetically. His stereotypical depiction led both Jew and gentile to wonder which side of the controversy he was on.

Keppler's religion-centered cartoons got noticed. When readers questioned *Puck*'s religious affiliation, Bunner remarked: "*Puck* professes no special form of religion. He is neither Catholic nor Protestant, Hebrew nor Mohammedan." As for Keppler, Bunner continued, "Mr. K. . . . seizes this opportunity to mention the fact that he . . . is a Roman Catholic, born, living and hoping to die in the faith and go .to the heaven of the late lamented Pontiff."[12] This, of course, was a disingenuous remark; Keppler's affiliation with the Catholic Church had ended long before this time, and he had no hope, particularly with the recent cartoons he had drawn, of ever seeing the same heaven of Pope Pius.

Keppler was too much of a cynic and a skeptic to have remained a Catholic. His empiricist tendencies led him to resent any religion that asked its followers to accept doctrine that flew in the face of logic and experience. Whether he believed in God is debatable. But he did believe in the forces and wonder of nature, and he revered the men of science—Galileo, Darwin, Spenser—whose works helped explain the world's mysteries. In his 1883 cartoon, "The Universal Church of the Future—From the Present Religious Outlook," he drew men, women, and children worshipping at the alter of geography, astronomy, and chemistry. Portraits of Paine, Spinoza, Darwin, and Copernicus dominate the walls, and the ceiling is inscribed with the legends, "Know Thyself" and "Knowledge Is Power." A good deal of the anger that Keppler directed toward men such as Pope Leo XIII, Beecher, and Talmage stemmed from the fact that he honestly regarded them as hucksters, taking advantage of the gullible, the ignorant, and the lost, ever willing to follow.[13]

International politics was next on Keppler's list of favorite topics (figs. 47, 48). He paid considerable attention to the 1877 Russian-Turkish War commenting frequently on the senseless violence of the conflict without taking sides. In a bit of grim satire, Keppler packed himself off to the front to report on the war for *Puck*, mimicking what was then regarded as a popular newspaper gimmick to boost circulation. When Russia subjugated Turkey, Keppler pondered the possibility that this turn of events would goad England into war with the czar, incidently presenting a rebellious Ireland with the opportunity to strike at a preoccupied Great Britain.[14]

During 1878, a dismayed Keppler watched France struggling under the increasingly suppressive regime of President MacMahon. He pictured Marianne at the mercy of the Catholic Church and the MacMahon-led military. Keppler considered MacMahon intractable and bigoted, and he rejoiced when MacMahon's political allies were defeated at the polls in October. The centerspread cartoon celebrating MacMahon's downfall prompted the French government to confiscate the October 24 issue of *Puck* in Paris. Keppler and *Puck* thumbed their noses at the French government, saying that such suppression merely justified their low opinion of the French leader.[15]

Keppler appeared to turn to national politics only when he tired of religious roastings and international affairs. One of Hayes's first acts as president was to dismantle the last vestiges of Radical Reconstruction by withdrawing the remaining federal troops from the South. For this, Keppler lauded him as "The Modern St. George" (fig. 49). In the cartoon, he portrayed Hayes as the dragonslayer of misrule and the severer of the South's chains, inscribing Hayes's lance with his famous words: "He serves his party best who serves his country best."[16]

Currency was a major issue during the Hayes administration. Midwestern and western senators pushed for the resumption of silver coinage to encourage inflation and help the depressed silver market. Keppler, forever a supporter of hard currency (see fig. 32 and fig. O) decried the silver bill on the grounds that it would debase U.S. currency. When the bill passed Congress, Keppler declared that the nation's honor had been sacrificed to the enrichment of a few. But Hayes was in step with Keppler and promptly vetoed the bill. When Congress overrode the veto, Keppler drew "The Impending Plague," which featured silver locusts feeding on the nation's field of gold.[17]

Keppler was once again in Hayes's corner when the president worked to fulfill his campaign pledge to advance the cause of civil service reform. The largest and most infamous patronage mill in the country, the Custom House at the Port of New York, had by tradition been the domain of the state political organization. Hayes believed that for the Custom House to run smoothly, it must be protected

from the pressures and whims of a parochial and politically motivated management. To effect this change, however, the president had to wrest control of the Custom House from New York's vain and powerful senator, Roscoe Conkling.

The deft and experienced Conkling knew how to extract maximum political advantage from the jobs he controlled. He jealously guarded New York patronage as his prerogative and was not ready to let go of a plum such as the Custom House without a fight. He had placed the Custom House under the direct supervision of his able lieutenant, Chester A. Arthur. When Hayes removed Arthur and nominated his own man for the job, Conkling was furious. He attacked Hayes as a hypocrite and a fraud, charging him with having used the power of patronage himself to win the presidency. Their bitter power struggle, lasting more than a year and a half, became one of the major issues of the Hayes presidency.

At the outset of the fight, in "The Political Pullback," Keppler pictured Hayes on the road to pure government being hindered by his political enemies. As the fight continued, Keppler's support for Hayes increased, but hope for his success diminished. In "The Erl King (New Version)" (fig. 50), Hayes is shown on horseback, with his civil service reform babe in arms, fleeing from the ghosts of opposition newspapers and his enemies in the guise of spooky-looking trees. The caption reads: "The father groaneth, he rideth wild/ He holds in his arms the sobbing child/ Arrived at the 'White House' with fear and dread/ Close in his arms, the child lay dead."[18]

The Custom House controversy came to a head in early 1879. Keppler lamented what he thought would be the outcome in "Design for a New Custom House in New York." Sherman, Evarts, and Hayes are depicted as pillars holding up the structure. Conkling, holding a victory flag after being elected to another six years in the Senate, straddles the top of the building. But two weeks later, to the surprise of many, Hayes had won. The Senate confirmed the president's nominee. In "Surveying the Field After the Battle," Keppler drew Hayes and Conkling peering at each other through opposite ends of a telescope. Hayes says, "How small he looks," while Conkling admits, "By Jove, he's a bigger man than I thought he was." Despite the outcome, Keppler wasn't entirely pleased with the president's methods. He labeled Hayes's suitcase: "Democratic Votes—Bought and Paid For."[19]

For all its political importance, especially to self-styled reformers like Keppler, the Custom House controversy received only cursory attention in *Puck*. And the villain in the drama, Roscoe Conkling, got off with hardly a rap on the wrist. While the cartoons suggest Keppler's dislike for the New York senator, none foreshadows the contempt Keppler displayed toward him in later cartoons. Had this political showdown happened a few years later, Keppler would have ham-

mered away at the controversy week after week. Why he didn't do so in the late-1870s says a good deal about his dispassionate interest in national politics during this period.

Another reason why Keppler went easy on Conkling was that the cartoonist and the senator had a common enemy, Tammany Hall, and Keppler disliked that organization more than any other. In 1877, Keppler derived grim satisfaction from following the criminal trial of former Tammany chief William Tweed, charged with embezzlement and fraud. The trial revealed for the first time to sickened New Yorkers the awesome dimensions of the Tweed Ring greed. Keppler advocated that the ring all be fitted with millstones and tossed into the sea.[20]

With Tweed's passing, city comptroller John Kelly emerged as heir apparent to the Tammany throne. Keppler chronicled with dismay Kelly's slow but steady accumulation of power. Kelly's ascendency, Keppler said, meant the death of reform in New York City. The defeat of the machine in the 1878 municipal elections gave Keppler heart and even prompted him to announce, rather precipitously, the demise of Tammany Hall. That occurrence, however, was not to be. As the decade drew to a close, Kelly was stronger than ever. The man seemed to lose every battle but win the war. This truly perplexed Keppler. In an August 1879 cartoon, he itemized "John Kelly's Political Pronunciamentos and the Dead Failure Thereof" and pictured two Kellys, one dressed in the robes of royalty and the other dressed in greasepaint and funny pants. He asked his audience, "King or Clown—Which?" (fig. 51). To Keppler's chagrin, he knew the answer: Kelly was king, and his rule would last for many more years.[21]

Instead of focusing on the headlines of American politics, Keppler devoted many of his early *Puck* cartoons to satiric dissections of American life. The theater naturally drew his attention, and cartoons of actors and plays predominated. The flawed jury system, preying plumbers, the death of a Fifth Avenue abortionist, life insurance fraud, the high cost of dying, female suffrage, conditions in the city schools, the psychic sham, additives in food, the rising divorce rate—these subjects and more caught Keppler's eye (figs. 52 through 60; see also fig. 17).[22] During this period, he seemed determined to dissect everything within view. Here was Keppler flexing his satirical muscle, eager to take on any and all of the false gods of American culture. The result was an eclectic satire, full of insight and humor, but with little purpose beyond giving credence to the line from Shakespeare that had become the magazine's motto: "What fools these mortals be!"

Not everyone, however, was entertained by showing people to be fools. Many Americans were uncomfortable with Keppler's frank and at times startling satires. His Germanic effusiveness often violated the boundaries that a predominately Anglo-Saxon Protestant society had defined as good taste. Of particular concern

to the thin-skinned were Keppler's attacks on Beecher and Talmage. Supporters of the two religious leaders regularly wrote complaining letters to *Puck*. Bunner adopted a defiant attitude, telling readers, "We are not in the habit of replying to letters criticizing our course on the principles we uphold.... Such communications are apt to get wastebasketed."[23]

In 1878 and 1879, anti-Beecher and anti-Talmage cartoons formed the core of *Puck*'s cartoon content. Virtually every other week, at least one color cartoon was devoted to skewering one or the other of these prominent religious leaders. When the Rev. Beecher traveled to Canada in May as chaplain of the 13th Brooklyn regiment, Keppler brutally satirized the trip, suggesting that Beecher's behavior was unbefitting a man of the cloth (fig. 61). The regiment, upon its return, held an anti-Keppler protest meeting. The *Puck* staff, however, was not cowed and Bunner used the event for comic purpose. He wrote: "Our devoted friends... prayed to us on bended knees,... [to] draw things just a little wee bit milder. But the prayers have been systematically ignored... [and now] *Puck* is to be wiped out of existence. Mr. Keppler is to be torn in pieces by wild horses, and then trampled into condensed meat by newly captured elephants."[24]

Sydney Rosenfeld, since leaving *Puck*, had established his own magazine, *The Rambler and Dramatic Weekly*. From this forum he regularly disclosed *Puck*'s indiscretions and did all he could to denigrate the talents of its staff. Regarding the Beecher cartoon, Rosenfeld reported that it had "aroused the indignation of the press throughout the country, and Keppler, the very clever cartoonist who prostitutes his skill in drawing them seems to be the particular object of censure."[25] Knowing something of the operation of *Puck*, Rosenfeld wanted to correct what he considered a misconception. Although Keppler "is inclined to be vulgar where he might be witty," said Rosenfeld, "the downright filth that gets into his pictures is directly inspired by his partner, a little undergrown German typesetter named Schwartzmann [*sic*], who has made it his business since *Puck* began to find a market for obscenity.... *Puck*'s artist is too clever to lend himself to such a disgraceful course of action. And as for his partner whom the plain Saxon words 'little beast' most fitly describe, a summer season in the penitentiary would bring him round."[26]

Rosenfeld was so bitter that he even included his old friend Bunner in his attacks. About Bunner's contribution to *Puck*, he wrote with derision: "If *Puck* were to republish weekly several columns of Blackstone's Commentaries, it would be an excellent matter to fill up with; and would scarcely be any less humorous than a great deal of the pablum that is now offered in the brightest and wittiest paper in the world—as it regularly calls itself in each issue, with characteristic modesty."[27]

Fortunately for Keppler and Schwarzmann, Rosenfeld did not represent the majority view. Many Americans shared Keppler's contempt and anger toward those who abused power and privilege. They were thrilled by Keppler's boldness, and they began coming back, week after week, for another dose. Slowly but steadily *Puck*'s circulation began to rise. In 1879, it found itself with more readers than its robust German brother. From that year on, *Puck* was more accurately an American magazine with a German-language edition, rather than the other way around. Perhaps the sign that *Puck* had arrived came in the winter of that year when Keppler and Schwarzmann licensed the "Puck" name to a pipe tobacco company, then a cigarette company, and finally a cigar company. The name "Puck" was becoming a part of the American consciousness.[28]

In October of 1877, Keppler and Schwarzmann had agreed to a realignment of their partnership.[29] Schwarzmann offered Keppler co-ownership in the *New-Yorker Musik-Zeitung*, forming in the process a full-fledged partnership. The new firm, Keppler and Schwarzmann, Inc., would publish the *Musik-Zeitung* and both editions of *Puck*. At the time, Schwarzmann's printing plant and other assets were valued at $9,000. Keppler bought into the partnership by agreeing to pay Schwarzmann $4,500 out of company profits over the next ten years. All company profits would be split 50–50, with Keppler relinquishing his claim to a weekly salary on top of that money. The act of incorporation took effect in March 1878.

As it turned out, the publishing company's health improved so quickly that Keppler paid off his debt to Schwarzmann in less than two years. During the same period, Keppler and Schwarzmann, Inc. began to outgrow its 13 North William Street headquarters. Looking back on these quarters years later, one anonymous *Puck* scribe reminisced, "The stairs would bend so freely as you walked up them that strangers thought they were made of rubber, and if a man fell going down and struck them, he would bounce off." Early on, Schwarzmann and his small business staff had moved across the way into 8 North William Street. The scribe recalled that this was where "all the capital was kept" so that the shaky building across the street couldn't cave in on top of it.[30]

In 1879, the construction of the Brooklyn Bridge forced a radical solution to the overcrowding. *Puck* had to evacuate its quarters to make way for the bridge's approach ramp. In April, Keppler and Schwarzmann, Inc. moved just across City Hall Park to its new home, a three-story building at 21–23 Warren Street, next door to *Puck*'s lithographers, Mayer, Merkel, and Ottmann (fig. 65b).[31] One of Keppler and Schwarzmann's publications, however, did not make the move. The financial success of both *Puck*s had diminished the role that the *Musik-Zeitung* played in the company's fortunes. Because it was never a big moneymaker, Kep-

pler and Schwarzmann decided to suspend its publication when they vacated the North William Street address.[32] This decision allowed them to devote more time to nurturing the growth of the two humor magazines and to give what little time was left to their families and to leisure.

At Keppler's Bolton Road home, on September 26, 1879, Keppler's third child and second daughter, Olga, was born, bringing his growing family to five. There it would have remained had not Keppler persuaded his father to come from Missouri and his mother from Vienna. Eventually, his in-laws also moved into the Bolton Road house. Udo, who was seven in 1879, discovered the old Algonquin Indian settlement nearby, and a lifelong love affair with Indian culture began. The fields and marshes of Inwood afforded Udo the perfect setting to imagine himself as a young Indian brave silently stalking the wild game of Manhattan Island.[33]

Keppler's nine-hour work day, six-day work week, and long commute prevented him from spending much time at home. On top of this, Keppler had many social obligations, most of which he hated passing up. As a smoking and drinking companion, Keppler was without peer. The White House under Mrs. Lucy Hayes may have been dry, but the alcohol flowed freely during an evening with "Joe" Keppler. (His enjoyment of liquor and beer, incidently, made him a life-long opponent of the prohibitionists. Anti-prohibition cartoons dot his career's work [fig. 131].) Many New Yorkers reminisced fondly about evenings in Keppler's company. The opening night of the annual American Water Color Society exhibitions, for example, was usually enlivened by Keppler's presence. On one of those evenings he tried "in vain" to teach his colleagues the "solemn drinking ceremony of the salamander," which required the drinker to swallow an entire stein of beer and then slap the stein down on the table with a peculiarly German flourish.[34]

Keppler's favorite time of year was the grand ball season. Each winter, in the two weeks before Lent, Keppler threw himself into a whirl of masquerade balls sponsored by the Academy of Music, the Leiderkranz Society, the Arion Society, and others fraternal orders. By the late 1870s, Keppler had not appeared on the stage in more than five years, so his starved actor's soul jumped at the opportunity to dress in costume and show off in public. He looked forward to these balls as a child does to Christmas. Once he even drew himself fast asleep dreaming of the wonderful sights and sounds of the masked balls (fig. 62). Always he seemed to find himself at the center of things. Almost every year he lived in New York, he drew the invitations to the Academy of Music and the Leiderkranz Society balls (fig. 63 and 64). For a time, he also served on the Leiderkranz board.[35]

In 1879, Bunner paid tribute to Keppler's extracurricular labors when he described the Leiderkranz grand procession, which Keppler choreographed.

"When we think that Mr. Keppler was personally responsible for a couple of hundred pairs of legs . . . , we cannot but admire the towering genius that drilled those naturally awkward legs into grace and precision, and made them a thing of beauty and a delight to the eye."[36] Two weeks later, Keppler—performing acrobatic feats and wearing tights—was the center of attention in the Arion Society ball's grand march. The showman was never happier.

One of the ball guests, however, took disdainful notice of Keppler's "display." Sydney Rosenfeld sourly reported to the readers of his new publication that Keppler, "not content with sacrificing all dignity by pirouetting on top of a globe in the procession and lowering himself to the level of a cheap circus performer, rigged himself up in a costume that was no more or less than indecent." Rosenfeld lectured to his readers that "no right-feeling American" would "sanction the career of this man Keppler."[37] Rosenfeld's magazine failed not long after that. In the years that followed, he supported himself as a playwright of little distinction. The cruel irony of Rosenfeld's life is that he would be entirely forgotten today had he not played an early, crucial role on the magazine he came to loathe.

Rosenfeld's charge that Schwarzmann and not Keppler was responsible for the "filth" in *Puck*'s cartoons was surely the most backhanded compliment Keppler ever received. It was also the first appearance of an accusation against Keppler that would surface again and again during his career and after his death: that Keppler did not conceive, but only drew, his cartoons. The charge was not without substance—Keppler readily admitted to using the ideas of fellow staff members in his work—but it was often twisted to such an extent that it became more falsehood than truth. Many who advanced the charge had an axe to grind: they disagreed with Keppler's politics, they resented his growing power and influence, they were contemptuous of his German origins and Germanic ways. Understanding the charge and why it was significant depends in part on an appreciation of Thomas Nast's travails of the same period.

Early in his career, Nast had taken a courageous stand: the work he did must be his own. He would not draw a cartoon he didn't agree with. Moreover, he would not allow someone to dictate what he drew. All work from the pen of Thomas Nast came from the brain and convictions of Thomas Nast. This was a startling concept in the days of party organ journalism. Most newspapers and magazines espoused a point of view in alignment with one of the major political parties or politicians of the day. The men and women whom they employed were expected to promote the same point of view in the work they handed in.[38]

Nast had become the first celebrity in journalism who was not an owner or an editor. His fame, and the pride that came with it, prompted him also to become

the first journalist to make an issue of professional integrity. Today, the concept is taken largely for granted. But in Nast's day, the idea was ridiculed. All of this talk about autonomy was well and good, critics said, when Nast and his editor G. W. Curtis agreed on things. But what did *Harper's Weekly* gain by running editorials that espoused one position and cartoons that contradicted the editorials? Why employ someone, the critics continued, whose work undermined and discredited positions of the management?

These questions and objections, although salient, failed to address the complex personal aspects of the controversy. Curtis respected Nast's power and understood that Nast had helped establish *Harper's Weekly* as the leading magazine in the country. Nast, for his part, couldn't imagine a more influential forum than the *Weekly*. In short, they were stuck with each other, and they spent a decade and a half together ruing that twist of fate.[39]

During his years with *Harper's Weekly* following the fall of the Tweed Ring in 1871, Nast waged a series of battles for independence. Usually Nast won, with owner Fletcher Harper coming to his aid. As Nast once put it, "Harper thought I was oftener right than Curtis." But when Harper died in 1877, Nast found himself increasingly on the outs at the *Weekly*. If Nast agreed with Curtis on a certain issue, he drew a concurring cartoon with a clear conscience. Then, too, if Curtis didn't have an opinion one way or the other on an issue or event, Nast was free to draw whatever he wished. But if Nast disagreed with Curtis, usually his only recourse was to not draw a cartoon on the subject. This, of course, infuriated Nast and caused him on many occasions to leave the *Weekly* for months at a time, only to return later with nothing to show for his absence except a diminished hold on the public's attention.[40]

This classic battle of wills became a war with the start of the Hayes presidency. Curtis liked Hayes and was an outspoken supporter of his civil service reform program and his anti-Reconstruction policy. Nast, in contrast, saw Hayes as a repudiator of his hero Grant: his civil service reform campaign was a calculated slap at Grant, and his decision to withdraw troops from the South and end the policies of Radical Reconstruction reneged on the noble aims of the Union cause. Curtis refused to allow Nast to use the *Weekly* as a soap box for attacks on Hayes. As a consequence, Nast's work was absent from the *Weekly* for months at a time throughout the Hayes presidency.[41]

It was in this atmosphere of defiance that Keppler's professionalism came to be judged. Keppler saw nothing wrong with using cartoon ideas volunteered by others on *Puck*. On *Harper's Weekly*, Nast was but one of many commentators. Keppler, on the other hand, as the guiding artistic spirit on *Puck*, was the orchestrator and organizer of many voices. He was responsible for determining what

cartoons would run in *Puck* each week. And once he had a staff of artists working for him, he was also responsible for determining who was best suited to draw the cartoons. Sometimes this led Keppler to use the ideas of others; sometimes, to supply others with ideas for their work. In other words, what was in *Puck*'s best interests served Keppler's interests. Nast had only himself to look out for.

But Keppler's frank admission was turned against him. His detractors said that Keppler relied on others for ideas because he lacked imagination. Those who worked with Keppler knew this wasn't true. Several have said that even when he did avail himself of others' ideas, he had a genius for vitalizing those ideas and giving them an energy they would not otherwise have had. Indeed, Keppler's distinctive tone, his irreverence and spirit, mark his work from first cartoon to last.[42]

Others said that Keppler's reliance on his staff for ideas proved that he was apolitical and lacked personal convictions. If this had been true, Keppler's work on different magazines with different staffs would have clashed like a badly designed quilt. But, as a survey of his work shows, this is not the case. Keppler's politics, save for the natural shifts that occur in a person's thinking over a lifetime, remained consistent for the thirty years he drew cartoons.[43]

Others charged Keppler with following business interests, not conscience, in deciding what to cartoon each week. As co-owner and art director of *Puck*, Keppler did have to balance many concerns, some perhaps in conflict with others. But these concerns never compelled him to draw a cartoon he didn't believe in. Only Schwarzmann had sufficient power to get Keppler to do something like that, and there's no evidence that Schwarzmann ever exercised that power. Considering all the controversial and unpopular cartoons that Keppler drew, the *Puck* staff surely must have laughed at the "lack of conviction" charge.[44]

Nast was deeply envious of Keppler's special position as part-owner of *Puck*. Nast came to believe that the only way he could end his struggle for editorial freedom was by owning his own publication as well. Then he could call the shots and flay any hides he chose. Almost from the day that *Puck* was founded, Nast began his quest for his own magazine. After seventeen years, in 1893, he finally realized that quest. But by the time he launched *Nast's Weekly*, his work was an anachronism, out of step with the sensibilities of the 1890s. The *Weekly* lasted only five months.[45]

The Curtis-Nast squabble, coming to a head as it did just after *Puck* made its debut, couldn't have been better timed to help Keppler and *Puck* establish themselves. By bowing out, Nast essentially gave over the national stage to Keppler. Moreover, when Nast's cartoons did appear, they seemed out of touch with the country's mood. He was determined to keep the causes of the Civil War alive,

a political gambit called "waving the bloody shirt." Nast would not be silenced in his campaign for the rights of freedmen and in his excoriation of the violent element of the white South. Keppler wanted to close that chapter in American history and move on to new challenges. Most of America shared Keppler's sentiments and supported Hayes's calming leadership. People were tired of thinking about the Civil War and the ten years of tension and violence that followed it. They preferred to look ahead.[46]

Even the way Nast and Keppler approached the art of cartooning bore out these differences in sensibilities. Nast was a dogmatist, content to view the political world as a struggle between good and evil. Consequently, his work was caustic and lecturing. The harshness of his heavy black line and the severity of his cross-hatching mirrored his angry politics.

Keppler's political vision was broader. He refused to believe that either side in a debate had a corner on the truth. Primarily a satirist, Keppler wanted to enlighten *and* to entertain. His lithographs were colorful, gentle-toned, and somehow soothing, even when his message was pointed. Nast's and Keppler's work epitomized two distinct eras in American politics. Keppler was unable to make his brand of cartooning succeed in Nast's era, and Nast faded into oblivion in Keppler's.

Keppler's broad-ranging satires and frequent comments on New York life presented him with challenges Nast never knew. Because he drew personalities not in the national press, Keppler frequently found himself, in those days before widespread photography, faced with the challenge of caricaturing a man he had no likeness of. Years later, in an interview with a reporter for the *New York Herald*, Keppler recalled that in *Puck*'s early days "very few men were willing to sit for me. . . . I remember one man, a banker in the city [of New York], who I chased for a long time trying to get his picture. I followed him into restaurants and all sorts of places but he always managed very adroitly to keep his face away from me.

"Of course I did not wish to be too rude about it. But at last I had to have his portrait, so I made a flimsy excuse for calling on him at his bank and managed to get into his private office without sending in my card. Being once inside I could not very well be put out, though I think he would have been glad to kick me into the middle of the street, but so long as I talked only of business matters and took out no notebook he could not treat me uncivilly. As we talked I studied his face very closely, and then when I went out I purposely left my umbrella standing in the corner. Outside I hastened to make a sketch of him, but found that I had overlooked one or two important features so I went back after my umbrella and,

stopping to say a few more words to him, closely observed the omitted features and then succeeded to get a first-rate likeness of him. . . . "[47]

This sort of awkwardness forced Keppler to learn a number of unusual artistic tricks. "For one thing," Keppler recalled, "I learned how to catch a man's face in the shortest possible time and hold it in my mind until I could go somewhere and sketch it. Of course, I was familiar with hundreds of faces of historic men, and soon found that almost every man I met looked somewhat like one or another of these. So I began to form a plan of noting in my mind how these men differed from the historically familiar faces. One man, for instance, would look like Napoleon, only his nose would not be quite so long. So, you see, I did not have to remember his whole face, but only the difference between it and Napoleon's

"Then, too, almost every man looks like or rather suggests to me some animal or bird or some inanimate thing. One man looks like a fish in the face, another like a bull, another like a frog, an owl, an eagle, and a great many call to my mind such things as bottles and domes and numerical figures. I know one man whose face always reminded me of the figure 3. . . . When I once have drawn a face, I remember it always and can draw it from memory giving it any expression I please. . . . I frequently meet men [with whom] I think I am acquainted, [but] after I have spoken to them [I realize] I know them only from having drawn their faces."

After completing these caricature subject search missions, Keppler would return to North Williams Street and later Warren Street and begin composing his cartoons (figs. A-D). Keppler's first step in the drawing process was to make a charcoal outline of the general composition of the cartoon on a piece of paper. (The *Herald* reporter observed, "This drawing has no detail in it, and is so devoid even of form that a layman would be unable to say whether it is a picture of a man or of a tree.") Then he would lay the charcoal sketch upside down on a piece of limestone, used in lithography because it is porous and can absorb water and wax, and pat it lightly, creating a faint outline suggesting the finished cartoon's composition. He did this on as many stones as the cartoon would have colors. Keppler had stopped using wood color plates in the summer of 1878 and now used the smooth, cool, cream-colored limestone exclusively. In 1879, he generally used three stones to make his cartoons, one for the black plate and the other two for color. Within a few years, five-color plates became routine, and as many as ten were employed for special printings.

Upon completing this preliminary work, Keppler would take up his wax lithocrayon and begin drawing the black plate. Because impressions made from stone are mirror images of what the artist creates, Keppler had to draw (and letter) his cartoons in reverse. He started with the face of one cartoon subject and

then worked downward, shading the figure as he advanced. He told the same reporter: "The secret of caricature is exaggeration, of course. But first we have to determine what feature is to be exaggerated. If a man has an extraordinarily prominent nose, we must make it more prominent, but we must preserve [its] character...." Character was the key. Caricature, observed Keppler, was not simply "faces and forms....If a man is notoriously stingy, that stinginess must be pictured in his caricature, and pictured extravagantly, so that it will stand out as the most prominent feature of the portrait. If he is proud, as Conkling was for example, this trait of character must be told in the expression of his body as well as his face."

In this manner, Keppler worked a single caricature to completion. Most of Keppler's cartoon portraits of political leaders of his day were restrained, as was the custom of the period. (figs. 79 a, b, c, d, 80). Instead of savaging all, he reserved his artistic venom for a select few. Beecher and Talmage are notable examples. Roscoe Conkling and Benjamin Butler also received rough treatment. Both men's physiognomies and personalities lent themselves to caricature. In drawing them, Keppler indulged his most wicked graphic whims. To say Conkling was proud was an understatement. Conkling was a preening, self-absorbed dandy who savored subjecting all who stood in his way to his withering wit. Keppler portrayed him as the rooster of the barnyard in mid-strut, with his chest thrown out and his eyes set imperviously toward heaven, undoubtedly acknowledging his only equal. Butler, in contrast, was a rumpled little lump of a man who trimmed his political sails to catch the prevailing popular wind. Keppler's Butler was invariably some lowly cold-blooded reptile, slimy and malodorous, who, with darting tongue or poisoned fangs, lay in waiting for the opportune political moment to strike.[48]

Once Keppler completed the execution of the black plate, he then spread a weak mixture of nitric acid and gum arabic over the stone. By coating the surface of the stone with the nitric acid and gum arabic mixture, Keppler sealed the part of the stone he had not drawn on, making it repel ink. This process also left the acid-resistant wax in slight relief, ready for printing. Keppler then proceeded to the other stones, filling in only the red areas of the cartoon on the red stone, green areas of the cartoon on the green stone, and so on. He managed to produce a spectrum of color using only three stones by overlapping the colors he had available to him. After he finished "tinting" the stones, each stone was mounted in a printing press and proofs were pulled, with a combined proof being the final object. Once Keppler was satisfied with registration, he supervised the mixing of the printing pigments to make sure that the colors were exactly what he wanted. Finally, he authorized printing. The entire process took Keppler about two days.

Considering how involved and obviously time-consuming the lithographic process was, the amount of work Keppler did in *Puck*'s early years is remarkable. Fortunately, *Puck*'s increasing circulation allowed Keppler to hire another cartoonist in 1879. Keppler looked no further than his old place of employment, the *Illustrated Newspaper*.

Not long after Keppler left the *Newspaper*, Leslie's extravagant living had caught up with him and forced him to surrender his publishing company to his creditors. By agreement, he received a salary as general manager, with all profits going to pay his debts. If all went well, Leslie would recover full ownership of the company that bore his name in January of 1881. The new regime brought with it new stringencies. The *Budget of Fun* and the *Jolly Joker*, for example, were suspended in 1878, removing Leslie from the humor field entirely.[49]

Leslie had brought in James A. Wales to replace Keppler as chief cartoonist.[50] During Leslie's period of travail, Wales was having some problems of his own. His marriage to one of the beauties of his hometown of Clyde, Ohio, was on the rocks. Eventually Wales would abandon her and his two sons for a footloose existence, relying on the generosity of his friends to house and feed him. But when Keppler and Schwarzmann offered him a job in January of 1879, this sorry story was yet to unfold. The broadly built, mustachioed, twenty-six-year-old jumped at the opportunity to work for *Puck*.

The February 12 issue contained Wales's debut cartoon, the first in a series of full-page woodcut portraits of leading figures of the day entitled "*Puck's* Pantheon." The faithfulness of these images were responsible for establishing Wales's reputation as a portraiturist. Wales immediately proved to be an able lieutenant, although he was neither the artist nor the humorist that Keppler was. His work lacked grace and wit, and he never learned how to use color to any effect. But under Keppler's direction and encouragement, he began developing a sense for composition and was able to rid his work of its roughest edges (fig. 92).

His earliest effective cartoon was, although lithographed, meant to look like a woodcut. It was a telling frontal assault on Thomas Nast. Entitled, "*Puck* Sends His Compliments to Mr. Nast Once More!," the cartoon pictured a fairly good copy of a Nast Lady Columbia holding a sword labeled "constitution." A Ku Klux Klan member, with bloodied knife, stands at the edge of the picture with his back to the viewer. Around Lady Columbia are posted dozens of signs bearing legends satirizing Nast's forced and melodramatic way of making a point. They say such things as, "Beware Solid South," "Watch and Pr(e)ay," "Preserve the sanctity of the pol(l)(e)s—North and South poles, liberty poles, bean poles."

The text accompanying the cartoon scolds Nast for ambiguities that were creeping into his work of late because of pressure from his boss to go easier on

some pet subjects. The text reads: "Our independent artist, finding ideas very scarce this week, has quietly left the last page to be filled by the unfortunate editor, who has been forced to avail himself of one of his esteemed friend Mr. Thomas Nast's patent double-back-action reversible cartoons, suitable to all occasions, and to all weathers. What is sauce for the *Harper's* is sauce for *Puck*. The reader can select for himself an idea appropriate to the young woman in the picture. Behold the works of the editorial genius. You pays your money and you takes your choice of ideas. This is a genuine Nast caption."[51]

The cartoon was meant to ridicule Nast's by-then predictable work. Inadvertently, it was also a tribute of sorts to the father of American cartooning. His fame was so widespread and his style so well-known that he had become as frequent a target for political cartoonists as some of the country's leading office-holders. Laugh as they might at Nast's current dilemma, Keppler and Wales longed for the stature Nast had attained. And because Nast was so inventive and prolific, Keppler and Wales, for all their protestations, knew they would always work in the shadow of his achievement.

Wales's smooth induction into the owners' ways and inclinations was surely encouraging. What had once been Keppler's stage alone was now shared by two and shared without awkwardness. Before long, *Puck*'s success allowed Keppler to add yet another artist to his staff. Once again, he raided the ranks at *Leslie's Illustrated Newspaper*. When Wales had departed that paper, Leslie had promoted another young Ohioan on his staff, Frederick Burr Opper, to replace him.[52]

As *Harper's Weekly* and *Puck* outdistanced and outclassed the *Newspaper* as a journal of opinion, Leslie chose to print fewer and fewer political cartoons. Consequently, Opper's work for the *Newspaper* consisted mainly of mild satiric cartoons to illustrate the back pages and to break up the advertising. When Leslie died on January 10, 1880, in the midst of financial troubles and publishing woes, Keppler and Schwarzmann took advantage of the turmoil to hire away the twenty-three-year-old Opper.

Selecting Opper as *Puck*'s third cartoonist was an interesting choice. He had none of the experience of Keppler or Wales as a political cartoonist. Artistically, his work looked childish, charming perhaps but definitely amateurish (fig. 93). Keppler, however, must have seen in Opper's work a comic spark, a certain light, that would complement his political bent and Wales's humorlessness. Time proved him correct. Opper would become *Puck*'s greatest comic artist.

Before Wales and Opper arrived, the inside pages of *Puck* were sparsely illustrated. To break up the gray columns of poetry and prose, Keppler had relied entirely on cartoons taken from European journals (without credit or payment) and on the work of a few free-lance artists. Now Wales and Opper filled *Puck*'s

inner pages with comic drawings and small political cartoons, making the magazine livelier and more distinctive than ever.

Puck's first three years had been arduous for Keppler. At times he had nearly given up hope. But by 1880, *Puck* had passed through the crucible that all new magazines must traverse on their way to cultivating a loyal readership. Now, with an experienced editorial and business staff and a multitalented art crew, *Puck* was poised, fully prepared, to meet the challenge of the 1880 presidential race. In the months that followed, Keppler would draw many of the best cartoons of his career. And *Puck* would emerge as an established success, assured of a long and prosperous life.

Figures 38–65

38. "The National Twins—Which of the Two will Live?" The disputed election of 1876 left the verdict of who would be America's next president in the hands of a specially appointed Returning Board. Keppler believed Tilden to be the rightful winner, but he never expressed strong feelings on the matter. Here Puck holds a beatific Tilden while Uncle Sam mourns the impending death of the sickly Hayes. Looking on are Republican party chairman Zachary Chandler, the midwife, and Democratic party chief Abram Hewitt, the doctor. (Author's collection; *Puck, Illustrirtes Humoristisches-Wochenblatt!*, Dec. [13], 1876)

THE NATIONAL TWINS — WHICH TWO WILL LIVE?

U. Sam: Das sind zwei Schmerzenskinder, die Vaterfreuden sieht's faul aus!

39. "Grand *Pas De Trois*." When the Returning Board named Hayes to the presidency, Keppler celebrated, despite the fact that he hadn't supported Hayes and had felt Tilden to be the rightful winner. Like most of the rest of the country, Keppler was glad the sordid, tension-filled affair had come to a peaceful close. (New York Public Library; *Puck, Illustrirtes Humoristisches-Wochenblatt!* March [7], 1877)

GRAND PAS DE TROIS.

Puck: Hurrah! they've counted us in!

40. "In Memoriam Brigham Young." This cartoon was *Puck*'s first hit. That it caused a stir, however, was surprising, because the idea was not new. In *Puck*, April [4], 1877, Rosenfeld made reference to a "grotesque cut in Mark Twain's 'Roughing It,' representing the Mormon chief in a bed of vast extent with innumerable wives snoring on each side of him." Keppler successfully popularized the image, because he resurrected it and gave it a twist at just the right time. "In Memoriam" made the September 5, 1877, *Puck* the most sought-after issue of the magazine. Through the eighties, Keppler and Schwarzmann offered to buy back that number for 50 cents a copy. (Author's collection; *Puck*, Sept. 5, 1877)

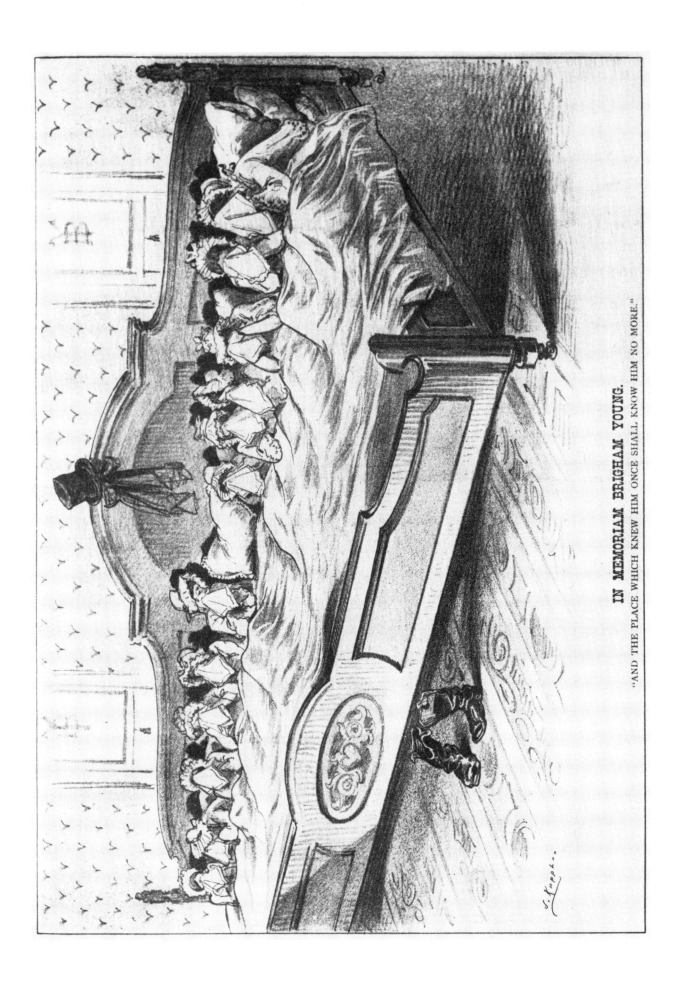

IN MEMORIAM BRIGHAM YOUNG.

"AND THE PLACE WHICH KNEW HIM ONCE SHALL KNOW HIM NO MORE."

41. **"Beecher's Theory and Practice."** This caricature of a smug, lizard-like Beecher summed up Keppler's disdain for the man. Throughout the late seventies, Keppler hammered away at Beecher for his profligate and amorous ways. (Author's collection; *Puck*, Aug. 8, 1877)

No 22.- VOL. I. AUGUST 8, 1877. Price, 10 Cents.

HUMOROUS WEEKLY

Puck

PUCK PUBLISHING CO. NEW YORK OFFICE Nº 13 NORTH WILLIAM ST.
COPYRIGHT SECURED 1877

BEECHER'S THEORY AND PRACTICE.

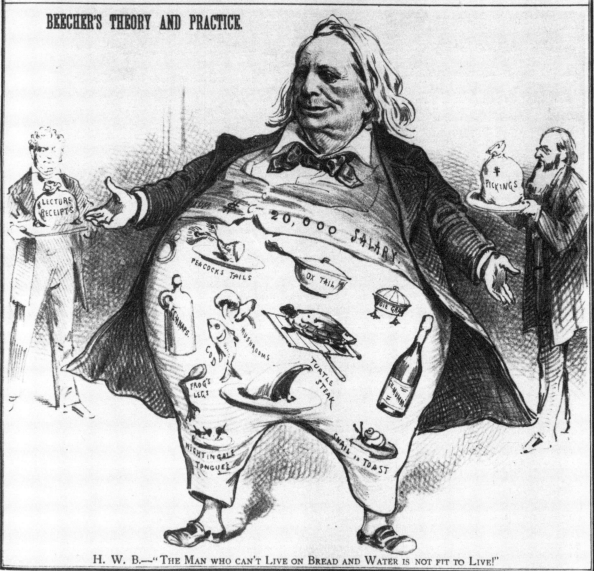

H. W. B.—"The Man who can't Live on Bread and Water is not fit to Live!"

Office of Puck 13 N. William St N.Y. MAYER, MERKEL & OTTMANN LITH. 22 & 24 CHURCH ST N Y

42. **"Talmage."** While Keppler allowed that Talmage was not the morally bankrupt religious leader that Beecher was, he nevertheless was disgusted by Talmage's calculated appeals to purient interests to pack his Brooklyn church. Before 1880, Keppler devoted more cartoons to ridiculing Talmage than to any other person. Talmage, instead of being upset, reportedly loved the attention and scrupulously saved all of Keppler's attacks on him. (Author's collection; *Puck*, April 10, 1878)

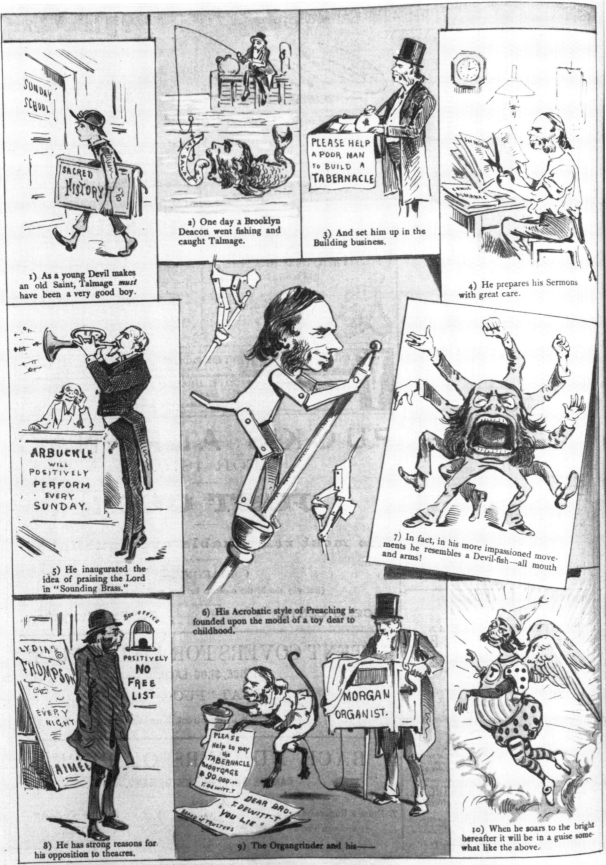

1) As a young Devil makes an old Saint, Talmage *must* have been a very good boy.

2) One day a Brooklyn Deacon went fishing and caught Talmage.

3) And set him up in the Building business.

4) He prepares his Sermons with great care.

5) He inaugurated the idea of praising the Lord in "Sounding Brass."

6) His Acrobatic style of Preaching is founded upon the model of a toy dear to childhood.

7) In fact, in his more impassioned movements he resembles a Devil-fish—all mouth and arms!

8) He has strong reasons for his opposition to theatres.

9) The Organgrinder and his——

10) When he soars to the bright hereafter it will be in a guise somewhat like the above.

TALMAGE.

43. "The Rival Sunday Shows in Brooklyn." Here, Keppler equates Brooklyn's two most celebrated preachers with circus barkers trying to lure the curious and pious into their "shows." Talmage decries fads and fashions of the day, while Beecher's sordid love life is his attraction. (Author's collection; *Puck*, Oct. 23, 1878)

PUCK.

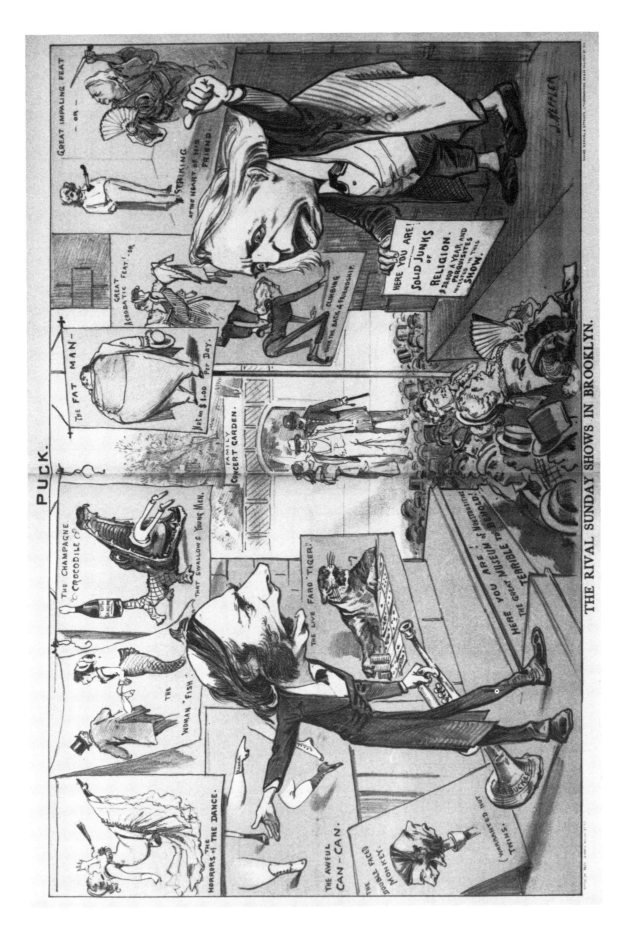

THE RIVAL SUNDAY SHOWS IN BROOKLYN.

44. "The Infallible." Keppler couldn't resist turning the knife as Pope Pius IX lay dying. He had no patience for the reactionary pope and got cruel satisfaction at the thought of all his arrogant pronouncements coming to naught in the face of death. (Author's collection; *Puck*, Nov. 21, 1877)

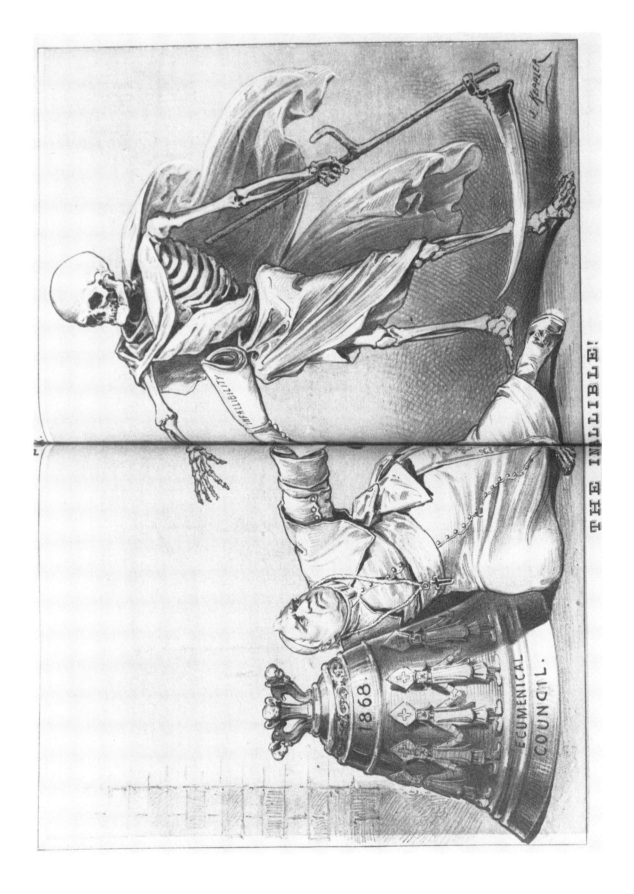

THE INFALLIBLE!

45. "Going for It." Workingmen of the period amused themselves at picnics by placing a ham atop a greased pole. The most agile and persistent among them who managed to reach the top claimed the prize for his efforts. As the Vatican prepared to select a new pope, Keppler equated the behind-the-scenes maneuvering with this popular pastime. (New York Public Library; *Puck*, Feb. 20, 1878)

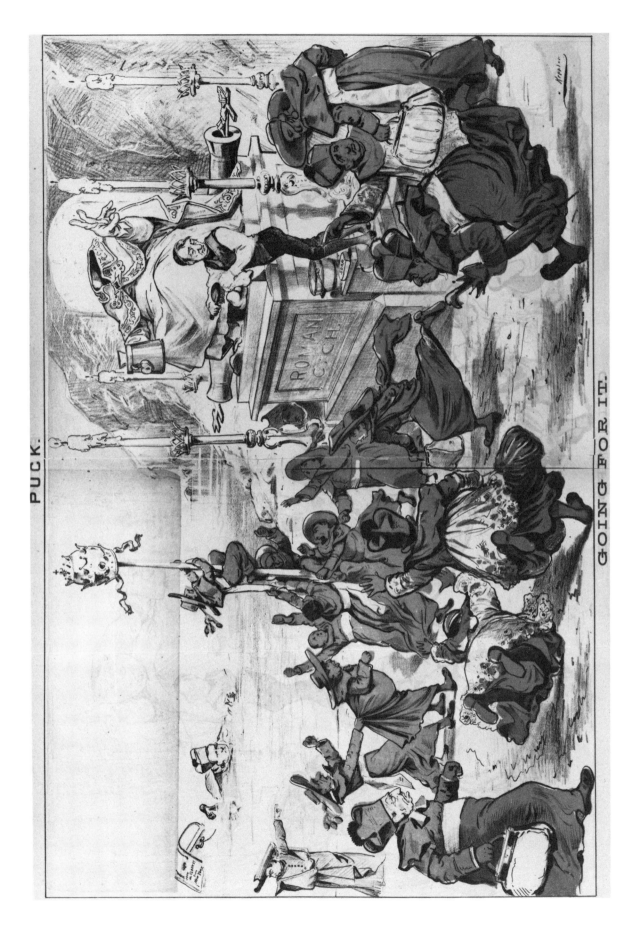

PUCK.

GOING FOR IT.

46. "Pope Leo XIII—A Physiognomical Study." Keppler's dislike for Leo's predecessor was based on his policies, but with this cartoon Keppler makes clear that his objections to the papacy went beyond the edicts and opinions of any one man. The institution, he believed, was built on a corrupt foundation. All who became pope received his harshest treatment. (Library of Congress; *Puck*, April 24, 1878)

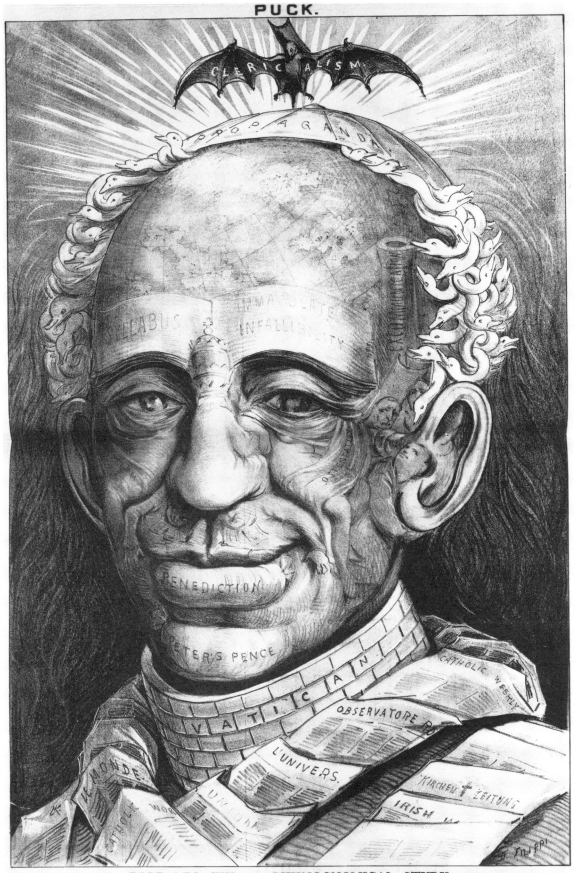

PUCK.

POPE LEO XIII.—A PHYSIOGNOMICAL STUDY.

47. **"The Theatre of War."** Keppler, never a jingoist, decried the perpetual bloodbath in Europe and censured its complacent leaders, who seemed forever ready to settle disputes with declarations of war. This cartoon, prompted by the 1877 Russian-Turkish War, features, in addition to Puck and Uncle Sam, who occupy the two third-level boxes, several past present European and Asian rulers. Under Puck's box sits France's General MacMahon on the second level and Austria's Emperor Franz Josef and John Bull on the first. Across the way, Amadeus and Isabella II, past rulers of Spain, sit with Russian Czar Alexander II and ex-President Grant in the box under Uncle Sam. Below them sits German Chancellor Bismarck. (Author's collection; *Puck*, May [9], 1877)

PUCK.

THEATRUM MUNDI

The Theatre of War.—The Latest Spectacular Tragedy.

48. "Monarchical Devotion—'A Mighty Fortress Is Our God.'" Keppler believed European politics to be ethically bankrupt; the state had simply become a tool of royal families to perpetuate their power. In this cartoon, France honors its General MacMahon, and Emperor Wilhelm of Germany bows to Field Marshall Helmuth Graf von Moltke, while Pope Leo XIII, Russian Czar Alexander II, Austrian Emperor Franz Josef, and Queen Victoria honor generic images of war. Chancellor Bismarck leads the choir, which includes England's Prime Minister Disraeli on tuba and French politician Lęon Gambetta on clarinet. (Author's collection; *Puck*, Jan. 7, 1880)

MONARCHICAL DEVOTION—"MIGHTY FORTRESS IS OUR GOD."

49. "The Modern St. George." Keppler repeatedly cast President Hayes in an heroic light during the early days of his administration. Hayes seemed sincere in his desire for civil service reform, and Keppler supported the president's good intentions. Ultimately, Hayes never got very far in his reform fight and Keppler commented less and less on the issue, but he continued to respect and sympathize with the president throughout his term. Keppler's use of the nude female figure in this cartoon, although not unique in his work, is unusual. But, like many of the historical genre painters of the period, Keppler was not above spicing his work with nudity under the guise of classical allegory. (Author's collection; *Puck*, May [2], 1877)

THE MODERN ST. GEORGE.

50. "The Erl King (New Version)." In the civil service reform fight, Hayes found himself opposed most strongly by congressmen of his own party. Senator Simon Cameron rises like vapor from the swamp. The visages of other senators, such as James G. Blaine and Roscoe Conkling on the right, can be seen in the twisted trees. Critical Republican newspapers sail ghostlike through the foreboding skies. (New York Public Library; *Puck*, Oct. 31, 1877)

Puck.

Der Erlkönig neue Version.

Das „Weiße Haus" erreicht er mit Noth: In seinen Armen das Kind war todt!

51. "King or Clown—Which?" John Kelly had bluffed and blundered his way through a number of elections since taking over as head of Tammany Hall, the Democratic organization of New York City. Keppler delighted in drawing attention to Tammany's failures and politically expedient changes of heart as it struggled to maintain its stranglehold on New York politics. (Author's collection; *Puck*, Aug. 13, 1879)

KING OR CLOWN—WHICH?

Some of Mr. John Kelly's political pronunciamentos and the dead failure thereof.

52. "Puck's Illustrated Theatre No. 1." "A Celebrated Case" was the first and last play featured in "Puck's Illustrated Theatre" series. The management frequently announced supplements and special series such as this that either began and ended quickly or never appeared at all. As an old thespian himself, Keppler reveled in depicting New York's diverse and lively theater and music scene. Before he became engrossed in American politics, he frequently drew *Puck* cartoons and caricatures that dealt with the stage. (Author's collection; *Puck*, Feb. 6, 1878)

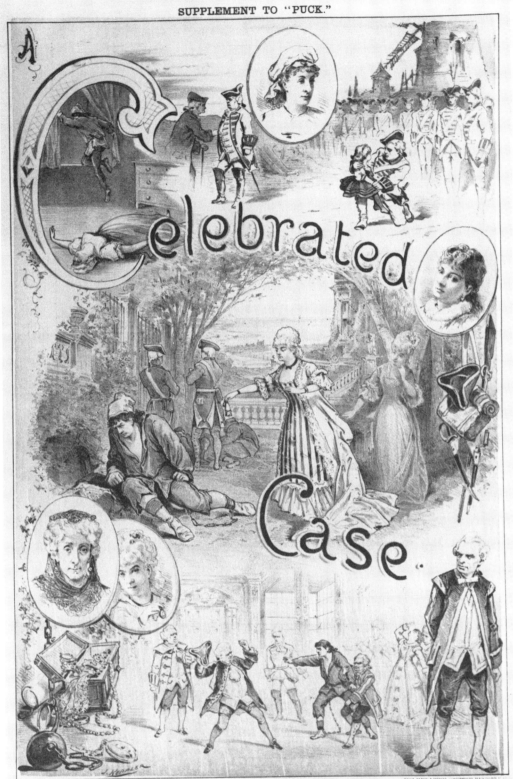

A Celebrated Case

PUCK'S ILLUSTRATED THEATRE.

No. 1.

Scenes, Incidents and Characters from "A CELEBRATED CASE," at the Union Square Theatre, New York.

53. "Sarah Bernhardt, the Modern Rizpah, Protecting Her Son from the Clerical Vultures." The great French actress Sarah Bernhardt had hardly begun her American tour in 1880 before she was denounced from pulpits across America as a harlot for having borne a child out of wedlock. Keppler thought the issue irrelevant to the woman's professional career. Drawing his inspiration from Becker's popular painting of the day, Keppler compared Bernhardt to the stoic Rizpah of the second book of Samuel, a woman who defended and cared for her children strung up to die by the Gibeonites. Bernhardt's leading critic, Dewitt Talmage, is the bird of prey in the cartoon. (Author's collection; *Puck*, Dec. 29, 1880)

SARAH BERNHARDT, THE MODERN RIZPAH, PROTECTING HER SON FROM THE CLERICAL VULTURES.

[*A little Variation on M. Becker's Famous Picture.*]

54. "Fifth Avenue Four Years After Mad. Restell's Death." In 1878, the New York City police arrested and jailed Madame Restell, a well-known abortionist. Her subsequent suicide prompted Keppler to draw this funny, grim, double-edged memorial. Keppler was no supporter of Restell. The year before he had drawn a cartoon critical of New York newspapers that printed classifieds advertising her services. While this carton makes light of her sad death, it's more of a statement on upper-class hypocrisy. (Author's collection; *Puck*, April 17, 1878)

FIFTH AVENUE FOUR YEARS AFTER MAD. RESTELL'S DEATH.

55. "Abuse of Wealth which Creates Communists Among Us." In 1878, yellow fever swept across the South, affecting nearly fifty thousand people. Ex-judge Henry Hilton, executor of millionaire merchant A. T. Stewart's estate, responded parsimoniously, donating a sum, as the cartoon says, that came to 2 cents for each sufferer. The political ramifications of such miserliness were not lost on Keppler. He was a constant critic of America's new rich who neglected their charitable responsibilities, but he always lauded those among them, such as Peter Cooper, who were philanthropists of the first rank. (Author's collection; *Puck*, Sept. 11, 1878)

PUCK.

THE ABUSE OF WEALTH WHICH CREATES COMMUNISTS AMONG US.

"Here, John Thoms, take this to the stricken South. It cost so much to build fancy Churches and Tombs that, really, I cannot possibly afford more."

56. "What We Eat and Drink." In the 1870s, sanitation became understood as an important factor in minimizing the spread of disease. Violations of this simple concept could be seen all over New York. Just as threatening to Keppler was the idea that merchants were introducing unnatural additives to food and the public didn't really know what it was buying. The raging dietary controversy of the day involved the ingredients for the new concoction oleo-margarine. The *Puck* staff was more indignant than amused by the issue and devoted a good deal of space to it in 1879 and 1880. (Author's collection; *Puck*, Feb. 19, 1879)

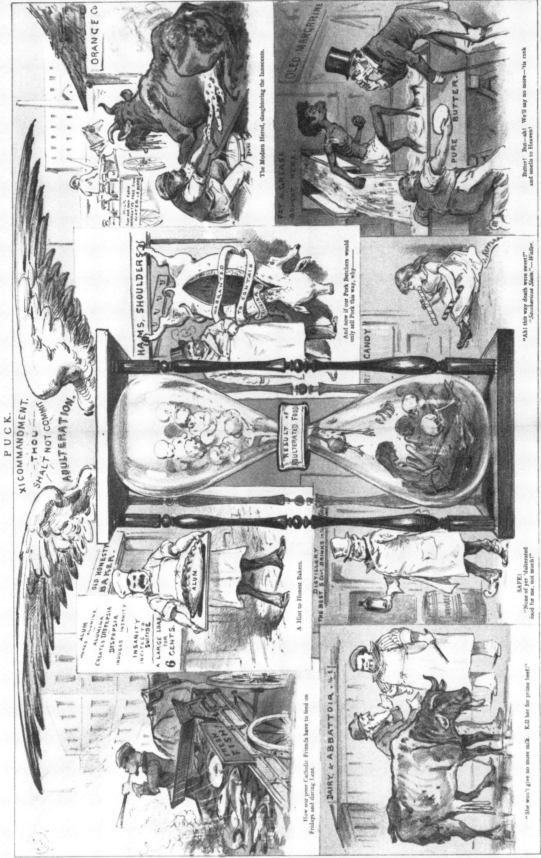

WHAT WE EAT AND DRINK.

57. "Marriage and Divorce." As the divorce rate rose among the rich, Keppler drew attention to yet another of society's double standards based on the ability to pay. (New York Public Library; *Puck*, Nov. 12, 1879)

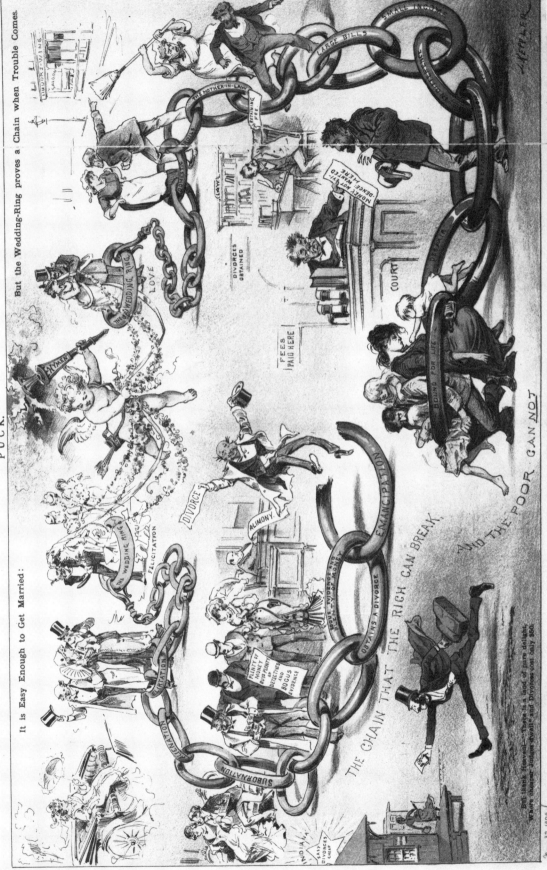

PUCK.

It is Easy Enough to Get Married: But the Wedding-Ring proves a Chain when Trouble Comes.

MARRIAGE AND DIVORCE.

58. "The Decadence of the Wizard of Menlo Park." Even the great Edison was dealt some swift whacks from Keppler's paddle when he promised quick riches to investors in his incandescent lamp and then was slow in producing results. (Author's collection; *Puck*, May 5, 1880)

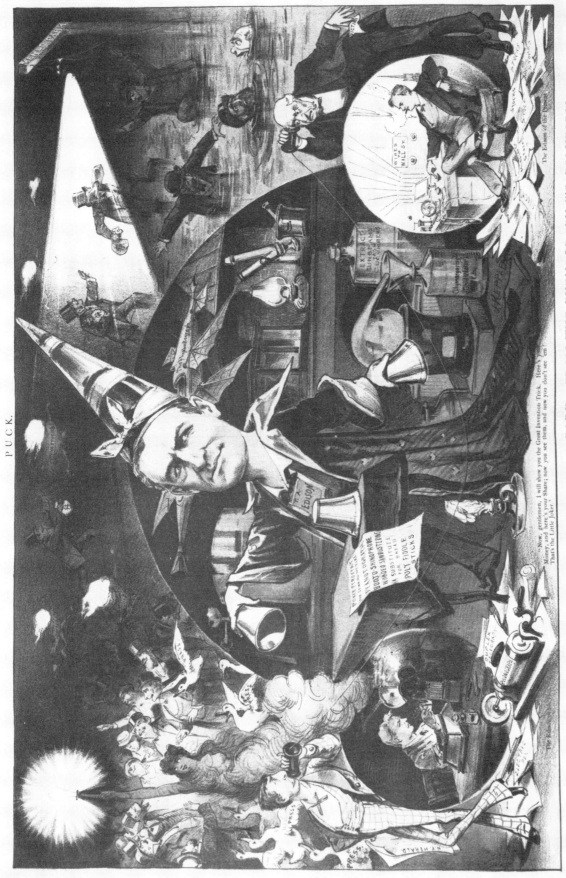

THE DECADENCE OF THE WIZARD OF MENLO PARK.—FROM THE PHONOGRAPH TO POLYFORM.

59. "A Female Suffrage Fancy." In his younger days, Keppler had supported female suffrage (see fig. 17), but after 1870, he belittled the idea. The central image in this cartoon is of a woman who has rid herself of the "disabilities" (her femininity) that prevent her from gaining the vote. In the upper left, Keppler contends, somewhat tongue-in-cheek, that this idyllic scene will be gone forever. Surrounding vignettes show what will happen in a world of female politicos, including the ultimate result: political victory for "a handsome fool." (Author's collection; *Puck*, July 14, 1880)

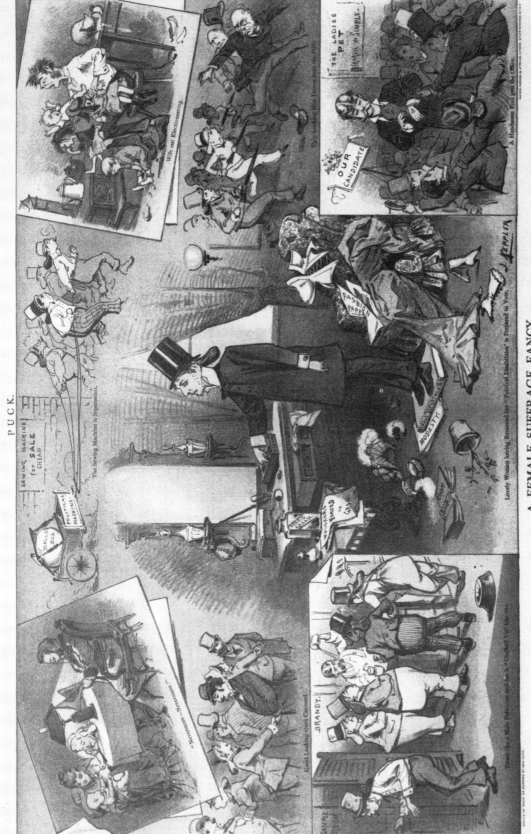

PUCK.

A FEMALE SUFFRAGE FANCY.

60. **"The Religious Vanity Fair."** Keppler summed up *Puck*'s nonsectarian view of what constituted the best religion—"clean hands and a pure heart"—in this 1879 cartoon. The prelate on the far right, representing the Catholic religion, is Archbishop John Purcell of Cincinnati, who had invested diocesan funds in a private bank that had gone bankrupt earlier that year. (Kendall B. Mattern, Jr. Collection; *Puck*, Oct. 22, 1879)

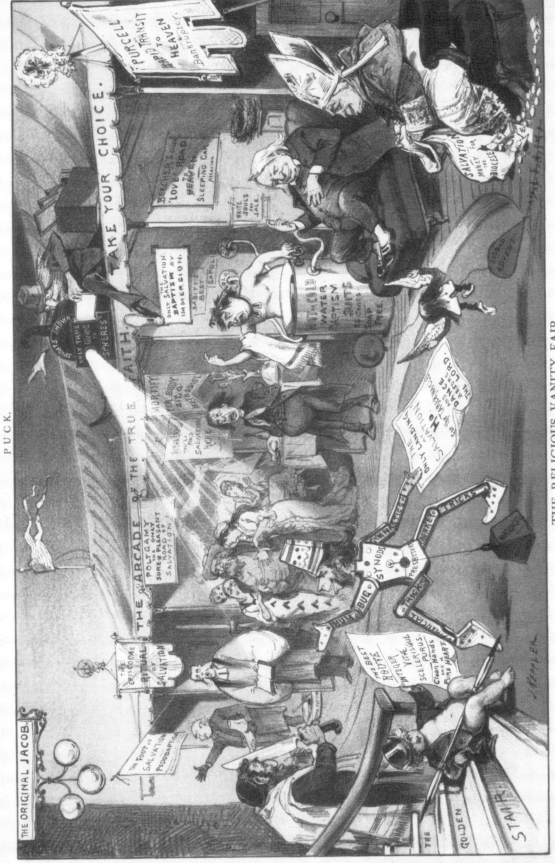

PUCK.

THE RELIGIOUS VANITY FAIR.

61. "Beecher and His Regiment in Canada." When Henry Ward Beecher traveled to Canada with the 13th Brooklyn Regiment to celebrate Queen Victoria's sixtieth birthday, Keppler had a field day imagining what might happen. The vignette in the upper left makes sly reference to the amorous Beecher as a trojan horse, pulled into an unsuspecting city. "Lorne" in the cartoon is the Scottish Marquis of Lorne, Canada's new governor-general and Victoria's son-in-law. Beecher's observation, "he looks like Theodore . . . ," is a reference to Theodore Tilton, the man who sued Beecher in 1874 for seducing his wife. The 13th Regiment was so incensed by the cartoon that they called for a boycott of *Puck*. It had little effect. (Library of Congress; *Puck*, May 21, 1879)

PUCK.

Suggestion for new regulation coat-tails for the 13th Brooklyn, when celebrating the Queen's birthday.

Appropriate Pioneer Corps to accompany the regiment. "Eyre's yer full account of the trial of Henry Ward Beecher!"

LORNE AS A HUSBAND.
"Get in quick, Louise, here comes Beecher."

Before departing, Chaplain B. receives a gift, "in memoriam," from the Lorne ladies.

THE QUEEN TELEGRAPHS LORNE:
"Am an honest, decent woman! Don't let any more Beechers celebrate me. Mind now!
"MOTHER-IN-LAW."

The 13th Brooklyn takes Chaplain Beecher to Montreal to celebrate the Queen's birthday.

CHAPLAIN B. SEES LORNE.
"Good gracious! he looks like Theodore when he used to hang up pictures in his shirt-tail," said to hang up pictures in

Is received by the low-necked brigade, and rubies likes it.

And Beecher "danced before the Lord"—Lorne.

BEECHER AND HIS REGIMENT IN CANADA—CELEBRATING THE QUEEN'S BIRTHDAY.

62. "Carnival Season." Keppler's favorite time of year was the few weeks before Lent when most of New York's fraternal and social groups held their receptions and balls. These grand parties afforded him his sole remaining opportunity to dress in costume and play a role now that he had left the stage forever. (Author's collection; *Puck*, Jan. 16, 1878)

OUR ARTIST'S

FEVERISH PHANTASMAGORIA AFTER THE LIEDERKRANZ BALL.

J. KEPPLER

63. Invitation to the Academy of Music Ball. For nearly two decades, Keppler drew the invitation for the Academy of Music ball held in the winter of each year. This one was for the 1877 ball. (New York Public Library)

64. Leiderkranz Carnival Gazette. From 1876 through 1880, Keppler illustrated the annual carnival program, the *Leiderkranz Gazette*. (New-York Historical Society)

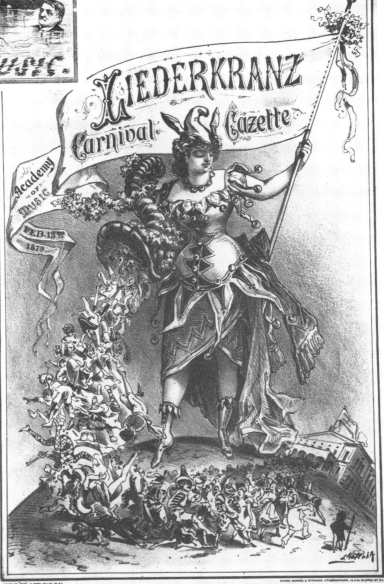

65. ***Puck*'s homes.** Initially, *Puck* was published at 13 North William Street in lower Manhattan, sharing quarters with Schwarzmann's other publication, the *New-Yorker Musik-Zeitung* (65a).

In 1879, construction of the Brooklyn Bridge forced the firm of Keppler and Schwarzmann to evacuate to newer, more spacious quarters at 21–23 Warren Street (65b), just off City Hall Park and next door to *Puck*'s lithographers, Mayer, Merkel, and Ottmann. The Warren Street address served as *Puck*'s home for seven years.

In 1886, the firm moved for the last time. The Puck Building on Houston Street stood as a testament to *Puck*'s resounding success (65c). This is how the original structure looked. In 1893, the building was extended to abut Jersey Street. In 1898, part of the building was sheared away to allow for the extension of Lafayette Street, leaving three arches instead of five along its northern face. The Puck Building, beautifully renovated in 1983, is now a national historic landmark. (Author's collection; *Puck*, March 2, 1887)

13 North William Street.

23 Warren Street.

FOUR

"Forbidding the Banns"

KEPPLER'S FIRST political cartoon on the 1880 presidential campaign appeared more than a year before the nominating conventions were scheduled to convene. In April 1879, he reported on the political scene in "The Candidates and Their Friends." In one-half of the cartoon he showed Tilden elbowing out several other Democratic contenders in an effort to possess the presidential chair. It is captioned, "The Democratic Candidate—He Would, and so Would They." In the other half of the cartoon, he pictured the Republicans kneeling to a reticent Grant. This half is captioned, "The Republican Candidate—They Would, but He—?"[1] The cartoon only incidentally expressed Keppler's dislike for both men, but he made it *Puck*'s aim in 1880 to see that neither of them won the nomination of his party.

Despite Keppler's characterization, Tilden had reason not to be interested in the 1880 Democratic party nomination. His spotless reputation had taken quite a beating since 1876. That year, and in the years that followed, the government made a public show out of investigating Tilden for tax evasion during the Civil War. Although the case lacked substance and was politically motivated, it dragged on until 1882, when the government finally dropped it. In the meantime, Tilden's image suffered irreparable harm.[2]

Then, after he had received praise for the selfless way in which he handled the 1876 election dispute, Tilden sanctioned the work of the Potter Committee, a House-sponsored investigation into 1876 election fraud charges. In Keppler's opinion, the election issue was dead and reexamining it would only open a Pandora's box. Ironically, the investigation proved to be more damaging to Tilden than to anyone else. The "cipher telegrams" surfaced, implicating two of Tilden's

191

lieutenants in a plot to purchase the votes of Louisiana and Florida electors. The affair was sufficiently shadowy so that Tilden escaped charges of impropriety, but the sensational telegrams further diminished his public stock.[3]

Partly because of these developments and partly because of his failing health, Tilden expressed little interest in renomination. But Keppler knew that Tilden's renunciation meant nothing until the convention completed its business and adjourned. Keppler feared that the financially strapped Democrats might turn to Tilden in order to gain access to his personal fortune. To ensure that that wouldn't happen, *Puck* waged a campaign against the man and his money.

While Wales drew most of *Puck*'s anti-Tilden cartoons, Keppler stepped in occasionally to lend a hand. His most striking anti-Tilden cartoon, "The Skeleton in the Democratic Closet" (fig. 66), showed office-seeking rats rummaging around a skeleton slumped in a money barrel. The skeleton, of course, is Tilden, pictured in an advanced state of decay.[4]

Keppler was devoting much more of his time to anti-Grant cartoons. Even though he had pictured Grant in the April 1879 cartoon as showing little interest in the nomination, Keppler stayed on guard. Later that year, in September, he drew "Soothing 'Em to Sweet and Happy Slumbers" (fig. 67). The cartoon featured Grant in the presidential nursery gently cooling off the Republican aspirants for the nomination with a fan on which is printed "'I have had all the honors. . . . There are other men who have fairly earned the Presidency, and should have it. . . .' - U.S.G." Keppler lets his viewers judge Grant's sincerity by drawing the general with a wonderful smirk on his face. When the general elaborated on his disinterest in the nomination by saying he had plans to go into canal construction, Keppler depicted, for *Puck* readers, "The Kind of Canal Business Grant Is Going Into" (fig. 68). It showed the general as a foreman, surveying the work of his political allies as they dig a third-term canal straight to the White House.[5]

Sure enough, the general's attitude soon changed. By the end of the year, he was not only interested in the nomination, but he was also the leading contender for it. Since leaving office in 1877 under dark clouds of scandal and mismanagement, he had taken a tour around the world. In every country he visited, he was welcomed and feted in a fashion befitting his military status (fig. 69). As Americans heard reports of how highly Grant was regarded abroad, they began to recall his military achievements with admiration and respect and seemed willing, once more, to forget his political bumblings. Grant's world tour had done much to restore his lustrous Civil War reputation.[6]

Keppler issued an early warning against confusing Grant the general and Grant the president. In "*Puck*'s Advice Gratis to Some Editorial Shriekers for Grant," Keppler drew a downtrodden Grant dogged by his corrupt cronies, who are pictured as a pack of mongrels. They walk in the shadow of a statue of Grant,

which portrays him in all his military glory. Keppler captioned the cartoon: "Don't Forget Your 'Man on Horseback' but Your Man on Foot Has too Many Curs at His Heels."[7] Suggesting that Grant was unfit for office because of his friends was Keppler's gentlest jab at the general.

As the political situation heated up and Grant's prospects for the nomination continued to improve, Keppler took off his gloves. The subsequent series of cartoons is one of the most spirited graphic arguments in cartoon history.

Keppler's orchestrated attack on the Grant candidacy began with the February 4, 1880 issue. In the brightly colored center-spread, Keppler drew Grant as a trapeze artist, straining to suspend a motley assortment of corrupt cronies from a strap clenched in his teeth. It was captioned, "*Puck* Wants 'A Strong Man at the Head of Government'—But Not *This* Kind!" (fig. E).[8]

The March winds brought "An Unexpected Blow." This cartoon showed Conkling and his Senate colleague Cameron trying to fly the Grant third-term kite. Their efforts are stymied by the lightning strike of an independent press and the swift gale of public opinion.[9]

Next came Keppler's "The Political 'Army of Salvation'" (fig. F), which showed the pious Conkling and friends raising their voices in song and collecting votes for "The savior of his country," U. S. Grant.[10]

In "The Worship of the Golden Calf" (fig. G), Keppler pictured Grant as a sacred cow, made luminous by gold ink, mounted on a pedestal. Conkling and other politicians dance and pray at its base. Puck as Moses is coming down the mountain holding a tablet containing the Ten Commandments, all of which say, "Thou shalt not covet a third term."[11]

In "The Modern Wandering Jew" (fig. H), Keppler depicted a harried Grant being driven throughout the world by "selfish friends" ever poised to take advantage of his war record for their own gain. Keppler's beautiful use of color in this cartoon makes the reader feel the damp and chilly place to which Grant has been exiled.[12]

Wales contributed a few strong cartoons to the campaign as well. His "15–14–13 Puzzle" was based on a fad of the day that required the player to maneuver interlocking blocks into numerical order. Wales's cartoon showed a perplexed Conkling trying without success to move Grant into the winning slot. In May, Wales replied with graphic sarcasm to a newspaper statement that charged Hayes with having a weak southern policy while Grant's had been strong. In one-half of the cartoon he drew Grant's "strong policy"—a triumphant general being carried in a carpet bag, supported by bayonets, on the back of a broken South. In the other half, he drew Hayes's "weak policy"—the current chief executive plowing under Grant's destructive programs and heralding in a new southern prosperity.[13]

Increasingly, the cartoons in *Puck* were sparking political conversations. The *Boston Evening Transcript* reacted to Keppler's "Worship of the Golden Calf" with this bit of doggerel:

> Have you seen the big picture in *Puck*,
> Where, high on a pedestal, stuck,
> The Grant golden calf—
> A sublime half-and-half—
> Receives bended knee and head-duck?
>
> There is Logan with reverent gaze,
> And Conkling—that hater of Hayes—
> And Childs, with his song,
> And Governor Long,
> And Belknap of whiskey-ring days.
>
> Let these worshippers think what they do!
> Their folly they'll certainly rue,
> When early next fall,
> With Grant, one and all,
> They shall form a salt river crew.[14]

The *Brooklyn Times* was particularly struck by the way *Harper's Weekly*, previously the dominant voice in presidential campaigns, seemed drowned out in 1880. Its editor suggested: "*Harper's Weekly* ought to engage for the campaign the services of Keppler, whose political cartoons have already given *Puck* the leading place as a popular and humorous pictorial journal."[15]

Keppler was anxious to play as large a role in the election as possible. He enhanced his power in May when he became an American citizen, thus enabling him to cast his first vote in November.[16]

As the Republican convention approached, Grant appeared certain to get the nomination despite Keppler's strong work. "To the Chicago Convention" (fig. 70) showed Grant's locomotive, engineered by Conkling, getting the "all clear" signal from Grant supporters Cameron and Washburn to proceed to the convention. Puck, Curtis, and Schurz, pictured in the background, stand mourning over the body of a young damsel, representing the Republican party, run over by the Grant locomotive in its headlong dash for the nomination. Keppler's last cartoon before the convention showed manacled and chained "Political Convicts" being herded into the meeting hall by the whip-wielding Conkling and Logan.[17]

For the cover of the June 9 issue, which appeared after the convention adjourned but was sent to the printer a few days before the convention convened,

Keppler daringly predicted Grant's defeat. "The Chicago Catastrophe" showed Conkling, Logan, and Cameron limping away from the twisted wreckage of their third-term train.[18] Luckily for *Puck*, the prediction proved correct.

Keppler capped his anti-Grant series with "The Appomattox of the Third Termers" (fig. 71), which showed a humbled Grant surrendering his battle sword to the Republican nominee, James A. Garfield. Keppler's comparison of Grant's political defeat in 1880 to Lee's military defeat in 1865 was a merciless masterstroke, upsetting many who considered the surrender at Appomattox a sacred event.[19]

As delighted as he was by Grant's downfall, Keppler could not work up much enthusiasm for the ticket the Republicans ended up nominating. The presidential candidate, James A. Garfield, had first come to Keppler's attention in the Crédit Mobilier scandal of 1872. While Garfield neither accepted nor refused the railroad stock that had been surreptitiously assigned to him, he did profit from the affair to the paltry tune of $329 (fig. 72). The vice-presidential nominee was none other than Chester A. Arthur, late of the New York Custom House. His nomination was a bone thrown to the defeated Grant-Conkling forces. While the Republicans could have done worse, *Puck* decided that they had fielded a decidedly weak ticket.[20] The question, of course, remained: What would the Democrats do?

Tilden was still a prime contender for the nomination. If he was given that plum, *Puck* would probably be inclined to support the Republican ticket, sullied though it was. But in the end the Democrats nominated Civil War general Winfield Scott Hancock (fig. I). Bunner was gleeful. He wrote, "The Democratic convention, true to its tradition, has blundered even in its efforts to blunder and has set before the country what no one can deny is a strong ticket—the strongest ticket the Democratic party has made up in twenty years."[21]

This type of dismissive compliment reflected Keppler's attitude toward both political parties (fig. 73). The Republicans may have had to bear the burden of Grant's ineptitude in office, but the Democrats, dominated by southerners, had to contend with the stain of secession and Civil War on their record. In "Inspecting the Democratic Curiosity Shop" (fig. J), Keppler showed Hancock being given a tour of effects from the Democratic party's checkered past. One museum case holds the robes of Ku Klux Klan members. Another holds the pistol Booth used to assassinate Lincoln. A whipping post for errant slaves and a stuffed slave-tracking bloodhound are also on display. The centerpiece to the exhibit, the Democratic donkey "stuffed in 1860," consists of just two hind quarters labeled "North" and "South," sewn together with stitches of "secession sympathy." Hancock, taken aback, says, "Great Scott! Am I to Be the Head of That?"[22]

Puck was especially pleased with Hancock because of what it called his "spotless record." Keppler cartooned Republican editors frantically searching for anything negative they could find about the general.[23] But *Puck* learned soon enough that the reason Hancock's record was so spotless was that he had no political experience whatsoever, something of a liability in a race for the presidency.

The novice politico immediately encountered problems with a disorganized and divided Democratic party. Keppler pictured Hancock wrestling with the challenge of reconciling solid southern support with northern interests.[24] The issue that caused the Democrats the most problems was the tariff. The industrial North had imposed a high tariff on foreign goods when the South had walked out of Congress during the Civil War. The South, which depended on foreign trade to keep its agricultural economy going, lobbied hard for lower duties. Hancock, caught unprepared, stated that he was not going to concern himself with the tariff question because it was a local issue. In one sense, Hancock was right—the tariff was an amalgam of local interests. But the press howled, and those who doubted Hancock's political knowledge took the statement as confirmation that he indeed knew little. *Puck* downplayed the faux pas, and Keppler never commented on it, but the damage was done.

Adding to Hancock's travails was the incredible demand several southern leaders were making for reparations from the North for the destruction it had caused in the South during the war. The Republicans even spread the rumor that if Hancock were elected, he would pay the claims. Hancock made short work of that bit of idiocy. Keppler pictured him manning a double-barrel cannon blasting away at the southern claimants and the Republican rumormongers.[25]

Keppler's support for the Democratic candidate was light-handed. If the issue clearly favored Hancock, Keppler came to his defense. If the issue meant little to Hancock's campaign, Keppler felt free to chide him about it. And if the issue reflected poorly on Hancock, Keppler ignored it. In contrast, he had nothing but criticism for Garfield. Like most of the Democratic press in 1880, Keppler made much of the Crédit Mobilier scandal and the $329 Garfield had gotten out of it. This issue served as the impetus for one of Keppler's most effective cartoons, "Forbidding the Banns" (fig. K).[26]

In that cartoon, he pictured Garfield as a bride at the altar with her intended, Uncle Sam. The ceremony, however, is interrupted at the fateful moment by Democratic Chairman W. H. Barnum, who runs into the room carrying a wailing baby labeled "$329, Crédit Mobilier." An aghast Uncle Sam, confronted with the child, asks his bride why he was not told about this. The coy Garfield explains, "but it was such a little one." Keppler's decision to equate Garfield's modest political

indiscretion with a monumental social one—bearing a child out of wedlock—was a shocking triumph. It made the cartoon the hit of the campaign.

Hayes received gentle notices in *Puck*'s pages as his administration came to a close. Keppler lauded him for his firm leadership and consoled him when Republican party leaders ignored his accomplishments. In "The Cinderella of the Republican Party and Her Haughty Sisters" (fig. L), Keppler pictured Hayes, surrounded by the fruits of four years' productive labor, suffering in silence as his two haughty sisters, Grant and Conkling, make off for the Republican ball.[27]

Early voting in Indiana and Vermont indicated a Republican victory in November. Keppler responded to the news by portraying Hancock as Samson, sure of himself in the face of possible defeat (fig. 74). In another cartoon, Keppler drew Hancock/Samson driving off his enemies by denying their intimations that he was willing to ally himself with the Greenback party to win the presidency. After Garfield won, Keppler concluded the series appropriately enough showing Hancock/Samson being shorn of his locks—and strength—by the Republican Delilah (fig. 75).[28]

Because Keppler needed a week to draw and another week to print the cartoons in *Puck*, he had to anticipate events if he wanted his cartoons to be current when they appeared. Predicting election results, however, was a risky proposition. Still, the magazine couldn't neglect treating such a big story. In late October, with many days to go before the election but with little time left before deadline, Keppler opted out of the dilemma through the use of the puzzle cartoon. Entitled, "Let Us Have Peace, Now a President's Elected—But Where Are His Features to Be Detected?" (fig. 76), the cartoon showed the Republican and Democratic parties in a bucolic setting reaching out to clasp hands. Hidden in the surrounding trees and rocks are the visages of the two presidential candidates and other party leaders.[29] This ingenious solution to a publishing dilemma may have made for a weak political cartoon, but whenever Keppler found himself in a similar bind in the future, he employed this handy device without hesitation.

Keppler viewed the 1880 election as a critical referendum for the Democratic party. In "Positively Last Awakening of the Democratic Rip Van Winkle" (fig. 77), he pictured the Democratic party as the ragged mountain man with a broken rifle labeled "States Rights" and a bottle of bourbon at his side. Bourbon, the drink of democracy, came to represent those southern Democrats who, says Bunner, "never learned anything and never forgot anything." The ghosts of twenty years' worth of Democratic candidates appear before Van Winkle's eyes and threaten to abandon him on his lonely mountain top. Van Winkle cries out to them: "Don't leave me here for another twenty years!"[30]

When Hancock lost, Keppler drew "The Wake Over the Remains of the

Democratic Party" (fig. 78). In that cartoon, he pictured the Democratic party laid out on a table with a sheet drawn over its head. The party leaders console themselves with drink. Most are in a stuporous state. Only Tammany chieftain Kelly and Massachusetts renegade Benjamin Butler—who, each for their own reasons, were happy to see the 1880 ticket defeated—are animated; they dance a jig around the remains.[31]

In the 1880 campaign, Keppler had lost the decisive battle—electing Hancock—but had won the war. Week after week, his work in *Puck* testified to his imagination, political insight, draftsmanship, and sense of color and composition. During the year, his star ascended at a breathtaking rate, crossing the path of Nast's descending star. At year's end, Keppler was widely regarded as America's premier cartoonist.

Puck came through the campaign in robust health, with a circulation of eighty-five thousand. The amount of advertising in the magazine swelled to the point where it was crowding out written matter. Even after Schwarzmann raised *Puck*'s rates twice in thirteen months, advertisers were still clamoring to have their products seen in *Puck*. Eventually, Schwarzmann added an extra advertising page to several issues to accommodate the overflow.[32]

Puck's success was most visible in several bold publishing programs that Keppler and Schwarzmann, Inc. embarked on during and after the election. *Puck's Annual* and *Puck on Wheels* were launched in 1880. The two one-hundred-twenty-four-page yearly publications contained all original material, resembling *Puck*'s weekly prose content. Keppler drew the color cover cartoons of both publications and, in their early years, contributed miscellaneous illustrations inside. *Puck's Annual*, issued at the new year, and *Puck on Wheels*, issued at midsummer, went through three or four printings each and earned bountiful encomiums from the press, which *Puck* dutifully reprinted on its advertising pages. The success of these two ventures guaranteed that they would become annual publishing events.[33]

Then, on August 29, 1881, Keppler and Schwarzmann published the first weekly number of *Fiction*, a thirty-two-page magazine devoted solely to "clear, wholesome, pure and clever" stories. Bunner, who inspired the publication, was editor; *Puck*'s associate editor, B. B. Vallentine, was business manager. Both were partners in ownership with Keppler, Schwarzmann, and the magazine's chief contributors—Julian Magnus, R. K. Munkittrick, Townsend Percy, and Ernest Harvier.

The press welcomed the magazine with extravagant praise. No record is left of how the public received it, although Schwarzmann printed a substantial thirty thousand copies of the magazine each week. On March 16, 1882, a fire that started in the shoe store at 21 Warren Street ravaged part of Keppler and

Schwarzmann's premises and destroyed all of *Fiction*'s manuscripts and correspondence. In the disarray following the fire, the magazine, after lasting only thirty-one issues, was suspended.[34]

While actively involved in establishing *Fiction*, Keppler and Schwarzmann undertook an even more ambitious project. On September 10, 1881, they brought out the first issue of *Um Die Welt* (Around the World), a German-language newsweekly. They modeled it after *Frank Leslie's Illustrirte Zeitung*, a publication on which Schwarzmann had played a major role during his time with Leslie's Publishing House. German-American poet Caspar Butz and journalist C. A. Honthumb were the editors; an old *Leslie's* protegé Alfred Berghaus, Keppler, and other artists its illustrators. Like the German *Puck*, it immediately found a respectable-sized audience.

Um Die Welt was a handsome product, expensive to produce. Keppler and Schwarzmann had their hearts set on making it succeed, but after three-and-a-half years, as cheap European illustrated weeklies began flooding the United States, the proprietors were forced to suspend publication of *Um Die Welt* as well.[35]

In the late summer of 1881, Wales, perhaps jealous of Bunner for getting a piece of *Fiction*, argued with Keppler and Schwarzmann about being cut in on a piece of *Puck*. When he was rebuffed, he approached dime novel publisher Frank Tousey with a proposition: Give me backing, and I'll give you a magazine to rival *Puck*. Tousey agreed. While Wales remained on *Puck*, the two began assembling a staff. They did this by picking through the remains of *Wild Oats*, a lame weekly satire magazine that had just ceased publishing. Comic writer George "Bricktop" Small had been its editor; Livingston Hopkins, Thomas Worth, and Mike Woolf its chief artistic contributors.[36] They were all working on the new magazine in late September when Wales finally joined them as art director and chief cartoonist. The first issue of *The Judge* appeared on October 29, 1881.

Thus, Keppler lost his first disciple. But Wales paid his mentor the greatest compliment possible by creating a publication that, except for its nameplate, was a duplicate of Keppler's *Puck*.

The Judge was not the first *Puck* imitator, nor would it be the last. After 1880, *Puck*, not *Punch*, became the model for American humor magazines. In the next twenty years, *Puck* look-alikes appeared in almost every large city in the country.[37] The central feature of all of these magazines, of course, was their color cartoons. The strength, grace, and visual appeal of Keppler's work was responsible for popularizing chromolithography as *the* medium for the political cartoonist of the eighties.

Figures 66–80

66. "The Skeleton in the Democratic Closet." Many Democrats favored Samuel Tilden for the Democratic party nomination because he had money and was willing to spend it for the cause. Keppler acknowledged Tilden's financial fortune in this cartoon but suggested that his frail health and ties to the "cipher dispatches"—communiques issued during the disputed 1876 election that implicated Tilden's lieutenants in a vote-buying scheme—were cause enough to pronounce Tilden dead politically. Democratic party leaders Allan G. Thurman and Thomas Bayard look in on Tilden's remains, left to the probing sniffs of office-seeking rats, denied food for twenty years. (Author's collection; *Puck*, May 12, 1880)

VOL. VII.—No. 166. MAY 12, 1880. Price, 10 Cents.

"What fools these Mortals be!"
MIDSUMMER-NIGHTS DREAM.

Puck

PUBLISHED BY
KEPPLER & SCHWARZMANN. NEW YORK OFFICE No. 21 – 23 WARREN ST.
TRADE MARK REGISTERED 1878.

"ENTERED AT THE POST OFFICE AT NEW YORK, AND ADMITTED FOR TRANSMISSION THROUGH THE MAILS AT SECOND CLASS RATES."

THE SKELETON IN THE DEMOCRATIC CLOSET.

67. "Soothing 'Em to Sweet and Happy Slumbers." When ex-President Grant issued a self-effacing statement of disinterest in the 1880 Republican party nomination, Keppler didn't believe him. Events proved Keppler's skepticism correct. (Author's collection; *Puck*, Sept. 3, 1879)

SOOTHING 'EM TO SWEET AND HAPPY SLUMBERS.

68. "The Kind of Canal Business Grant Is Going Into." Grant, amplifying on his decision not to return to politics, told reporters that he was going to assume the presidency of a canal building firm. Here he is directing leaders of the Republican party to build a canal that leads straight to the nation's capital for his benefit and that of his "uncles, cousins, and chums." In the foreground, G. W. Childs, publisher of the *Philadelphia Public Ledger*, mourns the political death of his candidate for the 1880 nomination, Secretary of State W. M. Evarts, who was unable to capture the support of his home state. (Author's collection; *Puck*, Sept. 17, 1879)

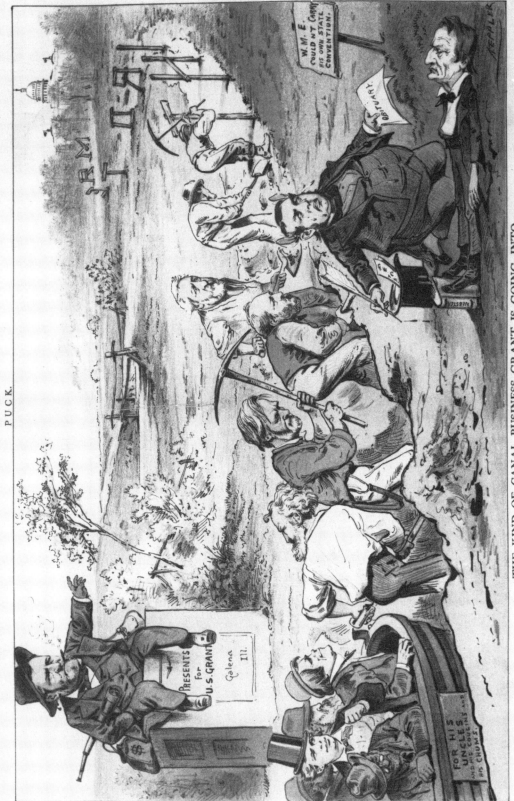

THE KIND OF CANAL BUSINESS GRANT IS GOING INTO.

69. "The Hero of a Thousand Feeds." Here Grant is shown surveying his dinner campaign strategy. His napkin is embroidered with the legend, "Let Us Have Feasts," a parody of his 1868 post-election pronouncement, "Let Us Have Peace." Although Grant's political career was over when Keppler drew this cartoon in 1881, he couldn't resist this final thrust at the man he loved to hate. (Author's collection; *Puck*, Jan. 19, 1881)

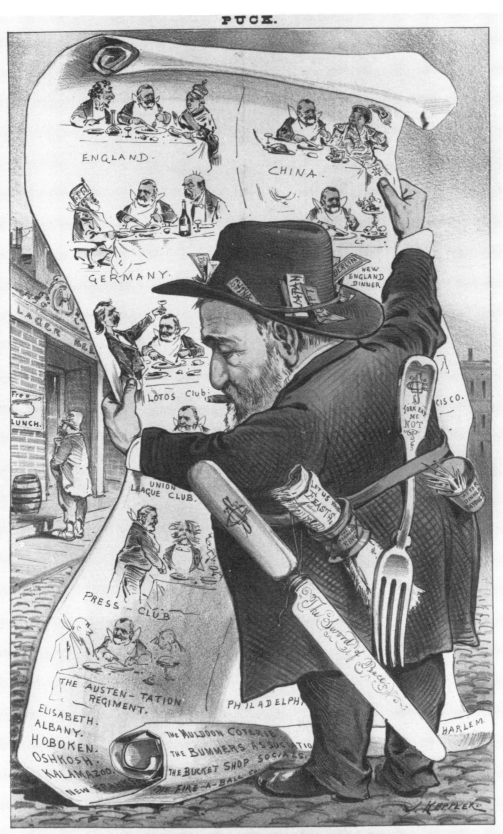

THE HERO OF A THOUSAND FEEDS.

GRANT: "I WILL EAT MY WAY TO THE WHITE HOUSE, IF IT TAKES ANOTHER FOUR YEARS!"

70. "To the Chicago Convention." As the Republican convention neared, Conkling got the "all-clear" sign for the Grant third-term locomotive. In its wake lies the body of the Republic party, mourned by *Harper's Weekly* editor G. W. Curtis, Secretary of the Interior Carl Schurz, and Puck. Hopefuls Sherman and Blaine, driving their own political carriages to the convention, have little chance of arriving before the locomotive. The passenger car label "Orpheus C. Car" is a pun on "Orpheus C. Kerr," the pen name of Grant supporter and humorist Robert Henry Newell. (Author's collection; *Puck*, May 26, 1880)

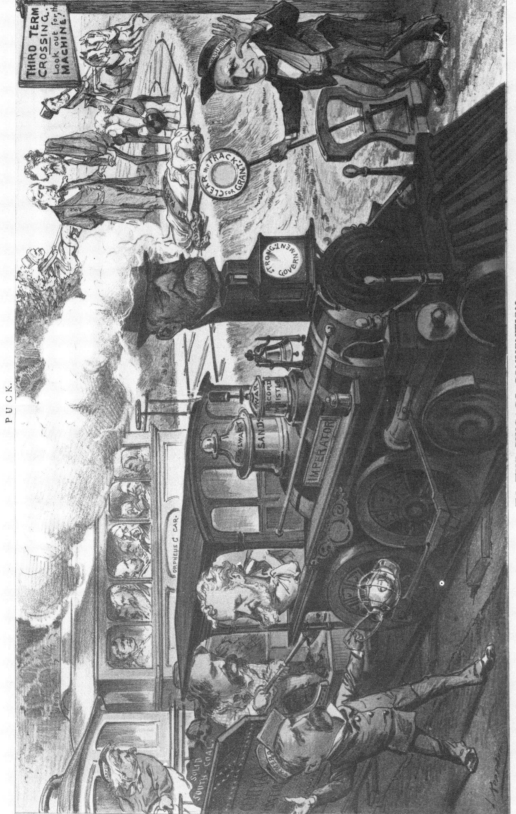

TO THE CHICAGO CONVENTION.

71. "The Appomattox of the Third Termers—Unconditional Surrender." In a reversal of the role he played at Appomattox Courthouse fifteen years earlier, Grant is cast as the vanquished in this searing cartoon that marked the end of the general's third-term hopes. Republican nominee James A. Garfield accepts Grant's sword as anti-third-termers, led by Puck, look on. Senators Sherman and Blaine, aspirants for the nomination themselves, take down the third-term flag. Grant's supporters lay down their weapons, each one inscribed with the office the supporter coveted. (Author's collection; *Puck*, June 16, 1880)

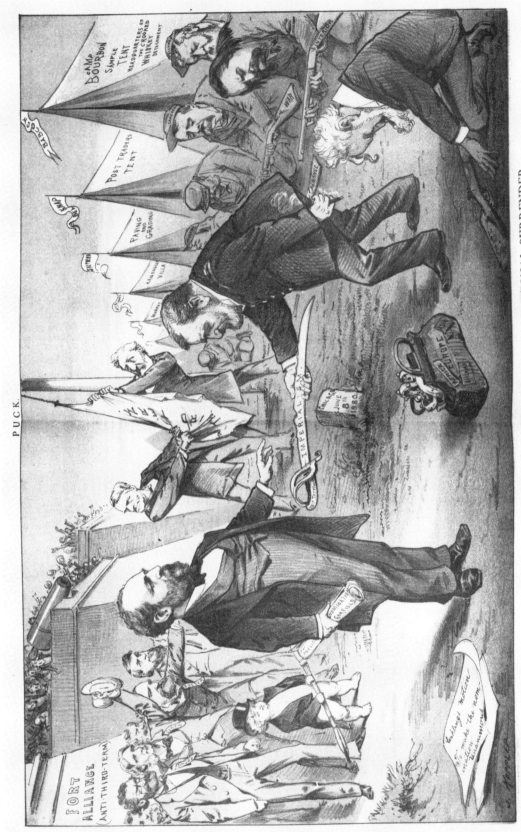

THE APPOMATTOX OF THE THIRD TERMERS—UNCONDITIONAL SURRENDER.

72. **"It Makes Him Sick."** As the Democratic press began to dredge up old political charges, Garfield was finding the nomination difficult to stomach. (Author's collection; *Puck*, Aug. 18, 1880)

VOL. VII.—No. 180. AUGUST 18, 1880. Price, 10 Cents.

"What fools these Mortals be!"
MIDSUMMER-NIGHTS DREAM.

Puck

PUBLISHED BY
KEPPLER & SCHWARZMANN. NEW YORK OFFICE No. 21 - 23 WARREN ST.
TRADE MARK REGISTERED 1878.
"ENTERED AT THE POST OFFICE AT NEW YORK, AND ADMITTED FOR TRANSMISSION THROUGH THE MAILS AT SECOND CLASS RATES."

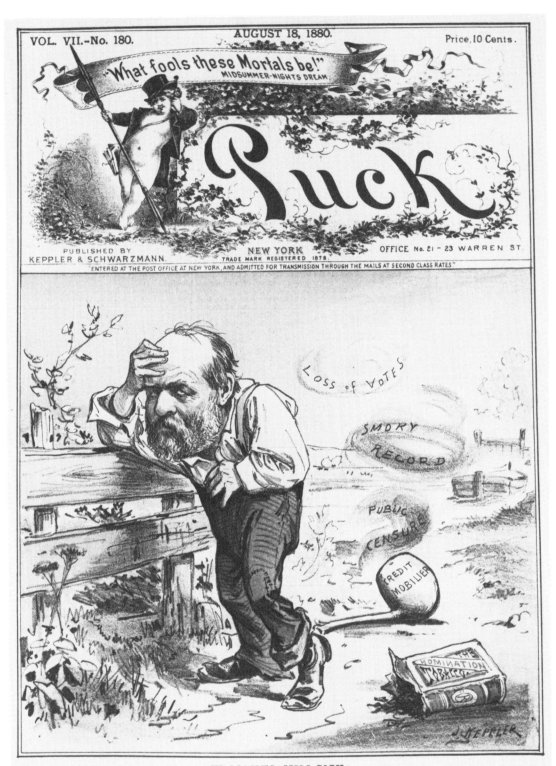

IT MAKES HIM SICK.

73. **"Just the Difference."** Keppler felt little allegiance to the Democratic party, but he celebrated their nominee, Civil War General Winfield Scott Hancock. Here Hancock is shown carrying the Democratic donkey and Kelly of Tammany Hall. "Crédit Mobilier" and "De Golyer Contract," the labels on the sack that Garfield carries, refer to political scandals in his past. (Author's collection; *Puck*, July 28, 1880)

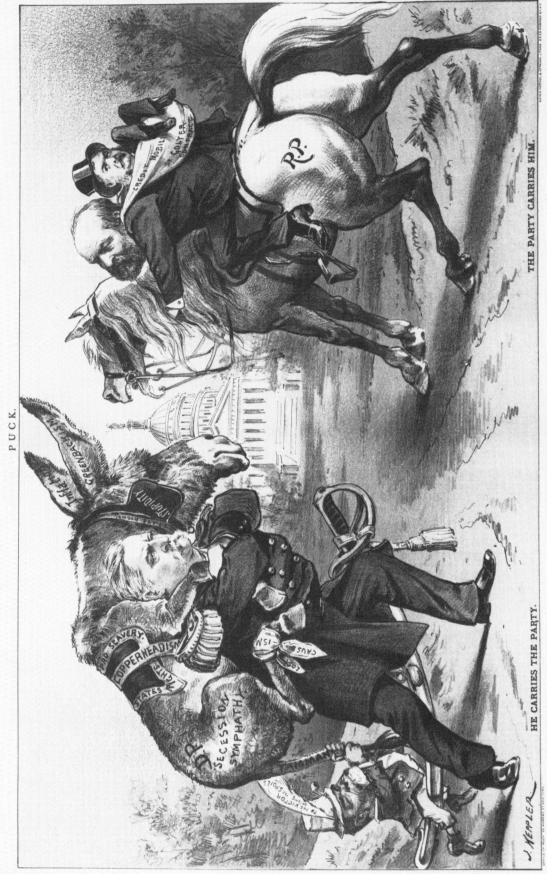

PUCK.

THE PARTY CARRIES HIM.

HE CARRIES THE PARTY.

JUST THE DIFFERENCE.

74. **"The Democratic Samson and the Republican Philistines."** Samson/Hancock demonstrates his legendary strength to his enemies, the Philistines/Republicans, by yanking out the jawbone of the Democratic ass. They, however, laugh in his face because the early election returns from Vermont are in and the Republican ticket has won. Like the fabled Samson who owed his strength to his golden locks, Hancock's strength came from his "Clean Record." (Author's collection; *Puck*, Sept. 15, 1880)

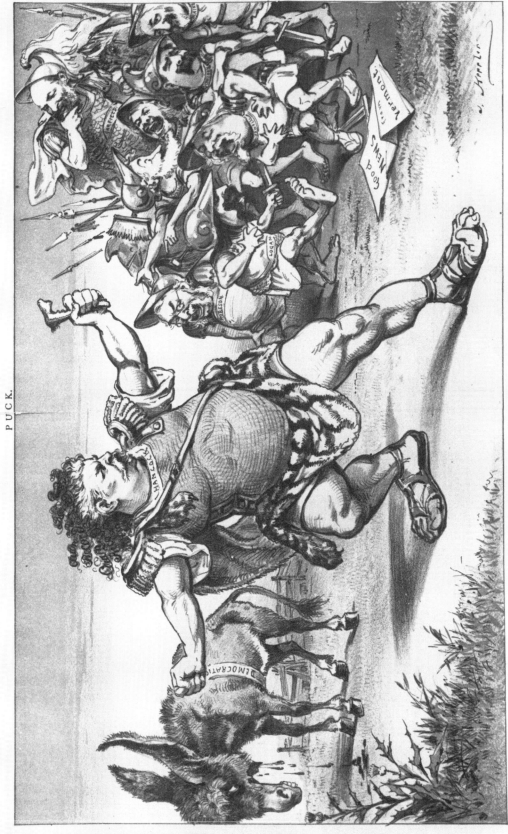

THE DEMOCRATIC SAMSON AND THE REPUBLICAN PHILISTINES.

SAMSON IS ALL RIGHT, AND THE JAWBONE IS ALL RIGHT; BUT THE PHILISTINES HAVE JUST HEARD THE NEWS FROM VERMONT, AND THEY ARE ALL RIGHT, TOO.

75. "The Republican Dalilah [*sic*] Stealthily Deprives the Democratic Sampson of His Strength." As Hancock slumbers, Delilah shears his "clean record" locks with "tariff issue" scissors, a reference to Hancock's naive statement that the tariff was a local issue. Republican Senators Blaine and Conkling and Republican Chairman Jewell watch from behind the curtains. (Author's collection; *Puck*, Nov. 10, 1880)

The Republican Dalilah stealthily deprives the Democratic Sampson of his Strength.

76. "Let Us Have Peace." Faced with the problem of drawing a cartoon on the results of an election still over a week away, Keppler employed this ingenious solution—hiding the faces of the leading politicians of the day in the landscape and making a puzzle out of the picture. Democratic candidate Hancock can be seen in the branches of the tree limb that stretches over the water. Republican candidate Garfield's visage is composed of trees and rocks just below and to the right of Hancock's. Keppler had previously drawn cartoons employing the puzzle devise during the disputed election controversy of 1876 and just before to local elections of 1879. (Author's collection; *Puck*, Nov. 3, 1880)

PUCK.

LET US HAVE PEACE, NOW A PRESIDENT'S ELECTED.

CHORUS OF INVINCIBLES.—But **Where** are his features to be detected?

77. "Positively Last Awakening of the Democratic Rip Van Winkle."
The Democratic party candidates of the last twenty years (left to
right, Samuel J. Tilden, Winfield Hancock, Horatio Seymour, George
B. McClellan, Horace Greeley, and Stephen A. Douglas) pass as phan-
toms before the eyes of a just-awakened Rip Van Winkle. Keppler
suggests in this cartoon that if the Democrats failed to win in 1880,
they could be out of power for another twenty years. The owls in
the tree are Massachusetts Congressman Benjamin Butler and Tam-
many chief John Kelly, unreliable allies in any political fight. The
issues that had previously sustained the party, "States Rights" and
"Bourbonism" (a reference to the intractable southern block), were,
by 1880, spent and worthless. (Author's collection; *Puck*, Oct. 27,
1880

PUCK.

POSITIVELY LAST AWAKENING OF THE DEMOCRATIC RIP VAN WINKLE.—"Don't leave me here for another twenty years!"

78. "The Wake over the Remains of the Democratic Party." As most of the Democrats lie in stuporous repose following the 1880 death of Democratic hopes, Tammany Chief Kelly and Massachusetts Congressman Benjamin Butler kick up their heels in an Irish jig. Many believed Kelly's lukewarm endorsement of Hancock had given New York state to the Republicans. Butler, a political chameleon, was in 1880 a member of the Greenback party and spoiler of Democratic party aims. (Author's collection; *Puck*, Nov. 10, 1880)

79. Puckographs. These charming cartoon portraits, modeled after the famous *Vanity Fair* caricatures, were begun in January 1881 as a monthly supplement to *Puck*. Eventually, nine appeared in the next fifteen months, seven of which were drawn by Keppler. The first three reprinted here are the best of these. The Twain portrait appeared four years later on the back cover of the December 23, 1885 issue. No other "Puckographs" were issued in this new series. (Author's collection; supplements to *Puck*, Jan. 12, 1881, April 13, 1881, and Nov. 16, 1881; *Puck*, Dec. 23, 1885)

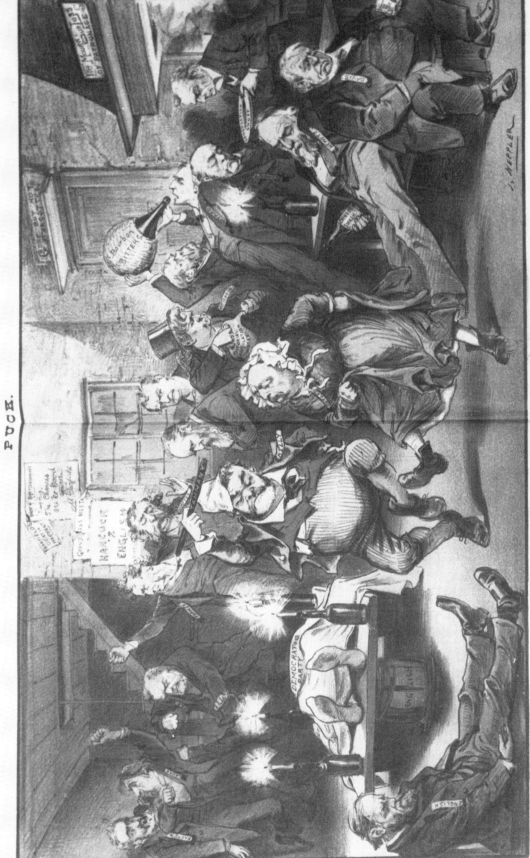

PUCK.

J. KEPPLER

THE WAKE OVER THE REMAINS OF THE DEMOCRATIC PARTY.

JAMES A. GARFIELD.
"FROM THE TOW-PATH TO THE WHITE HOUSE."

Allen G. Thurman,
THE VETERAN OHIO DEMOCRAT.

J. KEPPLER

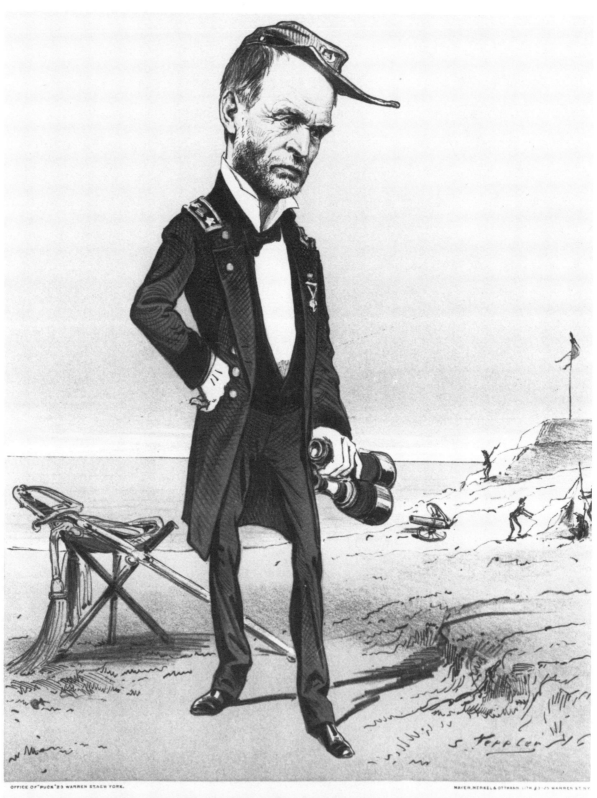

WILLIAM TECUMSEH SHERMAN,
THE GREAT GENERAL OF OUR SMALL ARMY.

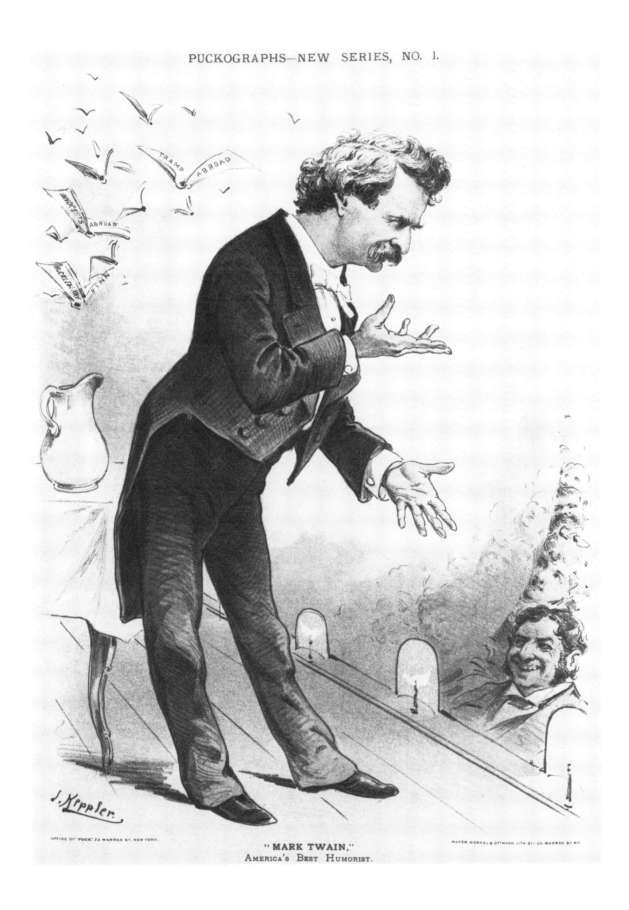

"MARK TWAIN,"
AMERICA'S BEST HUMORIST.

80. "A Mid-Summer Day's Dream." In this whimsy, Keppler naps precariously while those he has attacked over the years correct his misconceptions of them. Clockwise from the left are Generals Benjamin Bulter and U. S. Grant, the Reverends Dewitt Talmage and Henry Ward Beecher, Tammany chief John Kelly, *New York Herald* publisher James Gordon Bennett (the pun refers to his addiction to the game of polo, as does the tape on his nose—the result of a polo accident), ex-Governor Samuel Tilden, philanthropist Peter Cooper, *New York Tribune* editor Whitelaw Reid, and ex-New York Senator Roscoe Conkling. (Author's collection; *Puck*, Aug. 10, 1881)

PUCK.

A MID-SUMMER DAY'S DREAM.

While Our Artist Sleeps, His Favorite Subjects Are Left to Do Justice to Themselves, and to Correct His Conceptions.

Figures A–P

A. Keppler experiments with spot color. In cartoons such as this, published in October 1877, Keppler attempted to heighten the effect of one-color lithography by choosing the color carefully and applying it to just one element of the cartoon. Accurate registration was a problem. Previously, he used color only as shading to add some visual distinctiveness to the lithocrayon's soft edges. The cartoon concerns an angry Senator Roscoe Conkling, who vows to undo President Hayes because the new chief executive challenged Conkling's right to control patronage in his state. (Author's collection; *Puck*, Oct. 3, 1877)

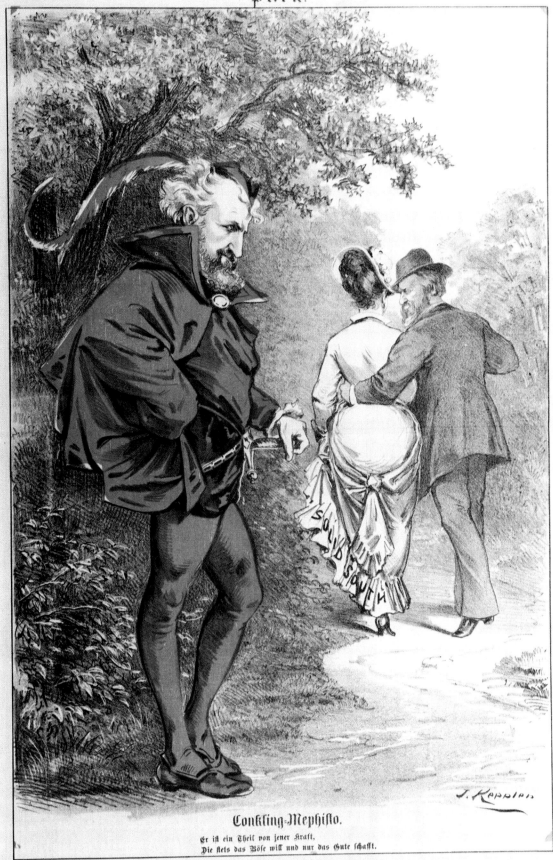

Conkling=Mephisto.

Er ist ein Theil von jener Kraft,
Die stets das Böse will und nur das Gute schafft.

B. Early attempts at multicolor printing. In *Puck*'s second year of publication, Keppler began routinely to employ two or three colors in every cartoon. The banding effect was created by sectioning off the printing inkwell and, in the case of this cartoon, filling the sections with burnt red, green, and aqua inks. (Author's collection; *Puck*, May 29, 1878)

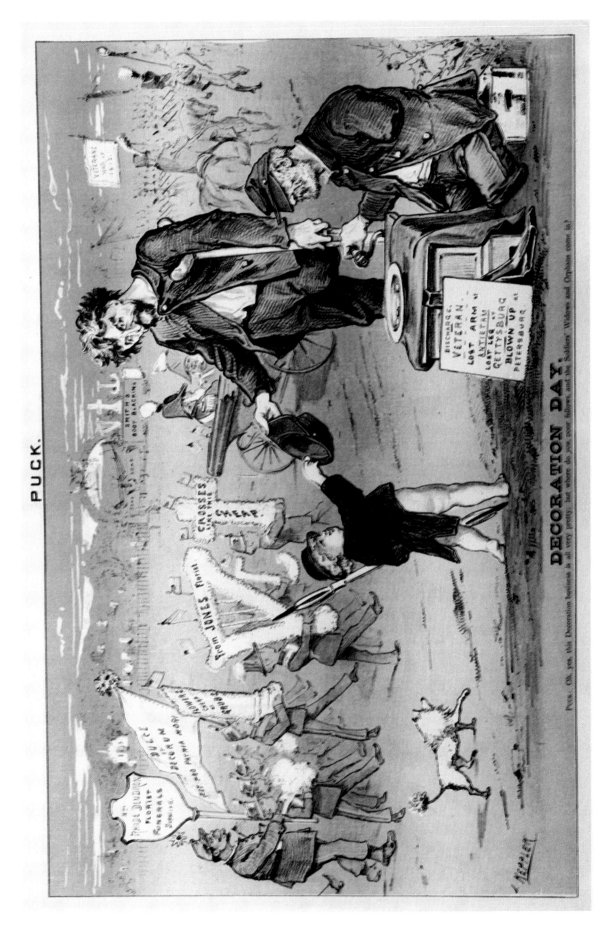

DECORATION DAY.

Puck: Oh, yes, this Decoration business is all very pretty; but where do you, poor fellows, and the Soldiers' Widows and Orphans come in?

C. Simulated full-color lithography. In late 1878, Keppler began combining the lithographic technologies he had been experimenting with over the previous two years. In so doing, he effectively achieved the appearance of full-color, even though he was simply sectioning off the inkwell as he had done before and then adding one plate for the discrete application throughout the cartoon of a fourth color. (Author's collection; *Puck*, Oct. 30, 1878)

THE ITALIAN OPERA SEASON.

D. *Puck* achieves full-color lithography. By 1880, Keppler had abandoned the inkwell-sectioning technique and wooden plates. Now he could afford limestone, and he routinely employed three or four of them in the production of all of his cartoons. In less than four years, Keppler, with help from *Puck*'s lithographers, Mayer, Merkel, and Ottmann, had successfully adapted lithographic printing to the pressures and constraints of a weekly publishing schedule, producing highly sophisticated specimens of the art such as the one reproduced here, which commented on the field of 1880 Democratic hopefuls. (Author's collection; *Puck*, June 23, 1880)

PUCK.

THE POLITICAL HANDICAP.—WHO WILL RIDE THE DEMOCRATIC ENTRY?

E. "Puck Wants 'A Strong Man at the Head of Government'—But Not *This* Kind." At the time of this cartoon, President Hayes was being criticized for not being "a strong man," implicitly as strong a man as Grant had been. Keppler wanted to make clear, as Bunner spelled out in his editorial, that "sheer brutal strength, without intelligence, education or character behind it, may be a curse instead of a blessing. . . . We had eight years of [a] strong man without a high and worthy purpose, and we ought to know pretty well what his 'strength' meant. It meant Babcock and Shephard and Belknap and Murphy and whiskey-rings and land-grabs and salary-grabs and stock-jobbing and Robeson and corruption in high places and generally and particularly the strength of moral rottenness—a stench in the nostrils of decency." (Author's collection; *Puck*, Feb. 1880)

PUCK WANTS "A STRONG MAN AT THE HEAD OF GOVERNMENT"—BUT NOT THIS KIND.

F. "The Political 'Army of Salvation.'" To convert political disbelievers to the Grant cause, "Commissioner" Roscoe Conkling and his forces sing long and hard in praise of the ex-president. (Author's collection; *Puck*, March 31, 1880)

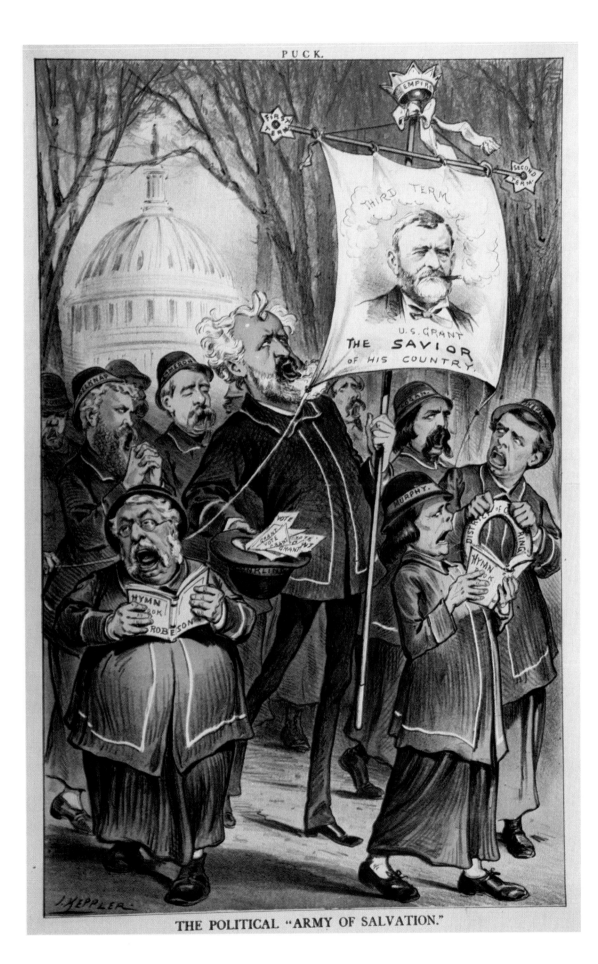

THE POLITICAL "ARMY OF SALVATION."

G. "The Worship of the Golden Calf." As Conkling's campaign to secure a third term for Grant began to gain momentum, Keppler's commentary shifted from ridicule to condemnation. Here is shown a horrified Moses/Puck, wrote Bunner, "[coming] upon this crowd of worshippers at the shrine of a false god, in defiance of unwritten law and political morality." (Author's collection; *Puck*, April 21, 1880)

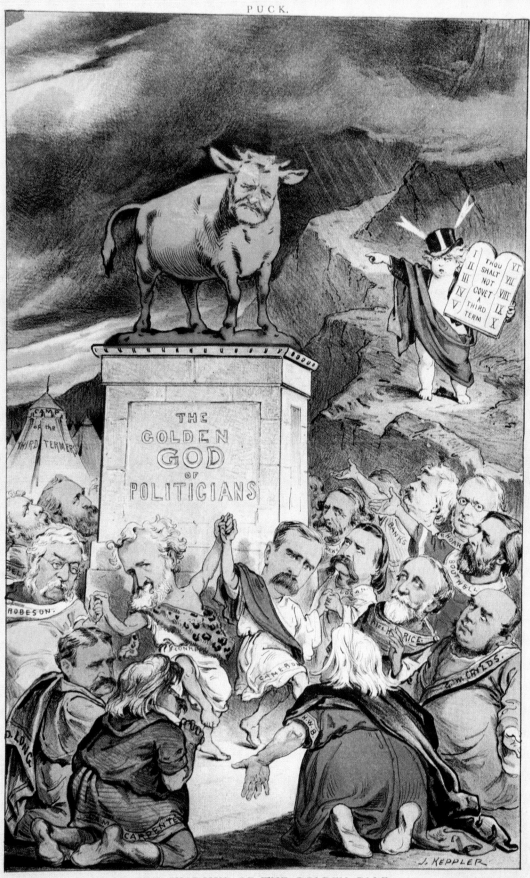

THE WORSHIP OF THE GOLDEN CALF.

H. "The Modern Wandering Jew." In his effort to discredit the third-term movement, Keppler rarely attacked the popular General Grant directly. Instead, he focused his barbs on Grant's frontmen. In this cartoon, Keppler took a different tack, portraying Grant as a man hounded into a third-term try by "many selfish friends." The visages in the clouds are those of (left to right) Senators Don Cameron and Roscoe Conkling, Congressman George Robeson, ex-Attorney General G. H. Williams, Senator John Logan, and ex-Secretary of War William Belknap. (Author's collection; *Puck*, May 19, 1880)

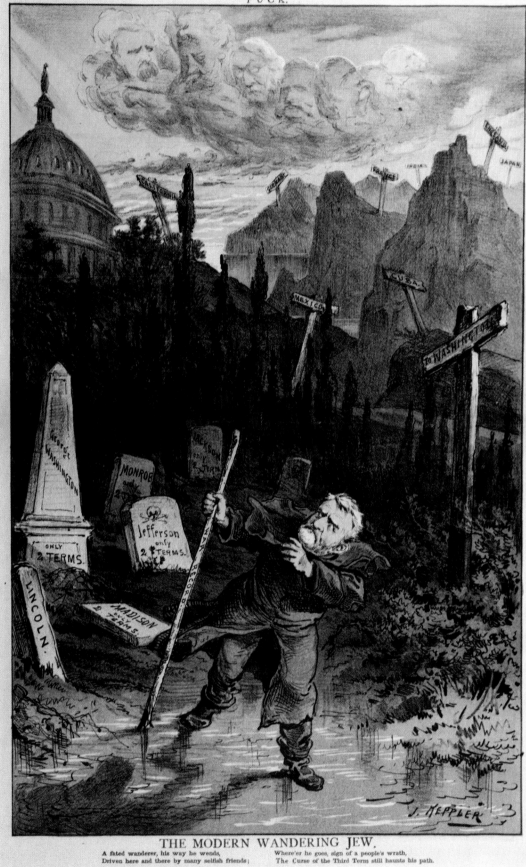

THE MODERN WANDERING JEW.

A fated wanderer, his way he wends, Where'er he goes, sign of a people's wrath,
Driven here and there by many selfish friends; The Curse of the Third Term still haunts his path.

1. "The Democrats Finding Their Moses." With the Democratic press looking on, southern Senators Wade Hampton and Benjamin Hill discover Democratic candidate Winfield Hancock among the bulrush. Hancock's Union war record endeared him to northern Democrats and his statesmanlike character won over the Democratic South. Many thought this potent alliance would prove to be the Democratic party's salvation. (Author's collection; *Puck*, Aug. 18, 1880)

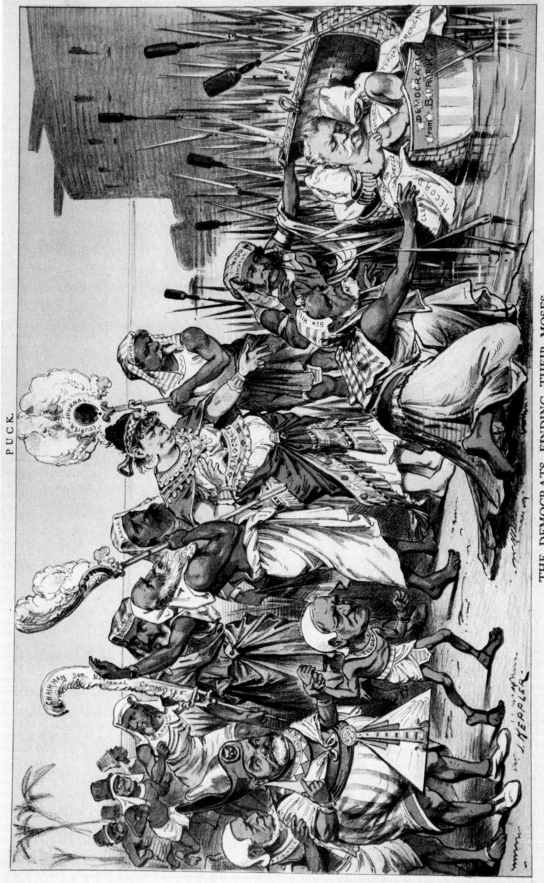

THE DEMOCRATS FINDING THEIR MOSES.

J. "Inspecting the Democratic Curiosity Shop." Accompanied by southern Senators Hill, Lamar, and Hampton, Democratic Chairman Barnum gives a guided tour of the Democratic Curiosity Shop to the party's newly nominated chief. On the left, the "disguise of Jeff. Davis" refers to the rumor that, to escape capture at the end of the Civil War, Confederacy President Jefferson Davis fled Richmond wearing a dress. The "Andersonville Skeleton" is a reference to the Georgia prison in which thousands of Union soldiers died of starvation. The "rag baby" was a Nast-invented symbol representing the inflationary practice (favored by many Democrats) of printing "rag" or paper money. (Author's collection; *Puck*, Sept. 1, 1880)

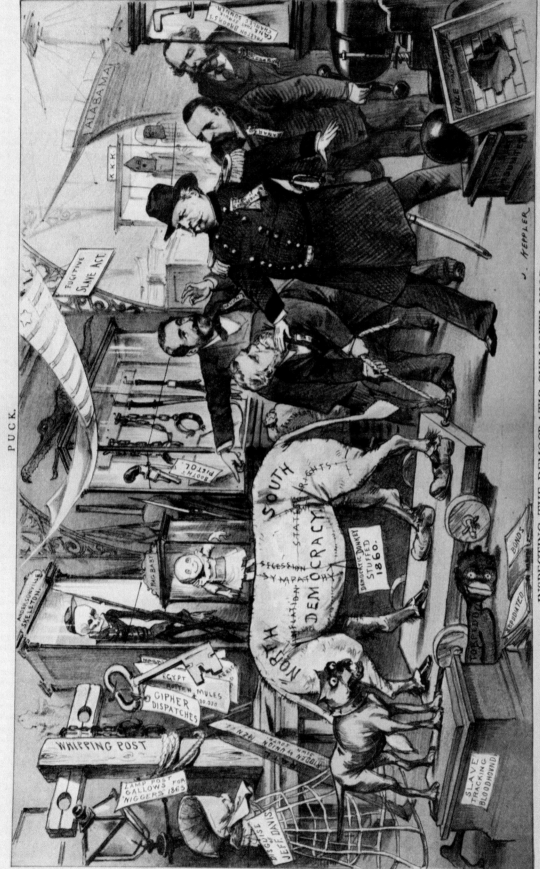

PUCK.

INSPECTING THE DEMOCRATIC CURIOSITY SHOP.

HANCOCK (*at sight of the Old Bourbon War Horse*): "Great Scott! Am I to be the Head of that?"

K. **"Forbidding the Banns."** As the ballot box begins to pronounce Uncle Sam and Republican nominee James A. Garfield man and wife, Democratic Chairman W. H. Barnum runs in to stop the ceremony. The baby he holds in his hands, labeled "$329," refers to the amount of money Garfield was said to have received in the Crédit Mobilier scandal of the early 1870s. Garfield's coy response, "But it was such a little one," doesn't seem to comfort the aghast groom. The bride's father is Republican Chairman Marshall Jewell. Her bridesmaids are a disconcerted Carl Schurz (secretary of the interior) and a pensive Whitelaw Reid (editor of the *New York Tribune*). Republican politicians make up the congregation. (Author's collection; *Puck*, Aug. 25, 1880)

PUCK.

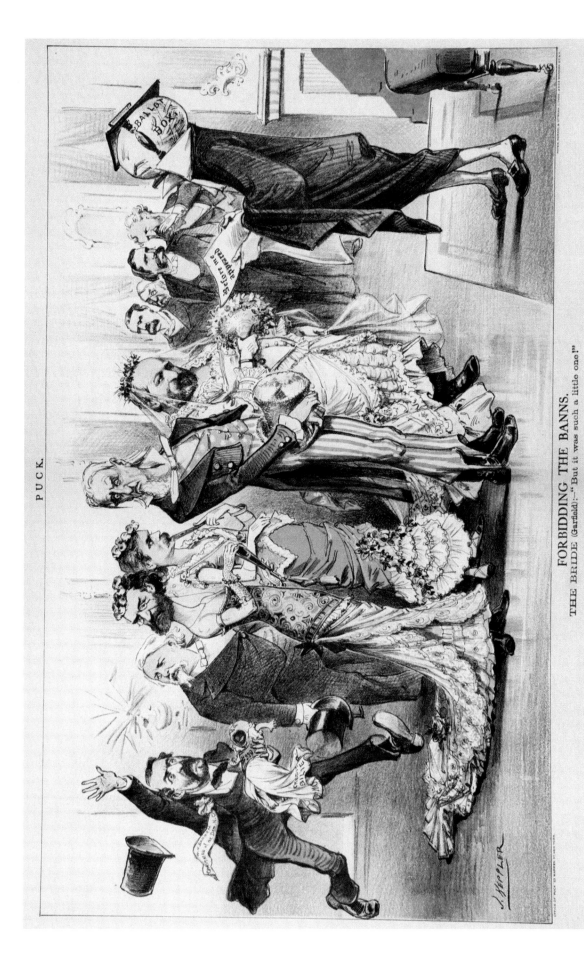

FORBIDDING THE BANNS.

THE BRIDE (Garfield):—"But it was such a little one!"

L. "The Cinderella of the Republican Party and Her Haughty Sisters." Keppler believed President Hayes didn't get enough credit for his administration's good work. Here his two "sisters," Grant and Conkling, leave him to his housework as they go off to a political ball. The "306" on Grant's hat refers to the number of delegates who held fast for Grant at the Republican convention. (Author's collection; *Puck*, Oct. 13, 1880)

PUCK.

THE CINDERELLA OF THE REPUBLICAN PARTY AND HER HAUGHTY SISTERS.

M. Keppler and the President. Keppler didn't want to be thought of as an apologist for Cleveland but, at the same time, he was honored to associate with the new president on a personal level. Although he protested a newspaper report that said he had tried to use his influence with Cleveland to secure a foreign post for his brother-in-law, he was not above exploiting this friendship to gain the unusual privilege of having Cleveland's young bride sit for him. The finished work was printed in ten colors and issued as a supplement to the 1886 *Christmas Puck*. (Author's collection; *Christmas Puck*, special issue, 1886)

J. Keppler
from life

Frances Folsom Cleveland.
October 20. 1886.

N. "**'Peace' Assured.**" In 1885, England and Russia almost went to war over some skirmishes that occurred in far-off Afghanistan. But the czarina's father-in-law, the King of Denmark, intervened and helped settle the dispute, leading Gladstone and Czar Alexander to kiss and make up. Despite the show of affection, Keppler believed that nothing between the two countries had really changed. (Author's collection; *Puck*, May 13, 1885)

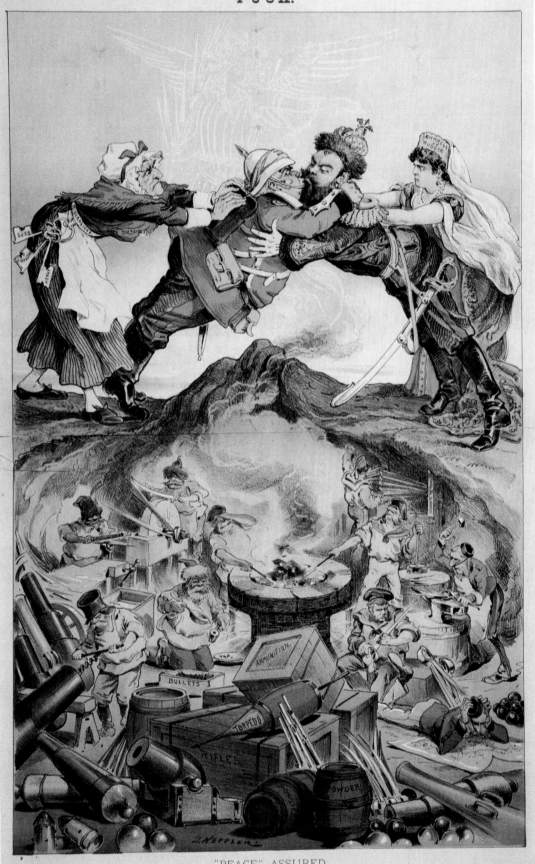

"PEACE" ASSURED.

O. "Snowed In." In 1878, Congress had passed the Bland-Allison Silver Act, which called for the minting of silver as currency. Silver was valued at a fixed ratio of sixteen parts silver to one part gold, but the silver dollar was honored around the country as legal tender equivalent in value to the gold dollar. This legislative sleight of hand had distressed Keppler in 1878 and continued to trouble him in 1886, when the minting of silver dollars had clearly become excessive. Cleveland was against the Bland-Allison Act as well, but to do something about it, he needed congressional support. In this cartoon, Keppler urges New York senator and money expert William Evarts to lead the fight to cut off, or at least slow down, silver coinage. Ultimately Evarts refused to take up the shovel. (Author's collection; *Puck*, Jan. 20, 1886)

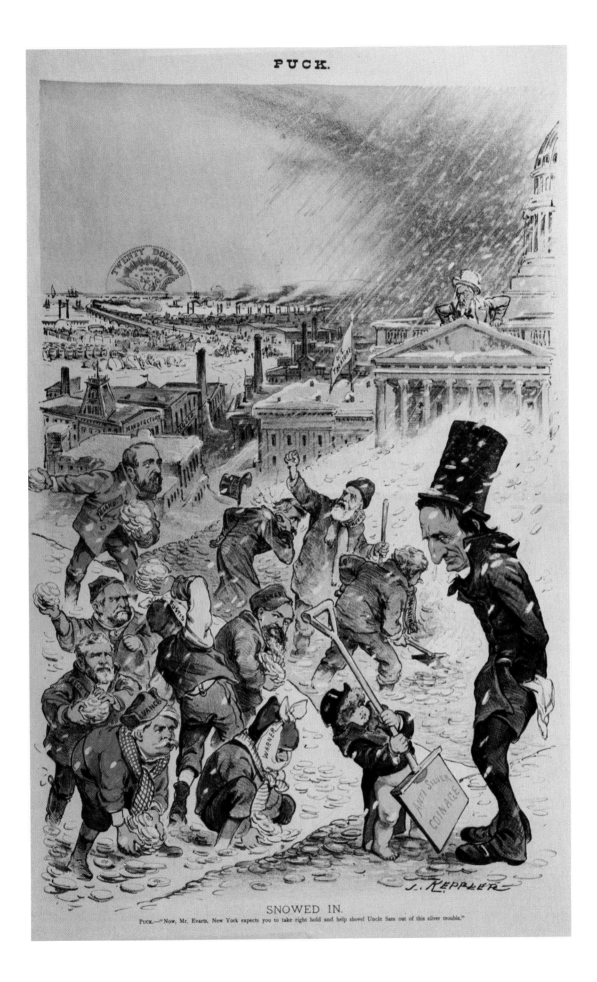

SNOWED IN.

PUCK.—"Now, Mr. Evarts, New York expects you to take right hold and help shovel Uncle Sam out of this silver trouble."

P. "The Mephistopheles of To-day." When economic theorist Henry George ran for mayor of New York on the Labor party ticket, Bunner recounted years later, "he started in with a reputation of a sincere and high-minded philosopher somewhat in advance of his time, but the moment he got the Socialist nomination . . . , he turned into as frank and downright a demagogue as ever tried to tempt a mob with promise of the pillage of the rich." In this cartoon, the devil's vision of candidate George has him standing on the back of monopolist Jay Gould as he distributes false promises to the workingman. (Author's collection; *Puck*, Nov. 3, 1886)

THE MEPHISTOPHELES OF TO-DAY—HONEST LABOR'S TEMPTATION

FIVE

"Through Night to Light!"

KEPPLER EXPRESSED nominal support for the newly inaugurated president, but that was more out of respect for Garfield's position than an indication of his hopes for the new administration. Then Garfield surprised Keppler. Like Hayes before him, Garfield decided to go to the mat with Roscoe Conkling on the patronage issue. Bunner wrote: "We are glad to see that President Garfield has shown that he has a mind of his own, and we hope that all [of Conkling's] bellowing . . . will not make him alter it."[1]

Garfield was not about to be moved. To prevent the affair from dragging on as it had in the Hayes's administration, Garfield withdrew all of the New York nominations he had made save the most controversial one, the collector of the Port of New York, forcing a confrontation with Conkling. When Congress supported Garfield, Conkling was furious, and *Puck* was "astonished." Wrote Bunner, "We rejoice that President Garfield has taken the first steps to curb this man's insolence."[2]

Keppler celebrated this "new" Garfield in the cartoon, "The American Sixtus the Fifth." The caption explained, "Sixtus V ingratiated himself with all who had to do with him. He feigned feebleness. All signs of weakness vanished with surprising suddenness the moment of his election as Pope." Garfield, drawn in an archbishop's vestments, throws away his crutches of "weakness" and "conciliation" to the astonishment and indignation of Conkling, Arthur, and other congressional powerbrokers.[3]

Conkling refused to admit defeat. He decided to take his case to the New York State legislature by resigning his Senate seat and then soliciting the legisla-

ture's reappointment as a show of support. His resignation, labeled "a bombshell" by many, prompted Keppler's effervescent cartoon, "A Harmless Explosion" (fig. 81). It pictured Conkling as an immense balloon, filled with his own hot air, bursting over the heads of his dancing Senate colleagues.[4] The New York legislature, for its part, decided to accept Conkling's resignation and appoint a less volatile representative to fill the chair. Conkling's strategy had backfired, effectively ending his political career. Keppler, who regarded Conkling as one of the more odious characters on the American political scene, would not miss him.

But patronage and civil service continued to be an issue. In the nineteenth century, the U.S. postal service relied on private contractors to deliver the mail to post offices not accessible by boat or train. Such post offices were designated on postal maps with an asterisk, earning them the name "star routes." Garfield had heard rumors of scandal in the awarding of the star route contracts, so he directed Postmaster General Thomas James to investigate. James's investigation revealed massive fraud. Star route contractors had submitted exorbitant bills for their services, and postal officials had approved them for a kickback fee. To Garfield's chagrin, the investigation implicated Second Assistant Postmaster Thomas Dorsey, one of Garfield's 1880 campaign lieutenants. But the president insisted on excising the entire ulcer from the body politic, regardless of who was involved.[5]

Bunner, disgusted by the weekly revelations from Washington, asked *Puck*'s readers: "Why must the public be constantly sickened with infamous developments of this kind?"[6] Gradually, Keppler, Schwarzmann, and Bunner became convinced that civil service reform was the nation's number one priority. Abuses of the public trust had to stop.

As troubling as this urgent matter was, the *Puck* staff had a more immediate, if more trivial, responsibility—to get out the forthcoming Independence Day celebration issue. It was a festive number of the magazine, complete with Keppler's double-spread of the nation's political leaders having a grand picnic.

Just before the issue was to go on sale, news came from Washington that Garfield had been shot. Time didn't permit alterations in the magazine's contents. As a hasty solution, Keppler drew a picture of Garfield clutching his heart at the rudder of the ship of state, and Bunner wrote a poem in tribute to the stricken president. Schwarzmann rushed this work through the presses and then bound the somber black and white drawing over the cover of the already printed holiday issue. Bunner explained to readers that *Puck* came before them that day "with a merry show and a sad heart."[7]

As Garfield fought for his life, the country learned the motive for the shooting: Garfield had denied the assassin a government job (fig. 82). Keppler viewed

this tragic act as the most grisly evidence to date that something had to be done about the patronage mess. The week after the shooting, Keppler drew the ship of state, battered and wrecked, on the verge of being pulled under by the whirlpool of a corrupt civil service.[8]

Since coming to America, Keppler had witnessed one distressing political event after another: the scandals of the Grant administration, the stolen election of 1876, the bitter patronage battles of the Hayes and Garfield administration, the star route frauds, and the shooting of a president over a government job. When Garfield died in September, the country was forced to swallow another bitter pill: Chester A. Arthur, Conkling aide and, in *Puck*'s opinion, notorious spoilsman, ascended to the presidency. Keppler found this too much to stomach (fig. 83).

Neither political party was anxious to take up the cry for civil service reform because it meant denying itself the spoils of political victory. Party indifference toward this issue created a political vacuum on the national scene. In 1882, Keppler and Schwarzmann decided to place *Puck* in the vanguard of the movement to fill that vacuum. That year, the magazine became the leader in the fight to establish a new national political party.

In April, the new party was depicted for the first time as an energetic, determined bull, ready to challenge the worn-out and decrepit elephant and donkey. The cartoon, "New Bull in the Ring," was captioned, "*Puck* presents another prophetic cartoon—and the sooner it is realized the better." Bunner stated *Puck*'s case: "We want a new party. A party that has the interests of the country at heart and the confidence of the people. We have no longer any use for the gang of Republican knaves, thieves and tricksters, any more than we require Democratic tricksters, thieves and knaves. They have shown that they both meet on the one common ground of robbery."[9]

To capture the public's imagination, one staffer recalled, "it became necessary to invent a mythological figure [to represent] the new party's good qualities and purposes. . . . So *Puck* offered as an appropriate symbol a vigorous-looking first voter, in red shirt, boots and slouch hat, bearing a brand new ax just bought for the occasion" of clearing away the rot of political corruption.[10] While the symbol of the Independent party appeared frequently in *Puck*'s cartoons over the next five years, it lacked the grandeur and dynamism to fulfill its raison d'être as a rallying point for reformers. Even in its prime, it worked merely as a convenient device for *Puck*'s artists.

Keppler used the Independent party symbol for the first time in his August cartoon, "Uncle Sam's Neglected Farm" (fig. 84). It depicted a distraught Uncle

Sam surveying his weed-choked fields as his two farm hands, the Democratic and Republican parties, bicker with each other. The Independent party, wielding a "civil service reform" hoe, admonishes Uncle Sam to "Look here, . . . isn't it about time you got rid of those two quarrelsome fellows, and gave the job to ME?"[11]

Bunner wrote, "It is too bad that [the country] should have been for so long a time in the hands of incompetents. Bundle them off at once, Uncle Sam; kick them out, voters, when you get a chance of doing so at the ballot-boxes."[12] The Independent party's goals, as formulated by the *Puck* staff, were a reformed civil service, a reformed tariff, no monopolies, and honest government.

In October, several leading New Yorkers mobilized to make *Puck*'s dream a reality. They formed, with the magazine's blessing, a Citizen's party and offered a slate of candidates to run in the city's November election. Such a hasty effort had no chance for victory, but the organizers hoped the party's showing at the polls would send a message to the major political parties. Keppler greeted the new party with the cartoon "Through Night to Light!" (fig. 85), which depicted a horde of politicians sleeping, arguing, or fist-fighting. Above them all is the glorious figure of the "Independent New Party," with shield and sword, pointing toward a gleaming capitol and the dawn of a new day.[13]

The Citizen's party didn't win any of its races. The party out of power, the Democrats, gained the most. But as the Democrats gloated, Keppler was quick to point out the force behind their victory. In "Scene from the New National Operetta, 'Election Surprises, or Who Did It?'," he showed a chorus of Democrats shouting, "Hallelujah! We did it! The victory's ours! The horde of defeated Republicans cowers." The Independent party, however, says to the audience, "I'm the man who has the floor, As they'll find in Eighty-four!"[14]

The election did introduce several new faces to the New York political scene who in time would prove to be just the sort of politicians *Puck* wanted to promote. One of them, Buffalo Mayor Grover Cleveland, was elected governor. Another, young Theodore Roosevelt, won a seat in the state assembly.

Popular sentiment made itself felt in Washington as well. As state party conventions across the country adopted pro-civil service reform planks, the lame-duck Congress saw the writing on the wall. In January of 1883, it passed the Pendleton Reform Act by overwhelming majorities. The act established a board of commissioners with power to develop and administer fitness tests and to investigate charges of civil service abuses for more than ten thousand government jobs previously subject to the whims of politics. The *Puck* staff didn't feel the act went far enough, but Bunner wrote that, although "it is a very little civil service reform bill, . . . 'tis enough; 'twill serve." Bunner hoped that future amendments would

increase the commission's power. For the moment, the Pendleton Act cooled the heated civil service reform debate.[15]

Next in importance to the *Puck* staff was the tariff question. This issue was as hot to handle as civil service reform, and both parties avoided it. In May of 1883, Keppler drew "The Greatest Show on Earth" (fig. 86), which pictured the tariff question as a bucking mule, throwing off all riders. Uncle Sam asks the crowd of spectators, "Who can ride the mule?," prompting the Independent voter to volunteer and climb into the ring. Bunner wrote: "The great political parties are in a quandary. They would be willing to give almost anything to get rid of the tariff question. But . . . it won't go down. . . . The question has been treated in so unstatesmanlike a manner that it is now too late to make it a plank in either presidential platform. It must be reserved for a great and honest new party—an Independent party—to put the tariff on a basis suited to the wants of the community. The existing parties have had their chance and have signally failed."[16]

Monopolies also concerned *Puck*'s new party. Keppler had been worried by the power of monopolists for several years. In February of 1881, he drew Uncle Sam being lashed to a telephone pole by communications magnate Jay Gould and railroad tycoon Cornelius Vanderbilt (fig. 87). Bunner wrote at the time, "The tremendous power of [Gould and Vanderbilt] can scarcely be realized. Uncle Sam is on the rack, and they can stretch him to any extent they please. . . . "[17]

Over time this concern grew. In 1882, Bunner wrote, "There must be something wrong, either in our laws or social system, by which one man can acquire so much wealth and power to the detriment of other men." He even went so far as to suggest that the government ought to own the nation's communications system. In September of that year, Keppler drew "The Garden Party of the Monopolists—Louis XV Style" (fig. 88). It pictured prominent capitalists as members of Louis' court being fondled and flattered by U.S. senators pictured as courtesans. The subtitle reads: "While the court 'beauties' are wooed, the people are discontented and threatening."[18]

In 1883, the monopoly issue was debated in the form of the Five Cent Fare Bill. This legislation, under consideration in Albany, would have forced the wealthy owners of the Manhattan el—Gould and Vanderbilt among them—to reduce the standard fare to 5 cents. *Puck* supported the bill. Bunner wrote, "Monopoly at the expense of the people has been having its own way too long, and it is time that the people had a show at the expense of the monopolists." The legislature agreed, but Governor Cleveland didn't. He vetoed the bill and warned against government meddling in business. Bunner was angry, saying, "It was not thought that [Cleveland's] first public act would be to play into the hands of the

monopolists."[19] Despite the fervent debate, the controversy soon died. But the larger question of the power and appropriateness of monopolies remained. *Puck* hoped the 1884 election would serve as a referendum on these and other pressing reform issues.

During this period of political unrest, Keppler's staff continued to grow. When Wales left to help found *The Judge*, Keppler and Schwarzmann countered that competitive threat by filling Wales's place with the most talented artist they could find. In October, they hired Bernhard Gillam, late of *Leslie's Pictorial, Harper's Weekly, The New York Daily Graphic*, and most recently, *Frank Leslie's Illustrated Newspaper*, for reportedly the largest salary then being paid to a cartoonist.[20]

Once more Keppler had made an unlikely choice. Gillam had been born and raised in England. All of his graphic influences had been English, and his work reflected that. To call him America's Tenniel would not overstate his indebtedness to the famous *Punch* artist. Like Tenniel's cartoons, Gillam's creations were suited for the woodblock. He spent years on *Puck* before he broke old habits and began exploiting the freedoms lithography afforded (fig. 96).

If Gillam's British drawing style was not enough to preclude him from *Puck*'s pages, his politics surely were. Had Keppler or Schwarzmann asked Gillam which Americans he respected most, Gillam's answer would have horrified them. He revered General Grant and Henry Ward Beecher.[21] But Keppler and Schwarzmann hired Gillam for his cartooning ability, not his convictions. This twenty-five-year-old conservative Englishman began working for the liberal *Puck* in October of 1881.

In March of 1882, as if to make the composition of the *Puck* art staff even more bizarre, Keppler hired Friedrich Graetz, an old friend from his Vienna days.[22] Graetz, in actuality, was not the first artist Keppler imported from Vienna. In December 1880, Carl Edler von Stur, former chief cartoonist for *Kikeriki!*, made his American debut in the pages of *Puck*.[23] Stur was an inspired addition to the staff but was unhappy in the United States and, after six months, returned to Vienna (fig. 94).

Graetz, glad to be in America, had a drawing style that was anything but "American." He drew with a feathery, loopy line that gave his work an exotic Eastern European, almost Oriental flavor (fig. 95). Because Graetz spoke no English and understood nothing about American politics, he needed precise instructions on what to draw and how to draw it. Without supervision, he was capable of producing nonsense. If, after laboring long and hard on a cartoon, Graetz was asked what he had drawn, he was likely to throw up his hands and exclaim, "Don't can tell."[24]

Despite the added help, Keppler was feeling the strain of his responsibilities and of his years of hard work. In 1883, he seemed always anxious, wanting to get things done but feeling exhausted before he began. His doctors recognized the symptoms of an impending nervous breakdown and prescribed several months of rest and relaxation. Keppler, happy to follow doctors' orders, began planning a grand family tour of all his favorite places on the European continent.[25]

Before the family departed in May, Keppler had one piece of unfinished business to take care of. Earlier in the year, he'd been given a scrapbook of drawings by a twenty-year-old sign painter from central New York State. The artist of those sketches insisted years later that the drawings were beyond hope. But Keppler liked what he saw. He asked the young man to come to New York for an interview.

Eugene Zimmerman called on Keppler not knowing how to act in the presence of the "great and distinguished cartoonist"—humble and awed, as he was feeling, or proud and self-assured, as he wished he were capable of feeling. But all temptation to play a role was wiped away when Keppler came down stairs to greet him, and Zimmerman discovered that "Mr. Keppler was merely a human being, kind and considerate." At that meeting, Keppler offered him a job assisting the artists for $5 a week the first year, $10 a week the second, and $15 a week the third. Zimmerman gladly accepted. Keppler was gratified to learn that his new young charge, born and raised in Switzerland, spoke German. In the months Keppler was away, Zimmerman became Graetz's translator and assistant.[26]

Keppler and his family spent the summer traveling all over Europe. They visited London, Paris, Munich and several other cities in Germany, and Vienna. Now that Keppler was a wealthy man, the family traveled in style, buying all sorts of souvenirs and European goods to ship home. The best part of the trip for Keppler was the opportunity to visit with friends he hadn't seen in more than fifteen years. Surely he felt something like a conquering hero, returning to his homeland as America's most prominent cartoonist and one of its leading publishers.[27]

When he arrived back in New York in late September, different thoughts—of all the money he had spent—prompted him to draw "The Return of the 'Prodigal Father'" (fig. 89). In that cartoon he drew himself, laden with trinkets from all over Europe, crouching down to receive the embrace of an ecstatic Puck. The art staff is on hand to greet him: Teutonic Graetz in toga as the Greek painter Apelles, British Gillam in an eighteenth-century frock coat as the British caricaturist Hogarth, diminutive Opper in cap and cape as the Italian Renaissance painter Raphael, and gawky Zimmerman in the background taking it all in. The German *Puck* staff is there, too. And Bunner appears as a goat, rummaging through the

trash for a poem. In truth, Keppler was hardly penniless. In 1883, his estate was valued at the considerable sum of $600,000.[28]

The Judge took a dim view of this kind of self-indulgent cartoon. In an article entitled "Artistic Egotism," *The Judge* editor surmised that Keppler had drawn the "Prodigal Father" cartoon because he "thought he was doing the public a kindness. Very possibly he never realized that everyone laughed at his ridiculous vanity and egotism. But he is from the country of Bismarck, and, after all, no one is perfect except in a picture."[29]

Without a doubt, Keppler was vain. He loved drawing himself into *Puck* cartoons. As his fame increased, he drew fewer and fewer self-portraits, perhaps because he felt less of a need to establish himself in the public's awareness. Still, his face appeared in *Puck* dozens of times in the eighteen years he served as art director. In fact, he was so vain that when Opper once drew a cartoon that featured Keppler, he allowed Opper to draw everything but his face, which Keppler finished himself.[30]

Some men called Keppler "pompous" and "self-centered." But Keppler protégé Zimmerman disagreed. He said that Keppler was never haughty, never one to fill another "with [the] fear that he might be treading on sacred ground.... " Zimmerman recalled him as "a man whose heart throbbed for others."[31] These qualities helped Keppler become the quintessential teacher. As leader of this new school of lithographic cartooning, he gave hours of his time to instructing those who worked under him and took almost paternal pride in their accomplishments.

During Keppler's trip abroad, the *Puck* staff had compensated for his absence by meeting each week for what became known as the "cartoon conclave" (figs. 90, 91). There, editors and artists discussed the events of the coming weeks and decided what material warranted cartoon treatment. Bunner remembered the conclaves as "a good place for the abasement of unwise vanity and the disciplining of overproud spirits." In these meetings, the majority ruled, and the suggested topics that didn't pass muster were "ruthlessly rejected—without thanks." After the staff agreed on topics, they thrashed out the details of how each topic should be treated. Then the artists left for their cubicles and sketched out the ideas. The conclave reassembled to look over and critique that work. After this, the artists retired once more, this time to draw the finished cartoons. Finally, before going to press, the staff assembled one last time to survey the work of the week and authorize printing.[32]

The conclave had been born out of necessity, but it proved so valuable that it was continued following Keppler's return. He responded enthusiastically to

these democratic discussion groups. He told a reporter once that "sometimes we hit upon the right idea the first thing, but oftener we begin with one idea and end with another so different that nobody would recognize a trace of the first suggestion in it." Keppler sketched continuously during the conclave. He said, "I cannot think things out . . . without my pencil in my hand. Frequently I start in to draw one picture and so insignificant a thing as a stray line will give me a suggestion so that I will change the whole idea. Sometimes, too, when I take up my pencil, even before I've made a mark with it, I can see the impossibility of producing an effect which a moment before I had regarded as a perfectly easy thing to do. . . ."[33]

As important as the conclave was in shaping the content of forthcoming cartoons, it didn't supplant Keppler's art direction. No artwork went into *Puck* without Keppler's initials on the printer's slip. More significantly, he played an ever-increasing role in shaping the work of all the men who drew for *Puck*.

His influence on Wales as a teacher was most evident *after* Wales left *Puck*. Wales's work on *Puck* had been generally successful, sometimes awkward, rarely graceful, but usually powerful and effective (fig. 92). At first, his work on *The Judge* continued along that competent line. But after about six months, it started to fall apart. He began using space with surprising carelessness, composing increasingly sparse cartoons. Too often his double-spreads looked like single-page cartoon ideas stretched to fill the space. Equally artless was his use of color. Subtlety gave way to harshness as he paid less and less attention to color selection, substituting blocks of vibrant colors for the more time-consuming tint blending. The all-too-frequent result: sloppy, garish cartoons.

As for the messages of his cartoons, he alternated wildly between illustrating the news instead of commenting upon it, and issuing savage political and religious indictments that went far beyond Keppler's trespasses. Clearly, Wales had benefited from Keppler's strong guiding hand. Without that direction, Wales seemed rudderless. His work on *The Judge* became an embarrassment. After weathering several partnership and editorship changes, none of which altered the magazine's bleak future, Wales admitted defeat in his attempt to launch a successful competitor to *Puck*. In March of 1884, he sold his interest in *The Judge* and began free-lancing.

As for Opper, Keppler needed to teach him nothing about humor. From the start of his association with *Puck*, Opper seemed to understand intuitively how to make his drawings extend and heighten the humor of an idea. Expressions, gymnastic postures, comical clothing—Opper knew how to use all the cartoon's elements to humorous advantage. What Keppler taught him was refinements in

his draftsmanship. Opper's drawing style in the early eighties was childlike, wacky in an untutored way (fig. 93). Under Keppler's watchful eye, his skill as a draftsman increased in several ways. Instead of compromising his wonderful natural sense of visual humor, his increasing skill accentuated it. By drawing his funny ideas as precisely as possible, he achieved near-perfect humorous expression.

When Gillam came to study under Keppler, he already had a strong sense of composition, one of the most pronounced characteristics of the English school of cartooning. But conceptually Gillam benefited from supervision. Zimmerman recalled that "Gillam was never more contented than when he was occupied on Shakespearean subjects, for he knew that field. Historical situations twisted into modern politics was his big hobby."[34] This propensity sometimes led Gillam to be more clever than was good for him. Keppler would have been the first to defend the use of scenes from classical literature to make a contemporary political point, but the process carried the considerable risk of being arcane and pretentious. Under Keppler and in the creative atmosphere of the *Puck* workshop, Gillam's classical bent was kept tightly reined. He rarely drew a classically based cartoon for *Puck* that wasn't energized by the execution or the appropriateness of the analogy. Moreover, he never drew better cartoons than those he drew under Keppler's watchful eye.

Zimmerman—or "Zim" as he signed his work—was the least tutored of all of Keppler's students, although he may have had the most natural talent, particularly as a draftsman (fig. 97). He worked more intimately with Keppler than any other artist on the staff, helping Keppler color the tinted stones, and he learned much simply by studying Keppler's work closely. He recalled, "[Keppler's] cartoons were more than that name implies. They were real works of art, both in drawing and coloring. . . . [He] was a master at graceful grouping: He made it a point to put a bit of interest in every figure, so that not a single one looked as if it could be spared from the picture."[35]

As for his own work, Zim recalled, "Keppler refuse[d] to condemn a drawing simply because it was poorly executed. . . . Being a true artist, he was able to see beneath the surface of a boy's capabilities." Moreover, Zim remembered, "Whenever [Keppler] detected defects in my draftsmanship he suggested changes that were always valuable."[36]

When the art staff had consisted of Keppler, Wales, and Opper, Keppler did most of the double-spread cartoons himself. But with Wales's departure, the division of labor changed. Keppler began sharing the double-spread cartoon regularly, usually alternating with Gillam and sometimes Graetz. Zim recalled, "Keppler could have insisted upon monopolizing the center double-page—the most impor-

tant cartoon location—but [he] preferred to pass it around so his associates might share in the glory. . . ."[37] Zim's observation summed up the way in which Keppler directed *Puck* during the 1884 campaign. The staff's glory came in helping to elect a president. Keppler was content to bask in that light.

Figures 81–97

81. "A Harmless Explosion." When New York Senator Roscoe Conkling got into a patronage fight with newly elected President Garfield, he thought he could dramatize his state's support for his cause by resigning his Senate seat. Some characterized this bold move as a "bombshell." Keppler saw it as a harmless explosion. The fizzling balloon tied to Conkling's coattails represents junior Senator Thomas Platt, who resigned his seat as well. Of all of the observers, only Conkling's former lieutenant, Chester A. Arthur (in the upper left), appears distressed. Conkling's plan fell apart when the New York State legislature chose not to reappoint him, effectively ending his political career. (Author's collection; *Puck*, May 25, 1881)

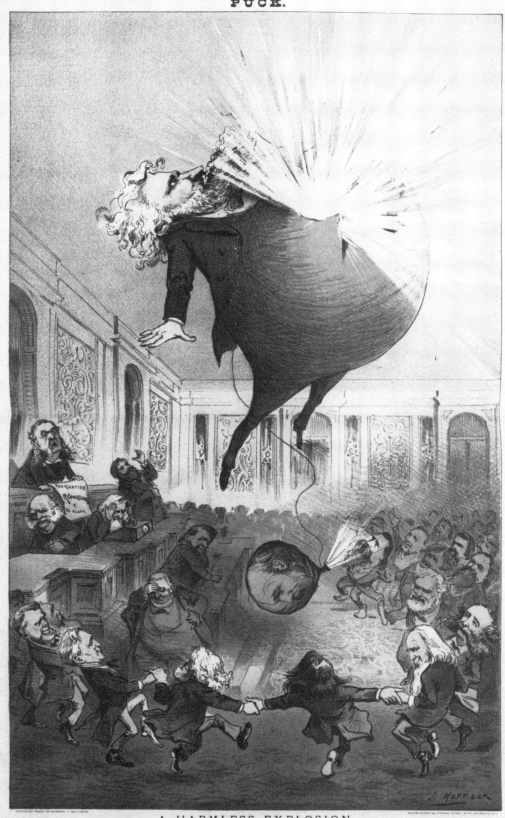

A HARMLESS EXPLOSION.

82. "The Only Road for Him." When Garfield's assassin Charles Guiteau was found to be deranged, he became the object of sympathy. During his trial, his lawyers argued that because of his insanity he was not responsible for his actions. Keppler refused to accept this plea, arguing for retribution by hanging. The jury, concurring, sent Guiteau to the gallows. (Author's collection; *Puck*, Dec. 14, 1881)

PUCK.

THE ONLY ROAD FOR HIM.

83. **"A Grand Shakespearean Revival."** In Shakespeare's *King Henry IV*, Prince Hal leads a profligate existence, associating with all sorts of shady characters. Then, he is called to the throne and, to everyone's surprise, renounces his disreputable companions. When Conkling's former aide Arthur became president after Garfield's death, Keppler sarcastically suggested that perhaps life would imitate art and Arthur would snub Conkling. As it turned out, this cartoon was more prophecy than pipedream. Arthur was a far more responsible and nonpartisan leader than his past promised. Keppler, however, never regarded Arthur as more than a caretaker. In most cases, Keppler judged whatever efforts Arthur made toward the cause of good government as inadequate. (Author's collection; *Puck*, Oct. 5, 1881)

A GRAND SHAKESPERIAN REVIVAL.

(Which We Have But Little Hope of Seeing on the Stage of the National Capital.)

Sir John Conkling.—Stand here by me. Master Shallow Platt; I will make the King do you grace *** Do but mark the countenance he will give me. *

My King! My Jove! I speak to thee, my heart!
King Chester I.—I know thee not, old man! Fall to thy prayers!

Presume not that I am the thing I was;
For heaven doth know, so shall the world perceive,
That I have turned away my former self;
So will I those that kept me company!

(2nd Part of King Henry IV., Act V.—Sc. 5)

J. Keppler

84. "Uncle Sam's Neglected Farm." In 1882, tired of politics as usual, Keppler and staff began advocating the formation of a new and independent political party that would be pro-civil service reform, pro-tariff reform, and anti-monopoly. This was Keppler's first cartoon in *Puck*'s Independent party campaign. (Author's collection; *Puck*, Aug. 20, 1882)

UNCLE SAM'S NEGLECTED FARM.

New and Independent Party:—Look here, Uncle Sam, isn't it about time you got rid of those two quarrelsome fellows, and gave the job to ME?

85. "Through Night to Light!" On the eve of the 1882 off-year elections, Keppler drew this powerful portrait of the Independent party making its way to the Capitol. (Author's collection; *Puck*, Oct. 25, 1882)

THROUGH NIGHT TO LIGHT!

86. "The Greatest Show on Earth." In this installment of Keppler's Independent party series, Uncle Sam asks for volunteers to ride the tariff question mule following unsuccessful attempts by the Democratic and Republican parties. The two clowns who watch the scene are Whitelaw Reid, editor of the Republican *New York Tribune*, and Henry Watterson, editor of the Democratic *Louisville Courier-Journal*. (Author's collection; *Puck*, May 2, 1883)

THE GREATEST SHOW ON EARTH.—"WHO CAN RIDE THE MULE?"

87. "The Two Philanthropists." In 1881, businessman Jay Gould cleared the final hurdle in his campaign to consolidate all of America's telegraph companies under his control. *Puck* contended that the master manipulator ostensibly controlled Vanderbilt and his railroad empire as well, making him the most powerful man in the country. Keppler was outraged that these men concealed their avariciousness behind philanthropic acts, all the while clutching, as Bunner wrote, "the United States and all its institutions by the throat." (Author's collection; *Puck*, Feb. 23, 1881)

PUCK.

THE TWO PHILANTHROPISTS.
"Don't fret, Uncle Sam, we only want to make a bigger man of you!"

88. "The Garden Party of the Monopolists." In this daring cartoon, Keppler portrays U.S. senators as courtesans in the laps of American monopolists. From the left, Senator Don Cameron gives his attention to a representative of Standard Oil, while millionaires Cyrus Field and Cornelius Vanderbilt are entranced by Senator Chauncey Depew. Ex-Senator Conkling entertains railroad man Jay Gould, Senator George Hoar dallies with the mine owner J. P. Jones, and financier Russell Sage is cheered by the company of Mrs. Put & Call, the Wall Street practice of trading options that Sage originated. Senator George Robeson whispers sweet nothings in shipbuilder John Roach's ear, and Senator Warner Miller entertains another representative of Standard Oil. (Author's collection; *Puck*, Sept. 20, 1882)

THE GARDEN PARTY OF THE MONOPOLISTS—LOUIS XV. STYLE.

While the Court "Beauties" are Wooed, the People are Discontented and Threatening.

89. "Return of the 'Prodigal Father' to the *Puck* Office." In October 1883, when Keppler returned home after a six-month European vacation, he drew this spirited cartoon of the happy reunion scene. On the left is his art staff, featuring Zimmerman, Gillam, and Graetz in the background, and Opper in the foreground. V. Hugo Dusenbury and F. Fitznoodle, in the center, were the noms de plume of editors Bunner and Vallentine. The temperance character was one of Keppler's creations. Coming out of the editorial offices, German *Puck* associate editor Carl Hauser, identified sarcastically as the "Religious" editor, and German *Puck* editor Leopold Schenck greet Keppler with open arms. Just behind Schenck stands dour *Puck* associate editor, B. B. Vallentine. *Puck* editor Bunner is the goat rummaging through the trash. (Courtesy of Library of Congress; *Puck*, Oct. 10, 1883)

PUCK.

THE RETURN OF THE "PRODIGAL FATHER" TO THE "PUCK" OFFICE.—DRAWN BY HIMSELF.

90. The cartoon conclave as it was. This 1887 photograph, taken in the Puck building, candidly captures the relaxed, democratic atmosphere of the cartoon conclaves. From the left, Keppler and Schwarzmann stand behind Bunner, discussing the piece of art in question. W. C. Gibson and Wilhelm Müller look on. G. E. Ciani and Carl Hauser stand behind the table. C. J. Taylor has his back to the camera. R. K. Munkittrick, Louis Dalrymple, A. B. Shults, and Fred Opper, seated in front, round out the staff. (New York Public Library)

91. The cartoon conclave as Keppler drew it. Keppler took considerable liberties translating the above photograph into a drawing for the tenth anniversary issue of *Puck*. Keppler, Schwarzmann, and Bunner appear as in the photograph. Taylor sits beside Bunner and Hauser, Müller, and Opper round out the abbreviated gathering. German *Puck* editor Leopold Schenck, who died the year before, is with the staff in spirit; Keppler added his portrait to the conclave wall. (Author's collection; *Puck*, March 2, 1887)

92. James Albert Wales, Keppler's first lieutenant, contributed his homegrown American cartoons to *Puck* for about two-and-a-half years. Keppler taught him much about composition and color. In the fall of 1881, he founded his own magazine, *The Judge*, to compete with *Puck*. Under his art direction, it was a failure. He returned to *Puck* in 1886, the year he died. (Author's collection; *Puck*, Jan. 12, 1881)

PUCK.

GARFIELD'S TALLYHO!—SELECTING THE PASSENGERS.

93. Frederick Burr Opper's work brightened *Puck*'s pages for nearly two decades. He was the magazine's comic star, mixing his home-grown wit with a charmingly näive drawing style to produce simple yet amusing pieces. Under Keppler's tutelage, he developed into a skilled draftsman without losing any of his comic spontaneity. (Author's collection; *Puck*, Nov. 16, 1881)

EUROPEAN NOTIONS OF AMERICAN MANNERS AND CUSTOMS.

94. Carl Edler von Stur was chief cartoonist of the Viennese comic weekly *Kikeriki!* when he gave Keppler his start as a comic artist back in 1863. Almost twenty years later, Keppler returned the favor by inviting him to work for *Puck*. Stur's distinctive work filled *Puck*'s pages for only six months. Unhappy in New York, he returned to Vienna and picked up his career where he had left off. (Author's collection; *Puck*, June 1, 1881)

THE MONKEY'S REVENGE.

95. Friedrich Graetz, another friend of Keppler's from his Vienna days, worked for *Puck* from 1882 to 1885. He could not speak English and drew his cartoons under the supervision of one of the German-speaking staff members. Many of his lithographs in 1882 and 1883 dealt with international affairs. (Author's collection; *Puck*, July 19, 1882)

PUCK.

CONEY ISLAND AND THE CROWNED HEADS.
Why Shouldn't the Wearied Monarchs of Europe Enjoy a Plunge in Our Republican Waters?

96. Bernhard Gillam joined *Puck* in 1881. Keppler recognized Gillam's superior talents by immediately inviting him to draw *Puck*'s centerspread cartoon every other week. Although Gillam disagreed with *Puck*'s politics, he created some of the weekly's most memorable cartoons, including this one, the first to brand James G. Blaine as the tattooed man. He left the weekly in 1885 on a sour note, but he never lost his high regard for Keppler, calling him later in life "the greatest cartoonist America ever saw." (Author's collection; *Puck*, April 15, 1884)

PUCK.

THE NATIONAL DIME-MUSEUM—WILL BE RUN DURING THE PRESIDENTIAL CAMPAIGN.

97. Eugene Zimmerman had served on *Puck* for almost two years before he drew his first lithograph in March 1885. This cartoon shows the strong influence Keppler had on his style. He left the magazine in December 1885 to work for *Puck*'s Republican rival, *Judge*. (Author's collection; *Puck*, Sept. 2, 1885)

PUCK.

DEMOCRATIC HOME. RESTORED IN 1884.

REPUBLICAN HOME. NO CIVIL SERVICE INFANT WANTED HERE.

REFORM

CIVIL SERVICE REFORM

LIBERTY

HENDRICKS

NO WELCOME FOR THE LITTLE STRANGER.

Father Cleveland Adopts the Abandoned Infant of the Republican Home, to the Great Disgust of the Jeffersonian Household.

SIX

"A Sail! A Sail!"

ROSCOE CONKLING'S premature exit from the national political scene had left James G. Blaine as the unchallenged leader of the Republican party. In 1884, Blaine seemed on the verge of receiving what he had coveted for a decade—the Republican presidential nomination.

Grandly dubbed "the plumed knight" by an avid supporter, Blaine was probably the most popular politician of his generation.[1] His charisma and oratory skills inspired a loyalty in his supporters that other politicians only dreamed of. Keppler had never liked him. In his opinion, Blaine epitomized the petty shadiness that pervaded postwar politics. To begin with, Blaine had been one of the congressmen caught with Crédit Mobilier stock when that scandal broke in 1872. In 1876, he became mired in yet another railroad scandal, this one involving the Little Rock railroad line. Press exposés of the affair charged that Blaine had acted as a stock broker for the railroad at the same time that he was guiding legislation preferential to the Little Rock line through Congress. Letters he wrote during the period to one of the railroad officers, James Mulligan, became the basis for the charges. After an artful and melodramatic self-defense on the Senate floor, Blaine was officially cleared of wrong-doing, but Keppler remained unconvinced.

Blaine's politics were equally offensive. He had attacked Hayes's policy for ending Reconstruction. He had hindered the president's efforts to reform the civil service. And he had enthusiastically supported a measure to restrict Chinese immigration. These illiberal stances, along with the questionable financial dealings, convinced Keppler that Blaine was not fit for national leadership.

Back in September of 1882, Blaine made a speech effectively announcing his candidacy. Keppler responded with "Opening a Little Campaign all by Himself."

It showed Blaine wearing ill-fitting armor labeled "war record" and a helmet with plumes labeled "Crédit Mobilier" and "Mulligan letters." He holds a battered sword labeled "alliance with monopolists." Puck says to him, "You will never succeed in that armor, Mr. Blaine—this is the winning suit," pointing to tariff reform armor, an anti-monopoly sword, and a banner espousing civil service reform.[2]

The first cartoon hit of the 1884 campaign came not from Keppler's pen, but from Gillam's. Despite Blaine's prominence, many men contended for both party nominations. In April of 1884, Gillam drew "The National Dime Museum" (fig. 96) which depicted those contenders and their backers as side-show freaks: Conkling is a bearded lady; President Arthur, a snake charmer. In the foreground, but to one side, stands Blaine, dressed only in trunks and tattooed from head to foot with the catchphrases of his checkered career: "Mulligan letters" and "bribery" adorn his back; "Anti-Chinese demagogism" and "bluster" wrap down his legs.[3]

No one on the *Puck* staff expected the response the cartoon provoked. Zim recalled, "'The National Dime Museum' was intended . . . to be a cartoon of comic satire, not a personal stab at James G. Blaine." But that's how the public read it and the issue sold out. Schwarzmann printed thousands of extra copies without meeting the demand. Gillam became a celebrity. But before he could savor fame's sweetness, the Republican press attacked his character and insulted him for his place of birth. Zim remembered that "Gillam was almost beside himself."[4]

Puck staffers realized the irony of the situation. First, unlike his employers, Gillam admired Blaine and wished his candidacy no harm. Second, the cartoon had not been Gillam's sole creation, but rather the product of one of the cartoon conclaves.

The tattooed image was not a new one. Keppler had used it twice before, once depicting Grant under the iron (fig. 29), and once showing an ashamed Columbia covering up her unsightly blemishes.[5] But exactly who suggested putting Blaine under the tattooing iron remains a mystery, with every *Puck* staffer on record recalling the events of the conclave differently. Gillam, Schwarzmann, Bunner, German *Puck* staffer Carl Hauser, and even a precocious office boy have been given credit for the masterstroke.[6] Contention for credit aside, no one debated Blaine's fitness for tattooing. Given Keppler's longstanding animosity toward Blaine, the Republican party leader seemed destined to be seared and scarred by *Puck*'s red hot iron.

The tattooed man idea quickly became common property among the staff. Keppler used it in May when he drew "More than She Can Carry." This cartoon

showed the Republican party crouching under the weight of a basket filled with bundles representing the sorrier events in the party's history, such as the "star route frauds" and "Grant's second term." Meanwhile, Whitelaw Reid, editor of the *New York Tribune* and leading Blaine supporter, loads one more sack on top. Labeled "rotten record," it contains the tattooed Blaine himself.[7]

On the eve of the Republican convention in June, Gillam once more stole the show with his double-spread cartoon, "Phryne Before the Chicago Tribunal" (fig. 98). Like "The National Dime Museum," this was intended as a searing indictment of Blaine and his supporters. It found its mark. Modeled after Gerôme's recently displayed scandalous oil of a white slave girl being disrobed in front of a Greek tribunal, Gillam's cartoon featured Whitelaw Reid unveiling Blaine before the Republican kingmakers. His body is tattooed all over, but Reid assures his audience, "Now, Gentlemen, don't make any mistake in your decision! Here's Purity and Magnetism for you—can't be beat!" The tattoos make a lie of the purity claim, but Gillam gave substance to the claim of magnetism by supplying Blaine with a magnetic bib around his neck.[8]

"Phryne Before the Chicago Tribunal" became the hit of the campaign. Democrats loved it. Republicans cursed *Puck* and its owners. Many newspapers around the country labeled the cartoon as blasphemy. Bunner replied, "We can remember the time when Tweed and his partners were cartooned in anything but a complimentary manner..., and everyone thought the cartoons splendid, and never expressed a word of sympathy for the Boss. We can also remember when Horace Greeley was weekly held up to ridicule. We can likewise remember when Hancock was treated the same as Greeley.... And yet, in these cases, everybody laughed, and thought it a good joke, and didn't call it blasphemy. It is never blasphemy to caricature, or rather show a politician up in his true light, unless he is a Republican. Then it is a sin and misdemeanor...."[9]

Others, claiming that *Puck* used to support Blaine, charged Keppler and Schwarzmann with political opportunism. Throughout the campaign, *Puck* printed the following as filler: "'See if you can make any change out of that!': 'The next largest delegate-owner is James G. Blaine, a tricky politician, of fishy character,' (June 2, 1880); and 'A man whose nomination is an insult to the country, whose election would be an ineradicable disgrace.' (June 11th, 1884)."[10]

When Blaine won the nomination, *The Judge* staffers were ecstatic. They saw Blaine's nomination as a stinging rebuke to *Puck* and its powerful tattooed man series. *The Judge*'s first post-convention issue pictured a laughing Blaine holding a copy of *Puck*'s tattooed man cartoon. It was captioned: "He who laughs last, laughs best." Inside, the editor wrote: "We have seen the dastardly stab which *Puck* attempted to inflict, like a noxious insect of night seeking its own sustenance

from the annoyance of a being as infinitely superior to *Puck* or its proprietors as a good man is to a bad bed-bug. . . . Venal pen and hireling pencil have collected all the filth and venom they could muster and poured it on Mr. Blaine's devoted head. Has the mud stuck? . . . The cheers and shouts which shook Chicago and found an echo in every corner of the land [last week] are the best answers to that question. . . ."[11]

Blaine's nomination drew an entirely different reaction from Bunner. He wrote: "Not content with the confidence of the people, with honor and with power, [the Republican party] has waxed gross with selfishness and fat with corruption. It has smirched beyond all cleansing its bright record; it has sold its honor for a bribe; it has maladministered the power entrusted to it."[12]

Some prominent Republicans agreed with *Puck*. G. W. Curtis and Henry Ward Beecher were the leaders of a group of Republicans (derisively called Mugwumps) who refused to support Blaine. Keppler heralded this group as the realization of *Puck*'s dream for an Independent party. He drew the Republican kingpins and their nominees at a Belshazzarian feast thrown into turmoil by a shaft of light, labeled "Republican revolt," which cuts into the room. The power-brokers flee for cover. Blaine, with his tattoos, is naked save for the pages of the *New York Tribune* he uses to shield his body from the light (fig. 100).[13]

As in 1880, Keppler looked anxiously to the Democrats to see whom they would nominate (fig. 99). Keppler's iconoclastic spirit yearned for the successful formation of *Puck*'s Independent party, but he realized the strength of the third-party movement in 1884 lay in its role as a spoiler, a powerbroker whose support was necessary for either side to win. At best, the Independents could set the national agenda, even without being in the majority. But the Democratic party had to nominate someone the Independents could support. Otherwise they would have no place to go.

Keppler told the Democrats in cartoon that they had a choice: Select an unworthy candidate and your party is lost; select a worthy candidate and your party is saved. In "A Sail! A Sail!" (fig. 101), Keppler pictured the Democratic party as a shipwrecked maiden. Strewn about her are empty bottles and boxes labeled with the names of issues that had sustained her for twenty-four years. Tammany chief John Kelly lurks behind a tree with a bow and arrow, labeled "deal," in hand. (Every four years Kelly threatened to withhold his support from the Democratic ticket if they didn't nominate someone to his liking.) Just as all hope appears lost, the maiden spots the bow of the "Independent Republican," sailing toward her in a ray of sunshine.[14]

At first, Keppler suggested tariff reformer and House Speaker John G. Carlisle as the Democratic party nominee. But public enthusiasm never materialized for Carlisle's candidacy, and his political stock declined. During the first several months of 1884, Keppler refused to give New York Governor Cleveland serious consideration as a contender; his many vetoes had lost him considerable support in his home state. During Lent, Keppler had drawn a cartoon portraying the presidential contenders as fish, with Cleveland as the blowfish "Clevelandus Blunderius."[15] But in June, when a national groundswell began for the New York governor, Keppler gave him a second look.

In "He Courts the Mother and Means the Daughter" (fig. 102), Keppler drew the Democratic party with his arm around Mother Tilden's waist surreptitiously offering a presidential nomination bouquet to the hard-working daughter, Cleveland. The ribbons in Cleveland's hair read "reform mayor" and "reform governor." He's shown at a sewing machine, stitching together his accomplishments as a public servant. The accomplishments Keppler came up with were vague ("municipal reform bills," "responsible mayor") or insignificant ("park commissioners bill," "repeal of the confirming power of the aldermen"), hardly the stuff of great presidents. But for all of *Puck*'s squabbles with Cleveland in the past two years, the magazine could in good conscience say to the Democrats that if they nominated Cleveland, they would be giving "manly and friendly aid to the cause of honest government."[16]

When the Democrats followed *Puck*'s advice, Bunner called Cleveland a "wise, honest, and strong man" who brought repute to the Democrats just as Blaine brought disrepute to the Republicans. When the Independents greeted Cleveland's nomination with the same enthusiasm, Keppler rejoiced. In "A Flag the Independents Will Fight Under" (fig. 103), Keppler drew the Democratic party presenting Cleveland as its candidate, while the Independent party hoists a "Cleveland for President" flag. Tammany chief Kelly, who hated Cleveland, and Greenback party candidate Benjamin Butler, who had hoped the Democratic party would endorse him, clutch each other in the foreground, wailing gumdrop tears.[17]

During the campaign Keppler alternated between drawing anti-Blaine and pro-Cleveland cartoons. The anti-Blaine cartoons hammered away at the Republican candidate's sordid record by using the tattooed man idea again and again. In the cartoon "He Can't Beat His Own Record" (fig. 104), Keppler drew Blaine at the Republican race track unable to overtake his own tattooed image in a foot race.[18]

Keppler's pro-Cleveland cartoons broadcast the message that the Democratic candidate was better than the party that had nominated him. The cartoonist made

this point by comparing the political situation with a recent scientific discovery that the eucalyptus tree purified the atmosphere. In "The New Democratic Eucalyptus Tree Purifies a Political Morass" (fig. 105), Keppler showed a magnificent "eucalyptus Clevelandus" spreading its limbs over the Democratic swamp and ridding it of the deadly vapors of "ward bossism," "spoils system," and "bourbonism."[19]

At the height of the campaign, Democrats in New York's business community organized a parade to advertise their support of Cleveland's candidacy. Thirty-five thousand men participated. Keppler had the honor of leading the publishers' section. Looking his most elegant in top hat, frock coat, and cream-colored gloves, the cartoonist triumphantly walked down Broadway, acknowledging the cheers of people in the crowd who recognized him and bowing to candidate Cleveland as he passed the reviewing stand.[20]

The campaign was hard-fought. Each week seemed to bring news damaging to the Democratic cause. In August, the charge surfaced in the Republican press that Cleveland had fathered an illegitimate child when he was a lawyer in Buffalo. Asked by Democratic leaders how they should respond to the charge, Cleveland declared, "Tell the truth!" The truth was that Cleveland was the father, but his artfully enigmatic response placed the burden of explaining on his supporters. Bunner, in *Puck*, accepted that burden with partisan rectitude. He said that Cleveland had been close to a widow in the early 1870s. When she gave birth, he voluntarily accepted paternity and provided financial support for the woman and her child. Bunner insisted that Cleveland "had nothing whatever to do, directly or indirectly [with the woman's condition]. And on this poor foundation is built the sickening slander which has defiled this presidential campaign as no other has been defiled in this generation."[21] Anti-Cleveland cartoonists had a field day with the issue. Keppler never commented on it.

Benjamin Butler's Greenback campaign posed a serious threat to the Democrats. Anti-Cleveland Democrat Charles Dana of the *New York Sun* aggressively promoted Butler and predicted that his candidate would receive one hundred thousand votes in New York City alone. If Butler siphoned off that many votes from the Democrats, the Independents' support for Cleveland might not make any difference. To dramatize this treachery, Keppler drew "Helping the Rascals In" (fig. 106). It pictured Butler and Dana hoisting Blaine through one of the White House windows. Unbeknown to them, the Independent party approaches in the dark, carrying a bully stick poised to foil their scheme.[22]

In October, despite his avowed support for the Democratic ticket, Tammany chief Kelly seemed ready to make a deal with the Republicans: Tammany votes

for patronage concessions. Keppler portrayed the deal in "A Sacrifice to the Political Wolf" (fig. 107), which shows Blaine and his lieutenant Whitelaw Reid riding in a sleigh. A hungry Tammany wolf runs threateningly alongside. To placate the snarling animal, Reid prepares to toss it a little girl labeled "New York City." Her only hope is the Independent voter, who stalks them in the background with a rifle in hand.[23]

As the election neared, *Puck*'s political rhetoric reached new heights. The mudslinging and melodramatic predictions of doom if either side won whipped the *Puck* staff into a frenzy, producing a torrent of anti-Blaine prose and pictures. Despite their commitment to the Cleveland cause, the proprietors anxiously strove to preserve the magazine's independent political identity. Throughout the fall, Bunner rather weakly asserted, "No portion of this paper will be sold for use in campaign documents or for other political purposes. . . . *Puck*'s print and pictures are for the people; not for politicians."[24] In fact, *Puck* had become a campaign document itself. Keppler and Schwarzmann wanted it both ways—to encourage support for Cleveland but not be perceived as a Democratic organ. This was impossible. Of course, *Puck*'s status as a leader in the pro-Cleveland press was not without its rewards. The magazine's circulation reached a peak of 125,000 during the 1884 contest.[25]

The campaign yielded other benefits for the magazine as well. Keppler and Bunner had always been kindred political spirits, iconoclastic reformers at heart, able to work comfortably with each other. But in 1884, they created a phalanx of cartoons and editorials for the Cleveland cause that surpassed all of their previous collaborations in power and persuasiveness.

Unlike his predecessor Rosenfeld, Bunner worked hard to augment and explicate Keppler's cartoons without taking anything away from them. One of Bunner's assistants recalled, "The necessities of [Bunner's] place made him a political writer; but his enthusiasm, his patriotism, his hatred of shams, together with his literary training, made him a political writer of high rank. To make the fine, violin-like tones of his 'Comments' heard through all the trumpet-blast of Keppler's cartoons, was no easy task, yet Bunner accomplished it. . . . His effort was to write so simply that the least educated of his readers could not help understanding him, and he did it so well that his most cultured readers enjoyed him."[26]

Readers of Bunner's 1884 editorials today may not share the generous views of his contemporaries. His writings, then powered by his fervor and asceticism, now seem emotional and condescending. Even then, Bunner was not without his detractors. Ambrose Bierce, editor of The San Francisco *Wasp*, the western competitor of *Puck*, was one of them. He wrote a poem to Keppler and Bunner:

Giant with pencil, but with pen
Pigmy! I, noting your success,
Nor meanly wishing it were less,
Yet wonder at my fellow men.

To get so noble wine they quaff
What seas of water with good heart!
They sift for golden grains of art
Such tons of literary chaff!

Great Keppler, if I do thee wrong,
To couple with thy name the sleek
Fat-witted fool whose words make weak
The pictures that you make so strong.

If noting how this quill cat whines
Apology for thy superb
Great indiscretions that disturb
The rogues and dolts in their designs

I link your fame with his dispraise,
Forgive me. Lo! He eats your bread,
Owes you the fat that fills his head,
And dares to glimmer in your blaze.[27]

Outside of work, Keppler rarely crossed Bunner's path. Occasionally they might have run into each other at the Metropolitan Opera or a theater on Broadway, but for the most part, they traveled in different circles. Bunner enjoyed the company of young writers and poets such as himself; Keppler spent time with fellow German-Americans. The two men were genial and respectful business associates. Neither apparently wished for anything more.

Never was the adage "Politics makes strange bedfellows" better illustrated than in 1884 when Henry Ward Beecher and Keppler found themselves in the same Independent camp. When the election totals were in doubt, Keppler drew "Men May Come, and Men May Go; but the Work of Reform Shall Go on Forever" (fig. 108). It showed several of the Independents building a monument to reform, Beecher being prominent among them. It was the first favorable portrayal of the Reverend that Keppler had ever drawn.[28]

Another old friend reentered Keppler's life during the 1884 campaign. Six years earlier, Joseph Pulitzer had come to New York and tried to buy part ownership in *Puck*. When Keppler and Schwarzmann rebuffed him, he returned to St. Louis and became the successful owner and editor of the *St. Louis Post-Dispatch*.

In 1883, eager to duplicate that success on a grander scale, he purchased the moribund *New York World* with dreams of making it a paper for the people. Pulitzer's support for Cleveland's candidacy never wavered. When Dana came out for Butler, Pulitzer's *World* became the recognized Democratic party organ in New York. Keppler and Pulitzer found themselves on the national stage fighting for the same cause. They renewed their acquaintance, meeting for an occasional meal when their busy schedules permitted.[29]

Pulitzer was dazzled by *Puck*'s strong performance and wanted part of that glory for the *World*. In August, free-lancer Walt McDougall dropped off a cartoon, already rejected by Keppler, at the *World* building for Pulitzer's consideration. Pulitzer saw in this amateurish but powerful piece of work the opportunity to take on Keppler on his own turf. He published the cartoon on the front page of the next day's *World* and hired McDougall as the *World*'s first editorial cartoonist.[30] Little did anyone think at the time that Pulitzer's precipitous decision to use political cartoons as a weapon in the New York press war would within the decade transform the grand art made famous by Nast and Keppler into just another feature in America's newspapers.

Despite their political alliance, Keppler never publicly embraced Pulitzer by featuring him in his cartoons. Keppler was uncomfortable with Pulitzer's shameless partisanship. In Keppler's view, Pulitzer would have supported anyone the Democrats nominated. He loved Cleveland for the opportunities his victory would present to a half-starved Democratic party. Keppler, in contrast, supported the man, not the party. He loved Cleveland most because of the enemies he had made. Keppler and Pulitzer wanted to see Cleveland elected, but Keppler realized that they wanted it for markedly different reasons.

They contrasted on a human level as well. Keppler, while proud to be an American, celebrated his Germanic heritage and remained in the social circle of that community. Pulitzer was enamored by and drawn to the powerful. He cultivated friendships with America's leading money men, many of whom he professed displeasure with in the pages of the *World*. Keppler loathed this type of toadying duplicity. Their political alliance was an uneasy one, their renewed friendship a fragile, largely nostalgic association.

The election was a squeeker. After receiving confirmation of Cleveland's victory, Keppler drew "The Transfusion of Blood—May the Operation Prove a Success." It showed Doctor Puck transfusing blood from the vigorous Independent voter to old man Democracy. The cartoon recognized that Cleveland's election was but a first step; the major work of reform lay ahead.[31]

In 1880, Keppler lost the political battle he waged but had won widespread popularity that assured his professional success. In 1884, something of the reverse

occurred. Although he won the political battle, his victory signalled the beginning of his professional decline.

Keppler's success and power originated in his satiric impulse, in his jaundiced, skeptical eye. He had defined himself as a gate-keeper, ever vigilant in protecting the public against falsehoods and charlatans. He saw himself as a partisan of no individual or party, only of the truth.

Now Cleveland had won. The man Keppler promised would bring honesty and reform to the federal government would soon hold the reins of power. Keppler had staked his reputation on Cleveland's commitment to reform. Regardless of what Cleveland did, Keppler could not deny his share of responsibility for Cleveland's presence in Washington in the first place. Indeed, Cleveland even went on record saying that he owed his election to *Puck* (fig. 109).[32] Despite occasional criticism of Cleveland in the years that followed, Keppler came to be viewed as one of the president's chief supporters. This blatant partisanship made Keppler soft, took the edge off his work, and compromised his effectiveness as self-appointed guardian of the truth.

Figures 98–109

98. The Tattooed Man. Bernhard Gillam drew this cartoon, the most famous of the 1884 campaign. It features Blaine advocate Whitelaw Reid, of the *New York Tribune*, revealing his candidate to the Republican kingmakers. Notables in the crowd include a shocked Benjamin Harrison standing with arms upraised in the back, a thoughtful Theodore Roosevelt sitting fourth from the right, and a distressed G. W. Curtis, editor of *Harper's Weekly*, sitting on the extreme right, who led the liberal Republican revolt against Blaine's candidacy. The cartoon parodied the contemporary middlebrow painting by Gerôme, "Phryne Before the Tribunal."

In the course of the campaign, Keppler, Gillam, and Opper used the tattooed man image repeatedly, creating, in the process, the strongest graphic attack ever made on an American politician, save only Nast's 1871 campaign against Marcus Tweed. Blaine's biographer wrote that "the 'Tattooed Man' became the picture of Blaine in the minds of the masses of people who were incapable of examining his record." (Author's collection; *Puck* June 4, 1884)

PUCK.

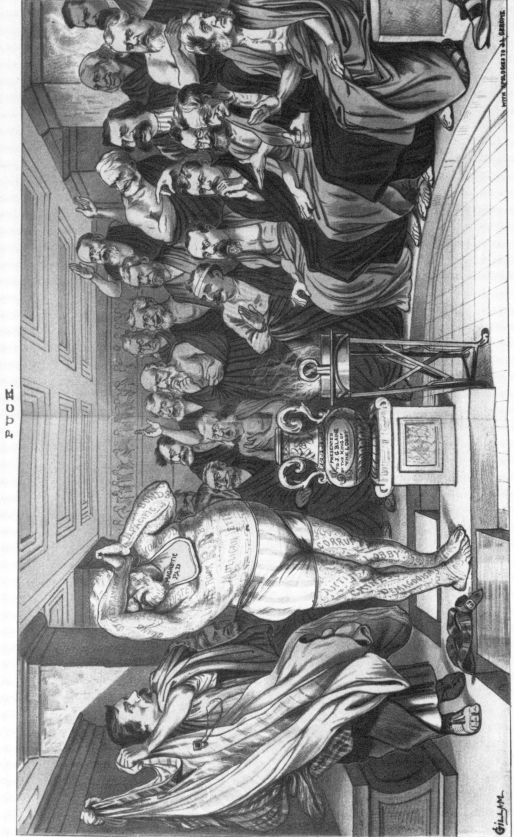

PHRYNE BEFORE THE CHICAGO TRIBUNAL.

ARDENT ADVOCATE.—"Now, Gentlemen, don't make any mistake in your decision! Here's Purity and Magnetism for you—can't be beat!"

99. "An Unpleasant Ride Through the Presidential 'Haunted Forest.'" As the 1884 nominating conventions loomed, the chances that the two parties would field two strong and worthy candidates were bleak. In this intricate drawing, Keppler hid the faces of even the darkest horses. (Author's collection; *Puck*, May 28, 1884)

AN UNPLEASANT RIDE THROUGH THE PRESIDENTIAL "HAUNTED FOREST"

100. "The Writing on the Wall." Following Blaine's nomination, Keppler drew this cartoon, which chronicled the growing dissatisfaction among many Republicans with the party's choice. The diners, all millionaires and journalists, run for cover as a shaft of light announcing a Republican revolt cuts through the room. Blaine and his running-mate, Indian fighter John Logan, try to shield themselves with the official Republican organ, the *New York Tribune*. The feather in Blaine's cap labeled "Gail Hamilton" refers to the pen-name of Mary Dodge, Blaine's cousin and publicist. Keppler drew a similar cartoon nine years earlier, with Grant in the starring role, cowed by the message on the wall that read, "No Third Term." (Author's collection; *Puck*, June 18, 1884)

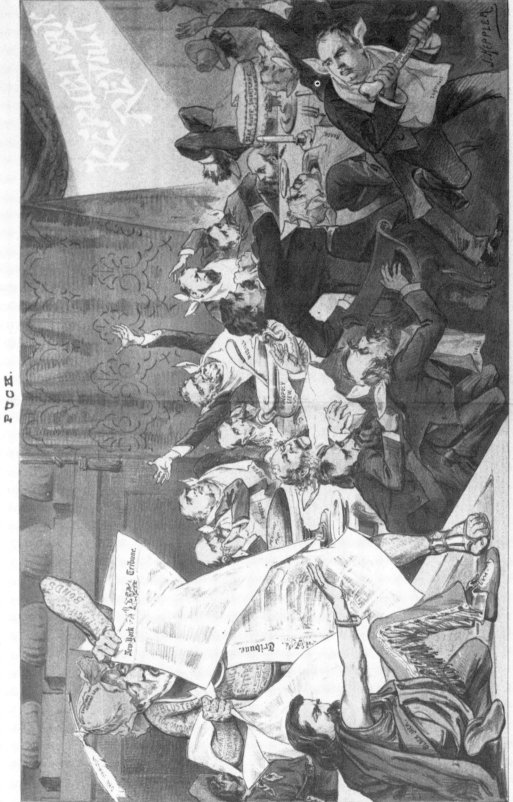

PUCH.

THE WRITING ON THE WALL.

101. **"A Sail! A Sail!."** The Democratic party, dependent on its southern strength and the 1876 election fraud issue to sustain it for twenty-four years, now looks to the Independent Republicans on the horizon for help. The ever-unreliable Tammany chief John Kelly is pictured poised to make a deal with the Republicans, which would effectively kill the Democrats' hope for rescue in 1884. (Author's collection; *Puck*, July 2, 1884)

PUCK.

KEPPLER

"A SAIL! A SAIL!!"

102. "He Courts the Mother and Means the Daughter." Ex-Governor Tilden was the favorite son of the New York delegation to the 1884 Democratic convention. But many believed this was just a courtesy paid to an old man and that most of the delegates actually favored New York's sitting governor, Grover Cleveland. After this cartoon appeared, Tilden withdrew his name from contention, and the New York delegation backed Cleveland unanimously. (Author's collection; *Puck*, June 4, 1884)

PUCK.

HE COURTS THE MOTHER AND MEANS THE DAUGHTER.

103. "A Flag the Independents Will Fight Under." When the Democrats nominated Grover Cleveland, Keppler rejoiced. He knew this meant the Independent Republicans would support the Democratic ticket and Blaine would almost surely go down to defeat. Benjamin Butler, who had hoped the nomination would be his, and Tammany chief Kelly, who hated the New York governor, did not share Keppler's enthusiasm. (Author's collection; *Puck*, July 16, 1884)

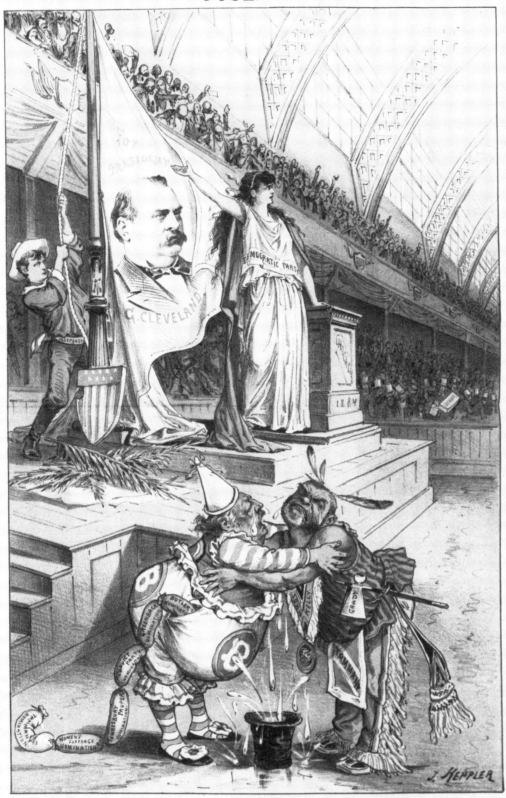

A FLAG THE INDEPENDENTS WILL FIGHT UNDER

When Party lifts a Flag like this on high,
Small wonder Clowns and Demagogues should cry.

104. "He Can't Beat His Own Record." Blaine is knotted in rage at his inability to overcome his tarnished record. His trainers, editor Whitelaw Reid and Congressman W. W. Phelps, look on helplessly. The bouquets are from prominent millionaires. (Author's collection; *Puck*, July 30, 1884)

PUCK.

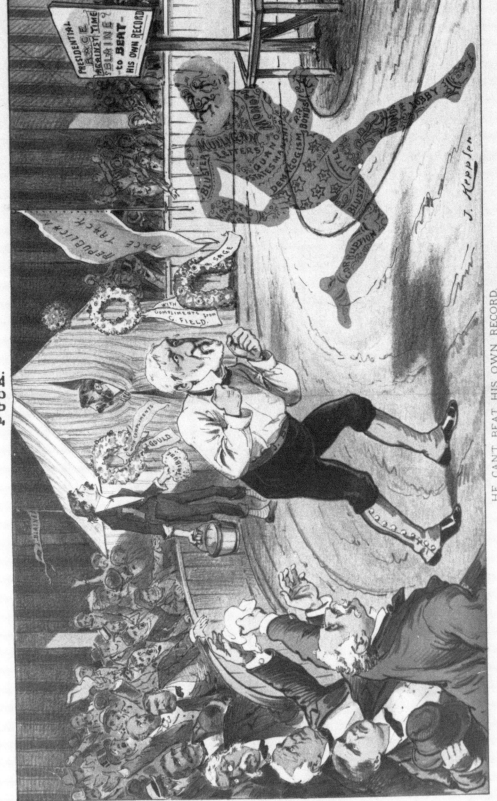

HE CAN'T BEAT HIS OWN RECORD.

CHORUS OF FRIENDS.—"Go in, Jim!—brace up! Can't you do any better than that?"

105. "The New Democratic Eucalyptus." Keppler was a reluctant Democrat, choosing between two parties equally tarnished. In 1880, he liked Hancock more than Garfield and so supported the Democrats. In 1884, he found himself once more among the Democrats, but he strove to make clear that he was supporting the man, not the party. The vapors labeled "Butlerism" refer to ex-Democrat, ex-Republican Benjamin Butler of Massachusetts, who in 1884 was the standardbearer of the Greenback party, which advocated paper money. "Bourbonism" refers to staunch but militant southern Democrats, who were the backbone of the party in its lean years after the Civil War but since had become an embarrassment. "Kellyism" refers to the self-serving and petulant Democrat represented by Tammany's John Kelly. The "Dynamiter" is a reference to the stereotype of the violent Irishman who made up a good portion of the Democratic party's urban rank and file. (Author's collection; *Puck*, Aug. 27, 1884)

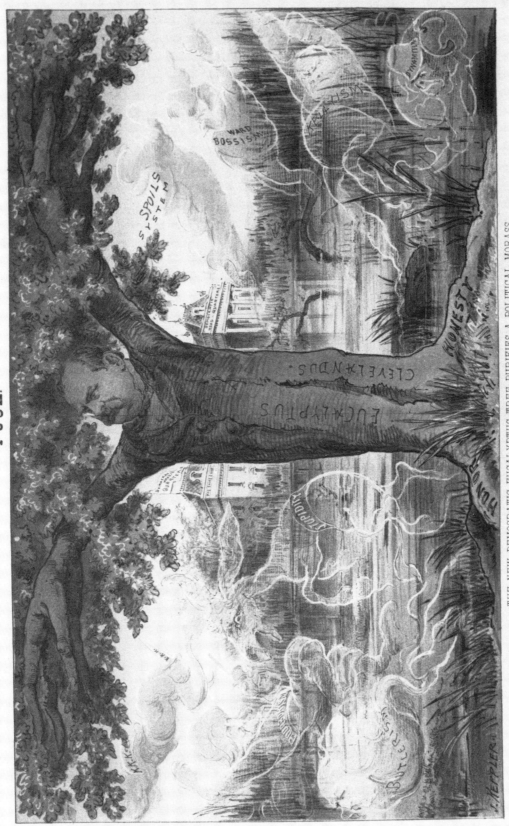

PUCK.

THE NEW DEMOCRATIC EUCALYPTUS TREE PURIFIES A POLITICAL MORASS.

The Eucalyptus Tree has recently been introduced into unruly and malarious regions, where it acts as a purifier of the atmosphere, driving away the deadly miasmatic vapors.—*Encyclopedia.*

106. "Helping the Rascals In." In June 1884, Charles Dana, editor of the Democrat *New York Sun* (pictured holding a copy of his newspaper), proclaimed that it was time to turn the Republican rascals out of office. He then proceeded to endorse Greenback party candidate Benjamin Butler (pictured on Dana's shoulders). Butler's candidacy threatened to siphon off tens of thousands of votes from the Democratic ranks, which would effectively elect Blaine. The only way this plan could be foiled was if enough independent Republicans voted for Cleveland. Such was Keppler's hope when he drew this cartoon two weeks before the election. (Author's collection; *Puck*, Oct. 22, 1884)

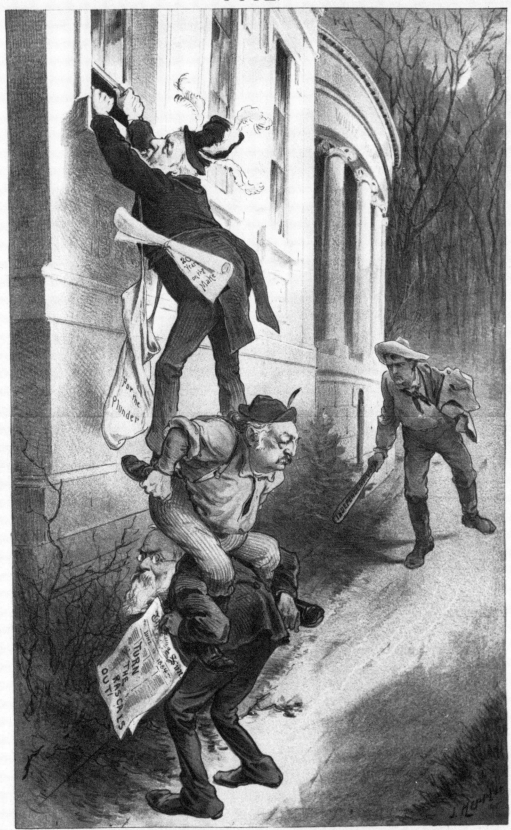

HELPING THE RASCALS IN.—A BURGLARIOUS SCHEME THAT MAY BE SUDDENLY SPOILED.

107. "A Sacrifice to the Political Wolf." As the election neared and the Republicans began to fear defeat, a rumor circulated that Republican leaders had cut a deal with Tammany Hall, the leading political organization of New York City. If Tammany would supply enough votes to elect Blaine, the organization would be treated to some patronage favors. Although the election in New York was a squeaker, Cleveland carried the city and the state. (Author's collection; *Puck*, Oct. 29, 1884)

PUCK.

A SACRIFICE TO THE POLITICAL WOLF.

REPUBLICAN DESPERATION AND THE PERIL OF NEW YORK CITY.

108. "Men May Come, and Men May Go." Before the election results were known, Keppler drew this cartoon celebrating the undying cause of reform. Prominent among the workers is Keppler's old nemesis Henry Ward Beecher and Nast's boss G. W. Curtis. (Author's collection; *Puck*, Nov. 5, 1884)

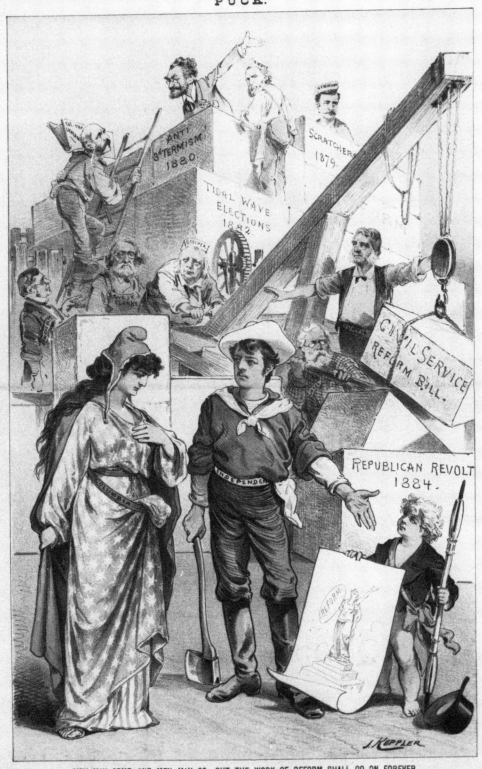

MEN MAY COME, AND MEN MAY GO; BUT THE WORK OF REFORM SHALL GO ON FOREVER.

109. Puck's Political Hunting Ground. After *Puck*'s 1884 election triumph, Keppler paused to celebrate the good work of his creation, Puck. With the help of his hunting dogs, Wit and Satire, he has bagged considerable game, including (from left) Butler the frog, Blaine the fox, ex-Congressman Dorsey "an animal of doubtful breed," ex-House Speaker Kiefer the hyena, Kelly the owl, Grant the lion, Conkling the pigeon, Robeson the boar, and Platt the monkey. Jay Gould, the hawk, makes off with a lamb, unaware of Wit's close pursuit. Bunner believed this to be one of *Puck*'s most popular cartoons, judging by the number of times he saw it hanging in people's homes and in public places. (Author's collection; *Puck*, Jan. 14, 1885)

PUCK.

PUCK'S POLITICAL HUNTING-GROUND.—HOW HE HAS MADE GAME OF THE POLITICIANS.

SEVEN

"Two Roads for the Workingman"

IN HIS CARTOON commemorating Cleveland's inauguration, Keppler finally gave Pulitzer some credit for the Democratic victory. He drew his friend, alongside himself, welcoming Cleveland into the nation's capital (fig. 110). Soon after that celebratory cartoon, however, Pulitzer's relationship with the new president soured. Pulitzer believed his contribution to the Cleveland campaign earned him right-of-access to executive decision making. In his role of self-appointed advisor to the president, Pulitzer suggested to Cleveland several people whom he felt deserved government jobs (fig. 111). Cleveland, wary of Pulitzer's motives, ignored the newspaperman's suggestions and then even refused his request for a meeting. Once Pulitzer realized that he was getting the cold shoulder, he began attacking Cleveland in the *World* as an ingrate, unwilling to reward the loyal Democrats who put him in power.[1]

Keppler saw the situation differently. To him, Cleveland was a man of high purpose, determined to exercise prudence and restraint in the distribution of government jobs (fig. 112). In July, he drew him trying to lead a stubborn "Bourbon Democracy" donkey into the stable of reform.[2] While Keppler tended to regard any enemy of the new president as his enemy too, he resisted identifying Pulitzer as a leader of the spoils-hungry Democrats. Or such was his inclination when he left for another European vacation in July 1885.

When Keppler returned in October, however, Pulitzer's attacks on Cleveland had escalated to the point where Keppler could not ignore them. In November, he drew a spindly Pulitzer feeding the supposed corpse of the Independent party into the Bourbon crematory made "for disbelievers in the spoils system." The Independent party and Puck watch the proceedings with amusement from a safe

315

distance. Says the uncremated Mugwump, "If those old Bourbons take that dummy for *me*, they'll be a little startled when they find out that I'm alive—and kicking!" (fig. 113). So began Keppler's fight with Pulitzer. After 1885, Keppler never again drew a friendly caricature of the owner of the *New York World*.

In contrast, Keppler's friendship with the president deepened. While he didn't want to be thought of as an apologist for Cleveland, he cherished their personal relationship and was not above exploiting it for professional gain. In 1886, when Cleveland announced his engagement to the young and beautiful Francis Folsom, Keppler was one of the few artists granted the privilege of drawing her portrait from life (fig. M).

That Keppler requested this favor was all the more extraordinary because he had only recently weathered conflict-of-interest charges leveled at him by the Republican press because of his relationship with Cleveland. In December 1885, the *Indianapolis Journal* reported that Keppler had asked Cleveland to appoint his brother-in-law to a German consulate post and that Cleveland had flatly refused. An indignant Keppler clipped the newspaper story and sent it to Cleveland asking him for a public refutation. Keppler got it, in the form of a searing indictment of the press. Cleveland wrote:

> I don't think there ever was a time when newspaper lying was so general and so mean as at present. . . . The falsehoods daily spread before the people in our newspapers . . . are insults to the American love for decency and fair play of which we boast. . . .
>
> While I am sorry that any friendliness you may have felt or exhibited to me has been the cause of embarrassment to you, I cannot refrain from saying that if you ever become a subject of newspaper lying, and attempt to run down and expose all such lies, you will be a busy man, if you attempt nothing else.[4]

Generally, Keppler followed Cleveland's advice and ignored falsehoods in the press. But in this case, he couldn't afford to ignore them. The *Journal*'s report made Keppler look like a hypocrite, begging for offices himself while he attacked Pulitzer for doing the same. Cleveland's letter, though, helped assuage Keppler's hurt feelings and ended the malicious story.

In 1886, labor unrest forced the patronage issue into the background. Keppler had always been a supporter of the workingman. Several years earlier, he had greeted the formation of the Knights of Labor as a necessary response to the growing power of monopolies. But when labor leaders introduced a new bargaining strategy, the boycott, Keppler became concerned. He considered this tactic unproductive and bullying. "Arbitration Is the True Balance of Power," drawn in

March 1886, reflected Keppler's attitude on the subject. It featured a capitalist and laborer both trying to turn the hands on the stately clock of business. Puck, standing below, says to them, "Don't meddle with the hands, gentlemen—this pendulum"—labeled "arbitration"—"is the only thing to regulate that clock!"[5]

More frightening than boycotts to Keppler was the labor movement's increasingly strident tone. Some of the newly anointed leaders of organized labor began demanding radical and dramatic changes in the capitalist system—something not on Keppler's reform agenda. He feared that a motley assortment of desperate men was co-opting the labor movement to serve their own revolutionary aims. The threat posed by this radical element so overwhelmed Keppler that he turned his attention away from labor's complaints—which he still considered valid—and focused instead on what he thought was the greater issue: respect for law and order. The result was a series of cartoons, some rather reactionary, that Bunner later characterized as probably *Puck*'s most influential series.[6]

In April, Keppler drew "The Latter Day Lord of Misrule." It featured King Boycott on a makeshift throne wearing a crown of violence. Capitalists and laborers kneel at his feet as a communist, an anarchist, and a socialist exhort a crowd of laborers to violence.[7]

Later in the month he drew Lady Order saying that the big Boycott Windbag looked "very formidable, but I think you will find this little instrument"—the quill she holds labeled "law"—"will soon make it collapse." (fig. 114).[8]

In May, perhaps in response to those who interpreted his latest work as anti-labor, Keppler drew "The Suckers of the Working-man's Sustenance" (fig. 115), which was intended to identify the villains in the current drama. It showed a common laborer and his forlorn family sitting at a table around a big, empty bowl. The viewer sees why the bowl is empty. Under the table crouch several radicals who are siphoning off the bowl's contents.[9]

In August, Keppler acknowledged that the labor movement was being driven by contrasting philosophies. In "Two Roads for the Workingman" (fig. 116), he drew the rationally organized Brotherhood of Locomotive Engineers on the track of law and order, heading for prosperity. In contrast, he pictured the trade unions and the Knights of Labor riding in wagons on the road to ruin, being pulled by the wild horses of "intimidation," "boycott," and "political intrigue."[10]

The 1886 New York mayoral election became a referendum of sorts on the labor question when the labor movement organized into a political party to nominate its own candidate. Labor's nominee was the radical economist Henry George, single-tax theorist and advocate of land redistribution. His opponents were elderly businessman Abram Hewitt for the Democrats and legislator Theodore Roosevelt, who would turn twenty-eight years old just before the election, for the

Republicans. Initially, *Puck* dismissed George as well-meaning but wrong-headed. But when the extent of his radicalism and popularity became apparent during the month-long campaign, Keppler jumped into action.

Because of the infuriating lag between deadline and publication date, Keppler was able to draw only two anti-George cartoons before the election. The more striking of the two, "The Mephistopheles of To-day—Honest Labor's Temptation" (fig. P), showed the devil in the guise of the anarchist press trying to persuade a laborer to sign away his soul. He has bewitched the laborer with a vision of a saintly George suppressing monopolist Jay Gould and spreading bounty from his "horn of promises."[11] Keppler's fears were not without justification. George piled up an impressive sixty-eight thousand votes, enough to edge out Roosevelt for second, but well behind Hewitt's ninety thousand winning total.

To Keppler's chagrin, however, this was not the last of Henry George. He refused to retire from the New York political scene. In partnership with the Reverend Edward McGlynn, George organized an "Anti-Poverty Society," which held rallies throughout the city. For $1 admission, the poor and the curious could hear George and McGlynn detail the injustices of the American economic system and urge the crowd to demand radical change. Throughout 1887, George and McGlynn played to packed houses. Also throughout the year, in lockstep with their lectures, Keppler attacked the two "showmen" for their profiteering and bluster (fig. 117).

By summer, many *Puck* readers had tired of Keppler's campaign against George and McGlynn. One letterwriter complained that these lecturers were not worthy of Keppler's attention. Bunner disagreed. He said *Puck* was obliged to respond to New York press blather that kept the George-McGlynn message before the public.[12]

Much more, however, was at issue here than this. Keppler's treatment of the George-McGlynn controversy and the larger question of the rights of labor cut to the very heart of his politics and dramatically exposed the limits of his liberalism. Keppler was opposed to corruption and inequity, but these were ills, he believed, that were brought about by bad men—unscrupulous politicians and avaricious businessmen—not ills inherent in the system. He promoted honest government, no monopolies, and free trade in the interest of an unfettered political and economic machine. Such a free market system allowed a person to go as far as his or her talents would allow. It was designed so as not to hinder an individual's inborn and healthy competitive instincts, but no one should look to the system for any special help.

Keppler came to these beliefs naturally—the events of his life told him they were true. It upset him to see the Knights of Labor and men like George and

McGlynn question them. He fought them so fervently because their success would mean the destruction of the foundation upon which he had built all of his views about politics, economics, and how people related to the two.

Ironically, during the years that Keppler wrestled with the labor question as a political issue, he also confronted it on a personal level as never before. The mid-1880s held one travail after another for the reluctant capitalist in charge of *Puck*'s art department.

In the midst of the 1884 campaign another employee dispute had erupted, this one involving the literary staff. Since the late 1870s, Bunner and his associate editor B. B. Vallentine had lobbied for a bonus. Schwarzmann never actually said no to their request, but he repeatedly put them off. In 1884, the two editors felt that if Schwarzmann wouldn't compensate them for their long hours and hard work now, when *Puck* was flying high, they'd never see any money. Bunner and Vallentine consulted a lawyer, who told them they had little legal recourse. He suggested they continue to press their demands informally. The two editors decided that Bunner, on better terms with Schwarzmann than Vallentine, should ask for compensation for both of them. Then, they'd split whatever Bunner got 50–50.

When Bunner made his demands, Schwarzmann acquiesced. Then, inexplicably, Bunner turned around and refused to pay Vallentine his agreed-on share. When Vallentine protested, Bunner got Keppler's and Schwarzmann's permission to fire him.

Vallentine couldn't believe what had happened. He told Bunner, Schwarzmann, and Keppler that they'd be hearing from his lawyer in the morning. In fact, the proprietors and their editor heard from Vallentine's lawyer for the next five years as Vallentine exercised every legal option open to him to gain restitution for his contribution to *Puck*.[13]

In December of 1885, Vallentine's suit against Bunner went to court. For Bunner, the timing couldn't have been less opportune; he was to be married the following month. Vallentine was suing him for half of the $2,000 bonus. The jury awarded it to him, and the judge ordered Bunner to pay an additional $100 for court costs.[14]

Bunner appealed the decision on the grounds that Vallentine was not entitled to a full 50 percent, presumably because of his shorter tenure with the magazine. The court considered Bunner's appeal and ordered a new trial, which came before a judge in October of 1887.[15]

By now the conflict, prolonged by the slow-moving legal system, had degenerated into a name-calling match. Vallentine and his lawyers subjected Keppler

and Schwarzmann to such epithets as "ignorant," "obscene," and "mendacious." They further contended that Bunner agreed with these characterizations, waging vicious verbal assaults on his employers behind their backs. *The Journalist*, the profession's trade paper, advanced the rumor that Keppler and Schwarzmann might even let Bunner go. The retrial resulted in another favorable verdict for Vallentine, but this time for only $605, which Bunner paid.[16]

Next, Vallentine began legal proceedings against Keppler and Schwarzmann for what he considered to be his rightful share in *Puck*: $50,000. In early 1888, the New York Supreme Court ruled in Vallentine's favor. Subsequently, an appeals court overturned the decision and ordered a new trial. Vallentine won this contest too, in March of 1889, with an award of $20,000.[17] Keppler and Schwarzmann paid it—a high price for dealing in bad faith with an employee.

The employers' labor travails didn't end there. In 1885, the art department became the scene of discomfort and upheaval. In February, Friedrich Graetz's contract was up for renewal. Graetz had played a diminishing role on the magazine, drawing fewer and fewer lithographs. After three years in the United States, his understanding of American politics remained superficial. Keppler and Schwarzmann discussed the situation. Keppler admitted that Zimmerman was ready to go to the limestone and was skilled enough to replace Graetz, but he loathed the idea of firing his old friend. So the proprietors settled on an artless solution. They offered Graetz a new contract at half his current salary, ostensibly because he wouldn't be drawing any more lithographs. As Zim remembered it, Graetz was "brokenhearted over the humiliation [and decided to] return to his former home in Vienna." His assistant recalled, "I felt almost as sorry as did the old fellow himself."[18] So ended another labor dispute poorly handled by Keppler and Schwarzmann.

Then, in December, Keppler and Schwarzmann were dealt a surprising blow: Gillam and Zimmerman announced they were leaving *Puck* for *The Judge*, *Puck*'s moribund competitor. *Puck*'s 1884 performance had so upset Republican party leaders that they bankrolled the purchase of *The Judge*. Their front man in the venture was a wily Albany entrepreneur named W. J. Arkell. His charge was to recast *The Judge* into a legitimate Republican response to *Puck*.

Gillam's Republican sympathies were no secret. Arkell learned from members of *The Judge* staff that Gillam, while savaging Blaine in *Puck* during the 1884 campaign, had provided *The Judge* with ideas for cartoons that savaged Cleveland. He offered Gillam the art directorship of *The Judge* and an option to buy stock in the new firm.[19]

Despite Gillam's political compatibility with the revamped Republican weekly, he was reluctant to leave *Puck*. He appreciated the opportunities that he

had been given, and he liked the prestige of working on America's leading humor magazine. But if he were to stay, he felt he was at least entitled to a raise because of his 1884 campaign performance. Schwarzmann, never inclined to make concessions to his employees, disagreed. He neither took *The Judge*'s chances of success seriously nor realized the threat that Gillam's departure posed to *Puck*. When Gillam resigned, Schwarzmann told him he'd be welcomed back when *The Judge* failed. Gillam, disgusted with Schwarzmann's hard-headedness, said he'd never return.[20]

Although Zim's role on *Puck* had increased dramatically after Graetz's departure, he felt he had a limited future there. When Gillam offered him a position on *Judge*, as the rejuvenated magazine would be called, for more than double his *Puck* salary, Zim felt he could not refuse. But he left the *Puck* art department with regret.[21] Keppler, in particular, had treated him well.

Zim recalled an incident that illustrated Keppler's generous spirit. One day, not long before Zim resigned, he was giving Keppler a hand with a trunk that Keppler had to transport downtown. As Zim told the story: "The great Keppler grabbed one strap-handle and I the other; we placed it upon the rear platform of a horse-car and he sat upon it. Looking at me with an amused grin, [he] remark[ed] that it wasn't often the world was treated to the sight of two great caricaturists carrying their own trunk. I had as yet achieved nothing that would warrant me in laying claim to any greatness—the glory belonged to him solely, but he seemed willing to share it with his humble understudy; just as willing, in fact, as he was to share the burden of the aforesaid trunk." They parted company in 1885, but Zim would always remember Keppler with respect and gratitude. Said Zimmerman, "[Keppler] showed me greater kindness and consideration than I ever dared to expect from my own parent."[22]

With the departure of Gillam and Zimmerman, Keppler lost his two best students after Opper. Gillam had already proven his ability. In fact, none of his subsequent work for *Judge* ever matched the powerful cartoons he did under Keppler. Zim, conversely, was just beginning to blossom. His 1885 lithographs for *Puck* were beautifully drawn, as sensitive in many ways as Keppler's work (fig. 97). After going over to *Judge*, he adopted a looser style, more exaggerated, more comic, and he became one of the most popular and enduring cartoonists of the turn-of-the-century period. Gillam's and Zim's cartoons, along with aggressive management, made the new *Judge* a success within a few years. After Keppler's death, Schwarzmann lived to see *Judge* overtake *Puck* as America's most popular humor magazine.

Within ten months, Keppler's staff of four had shrunk to one, Opper. He needed help fast. In 1885, James A. Wales was enjoying a successful free-lance

career, but when Schwarzmann asked him to rejoin *Puck*, he agreed. Soon he was drawing cartoons comparable in conceptual and artistic quality to those he had drawn in his earlier years with *Puck*. Wales's tenure on *Puck* the second time around, however, was brief.

The restless Wales never seemed satisfied, never seemed able to stay in one place for long. He left *Puck* for the last time in August of 1886 to pursue a new dream: establishing a *Puck*-like humor magazine in England. Given the British emphasis on decorum and Wales's boat-rocking tendencies, the plan seemed doomed. But Wales never got to England. In December, after purchasing his ticket to go abroad, he died of an accidental sedative overdose.[23]

As Keppler scrambled to rebuild his art staff, he relied heavily on free-lancers. E. N. Blue, known primarily for advertising art, contributed a half dozen beautiful lithographs over five months in 1886 and 1887. Other artists who appeared in *Puck*'s pages during this period included Charles Dana Gibson, A. B. Frost, and C. G. Bush. At this time, Gibson was contributing heavily to *Life*, a new humor magazine. His tacit commitment to that magazine forced him to decline Keppler's offer of full-time employment.[24] A. B. Frost, a well-known illustrator by the mid-1880s, probably contributed to *Puck* at Bunner's urging. Bunner had been introduced to Frost by his publisher, Scribners and Company, which had matched the two for a recent book project. C. G. Bush, a delightful penman, contributed his scratchings to *Puck* until 1889, when he was hired as editorial cartoonist for the *New York Herald*.

By using free-lancers, however, Keppler was simply postponing the inevitable. He needed talent he could count on every day. In his rush to assemble a staff, he hired two artists of questionable talent, G. E. Ciani and A. B. Shults, but neither man remained on the staff for long. Two much more accomplished artists, Syd B. Griffin and Frank M. Hutchins, also had brief associations with *Puck*. Griffin chose to become a free-lancer after his two years on the staff, and Hutchins died an untimely death at the age of twenty-seven.

Some of the men Keppler hired, though, remained with *Puck* for many years. One was Charles Jay Taylor, late of the *New York Daily Graphic*, whom Keppler hired in April 1886.[25] Taylor had studied art in New York, Paris, and London, and had worked for several New York illustrated magazines before joining *Puck*. Although Keppler immediately pressed him into service drawing political cartoons, he soon realized Taylor's forte was as an illustrator, working in pen and ink. Under Keppler's direction, Taylor devoted most of his energies to social cartooning. His greatest splash came with his creation of the "Taylor-made girl," a breathtakingly beautiful daughter of society, introduced several years before Gibson drew his first "Gibson girl" in *Life*.

In the late 1880s, Taylor became intrigued with the work of the French impressionists, particularly Claude Monet. By adapting the line quality of Monet's color work to his own pen and ink studies for *Puck*, Taylor attempted to suggest, rather than delineate, form. His bold experiment with impressionism was largely successful. Although it failed to impress a public weaned on realism, it earned him the respect of his peers.

Later in 1886, Keppler hired Louis Dalrymple.[26] Although this Illinois native was only twenty, he had already had several years' professional experience. Wales, who had hired Dalrymple in 1883 to work on *The Judge*, may have suggested him to Keppler. Dalrymple had worked on *The Judge* for a year before returning to school. In 1886, his work surfaced again in the pages of *Tid-bits* and the *New York Daily Graphic*.

Keppler had high hopes for his new protegé, calling him "a born caricaturist." Dalrymple's earliest work for *Puck* bears out this estimation. His cartoons, while unrefined by *Puck* standards, nevertheless had a certain charm and light-handed comic tone to them that ultimately made them quite effective. But as the years went by, this lack of refinement hardened into a trademark. As the novelty of his style wore off, his work became just plain sloppy. Perhaps Keppler gave him too much freedom too soon. Whatever the explanation, he never lived up to Keppler's expectations.

In January of 1888, yet another artist joined *Puck*. Samuel D. Ehrhart's cartoons had first appeared in the magazine in 1880. After studying art in Munich, he then submitted work regularly to *Judge*.[27] Ehrhart was competent in lithography but even more skilled with pen and ink. His drawing style was more formal than Opper's but more comical than Taylor's. One critic described Ehrhart's work as having "a flavor of refined humor. . . . " Like Dalrymple and Taylor, he became a *Puck* mainstay.

Keppler was now playing a less dominant role as art director than he had in the magazine's first ten years. In 1887, he delegated pen-and-ink art approval to an assistant, W. C. Gibson, while retaining authority over the lithographs. Keppler's loosening hold reflected, in part, the maturity of his new art staff. Even the youthful Dalrymple had more formal training when he joined *Puck* than Opper or Zimmerman had. But just as important, Keppler by now had achieved more than he had ever hoped for in fame, fortune, and influence. The drive he had once felt to make his mark was now largely satisfied. He coasted for the last half dozen years of his career. Yet, even at that leisurely pace, he remained the unrivaled leader of American political cartooning.

By the mid-1880s, Keppler and Schwarzmann, Inc. had become a major New York company, employing nearly four hundred people and leasing space in twenty-

two premises adjoining *Puck*'s Warren Street address.[28] The time had come for the firm to build a home expressly suited to its needs.

In March of 1885, Keppler and Schwarzmann joined with Jacob Ottmann, who had recently become sole owner of Mayer, Merkel and Ottmann, to buy a building lot. They found the land they wanted on the southern edge of the publishing district that had the Astor Library on Lafayette Street as its center. The lot, owned by the Sisters of Charity, was bounded by Houston Street to the north and Mulberry Street to the east. German-American architect Albert Wagner designed the Romanesque Revival structure that rose out of the rubble on the Houston Street site. Within a year, the seven-story Puck Building dominated the skyline of the depressed Irish and Italian neighborhood (fig. 65c).[29]

Just before the building was completed, a nine-foot-high statue of Puck by sculptor Henry Baerer was placed two stories above the main entrance on the corner of Houston and Mulberry. *Puck*'s neighbors didn't always know what to make of this icon to satire. Joseph Keppler's son remembers the staff's merriment watching marchers in Italian processions pass through Mulberry Street and bow to the statue, believing it to be some saint.[30]

The two firms occupied their new home in early February 1886. Ottmann's printing establishment occupied the first floor to facilitate his transactions as a commercial lithographer. *Puck*'s business offices were on the second floor; the library and the editors' and artists' offices were on the third. Successive levels were given over to the composing and transfer rooms, the photolab, the cutters and binders, and Ottmann's presses on the top floor.[31]

Though Keppler could have designed an elaborate studio had he wanted one, he chose instead a simple and efficient work space. Zim had characterized the artists' studios at Warren Street as "unpretentious compartments, . . . about as imposing as the stalls of fine racehorses."[32] The new quarters on Houston Street, although more spacious, were no grander. Keppler's "workshop," as he called it, was located in the northwest corner of the building to catch what one writer described as the "true north light." Two walls were windows, the other two glass partitions. His workshop furniture consisted of several chairs, a large cupboard in which he stored photographs and materials, and a large library table sturdy enough to support the weight of the heavy lithographic stones. One visitor noted with surprise: "There are no decorations, no pictures on the walls, no suit of armor in the corner."[33] Keppler's quarters were laid out simply and furnished economically—as if to say, this is an office where work is done.

Figures 110–117

110. "Cleveland's Entry into Washington—March 4th, 1885." Politicians and journalists who worked for Cleveland's candidacy figure prominently in this inaugural celebration cartoon. Cleveland gestures directly at Puck, clothed to suit the occasion, and Keppler, who kneels beside him. Bernhard Gillam looks over Keppler's shoulder, while Joseph Pulitzer sits by his side. Just to the right of the donkey is ex-President Hayes, labeled as "de facto" president, carrying the returning board that put him into power like a crucifix, and Tilden, labeled "de jure" president. During the Hayes administration, Keppler showed resentment toward those who questioned Hayes's right to the presidency, but now, as a supporter of the new Democratic president, he dredged up the partisan charge himself. Later in the year, as a further indication of *Puck*'s increasing partisanship, Gillam drew a cartoon of Cleveland helping the cause of civil service reform—a cause, Gillam unfairly charged, that had been ignored by his predecessors, Hayes and Arthur. (Author's collection; *Puck*, March 4, 1885)

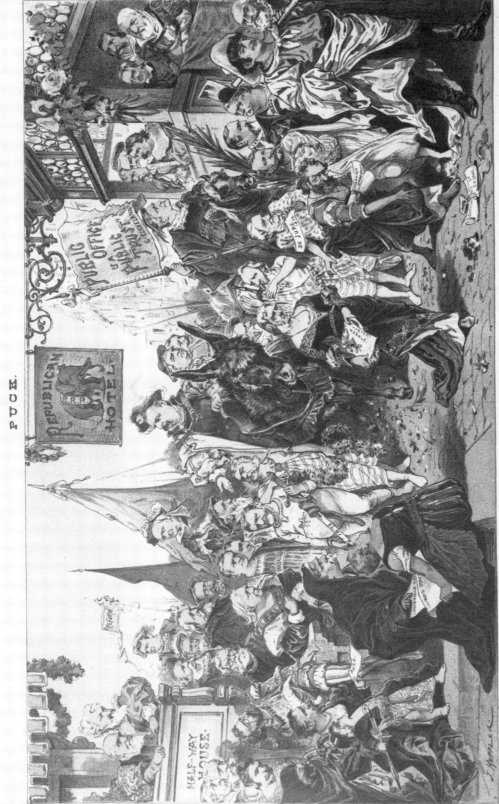

PUCK.

CLEVELAND'S ENTRY INTO WASHINGTON.—MARCH 4TH, 1885.

With Puck's Regards to Hans Makart and Charles V.

111. "Crowding the Cabinet-Making Business." As newspapers across the country offered Cleveland unsolicited advice on whom he should name to his cabinet, Keppler had some fun at the expense of New York's press giants. Of these men, only Pulitzer had any hope of influencing the president-elect's decision making. Dana of the *Sun* had supported Greenback party candidate Butler (whose bust is shown tumbling toward "oblivion"). Reid and Bennett were Republicans. But Pulitzer, depicted here with busts only of himself, had been one of Cleveland's most active supporters and, for that, expected some rewards. At the time of this cartoon, Keppler had no way of knowing that Cleveland would shut Pulitzer out of the administration entirely. This cartoon, like the many other gently critical ones Keppler had done, amused Pulitzer. The two made arrangements to have dinner during the holidays at the end of the month. (Author's collection; *Puck*, Dec. 17, 1884)

PUCK.

CROWDING THE CABINET-MAKING BUSINESS.

CHORUS OF JOURNALISTIC CANDIDATE-PEDDLERS.—"Here y'are now!—I've got the only genuine article!—Don't mind that other fellow!"

112. "The Administration Sawmill." During Cleveland's first term, Keppler drew a number of cartoons like this one that lauded the president's good work and belittled his opponents. This cartoon, however pretty, lacks the power of Keppler's critical work and illustrates the professional dilemma Keppler the gadfly faced as a supporter of the man who held the reins of power. (Author's collection; *Puck*, Feb. 3, 1886)

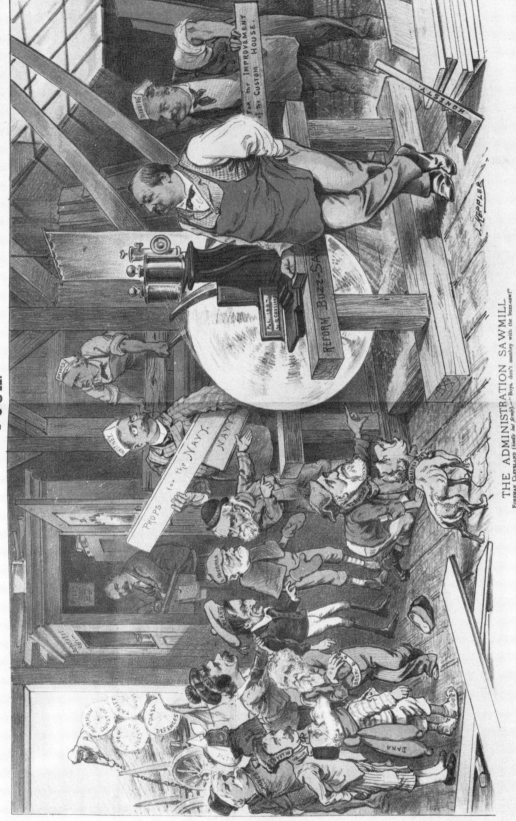

THE ADMINISTRATION SAWMILL.
FOREMAN CLEVELAND (*kindly but firmly*)—"Boys, don't monkey with the buzz-saw!"

113. "A 'Bogus' Cremation for the Benefit of the 'Life-long Democrats'." Leaders of the Democratic press, frustrated by Cleveland's conservative dispensation of government jobs, proclaimed the death of the Independent Republican (or Mugwump) movement that had been responsible for Cleveland's election. They knew that if the president's Mugwump support evaporated, he would have to be more responsive to the demands of the spoils-hungry, lifelong Democrats. Keppler and Puck contended that the Independents were alive and kicking. This cartoon marked the beginning of Keppler's antagonistic relationship with his old friend Pulitzer. (Author's collection; *Puck*, Nov. 18, 1885)

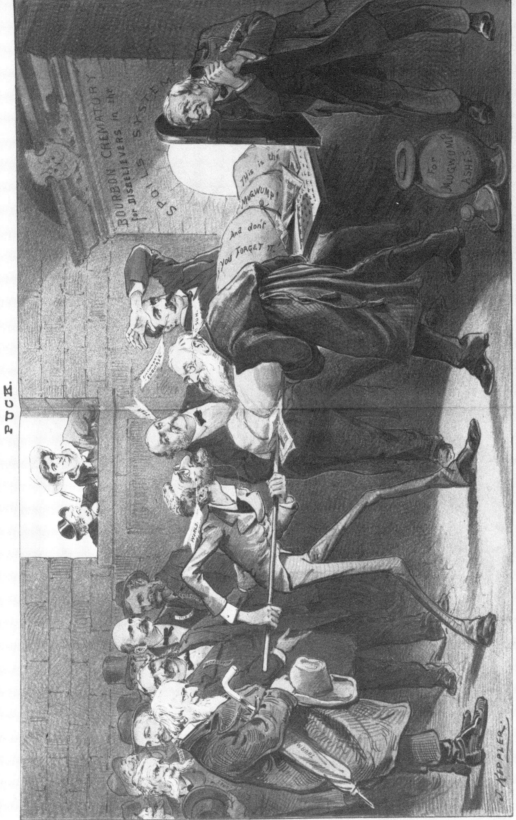

A "BOGUS" CREMATION FOR THE BENEFIT OF THE "LIFE-LONG DEMOCRATS."

UNCREMATED MUGWUMP (from outside).—"If those old Bourbons take that dummy for me, they'll be a little startled when they find out that I'm alive—and kicking!"

114. "The Big Boycott Wind-bag." Initially, Keppler, who considered himself a champion of the workingman, had enthusiastically supported the trades-union movement. But when radicals took control and began espousing such "unproductive" tactics as strikes and boycotts, Keppler was no longer sympathetic. In 1886, he began a campaign to rid the labor movement of its most incendiary elements. (Author's collection; *Puck*, April 28, 1886)

PUCK.

THE BIG BOYCOTT WIND-BAG.

ORDER.—It looks very formidable; but I think you will find that this little instrument will soon make it collapse.

115. "The Suckers of the Working-man's Sustenance." Keppler understood that economic inequities had bred the radical element of the labor movement, but he insisted that there were better ways to solve the problems of industry than through confrontation. Those who advocated otherwise posed a greater threat to the interests of the workingman than did any robber baron. (Author's collection; *Puck*, May 19, 1886)

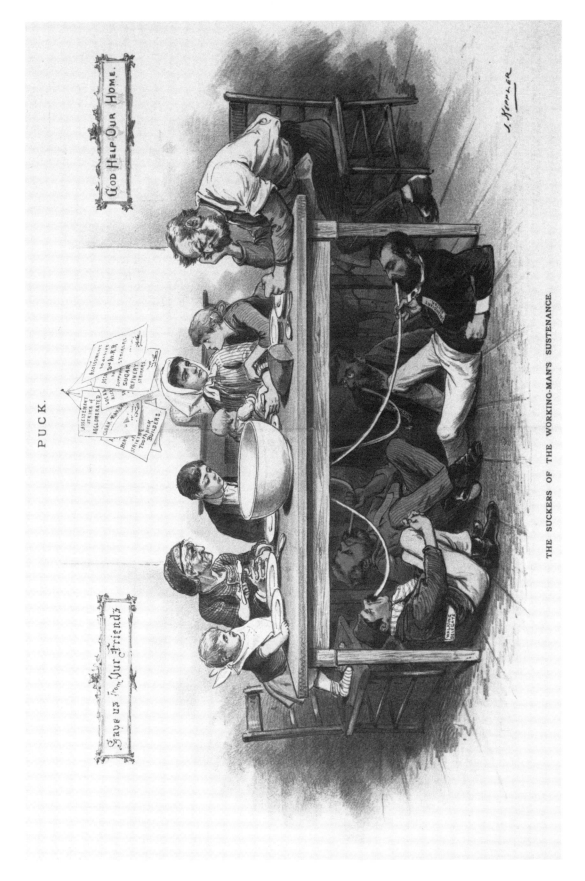

PUCK.

GOD HELP OUR HOME.

Save us from Our Friends

THE SUCKERS OF THE WORKING-MAN'S SUSTENANCE.

116. "Two Roads for the Workingman." The conservative Brotherhood of Locomotive Engineers got Keppler's endorsement in this cartoon, which compares the brotherhood's conciliatory ways with the confrontational methods of the Trades Union and the Knights of Labor. (Author's collection; *Puck*, Aug. 25, 1886)

TWO ROADS FOR THE WORKINGMAN.—ONE LEADS TO PROSPERITY, AND THE OTHER TO VIOLENCE AND RUIN.

117. "The Poverty Problem Solved." After his failed mayoral bid, Henry George and his disciple, the Reverend Edward McGlynn, formed the "Anti-Poverty Society" and lectured under its banner to packed houses throughout New York. Keppler regarded them as showmen out to make a buck at the expense of the status quo. (Author's collection; *Puck*, May 18, 1887)

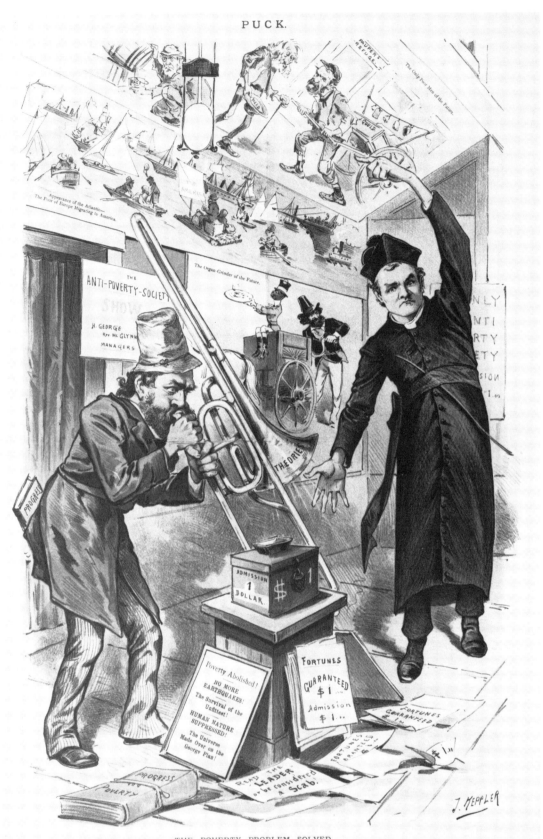

THE POVERTY PROBLEM SOLVED.

George & McGlynn's Great Millennial Show — They will Promise Anything and Everything for One Dollar.

EIGHT

"A Hydra
That Must Be Crushed!"

AFTER THE CIVIL WAR, as blacks made their way North, and immigrants flooded America's port cities, humorists, in prose and pictures, tapped into American prejudices and fears to produce wicked, shameful libels, chiefly against Irish, Jews, and blacks. Keppler, throughout his career, drew many cartoons attacking religious leaders. He devoted much less of his attention, however, to the broader subjects of religion, ethnicity, and race. The picture that emerges from a survey of those cartoons is complex. For example, on the face of it, Keppler treated the Irish poorly in cartoons. He advanced all the common stereotypes, picturing them as loutish drunkards prone to violence, or as insolent and lazy domestic help. In "Uncle Sam's Lodging-House" (fig. 118), which appeared in June 1882, he drew people of all nationalities trying to get some sleep over the protests of the Irishman, who screams at Uncle Sam about such things as Irish independence and Chinese deportation.[1]

But Keppler's problems with the Irish went beyond simple prejudice. He viewed them as pawns in a power game being played by Tammany Hall and the Catholic church. Tammany Hall was quick to extend a helping hand to Irish immigrants—locating housing, arranging for a job, whatever was needed. The Irish in general returned this friendliness by giving Tammany their votes, ensuring Tammany's control of New York's public offices. As long as Tammany could take the Irish vote for granted, it would never have to deal substantively with the issue of municipal reform. A frustrated Keppler held the Irish partially responsible for this sorry state of affairs.

To Keppler, Irish allegiance to the Catholic church represented a dangerous internal threat. He objected in principle to the idea of a large and growing group

343

of Americans who seemed willing to follow the dictates of a foreign power before those of their own government. In May 1877, in "The New Pilgrims' Progress—Enlightened Americans Paying Homage to 'Infallibility'," the pope is shown receiving a group of Irish-Americans. Keppler pictures them scraping at the pope's feet, licking his shoes, and presenting him with sacks of money.[2]

On the local front, he believed that the Catholic church, in league with Tammany, threatened to subvert the sanctity of separation of church and state. Such was the case in 1885 when Tammany, under pressure from the Catholic church, introduced the Freedom of Worship Bill. The bill's ostensive purpose was to secure the right of Catholics confined in public institutions for one reason or another to ministrations from a church official. Keppler saw it as an attempt to install Catholic clergy in schools and prisons. In April, he drew "The Attack on Our Outer Ramparts," which showed Catholic clergy trying to force open a fortress door that protected "non-sectarian institutions" with a "freedom-of-worship" bill battering ram. They storm the door under a banner of Irish votes. Within the fortress walls stand the public schools, the house of refuge, and a statue representing the Constitution.[3] While Keppler tended to direct his condemnations at the church and Tammany, not the Irish per se, the anger and fear he felt toward these institutions were at the root of his anti-Irish depictions in general.

Keppler continued his practice of employing anti-Semitic characterizations of Jews into the nineties, but his overall treatment of them remained sympathetic. In 1881, Keppler collaborated with Opper to produce "The Modern Moses," which showed Uncle Sam in the process of parting the sea of "oppression" and "intolerance" to allow the Jews of Europe to make their way to the sunny prospect of "western homes." The cartoon was at the same time celebratory and chiding, although Keppler and Opper surely drew it without malice. When the *Jewish Messenger* accused *Puck* of anti-Semitism, the staff was nonplused. Bunner defended Keppler's and Opper's drawing by saying "if mere caricature is objectionable, the Irish have surely much more reason to complain than the Jews, who have always found a champion in *Puck*. Our Hebrew friends must not be so sensitive; and, like sensible people as they are, must take a joke as their neighbors take one."[4]

If Keppler had been daunted by that episode, it wasn't apparent ten years later when he drew "They Are the People" (fig. 119). The cartoon showed rulers of many countries and from many ages, including the current Czar of Russia, issuing edicts against the Jew. But "the downtrodden one," as Keppler calls him, is shown in the center of the cartoon, the picture of prosperity and self-importance. He says, "They have always persecuted us; But we get there all the same!"[5]

Keppler rarely commented on blacks in America. Back in St. Louis, he drew a few light-handed cartoons satirizing the Ku Klux Klan. In 1879, he drew "The New Exodus," which featured a black family, loaded with their earthly possessions, including the ballot box, heading for Kansas. The head of the family, whom Keppler calls "Sambo," says to his former master, shown digging a ditch, "Now Boss How You Like It You' Self?"[6]

On the issue of black rights, Keppler was upstaged by Nast, who had zealously adopted the cause of the freedman. Part of the reason why Keppler didn't comment on black rights was because anything he did would have sounded like a faint echo of Nast's vigorous rallying cries around the issue. Of course, perhaps more important, the blacks' plight was no longer of much interest to most northerners and was never a major concern of immigrants such as Keppler.

In advancing stereotypical racial and ethnic images, Keppler was perhaps a bit more restrained than most of his cartoonist contemporaries. Moreover, he did produce several notable cartoons that challenged his audience to think differently about race and ethnicity (figs. 120, 121, 122). Drawing these cartoons, few and far between as they were, may not have required great courage. But, through them, he did exhibit a degree of enlightenment on the issue of prejudice that was rare for its day.

More broadly, *Puck* too exhibited this enlightenment. All of its competitors went through phases of hysterical bigotry. For example, from 1879 to 1883, the San Francisco *Wasp* was feverishly anti-Chinese; in 1882 and 1883, *The Judge* wildly anti-Semitic, as was *Life* around the turn of the century. *Puck* never went through such a phase. Although its artists and writers frequently indulged in religious and ethnic jokes and graphic characterizations, this material was invariably relegated to the magazine's black and white pages, considered unsuitable subjects for the lithographs. Unlike its contemporaries, *Puck* usually treated this material for what it was, a cheap way to get a laugh. Only rarely did it presume that trading in religious and ethnic slurs was part of the nation's business.

Whatever his mixed personal beliefs about one group or another, Keppler had no patience with those who wanted to restrict immigration. In 1879, he had fought against congressional action to limit Chinese immigration, and he never forgave Blaine for his support of that legislation. In 1893, he encapsulated his feelings on immigration quotas in the cartoon "Looking Backward—They Would Close to The New-Comer the Bridge That Carried Them and Their Fathers Over" (fig. 123). It featured several well-dressed Americans on a New York dock blocking the way of a poor German immigrant. Each of the Americans casts a shadow that reveals what he looked like when he arrived, poor and unemployed, on American shores.[7]

Ultimately, Keppler believed in an America that subsumed and absorbed all nationalities. He castigated those immigrants who continued to think of themselves as anything but American. In October 189l, he drew "Nearly at the End of His Patience," which showed Uncle Sam with flags of all nationalities sticking out of his coat, pants pockets, and boots. He says angerly, "What's the matter with all you fellows? Isn't the American flag good enough for you?"[8]

Keppler believed in America as the great melting pot. He resented politicians and journalists who played to "voter blocks," perpetuating factionalism based on nationality or ethnicity. In November 1888, he drew the Democratic and Republican parties kissing the feet of a Jew, a German, and an Irishman. The caption expressed his sentiments on this issue in a nutshell: "The Disgrace of American Politics—Truckling to the 'Foreign Vote'. Why can we not treat American citizens as American citizens, no matter where they were born?"[9]

Near the end of its first decade, *Puck* entered a new phase of maturity and sophistication, evidenced by a fresh look and an enlightened attitude. The fresh look was prompted by an advance in printing technology. In 1886, zinc-plate engraving was introduced. This new process, which relegated the old woodcut method of reproduction to the trash heap, allowed artwork to be enlarged or reduced at whim. To take advantage of this innovation, *Puck* retired its ruled, three-column format in favor of a more open and flexible two-column design.

Puck's enlightened attitude meant the gradual replacement of ethnic and religious jokes with a gentler, more urbane humor. In Keppler's work, this shift was typified by his willingness to create cartoons that did nothing more than remark on Cleveland's growing popularity. None of his work since *Puck* became a success was ever this tame. Colleague Taylor began specializing in cartoon portraits of life among Lady Astor's fabled "Four Hundred," the cream of New York high society. Bunner, enamored with Maupassant, started contributing sentimental short stories that aspired to belles-lettres, not comedy. *Puck*'s contributors followed his lead. Bunner's interest in this form of fiction spawned a new publishing enterprise for Keppler and Schwarzmann. In the early nineties, they began issuing book-length collections of short stories under *Puck*'s imprint.[10]

Within a decade of its founding, *Puck* had moved from America's barbershops into America's drawing-rooms. The magazine, however, was not blinded by the glitter of gold, nor had it gone soft in the head. It remained true to its motto, "What Fools These Mortals Be!," by portraying the fatuousness and snobbery of the rich as well. *Puck*'s artists took aim at the calculating beauty who delighted in torturing her male suitors and the young dude who talked with a lisp and sucked on the end of his walking stick. Keppler took New York's privileged

class down several notches in "The Original Four-Hundred" by picturing their ancestors: snobbish and effete chimpanzees.[11]

This interest in New York society, although new, was not out of character with the magazine's generally eastern bias. The most thorough *Puck* reader found only scant evidence of a vast American West being tamed and settled at the same time that *Puck* flourished.

On the political front, the labor question would not down. No longer content simply to censure the labor movement, Keppler looked for a solution that would treat labor's legitimate complaints without stripping the capitalist of what was his.

In July 1886, Keppler concluded that the high tariff was the cause of America's problems. In "An Apparition of To-day," he drew the "High Tariff and Corrupt Legislation" cauldron heated by the flames of agitation. Billowing smoke labeled "union slavery," "strikes," "$ tyranny," and "monopoly" blots out rays of sunlight labeled "law and order."[12] As Keppler saw it, the high tariff protected businesses that didn't need protecting and inflated prices to levels that common laborers could ill afford.

Cleveland captured the tariff issue for his own in December 1887, when he told Congress that the most sensible way to reduce the U.S. Treasury's enormous surplus permanently was by lowering customs revenues. Bunner labeled Cleveland's declaration "the boldest step that has been taken in our politics since the issuing of the Emancipation Proclamation. . . . " Keppler drew Cleveland as "Siegfried the Fearless in the Political 'Dismal Swamp'" (fig. 124) defiantly confronting the hideous war tariff monster with his sword of sound policy.[13]

By coming out for a lower tariff, Cleveland assured himself of Keppler's support in his upcoming reelection bid (fig. 125). Of course, Cleveland had little reason to expect otherwise. On a number of occasions, Keppler had portrayed the president as a heroic figure such as a fearless sea captain lashed to the mast during a storm. Even when the magazine took issue with Cleveland, *Puck*'s artists drew apologist cartoons that admitted the president had made a mistake, but emphasized that it didn't undo all the good he had accomplished. Perhaps the most compelling indication of *Puck*'s wholehearted support for Cleveland came after the president's 1887 tariff speech: Neither Keppler nor his staff ever drew the Independent party symbol again. Keppler had cast *Puck*'s lot wholeheartedly with the Democratic party.[14]

Blaine was still so popular that the Republican nomination was his for the asking. In February, however, he renounced any interest in it. Keppler responded to Blaine's announcement with laughter. In "The Best of Friends Must Part" (fig. 126), Keppler drew Puck and Blaine shaking hands in front of a poster-size

copy of Blaine's letter of withdrawal. Blaine, on the sly, says to the viewer, "He thinks I mean it!," to which Puck responds, "He thinks I believe it!" Despite Blaine's pronouncement of unavailability, Keppler continued to draw him as the leading hopeful.[15]

In April, Keppler drew Blaine at one end of the "Republican Presidential See-Saw," wearing the absurd, ill-fitting suit of armor that *Puck* had forged for him in 1884. At the other end stand ten other aspirants for the GOP nomination. Their combined weight fails to tip the seesaw in their favor, even with help from Puck, who assists "for respectability's sake."[16]

In the following month, Keppler paid Blaine a backhanded tribute in "An Ever-Popular Game—Chucking at Tough Old Uncle Jim" (fig. 127). The cartoon portrayed the Republican aspirant as a target in a carnival sideshow, being pelted with bricks, rocks, balls, even an anchor. Puck asks huckster Whitelaw Reid, "Doesn't it hurt him?"—to which Reid responds, "Hurt him! Not a bit, sonny, not a bit! He pervides the ammunition hisself."[17] By 1888, Blaine had apparently tired of "perviding the ammunition," because as the Republican convention neared, he continued to deny interest in the nomination.

In June, Keppler finally accepted Blaine's renunciation as sincere but still regarded it cynically. He pictured Blaine as the engineer of the Grand Old Party train, jumping to safety as it plunges into the waters of reform. The caption: "Saving his own skin—for 1892."[18]

The next month, the Republicans, mournfully respecting Blaine's desire not to be a candidate, nominated Benjamin Harrison of Indiana instead. Keppler immediately began attacking Harrison and Levi P. Morton, his running-mate, on several fronts. He greeted their nomination with "The Best the Grand Old Party Can Do," which showed a diminutive Harrison standing on a "war tariff" platform mired in the bog of old issues. The platform is shored up by sacks of money, the war tariff's ill-gotten gains. Harrison holds a banner that proclaims, "Harrison and High Tariff! Harrison and Free Whiskey!" (Under the Republican high tariff, luxury items such as alcohol were untaxed.) "Vote for the Grandson of his Grandfather!...for the Great-Grandson of his Great-Grandfather!...for the Great-Great-Grandson of his Great-Great-Grandfather!" —an allusion to Harrison's status as the grandson of ninth president William Henry Harrison, which the Republicans seemed to offer as a legitimate qualification for office.[19]

Keppler took issue with Harrison's competence. He routinely emphasized Harrison's short stature to symbolize his modest political prestige and dressed him in oversized clothing to suggest his inability to fill the office. The GOP candidate's inexperience made him, in Keppler's opinion, Blaine's pawn. He contended that Blaine still "owned" the party and was using Harrison merely as a front.[20]

These juicy political charges, however, actually occupied little of Keppler's direct attention. The premier issue of the campaign was the tariff. In "A Hydra That Must Be Crushed—And the Sooner the Better" (fig. 128), Keppler drew a club-wielding Uncle Sam facing off against the war tariff monster. The hideous beast is depicted with ten tentacles coming out of its forehead, each representing a powerful trust whose lobbying clout stood in the way of tariff reform.[21]

After the strident and slanderous 1884 campaign, a mortified nation vowed never again to wallow like that in the muck of personalities. The 1888 contest—pitting the stolid Cleveland against the humorless Harrison—provided all participants with the perfect opportunity to make good on that pledge. Cleveland had transformed himself into the champion of tariff reform. The Republicans gladly took up the cause of protectionism. By mutual consent, this campaign would operate on higher, theoretical ground.

Toward that end, in July, Keppler and Schwarzmann exchanged *Puck*'s tattooing iron for the teacher's rod when they published "The Tariff?—Cartoons and Comments from *Puck*," a compendium of *Puck*'s anti-tariff cartoons and editorials. Ingeniously, they undermined Gillam's pro-tariff work in *Judge* by reprinting the best anti-tariff cartoons he had done previously for *Puck*. The booklet was immediately lauded for its compelling and simple arguments. *The Boston Times* wrote, "For a clear and concise exposition of the workings of the present tariff laws, this little book surpasses anything we have seen."[22]

The Republicans countered Democratic claims that lower tariffs meant lower prices by charging that Cleveland wouldn't be satisfied reforming the tariff until all tariff barriers had fallen, leaving American industry dangerously vulnerable. In August, Keppler drew "A Dead Failure" (fig. 129), which showed Republican leaders in the graveyard of Republican hopes, waving a makeshift "free trade" ghost at the passing Uncle Sam. Sam tells them, "Go home, boys, go home! You can't scare me worth a cent!"[23]

The Republicans also contended that Cleveland advocated tariff reform because he was a British pawn. Bunner replied: "This [charge] is a plain and simple lie, told only to catch the Irish vote, on the supposition . . . that every Irishman is a fool." When Cleveland asked Congress for special powers to deal strictly with the strained trade situation between the United States and Canada, England's satellite, Bunner considered this sufficient answer to the charge. "Hereafter," he said, "nobody will accuse Grover Cleveland of betraying his own country to please the English." Keppler pictured him brandishing a red-hot iron, bringing the British lion to heel.[24]

Congress tinkered with the Mills bill, which incorporated most of Cleveland's suggested tariff rate restructurings, throughout the 1888 campaign. The Democra-

tic House passed the legislation. But the Republican Senate balked, ultimately deciding to let the presidential election serve as a referendum on the bill.

Keppler believed in tariff reform, but it was not an issue that provided him with great cartoon opportunities. As exhilarating as the 1884 campaign had been, a heart could take just so much of that sort of tension, and Keppler did not want to repeat it. But the colorless 1888 campaign stymied him. In the two months before the election, usually a cartoonist's most productive period, Keppler drew few cartoons worthy of note. One such lame effort was "The Two Champions," in which Keppler pictured Cleveland leading the way into battle with "the people at his back," while Harrison cowers behind Blaine and the monopolists and lets them wage the fight for him.[25]

Bunner was convinced that Cleveland was the "choice of the majority," and that he would be denied a second term only by "absolute fraud and treachery"— or, as it turned out, the quirky mechanisms of the electoral college.[26] When the returns were counted, Cleveland was victorious by more than one hundred thousand votes. But Harrison won a majority in more states and consequently was elected president.

Bunner was despondent. "Mr. Cleveland has been defeated at the polls; and with his defeat all hope of political reform stops short—for four years at least." The Republicans had won the contest through sheer organizational brilliance, and the Democrats had been caught sleeping. Appropriately, in December, Keppler drew "New Year's Eve on the Democratic Camp-Ground" (fig. 130), which showed the slumbering soldiers of the Democratic party bivouacked in the snow. Above them hovers a vision of the Democratic troops storming the halls of Congress in 1892. Keppler, quoting Shakespeare, asks, "Is This a Dream? Then Waking Would Be Pain!"[27]

The tariff controversy put U.S. international relations in high relief. Throughout its history, *Puck* paid sporadic attention to international and foreign politics. Bunner expressed reluctance to comment on the affairs of other nations because of their political unpredictability. But Keppler felt differently. In *Puck*'s early years, he devoted as many cartoons to various events in Europe as he did to events in Washington, D.C. In the early 1880s, he became so wrapped up in American politics that he drew virtually no European cartoons, leaving that task largely to Graetz. But after he rebuilt the *Puck* staff in 1886 and 1887, he once more turned his attention to European matters (fig. N). Interest in his homeland obviously prompted some of the cartoons. Zim suggests that international subjects appealed to Keppler "because the pomp and ceremony of the Old World afforded [him] opportunities for more vivid color effects."[28]

Invariably, Keppler's European cartoons revolved around Bismarck. His once tentative support for the German chancellor had become, by the late 1880s, unconditional. He saw Bismarck as the grand conductor in European politics, the one man chiefly responsible for European stability. In "The European Equilibrist" (fig. 132), he drew, as Bunner described him, the "stern, shrewd, stubborn, over-bearing, foxy, sinister, loyal, fearless old man, named Bismarck" balancing the European political seesaw between war and peace. And as if this feat weren't enough, he is, at the same time, skillfully juggling the rulers of Europe like so many oranges.[29]

Bismarck's patron and Germany's ruler for twenty-five years, Kaiser Wilhelm, died in 1888. Keppler's memorial cartoon showed Germania laying a wreath on his funeral bier. Bunner said of him, "There was one King in Europe two weeks ago, one King worthy of the name, and there is none to-day." Keppler's deep distrust of royalty was confirmed when Wilhelm's grandson, Wilhelm II, ascended to the German throne and proclaimed that he was "an emissary from God, sent to take charge of the future of the German nation . . . and . . . to shatter all who oppose him in his plans."[30]

Keppler considered Bismarck and the elder Wilhelm exceptions in a Europe led by weak and narrow-minded men. Enlightened European leaders were too few and far between for Keppler ever to look longingly across the Atlantic. He never wavered in his view of the governments of Europe as anachronisms; out-moded and impotent at best, cruel and brutal at worst. In "Unconscious of Their Doom" (fig. 133), he drew the kings, emperors, and czars of the world issuing edicts and proclamations left and right. They sit on a large rock labeled "divine right." A damsel wearing a "spirit of the age" crown uses the staff of "education" to edge the rock ever closer to the brink of oblivion.[31]

Still, these views didn't stop Keppler from appreciating the cultural and scenic wealth of the continent. In August of 1889, he returned with his family to Europe for six months. During the continental tour, Keppler and son Udo, who was then seventeen, took some time to paint. On the back of one of Udo's watercolors, a pastoral view of the Parthenon, the young artist noted, "Father helped me with the sky." At the end of their trip, the family left Udo in Munich to begin training under Wilhelm Dietz at the Academy of Arts.[32]

Keppler could hardly contain his pride in his talented son, but it pained him that they had never been close. Keppler was always working, and Udo, shy and contemplative, always seemed to be in his own world. Although Udo excelled in his studies at Munich and impressed those who came in contact with him as a thoughtful young man, he was desperately homesick. In response to a letter Udo wrote in August, Keppler reflected on their distant relationship: "You were always

noncommunicative towards me which I have always regretted, because sometimes I felt the urge to talk with you about certain things but I always found you rejective and shy and therefore I decided to wait patiently till you approached me. . . . I wish by God that the time would have already come where you felt comfortable telling me your thoughts and desires. You will always find me willing to support you with advice and practical help. . . . " In response to Udo's current heartache, Keppler told him, "I have to admit that I accuse myself now of having left you alone and without any help, but I have so much confidence in you that I think not everything is lost. [However] should you not like it in Munich for whatever reason, then pack your stuff and come into our arms. Don't let home-sickness torture you. Here you are always welcome." He assured his son that there was a place on *Puck* for him if he wanted it.[33]

After Udo received this letter, he returned home to join the staff of the weekly. Within six months' time, however, he decided to continue his artistic training in Heilbronn, Germany, a move Keppler supported.[34] When Udo returned to the pages of *Puck* in November of 1891, he returned for good (fig. 134). Everyone on *Puck* knew Keppler was grooming his son to take his place one day on the magazine. No one imagined that day was less than two-and-a-half years away.

Figures 118–134

118. "Uncle Sam's Lodging-House." The Irish never fared well in Keppler's cartoons. His prejudice against them was rooted in his fear and hatred of Tammany Hall and the Catholic church, institutions that owed much of their strength to Irish allegiance. But he also disliked the Irish for what he considered to be their excessive interest in the issues and events of their homeland. Instead of living and thinking like citizens of the United States, Keppler felt that the Irish used their newfound political power as American citizens to affect American-British-Irish relations. On a different front, the Irish led the anti-Chinese movement in the American West, even committing violence against these peaceful immigrants. Keppler was not above making veiled references to Irish deportation. (Author's collection; tion; *Puck*, June 7, 1882)

PUCK.

J. KEPPLER

UNCLE SAM'S LODGING-HOUSE.

Uncle Sam.—"Look here, you, everybody else is quiet and peaceable, and you're all the time a-kicking up a row!"

119. "They Are the People." Judaic historians argue over just how anti-Semitic cartoons such as this one are. In 1881, when the *Jewish Messenger* charged Keppler and his magazine with anti-Semitism, the cartoonist was bewildered and peeved. In response, Bunner suggested that Jews work harder to assimilate into American culture, rather than emphasize differences and cling to old and peculiar religious ways. While Keppler employed all the visual stereotypes common in graphic representations of the Jew in this cartoon, he conceived the piece as a celebration of Jewish fortitude in the face of overwhelming odds. (Author's collection; *Puck*, July 29, 1891)

PUCK.

THEY ARE THE PEOPLE.

THE DOWNTRODDEN ONE.——THEY HAVE ALWAYS PERSECUTED US; BUT WE GET THERE ALL THE SAME!

120. "A Desperate Attempt to Solve the Mormon Question." As religious leaders and politicians gravely pontificated on the "corrupting" Mormon practice of polygamy, the *Puck* staff enjoyed themselves in this collaborative 1884 cartoon. The shrew in Gillam's vignette of domestic disharmony was imaginary; he was a bachelor until 1889. Opper depicted anti-Mormon hystery in the extreme, showing the Morman octopus reaching out to ensnare just about everything in the world. Graetz focused his attention on the rising divorce rate, while Keppler portrayed himself as the contented master of a harem. (Library of Congress; *Puck*, Feb. 13, 1884)

How long will this destructive monster be allowed to live?—*Opper.*

I think one wife is enough.—*Gillam.*

SATURDAY
DIVORCE DAY
IN CHICAGO.

Divorces procured
without delay Liberal Charges

Divorces
obtained
for $5.00

What is the use of Mormonism, when a man can change his wife whenever he likes?—*Graetz.*

I imagine it must be a perfect Paradise.—*Keppler.*

A DESPERATE ATTEMPT TO SOLVE THE MORMON QUESTION.

Four artists who differ in style and in mind
The result of their labor is here—and, what 's more,
We 'll remark that in Utah they laugh at all four.
This cartoon on the Mormons have jointly designed.

121. "The Chinese Invasion." At the height of the anti-Chinese agitation on the West Coast, Keppler proclaimed that New York would welcome all the Chinese who chose to come. If the truculent anti-Chinese Irish weren't careful, he suggested, they would lose their jobs to these conscientious and peaceful people. (Author's collection; *Puck*, March 12, 1880)

PUCK.

THE CHINESE INVASION.

122. **"Consistency."** Is his entire career, Keppler drew only a handful of cartoons on the plight of the American Indian. Udo Keppler's all-consuming interest in Indian culture undoubtedly heightened his father's awareness of the injustices done to the Indians by the U.S. government. In juxtaposing this treatment with the missionary zeal Americans showed in helping the unfortunate around the world, Keppler was saying that charity should begin at home. (Library of Congress; *Puck*, Jan. 21, 1891)

CONSISTENCY.

123. "Looking Backward." In Keppler's day, there were no quotas limiting immigration into the United States. But he had witnessed the immigrant Irish lobbying to keep out the Chinese and he knew many European expatriates anxious to close the door even to those from their own homelands. He had no patience with such selfish and narrow-minded talk. (Author's collection; *Puck*, Jan. 11, 1893)

LOOKING BACKWARD.

THEY WOULD CLOSE TO THE NEW-COMER THE BRIDGE THAT CARRIED THEM AND THEIR FATHERS OVER.

124. "Siegfried the Fearless in the Political 'Dismal Swamp'." When President Cleveland announced that he favored reducing excessive tariffs on imports, Keppler pictured him as a courageous loner in a swamp populated by politicians and editors constitutionally incapable even of helping in the fight. (Author's collection; *Puck*, Dec. 28, 1887)

PUCK.

SIEGFRIED THE FEARLESS IN THE POLITICAL "DISMAL SWAMP."

125. "Quality Counts." In 1888, the Republican party had a host of contenders for their presidential nomination. The Democrats had only one, but, as Keppler observed, one of this sort was all they needed. (Author's collection; *Puck*, April 11, 1888)

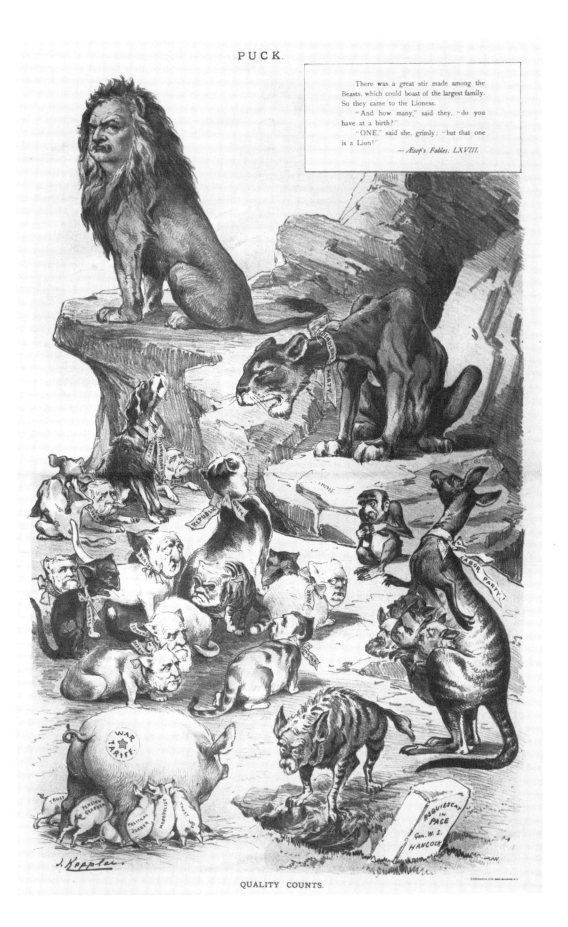

QUALITY COUNTS.

126. "The Best of Friends Must Part." When perennial presidential aspirant James G. Blaine withdrew from the 1888 contest, Keppler treated the event with the same cynicism that had marked his relationship with Blaine since the 1870s. As it turned out, Blaine's disavowal of interest this time was for real. (Author's collection; *Puck*, Feb. 22, 1888)

VOL. XXII.—No. 572.　　　　　NEW YORK, FEBRUARY 22, 1888.　　　　　PRICE, TEN CENTS.

KEPPLER & SCHWARZMANN, Publishers.　　　　COPYRIGHT, 1888, BY KEPPLER & SCHWARZMANN.　　　　PUCK BUILDING,　Cor. Houston & Mulberry Sts.

ENTERED AT THE POST OFFICE AT NEW YORK, AND ADMITTED FOR TRANSMISSION THROUGH THE MAILS AT SECOND CLASS RATES.

"THE BEST OF FRIENDS MUST PART."

J. G. B., *(aside).* — He thinks I mean it!
PUCK, *(asider).* — He thinks I believe it!

127. "An Ever-Popular Game—Chucking at Tough Old Uncle Jim." For most of its run, *Puck* had been the first in line to "chuck at tough old Uncle Jim Blaine." In this 1888 cartoon, Keppler cast his little mascot in the unfamiliar role of the innocent. Blaine's ceaseless promoter, Whitelaw Reid of the *New York Tribune*, plays the huckster. (Author's collection; *Puck*, May 16, 1888)

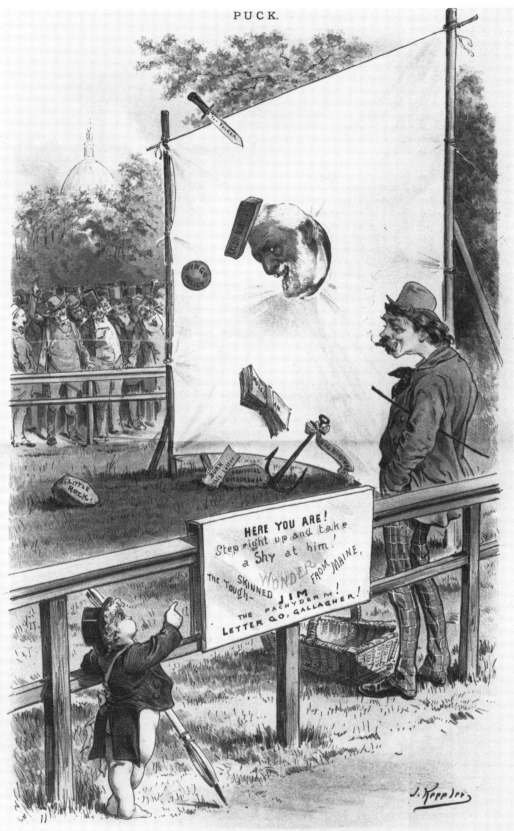

AN EVER-POPULAR GAME—CHUCKING AT TOUGH OLD UNCLE JIM.

PUCK.—Does n't it hurt him?
SHOWMAN REID.—Hurt him! Not a bit, sonny, not a bit! He pervides the ammunition hisself.

128. "A Hydra That Must Be Crushed—And the Sooner the Better."
The high tariff, a legacy of the Civil War, generated an excessive U.S. Treasury surplus. Money that could be put to more productive use was tied up in U.S. vaults. But many major American industries thrived because the tariff effectively excluded foreign competition. These protected American businesses, some of them represented as tentacles on the head of the war tariff monster, brought to bear all of their lobbying might on the two houses of Congress to prevent tariff reduction. (Author's collection; *Puck*, March 7, 1888)

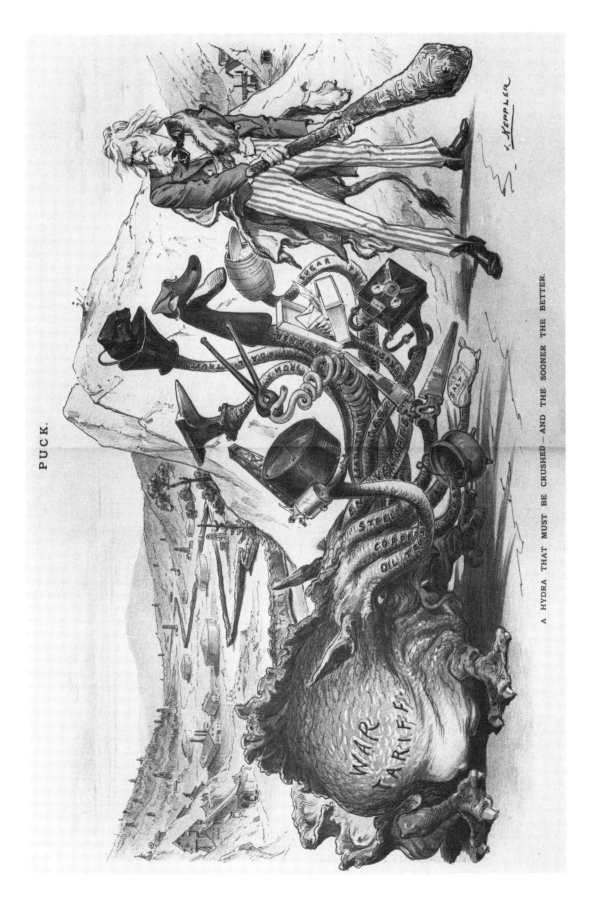

PUCK.

A HYDRA THAT MUST BE CRUSHED—AND THE SOONER THE BETTER.

129. "A Dead Failure." When Cleveland came out for tariff reform, the Republicans twisted his words and charged him with advocating free trade—no tariffs at all. In this cartoon, Keppler confidently labels their attempt to mislead the public as a failure, but in private he was not so sure that they hadn't succeeded. (Author's collection; *Puck*, Aug. 22, 1888)

PUCK.

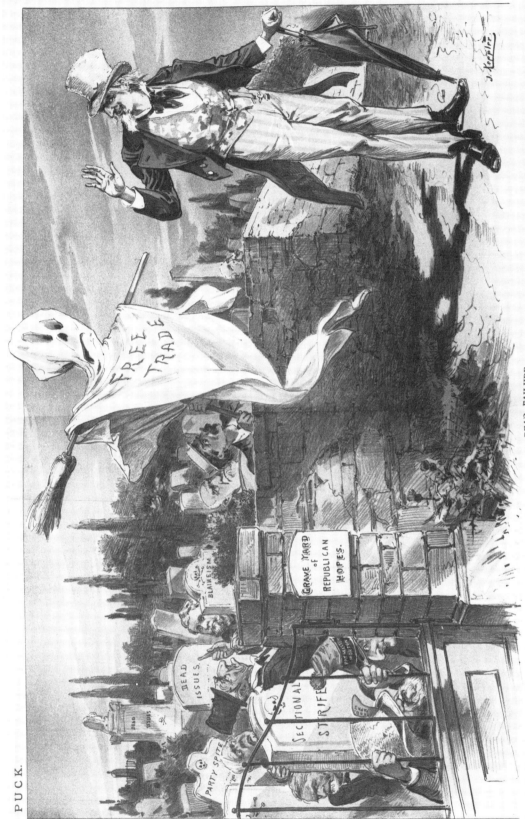

A DEAD FAILURE.

Uncle Sam.—Go home, boys, go home! You can't scare me worth a cent!

130. "New Year's Eve on the Democratic Camp-ground." After Keppler had recovered from the shock of the Democrats' surprise defeat in 1888, he looked with optimism to the future. As the field soldiers of the Democratic party sleep (General Cleveland undoubtedly in his own tent), Democratic imposters Pulitzer of the *New York World* and Dana of the *New York Sun* steal into camp in search of guarded party secrets. (Author's collection; *Puck*, Dec. 26, 1888)

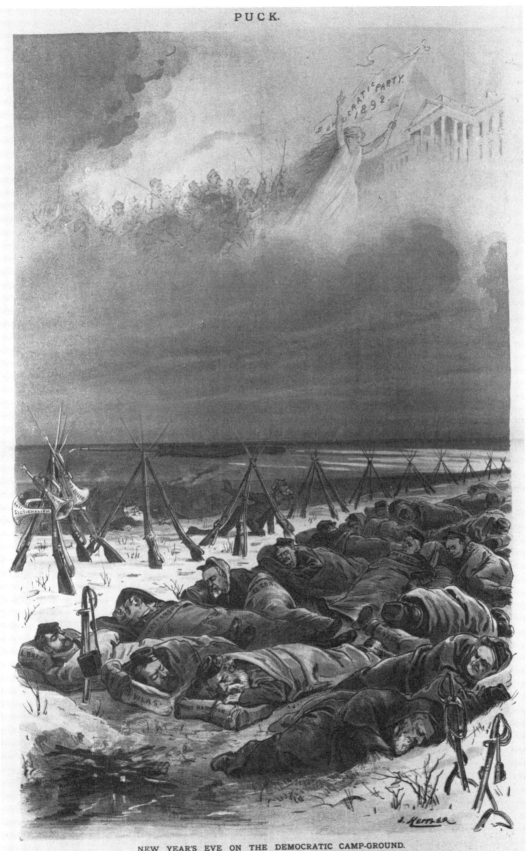

NEW YEAR'S EVE ON THE DEMOCRATIC CAMP-GROUND.

"Is This a Dream! — Then Waking Would be Pain!"

131. "A Cold Reception Everywhere." Even back in his St. Louis days, Keppler had viewed prohibitionists as cranks. Spirits, camaraderie, and festive occasions were all one to Keppler. This cartoon celebrated the recent defeats of prohibition referendums in Rhode Island, Massachusetts, and Pennsylvania. In the 1920s, cartoonist Rollin Kirby of the *New York World* would resurrect Keppler's Old Man Prohibition and make him the derisive symbol of the "noble experiment." (Author's collection; *Puck*, July 3, 1889)

PUCK.

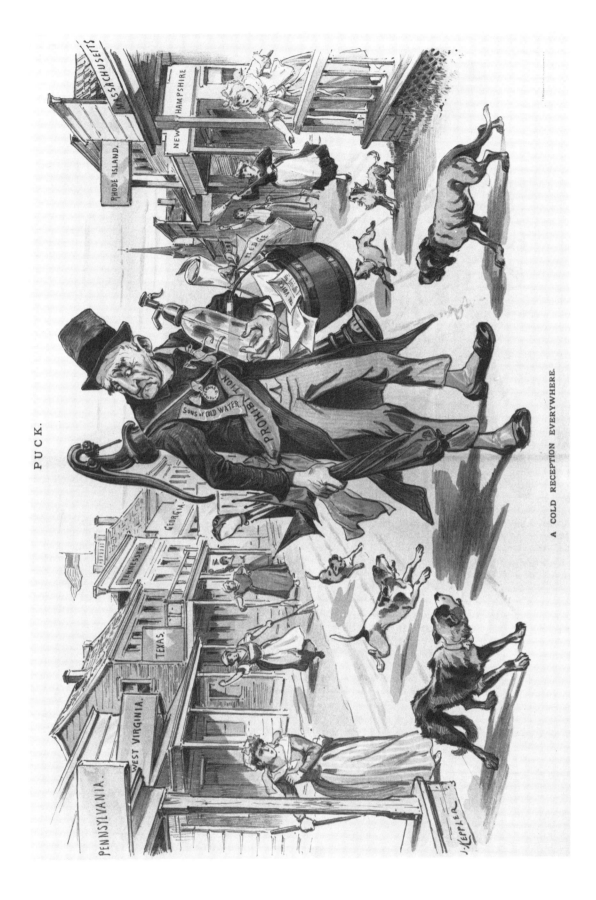

A COLD RECEPTION EVERYWHERE.

132. "The European Equilibrist." In Keppler's opinion, the shrewd, enlightened Chancellor von Bismarck of Germany was singlehandedly responsible for the delicate peace then reigning throughout Europe. (Author's collection; *Puck*, March 30, 1887)

PUCK.

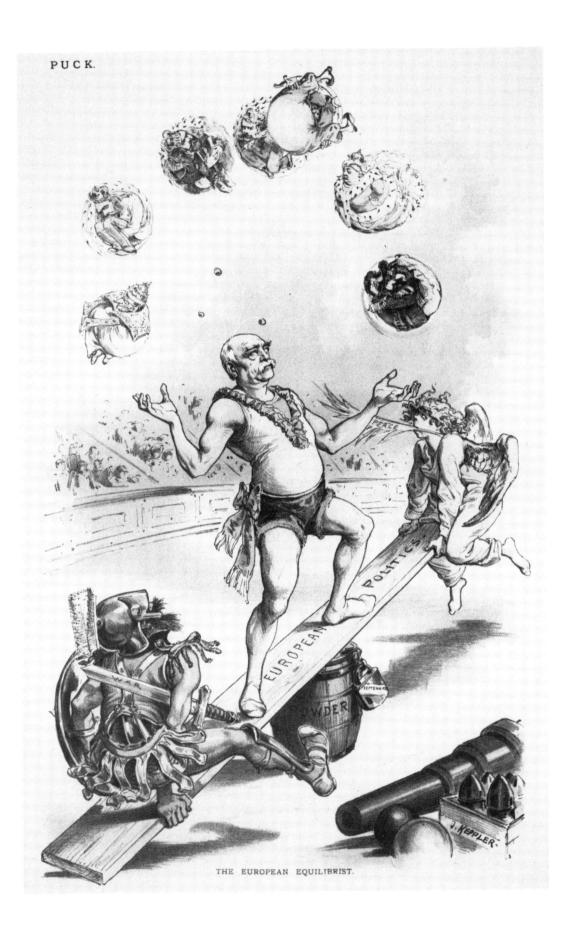

THE EUROPEAN EQUILIBRIST.

133. "Unconscious of their Doom." During the nineteenth century, the Western world underwent a transformation in sensibilities. Reason and scientific inquiry replaced sentiment and faith. "The Spirit of the Age" required things to make sense. Kings, Keppler argued, no longer made sense. They were costly to maintain and willful and idiosyncratic in their management of national affairs. Education had fostered an appreciation for scientific and dispassionate methods of business management that could be applied to governing as well. Because of this, not a shot needed to be fired in order to dispatch the royal heads of Europe into oblivion. (Author's collection; *Puck*, April 29, 1891)

"UNCONSCIOUS OF THEIR DOOM."

134. "A Despotic Attitude." Joseph Keppler's son, Udo, drew his first lithograph for *Puck* in May 1892. Although Udo's style was simpler and bolder than his father's, his work reflected Keppler's strong influence. In this cartoon, Udo castigates Germany's young Kaiser Wilhelm II for his arrogance and bravado. (Author's collection; *Puck*, May 25, 1892)

VOL. XXXI.—No. 794. PUCK BUILDING, New York, May 25th, 1892. PRICE, 10 CENTS.

Copyright, 1892, by Keppler & Schwarzmann.

Entered at N. Y. P. O. as Second-class Mail Matter.

J. Keppler Jr.

A DESPOTIC ATTITUDE.

WILLIAM THE WAR-CRANK.—I and my army stand here by divine right.

NINE

The Festooned Sarcophagus

THE 51st CONGRESS that convened in 1889 was dubbed "the billion dollar Congress" in reference to the total wealth of its members. The lawmakers' healthy financial status, however, did not make them immune to the entreatments of powerful and generous corporate lobbies. Keppler decried this shameless state of affairs in one of his most famous cartoons. "The Bosses of the Senate" (fig. 135) pictured the U.S. Senate chamber with barred and locked doors. Under a sign that proclaims, "Of the monopolists, by the monopolists and for the monopolists," the gargantuan trusts block all exits, forcing the senators to do their bidding.[1]

In early 1889, that body made good on its promise to take action on tariff reform following public sentiment as expressed in the 1888 election results—it voted down the Mills tariff reform bill. The following year, the Republicans introduced their own tariff reform measure. Sponsored by Congressman William McKinley, this legislation interpreted reform of the high tariff in a peculiar way: it discontinued or lowered rates for only a handful of items, while it raised many others.

Keppler campaigned actively against the McKinley bill. In September, he predicted politically fatal consequences for all who linked themselves with this noxious bill when he drew McKinley and his congressional cronies "Building the High-Tariff Tomb for the Republican Pharoahs" (fig. 136).[2] The bill passed, but only after the Republicans gave in to the demands of western Democrats to liberalize the 1878 Bland-Allison Silver Act. This new legislation, the Sherman Silver Purchase Act of 1890, put higher monthly quotas on the amount of silver the federal government was obligated to buy with treasury gold, easing the tight money supply and pleasing the powerful western mine owners.

Keppler's prediction that the bill would be the Republicans' tomb proved prophetic in the November off-year elections, when McKinley and many other Republicans went down to defeat. Keppler celebrated their loss in a parody of Meissonier's historical painting "Campaign in France, 1814," which showed McKinley, Blaine, and other GOP congressmen leading their defeated and bedraggled troops home from battle.

Still, the odious bill that bore McKinley's name remained on the books. In November 1891, Keppler drew "Rally Round the Flag, Boys!," which featured Cleveland instructing the Democrats to hoist a flag proclaiming "Tariff Reform—The Issue for 1892."[3] It would become as central to that year's campaign as it had been to the one in 1888.

President Harrison was a minor player in these dramas. When Keppler drew the president, he depicted him as diminutive, befuddled, and ineffective (fig. 137). His "The Little Republican Lord Fauntleroy" (fig. 138) featured a prissy little Harrison naïvely intent on satisfying the demands of all GOP factions.[4] With Cleveland out of office, Keppler no longer had to play cheerleader. This had a liberating effect on his work. Many of his Harrison cartoons exhibit the same drollery and wit that made his pre-Cleveland political cartoons so entertaining and irreverent.

Blaine, now Harrison's secretary of state, continued to figure prominently in Keppler's cartoons, primarily as the power behind the Harrison throne. As secretary, Blaine was anxious to improve relations with other countries of the Western Hemisphere. But the prohibitive tariff championed by the Republicans, which kept cheap foreign goods out of the United States, made friendly relations difficult. Blaine became an advocate of reciprocity: granting special trade concessions to countries willing to grant the United States similar concessions. Keppler found sweet irony in Blaine's conversion from protectionist to tariff reformer, and he twitted the secretary for having the misfortune of running up against the McKinley tariff at every turn in the international trade road.

Meanwhile, Blaine was becoming increasingly vexed by his inability to influence the more conservative Harrison, who refused to embrace Blaine's internationalist politics. Keppler took pleasure in thinking that Blaine regretted his decision to forego the 1888 nomination, thereby clearing the way for Harrison. In August of 1890, Keppler caricatured this imagined state of affairs in one of his best cartoons, "The Raven" (fig. 139). A dwarfish Harrison, wearing his absurdly oversized grandfather's hat, sits at a writing table. Above him, atop a bust of William Henry Harrison, perches the raven, James G. Blaine. He casts an ominous shadow over his chief that, quoth the Raven, "shall be lifted—nevermore!"[5]

In September of 1891, Keppler pictured Blaine and Harrison as rival generals arguing over 1892 campaign strategy. Blaine says, "I would consolidate the whole army; start the war-cry of 'Reciprocity,' and knock the enemy out wherever I found him." Harrison counters, "I would divide my army into three parts—on the right, the corps of Pension-Grabbers; on the left, the legion of Office Seekers; and in the centre I would plant my American Silver battery, and blow the enemy to pieces!"[6] As Keppler observed, Harrison controlled patronage, and with it could seriously challenge Blaine's popularity. As tempting as the nomination was to Blaine (fig. 140), in the end he chose not to challenge his boss. When Blaine declined the fight, Harrison's renomination was assured.

In the Democratic camp, Cleveland was the only man with a national following. His prime opponent was David Hill, the man he had made governor of New York back in 1885, and who had since become senator. Hill, more pragmatic than Cleveland, worked hard to mend New York party fences, even if that meant doing business with Tammany. Hill's loyalty to party over principle did not ingratiate him to Keppler, but the cartoonist's first concern was to avoid an intra-party fight that might ensure Harrison's reelection. In July of 1891, he drew "The Rival Toreadors," which showed Cleveland and Hill squaring off against each other while the Republican bull prepares to charge. Keppler admonishes, "They had better stop fighting and finish the bull, or he will get the best of them."[7]

Ultimately, the Hill candidacy did not pose a serious threat. As the convention neared, the New Yorker's national support evaporated. In April, Keppler's "The Sinking Ship" showed Hill looking on with alarm as his supporters, pictured as rats, scurry off the side of his campaign ship.[8]

Cleveland staked his candidacy on making tariff reform the one great issue of the coming campaign, shutting his ears to the increasingly desperate cries from debt-ridden western farmers and other disaffected Democratic factions for the free coinage of silver. The candidate, aware that the issue was a political hornet's nest, downplayed his staunch advocacy of the gold standard to avoid alienating a large and growing segment of his party. Keppler shared Cleveland's free silver fears, but none of his timidity. He campaigned hard against those Democrats who advocated free silver. In February 1892, Keppler drew a "Silver Syren" seductively playing her harp as the boat of the democracy passes by. Mesmerized by her music, David Hill and a few western Democrats seem unaware of the surrounding jagged rocks that spell defeat.[9]

In June, when Harrison won the Republican nomination, Keppler drew "The Little Man's Triumph" (fig. 141), which showed Harrison atop an ornately appointed GOP elephant. Perched behind him is his running-mate Whitelaw Reid,

editor of the *New York Tribune* and an old Blaine ally. Above Harrison's head hangs a sign that reads "Protection to American Monopolists." In August, Keppler followed up that cartoon with "Puck's Candidates," in effect a campaign poster for Cleveland and his running-mate Stevenson.[10]

In the following months, Keppler didn't even deign to acknowledge Harrison. Instead, he attacked the Republicans where he felt they were weakest—for their advocacy of the McKinley Tariff. At the end of August, Keppler drew "Protected," which showed a beatific McKinley with hands clasped sanctimoniously, saying "Peace reigns, Prosperity smiles, Capital is confident, the Workingman is happy and contented, and it's ALL due to my Glorious War-Tariff-Eclipsing Protective system!" Surrounding McKinley are vignettes of labor strikes and violence from around the country.[11]

"The Republican Galley," which appeared in September, pictured McKinley snapping his "war tariff" whip over the heads of exhausted workingmen-oarsmen. At the stern, wealthy Republican businessmen and politicians toast McKinley and his bill over a sumptuous dinner.[12]

When Cleveland piled up a 450,000 vote majority to win back the presidency, a jubilant Keppler served up the campaign's coup de grace: a cartoon featuring Uncle Sam, peering into a giant-sized grandfather's hat, slyly asking his audience, "Where is he?" (fig. 142).[13]

Cleveland's thundering return to Washington deeply gratified Keppler. Bunner labeled the election the "great tidal-wave of '92." He could hardly contain himself when he wrote: "The election of Mr. Cleveland to the Presidency, with a Democratic majority in the House of Representatives and with a working majority in the Senate in sight, means more to *Puck* than it means to most of the papers that have supported Mr. Cleveland's candidacy. It means practically the end—at least, the beginning of the end—of the fifteen-year fight which we have made for the three reforms [that] we pledged ourselves [to] when we began the publication of this journal—Tariff Reform, Civil-Service Reform and Ballot Reform."[14] Aside from Bunner's creative mathematics—the *Puck* staff hadn't begun championing the first two reforms until the early 1880s and the last one until the 1888 election had come to its odd conclusion—he was right about Cleveland's election being the beginning of the end, but not exactly in the way he meant the phrase. The reform era was dead. In the years that followed, growing populist sentiment in the West and the devastating financial crash of 1893 forced the nation to consider a new agenda, with the free coinage of silver topping the list. Cleveland and his supporters found themselves on the defensive. Keppler and *Puck* had never been effective in retreat. The 1892 election did mark the beginning of the end—for the *Puck* that Keppler knew and loved.

In the early 1890s, Keppler embarked on several ambitious personal projects. In 1891, he built a spacious four-story brownstone at 27 East 79th Street. This became the Keppler family's primary residence, although they continued to maintain the Inwood property as well. Foreseeing the day when he might retire from *Puck*, Keppler bought property in Elka Park, a resort community in the Catskills, and began building a summer cottage on the land. Both projects cost Keppler a good deal of money. Throughout 1891, 1892, and 1893, he borrowed tens of thousands of dollars from the company account to be paid back to the firm out of future profits.[15]

For about six months following the election, Keppler also devoted his energies to a smaller but equally satisfying project: the production of a major collection of his work. No American publisher had ever before issued a book of political cartoons, and Keppler doubted anyone would buy one. But Schwarzmann and Bunner contended that a market existed for finely produced limited editions.

In May, the Puck Press published *A Selection of Cartoons from Puck by Joseph Keppler (1877–1892)*. It was a lavish folio, limited to three hundred signed and numbered copies that sold for $10 apiece. The book featured fifty-six cartoons, reproduced in soft tints rather than in the original prohibitively expensive full color, accompanied by brief explanations by Bunner.

What Keppler considered his best work was a curious selection. He ignored many of his most powerful cartoons and included several expendable commemorative cartoons. For example, the book contains only one cartoon from his great anti-Grant campaign of 1880. Apparently, the selection was guided more by commercial than professional considerations. To Keppler's satisfaction and relief, the book sold out in four months.[16]

By the time the book appeared, Keppler had moved to Chicago to be a participant in the 1893 World's Fair. Over the previous three years, *Puck* had avidly supported the idea of a World's Fair to commemorate the voyages of Columbus (fig. 143). Keppler and Schwarzmann had wanted the fair to be held in New York. When Chicago won the honor, Bunner cried foul, or, more precisely, pork. He charged that Chicago was really only qualified to host a fair celebrating swine and plows. But within a short time the staff reconciled itself to Chicago's good fortune and once more became fair boosters. Keppler and Schwarzmann were delighted when the fair commissioners invited them to participate.[17]

The chosen site was a two-mile stretch along the shore of Lake Michigan, made up largely of boggy marshes and lagoons. Within two years, this inhospitable setting was transformed into an international city of broad palisades and more than 250 domed and corniced exhibition halls. Believing that the fair would "be the most notable and monumental architectural exposition . . . ever been under-

taken in the world's history," Keppler and Schwarzmann spared no expense in building *Puck*'s Chicago home. To design it, they engaged one of the era's leading architects, Stanford White, of McKim, Meade, and White.[18] In March of 1893, Keppler travelled to Chicago to supervise the outfitting of the nearly completed building.

The *Puck* building that White designed resembled an eighteenth-century French chateau. The roof had two domes, one supporting a flag and the other adorned with an elaborate three-figure statue of Puck and friends by sculptor Henry Baerer.[19] Other figures, holding banners, stood atop pedestals at each corner of the roof. The walls and windows were equally ornate, with pronounced cornices that gave the whole structure the appearance of being draped in garlands (fig. 144). Only with hindsight would this lovely building be revealed as the festooned sarcophagus that it was.

Inside the front door was a visitors' center where people could rest or write notes to friends on *World's Fair Puck* stationery. Stepping further into the building, visitors found the central portion of the first floor open, allowing them to peer down into the basement for a bird's-eye view of the workings of seven R. Hoe lithographic presses, the same model of those that printed the New York *Puck*. Surrounding this central gaping hole were two galleries, sectioned off into several compartments. In these compartments, visitors could see all of the pre-press processes that went into making a magazine such as *Puck*, including stone grinding and lithography, metal engraving, typesetting, and transfer manufacturing. The editorial and art department offices were also on the first floor, but the work that went on there was not intended for public view.[20]

Keppler was in charge. Bunner's associate editor, Henry Gallup Paine, was designated editor of the *World's Fair Puck*; his assistant was Roy McCardell. Keppler's staff consisted of young Frank Hutchins of the New York *Puck* staff and W. A. Rogers, longtime *Harper's Weekly* illustrator and cartoonist. Rogers had been hired to a one-year contract specifically to work with Keppler in Chicago.[21]

The *World's Fair Puck* appeared May 1 and then, after May 15, weekly until October 30. The twelve-page magazine was smaller than its New York namesake and scrupulously apolitical (fig. 145) and Keppler couldn't stop himself from commenting on the high cost of food at the fair or on keeping the fair open on Sundays, which he heartily approved of (fig. 146), but he made sure the magazine never concerned itself with events and issues outside the fair gates.[22]

For Keppler, the promising exhibition soured from the start. *Puck*'s lavish sixty-four-page souvenir issue was not selling well, and Schwarzmann, unhappy

with the cover Keppler drew for it, blamed his colleague. Others on the staff felt that Keppler's May 1 cover cartoon fell below his normally high standards. Both charges wounded Keppler.[23]

After only a few weeks, Rogers complained to Keppler that he couldn't work under the conditions in Chicago. Keppler commiserated. As the cool spring breezes turned into stagnant summer heat, the poorly ventilated, overcrowded building became a pressure cooker. The building, Paine recalled, "was beautiful to look at, but hell to work in." Keppler and his colleagues could not escape, even for a minute. To close a door in the stultifying heat was unthinkable, but the alternative was just as bad. Curious sightseers, eager to see everything, innocently trampled on the staff's privacy. Paine recalled, "Nine out of ten of the thousands who shuffled past [my compartment] daily stopped to watch a joke-smith at work; five, out of the ten, to make some audible comment; three, to come in and walk around; two to ask some fool question; and one, to sit down to rest and make himself or herself at home."[24] To make matters worse, Schwarzmann had ingeniously directed White to allocate space in the building for bedrooms, so that *Puck* could save money on boarding and staffers would have the convenience of living where they worked. It was difficult to imagine a poorer arrangement.

Getting out the weekly issue became a test of endurance. Everyone was unhappy and irritable, Keppler most of all. He was at his wits' end trying to placate staff members and laborers who grew increasingly resentful that they were being forced to work under such conditions. And just when Keppler thought nothing else could go wrong, putrid swamp water began seeping into the basement, and sand from the Lake Michigan shoreline somehow found its way into the lithographic presses.[25]

Keppler took it until July. Then he put in a call to New York demanding that Opper come to relieve him. Paine left Chicago about the same time, returning to New York and editing enough material there to complete the series. Then he resigned to accept the less harrowing position of assistant editor of *Harper's Weekly*. In August, Rogers also returned to Houston Street. From afar, the New York staff pitched in to illustrate the magazine until the end of its run in October.[26]

Keppler was exhausted. Instead of returning to work, he went to his summer cottage in Elka Park. He stayed there for more than a month before recovering sufficiently to resume his duties on the magazine (fig. 147). But, after a few weeks in New York, he fell ill again. His health fluctuated throughout December and January; he seemed incapable of shaking off a feeling of great fatigue. On Feb-

ruary 1, he celebrated his fifty-sixth birthday, in bed. Friends and family were naturally concerned about his health, but no one realized that he was battling for his life. In mid-February, he contracted a spinal and lung infection, and his condition suddenly became grave. In the early evening hours of the 19th, with his wife and children at his bedside, Keppler died of a heart attack.[27]

His death was front-page news across the country. Assessments of his career soon followed. The *New York Recorder* said: "The public knew [Keppler] as an intelligent humorist, a brilliant caricaturist and a successful business man. His friends, who were legion, knew him as a thoroughly good fellow, devoted to his home and his work and his circle; public spirited, warm hearted, open handed."[28]

The *Chicago Herald* said: "[Keppler's] death leaves a place in modern caricature that cannot soon be filled. Of the younger cartoonists of the eastern weeklies few, if any, have the characteristics, the accuracy in drawing, combined with keen humor, that made the dead artist an example for all others of his class. . . ."[29]

The *Louisville Courier Journal* wrote: "[Keppler] gave to caricature a fresh lease of power in politics. Quick to seize the salient points of any event or any issue, he concentrated into a picture columns of argument, ridicule and invective, and made the whole so attractive by his art that men and women, and children, too, saw and inquired and remembered. In his way he was an educator, and assuredly a power in any cause. His pictures, reaching thousands who had no previous interest in their subject matter, caught their attention, stimulated their interest, added to their knowledge and influenced their opinions. . . ."[30]

Udo asked the aged Carl Schurz to speak about his father at the funeral. Schurz had to decline, but wrote in condolence, "That I would love to contribute to grant your father the last honors I think I don't have to assure you. When I read the news about his death in the papers this morning I felt very deep pain. . . . It might be, for all of you, a consoling thought to know that the genius and the art of your deceased father will be honored by numerous friends and his death will be regretted deeply."[31]

One of the warmest letters the family received came from Keppler's student and, then, rival, Bernhard Gillam. He wrote to Mrs. Keppler, "The death of Mr. Keppler is a great loss to the art world. He was a master of art and satire. I feel it as a personal grief. He was a good friend of mine, and I owe a great deal of what little success I have achieved to his kindness. . . . I consider that he was the greatest cartoonist America ever saw, and the country will sorely miss him."[32]

The funeral was a simple ceremony. After several staff people and friends spoke at the Keppler home on East 79th Street, Keppler was buried at the family plot in Woodlawn Cemetery in the Bronx.[33]

Puck was changed immeasurably by Keppler's death. Dalrymple took over as chief cartoonist. His slapdash cartoons paled in comparison with his mentor's. For a while, Bunner continued to fill the magazine with lively poetry and prose, but he died suddenly two years after Keppler, at the age of forty. As the turn of the century approached, Schwarzmann, growing increasingly conservative with age, steered *Puck* on an illiberal path that Keppler and Bunner would have surely moderated. In 1901, Joseph Keppler, Jr., the name Udo had legally adopted soon after his father's death, became *Puck*'s chief cartoonist. When Schwarzmann died in 1904, his twenty-four-year-old son, Adolph, Jr., joined Kep, as Udo was called, in the management of the venerable magazine.

With Schwarzmann's passing, the magazine burst forth once more as a journal of strong, progressive thinking. But the days of the cartoon weekly were numbered. Editorial cartoons in the daily papers made weekly cartoons seem dated and out of step with the fast-paced twentieth century. Keppler and Schwarzmann sold *Puck* in 1913. After weathering several owners and the hardships of wartime shortages, *Puck* made its last appearance in September of 1918. It had been a power for only a generation.

At the height of his influence in the 1880s, Keppler had guided and inspired dozens of cartoonists. Lithography became the political cartooning medium of choice. But Keppler's school of art waned for the same reasons *Puck* declined. The chromolithographic process, with its striking and beautiful product, was replaced by ink, paper, and a camera—a simpler, more efficient method that many argued did the job just as well.

But if Keppler's methods did not last, his approach lives on. While it was largely forgotten by the practitioners of the art during the first sixty years of the twentieth century, contemporary political cartoonists have reclaimed Keppler's legacy and made his approach to cartooning theirs as well. Led by the masterly Pat Oliphant, and championed by talents such as Jeff MacNelly, Mike Peters, and Tony Auth, today's cartoonists employ satire to make their most telling political points. Like Keppler, they play out their little political fantasies on stages of their own making. They prefer straightforward caricature to abstract symbolism, and they consider all aspects of American life fair game for their sharp pens.

The power of satire is such that Keppler's work continues to pulse with the energy that enlivened it when it first appeared. This is because the challenges we face as a democratic society have not changed appreciably in the hundred years since Keppler worked. Keppler felt that a democratic society must be ever vigilant, not so much to external threats as to internal threats, those that stand in the way of the society achieving its promise. He saw that the duplicitous and greedy

tendencies of those who exercise political and religious leadership must be monitored; the callousness and lack of humanity of those with money and those who seek it must be moderated; and the suffering of the poor and discriminated against must be alleviated. In his graphic examinations of late-nineteenth-century America, Keppler probed the country's mores, exposed its shortcomings, and celebrated its strengths. The power of Keppler's art endures because time cannot erode the truth.

Figures 135–147

135. "The Bosses of the Senate." By 1889, Keppler had become fed up with the role that the moneyed interests played in the selection of U.S. senators. This, his most forceful cartoon on the subject, has been reprinted repeatedly in the hundred years since it first appeared. (Author's collection; *Puck*, Jan. 23, 1889)

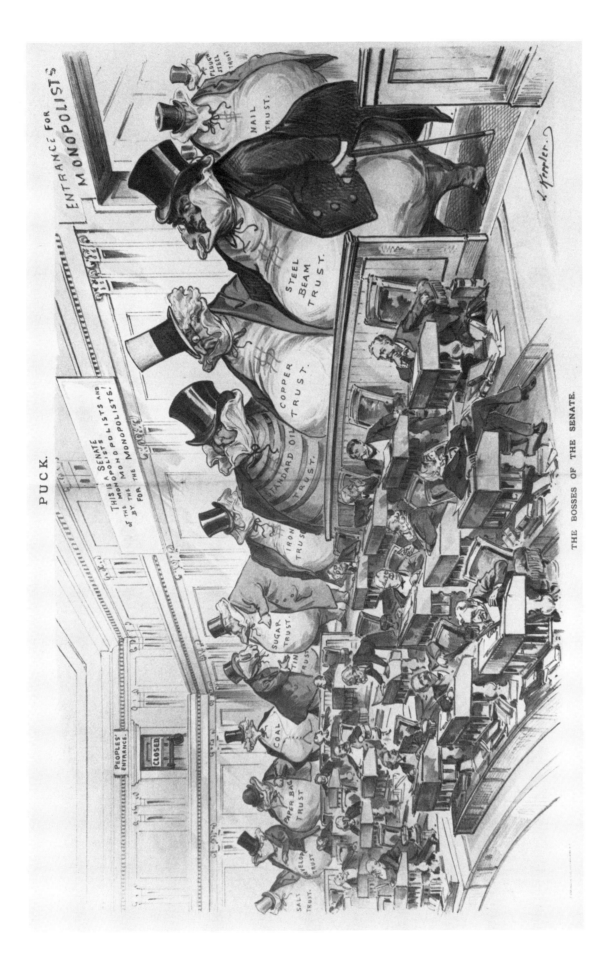

PUCK.

ENTRANCE FOR MONOPOLISTS

THIS IS A SENATE
OF THE MONOPOLISTS AND
BY THE MONOPOLISTS!
FOR THE MONOPOLISTS!

PEOPLES' ENTRANCE.

CLOSED

NAIL TRUST.

STEEL BEAM TRUST.

COPPER TRUST.

STANDARD OIL TRUST.

IRON TRUST.

SUGAR TRUST.

TIN TRUST.

COAL

PAPER BAG TRUST

SALT TRUST.

THE BOSSES OF THE SENATE.

136 "Building the High Tariff Tomb for the Republican Pharoahs." In 1889, when the Republican-controlled House and Senate revised the tariff schedule upward, Keppler predicted that the Republicans would suffer the mighty wrath of the American voter. William McKinley of Ohio, the author of the tariff bill, was singled out by Keppler and *Puck* for particular censure. When Keppler's prediction was born out at the polls and McKinley and many other Republicans went down to defeat, Keppler was jubilant. (Author's collection; *Puck*, Sept. 3, 1890)

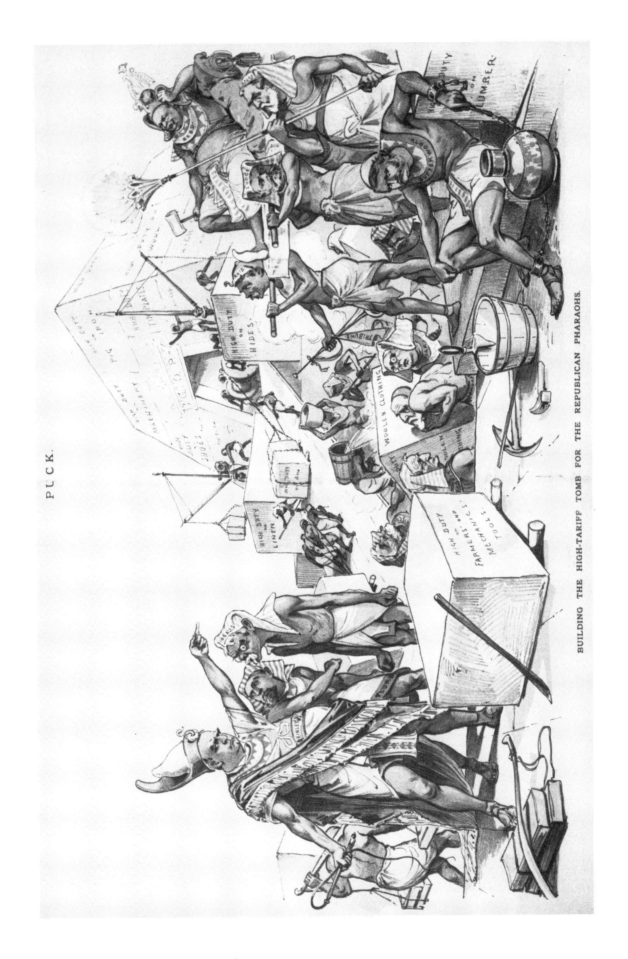

PUCK.

BUILDING THE HIGH-TARIFF TOMB FOR THE REPUBLICAN PHARAOHS.

137. **"One Slave and Many Masters."** If partisan politics were not removed from the civil service, it would control it. Here Harrison works the patronage mill to grind out more and more offices for those he was beholden to—voting blocks such as the Grand Army of the Republic veterans and the Irish, and party leaders such as Platt of New York and Quay of Pennsylvania. (Author's collection; *Puck*, Sept. 18, 1889)

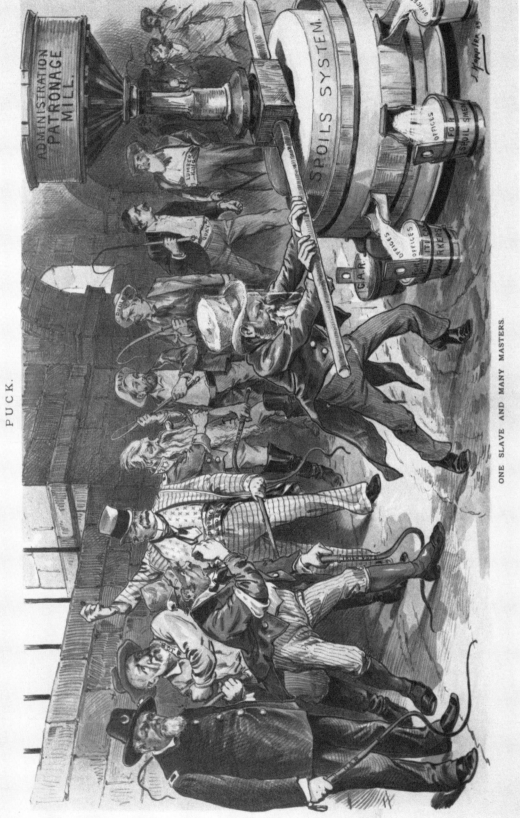

ONE SLAVE AND MANY MASTERS.

138. "The Little Republican Lord Fauntleroy." In 1889, Francis Hodgson Burnett's saccharine *Little Lord Fauntleroy,* the story of a boy who loved everyone and through his beatific presence restored peace to a warring household, was very popular. Mothers, desperately hoping their incorrigible offspring would become equally loving and angelic, dressed and coiffed their sons to resemble the little lord. Keppler suggested that President Harrison needed to adopt the costume and the ways of little Lord Fauntleroy if he wished to reconcile the factions in the Republican party. (Author's collection; *Puck,* March 6, 1889)

VOL. XXV.—No. 626. NEW YORK, MARCH 6, 1889. PRICE, TEN CENTS.

KEPPLER & SCHWARZMANN, Publishers. COPYRIGHT, 1889, BY KEPPLER & SCHWARZMANN. PUCK BUILDING, Cor. Houston & Mulberry Sts.

ENTERED AT THE POST OFFICE AT NEW YORK, AND ADMITTED FOR TRANSMISSION THROUGH THE MAILS AT SECOND CLASS RATES.

THE LITTLE REPUBLICAN LORD FAUNTLEROY.

He is going to try to please and reconcile everybody, bless his little heart!

139. "The Raven." President Harrison and Secretary of State James G. Blaine never shared more than a cordial regard for one another. Even that soured when Blaine came to embrace reciprocity—granting trade privileges to countries that extended the same or similar privileges to the United States—and Harrison continued to espouse protectionism. Keppler believed that Blaine's patience with the man he "allowed to become president" was now exhausted. As the raven, Blaine casts an ominous shadow over Harrison, a shadow symbolizing the impending end of the president's political career. (Author's collection; *Puck*, Aug. 13, 1890)

THE RAVEN.

140. "In Suspense." Keppler contended that Blaine, the political giant of the Republican party, could snuff out President Harrison's political life simply by announcing his availability for the 1892 nomination. It was not that simple. As president, Harrison had won the allegiance of a good many Republicans, but this cartoon imagery suited Keppler's design to portray Harrison as Blaine's pawn. (Author's collection; *Puck*, Sept. 9, 1891)

PUCK.

"IN SUSPENSE."

GIANT BLAINE.— To eat or not to eat — that is the question! I suppose I ought to be dieting — but would n't he make a juicy mouthful!

141. "The Little Man's Triumph." When Benjamin Harrison won his party's renomination in 1892, Keppler issued this caustic picture of the event. Party bosses Platt (with assistant Fassett), Quay, and Clarkson had maneuvered for Blaine's nomination but had lost, hence the bandages and chains. Railroad man Chauncey Depew and Indianapolis politico J. C. New led the drive for Harrison. Vice-presidential candidate and Blaine supporter Whitelaw Reid sits behind Harrison, tending to the patronage pig. (Author's collection; *Puck*, June 22, 1892)

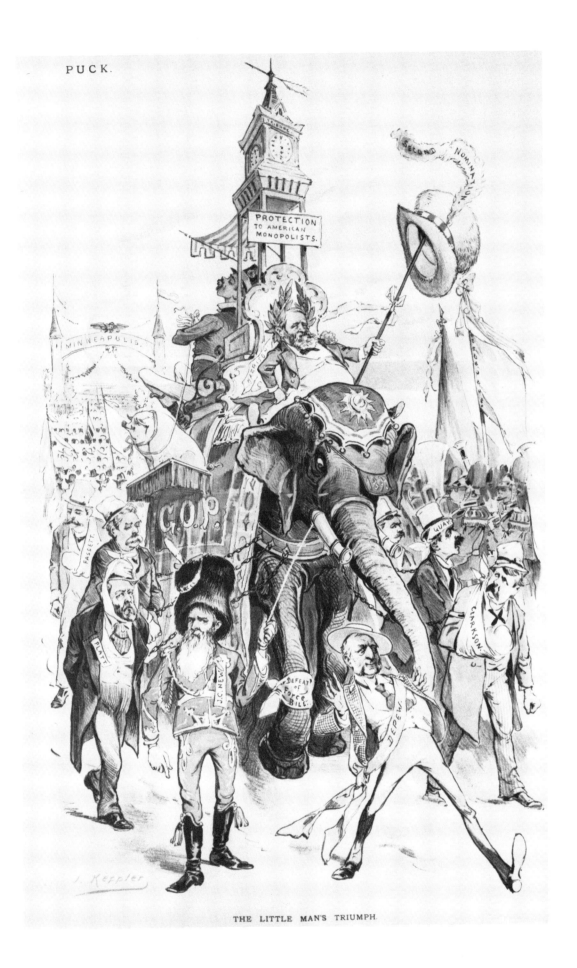

THE LITTLE MAN'S TRIUMPH.

142. **"Where Is He?"** Keppler's campaign to denigrate President Harrison by emphasizing his diminutive stature found its natural conclusion with this cartoon. Cleveland's landslide victory over Harrison ended Harrison's political career and influence. (Author's collection; *Puck*, Nov. 16, 1892)

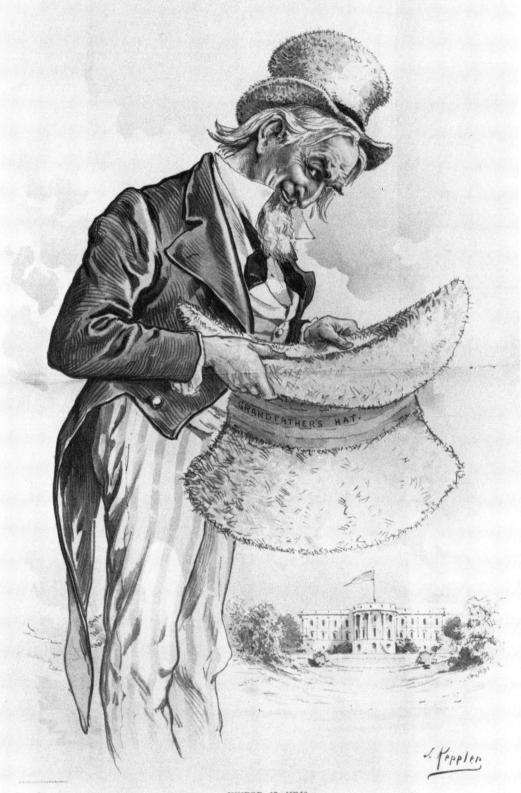

"WHERE IS HE?"

143. "Columbus Puck Discovering American Humor." Keppler drew this whimsical cartoon to mark Columbus Day, 1892. Surrounding Puck is the *Puck* staff. Artists Udo Keppler, Dalrymple, Taylor, and Opper stand to the left of Puck. Schwarzmann and Keppler kneel before him, while *Puck* editor Bunner and corporate cashier H. Wimmel stand to the right. Former staffers Carl Hauser and Leopold Schenck pull *Puck*'s boat ashore. The characters awaiting Puck on the left are the comic types that populated the magazine—ethnic groups, social classes, and professions. To the right flee the politicians and journalists who had felt *Puck*'s wrath over the preceding fifteen years. (Author's collection; *Puck*, Oct. 12, 1892)

COLUMBUS PUCK DISCOVERING AMERICAN HUMOR.

144. World's Fair Puck Building. When the Columbian Exposition Commission named Chicago as the site for the 1893 Fair, Keppler and Schwarzmann angled to secure a place there to display the art of lithography to the public. Noted architect Stanford White designed the building where the *Puck* staff produced a special edition of *Puck*—the *World's Fair Puck*. At the close of the fair, the Chicago Puck Building, like many other fair buildings, had to be sold at a loss. (Author's collection; supplement to *Puck*, Oct. 12, 1892)

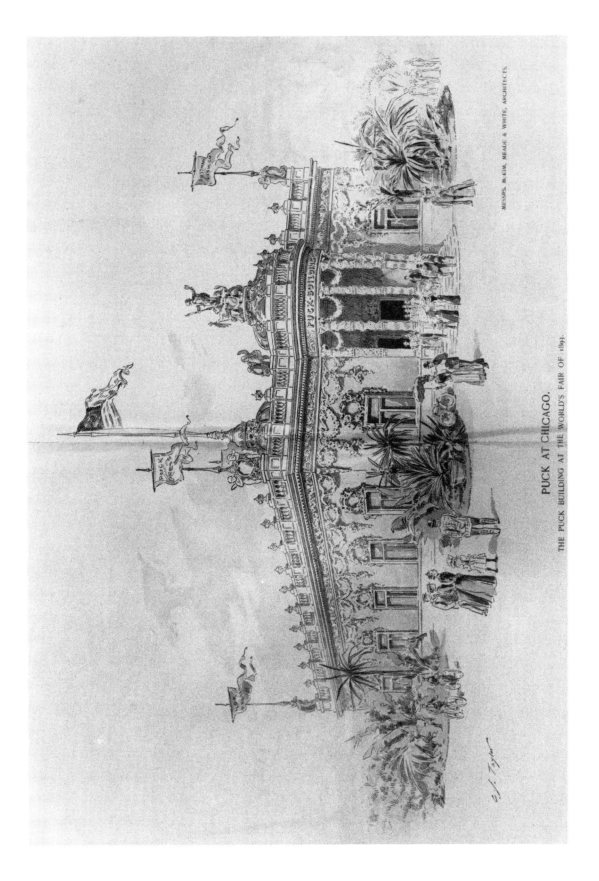

PUCK AT CHICAGO.

THE PUCK BUILDING AT THE WORLD'S FAIR OF 1893.

MESSRS. M'KIM, MEADE & WHITE, ARCHITECTS.

145. "A Peaceful Solution." While Keppler had more problems than he could handle in Chicago, the World's Fair itself was largely free of controversies. In this cartoon, he lampoons the fuss that was made over the brand of piano that Ignace Paderewski played at his World's Fair debut concert. (Author's collection; *World's Fair Puck*, May 15, 1893)

No. 2. PUCK BUILDING, Jackson Park, Chicago, May 15, 1893. PRICE 10 CENTS.

World's Fair Puck

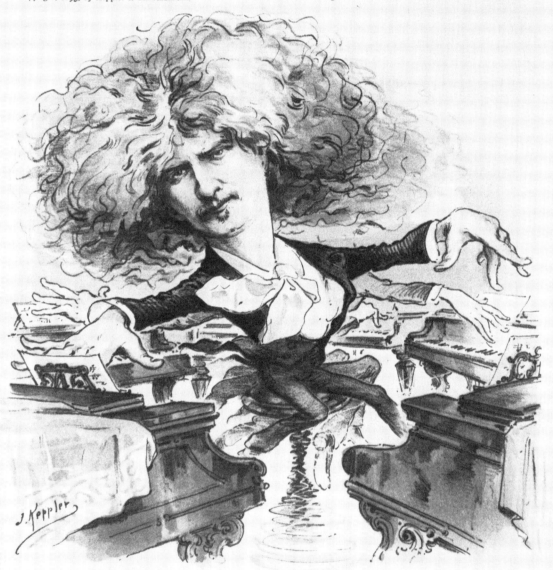

A PEACEFUL SOLUTION.

AT THE NEXT WORLD'S FAIR PADEREWSKI WILL PLAY ON ALL THE PIANOS AT ONCE.

146. **"We Don't Give Up the Fight."** Most of Keppler's *World's Fair Puck* cartoons were appropriately light-handed and celebratory, but he refused to be silenced on the matter of letting as many people as possible, especially the working class, enjoy the wonders of the fair. (Author's collection; *World's Fair Puck*, June 19, 1893)

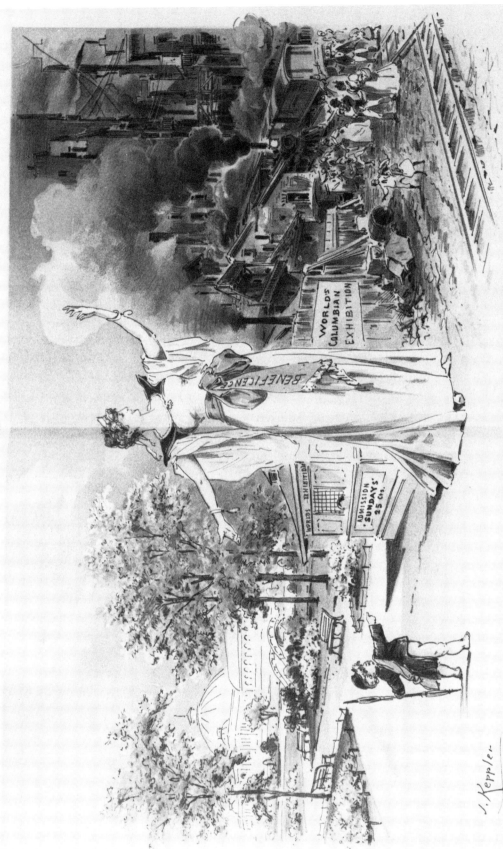

WE DON'T GIVE UP THE FIGHT.

THAT'S WHAT WE WANT TO SEE — THE FAIR NOT ONLY OPEN FOR THE PEOPLE ON SUNDAY BUT AT A POPULAR PRICE.

147. "Throw 'Em Out!" Reelected President Cleveland made his first order of business the repeal of the 1890 Sherman Silver Purchase Act, which he believed to be the chief cause of the depression just then beginning to grip the nation's economy. Ironically, Democratic senators, not Republicans, representing farm and silver mining states, were Cleveland's opponents in this fight. Keppler suggested a rather undemocratic plan for dealing with them. This, Keppler's last political cartoon, presaged the fight over the silver question that split the Democratic party and the country in the years that followed. (Author's collection; *Puck*, Nov. 1, 1893)

THROW 'EM OUT!

WHAT A PITY THIS IS ONLY A FANCY SKETCH!

Appendix:
Keppler's Colleagues and Students

BINDER, HEINRICH, editor (b. Vienna, 1829 - d. Detroit, 1894?). Took part in the 1848 revolution. Fled to Switzerland, then travelled to Italy, France, and, in 1852, the United States. Worked for tri-weekly *Albany Freie Blätter* (1854), Chicago daily *Illinois Staats-Zeitung* (1855–61), and St. Louis dailies *Westliche Post* (associate editor) and *Abend-Anzeiger* (associate editor). Founded, edited, and owned *St. Louiser Abendzeitung* (Dec. 1867–Oct. 1868). Co-founded, co-edited, and co-owned (with Karl Röser) *Die Neue Welt* (Nov. 1868–July 1869). Co-founded and co-owned (with Joseph Keppler) and edited *Die Vehme* (Aug. 1869–Aug. 1870). Founded, owned, and edited *Frank und Frei* (Sept.?–Oct.? 1870). Worked for *Chicagoer Freie Presse* (associate editor, 1873) and *Detroiter Abend-post* (editor, 1875–94, except for one year, March 1888– March 1889, when he served as editor of *Puck Illustrirtes Humoristisches-Wochenblatt!*).

BUNNER, H. C., editor (b. Oswego, N. Y., Aug. 3, 1855 - d. Nutley, N. J., May 11, 1896). Educated in public and private New York City schools. Contributed to literary magazine *Arcadian* (1873–77), and Rosenfeld's theater weeklies, *Figaro* and *Hornet* (1874). Worked for *Puck* (associate editor, March 14, 1877–April 24, 1878; managing editor, May 1, 1878–Oct. 16, 1878; editor, Oct. 23, 1878–May 11, 1896). Contributed to *Scribner's* and *Century*.

Novels: *A Woman of Honor* (1883), *The Midge* (1883), *The Story of a New York House* (1887). Short story collections: *In Partnership* (with Brander Matthews, 1884), *Short Sixes* (1890), *Zadoc Pines and Other Stories* (1891), *The Runaway Browns* (1892), *Made in France* (1893), *More Short Sixes* (1894), *The Suburban Sage* (1895), *Jersey Street and Jersey Lane* (1896), *Love in Old Cloathes*

(1897). Poetry: *Airs from Arcady* (1884), *Rowen* (1892), *The Poems of H. C. Bunner* (1897). Operettas: *Three Operettas* (1897).

BUTZ, CASPAR, poet (b. Hagen, Germany, Oct. 23, 1825 - d. Des Moines, Iowa, Oct. 19, 1885). Worked for *Hagener Zeitung* (editor, 1848). Took part in the 1848 revolution. Arrived in the United States in 1849. Worked for Detroit German-language literary magazine *Atlantis* (1853–54) and Chicago daily *Illinois Staats-Zeitung* (editor, Sunday edition, 1858?–63?). Founded and edited Chicago literary magazine *Deutsch-Amerikanische Monatshefte für Politik, Wissenschaft und Literatur* (1864–65). Contributed poetry and prose to *Puck Illustrirtes Humoristisches-Wochenblatt!* (1878–81). Worked for Keppler and Schwarz-mann's *Um Die Welt* (editor, Sept. 1881–Dec.? 1881). Died in Des Moines while establishing a family business there.
 Poetry: *Gedichte eines Deutsch-Amerikaners* (1879), *Grossvater-Lieder* (1887).

CIANI, G. E., cartoonist. Worked for *New York Daily Graphic* (1885), *Puck* (Dec. 1885–March 1887). Left the magazine to return to his native Italy.

DALRYMPLE, LOUIS, cartoonist (b. Cambridge, Illinois, Jan. 19, 1866 - d. Amityville, N. Y., Dec. 27, 1905). Studied at Art Students' League (1882) and Pennsylvania Academy of Fine Arts (1883). Worked for *The Judge* (Aug. 1883–March 1884), *New York Daily Graphic* (1886), and *Puck* (Nov. 1886–Oct. 1901). Editorial cartoonist for *St. Louis Post-Dispatch* (Oct.–Dec. 1901), newspapers in Philadelphia and Pittsburgh, and *Chicago Tribune* (Jan.–Feb. 1903). Worked for *Judge* (April 1903–April 1905) until he was overcome by effects of a venereal disease, which caused him to become blind and insane before his death at the end of the year.

EHRHART, SAMUEL D., cartoonist (b. Pottsville, Pa., circa 1862 - d. Mount Vernon?, N. Y., circa 1920). Educated in New York City school system. Contrib-uted to *Harper's Monthly* (1878–79) and *Puck* (1880). Studied art in Munich. Worked for *Judge* (1887) and *Puck* (April 1888–Dec. 1913).

GIBSON, WILLIAM CURTIS, editor (b. New York City, 1857 - d. New York City, circa 1915). Worked for *Puck* (office boy and subscription clerk, 1878–86; assistant editor, 1886–94; art editor, 1894–1906). Later became art editor of *Cosmopolitan*.

Books: *The Log of the Water Wagon* (with Bert Leston Taylor, 1905), *Extra Dry* (with Bert Leston Taylor, 1906).

GILLAM, T. BERNHARD, cartoonist (b. Banbury, England, April 28, 1856 - d. Canojoharie, N. Y., Jan. 19, 1896). Came to United States in 1866. Educated in Williamsburg, New York schools (1866–69). Worked as law clerk (1870). Contributed to *Wild Oats*. Worked for *Leslie's Pictorial* (1879). Contributed to *Harper's Weekly* (1880) and *New York Daily Graphic* (1880–81). Worked for *Frank Leslie's Illustrated Newspaper* (1881) and *Puck* (Oct. 19, 1881–Dec. 18, 1885). Was art director and later part-owner of *Judge* (Dec. 1885–Jan. 1896) and art director of *Leslie's Illustrated Newspaper* (Feb. 1889–Jan. 1896).

GRAETZ, FRIEDRICH, cartoonist (b. Vienna?, circa 1840 - d. Vienna?, circa 1913). Worked for *Puck* (March 1882–March 1885), Berlin's *Lustige Blätter* (1885?–90?), Vienna's *Floh* (1890?–1913?).

GRIFFIN, SYDNEY B., cartoonist (b. Boston, Oct. 15, 1854 - d. circa 1910). Educated in Detroit school system. First worked for a Detroit lithography company. Worked on *Puck* (1888–90) and free-lanced for *Judge, Hallo!, Truth,* and other magazines of the 1890s. Also was a partner with Walt McDougall in a poster company during this period. Created the comic strip "Clarence the Cop" for the New York *World* in 1901.

HAUSER, CARL, editor (b. Hungary, 1846 - d. New York City, April 15, 1915). Came to United States in 1875. Worked for *Puck Illustrirtes Humoristisches-Wochenblatt!* (office staff, 1876–82?; associate editor, 1882?–July 1892). Founded and edited German-language comic weekly *Hallo!* (July 24, 1892–March 21?, 1894). Worked for *Frank Leslie's Illustrierte Zeitung* (last editor, 1894) and comic weekly *Der Freischütz* (editor, 1894–1908).

HEROLD, FRIEDRICH, editor (b. Nuremberg, 1843 - d. St. Louis, Aug. 11, 1871). Educated at Munich University. Immigrated to the United States in 1866. Worked for Pittsburgh weekly *Der Freiheits-Freund*. Founded and edited Pittsburgh weekly *Die Glocke* (1868?). Worked for Chicago daily *Illinois Staats-Zeitung* and St. Louis *Abend-Anzeiger's* weekly edition, *Anzeiger des Westens* (associate editor). Co-founded and co-owned (with Joseph Keppler) and edited St. Louis *Puck* (March 18, 1871–Aug. 11, 1871).

Honthumb, Caspar Alexander, editor. Founded and edited Cincinnati comic weekly *Die Kratzbürste* (1870). Edited German-language dailies, *Cincinnati Courier* (1873?–74) and *Cincinnatier Freie Presse* (1874–79?). Worked for *Puck Illustrirtes Humoristisches-Wochenblatt!* (associate editor, 1879?–82). Edited *Um Die Welt* (Jan.? 1882–Feb. 28, 1885).

Hutchins, Frank Marion, cartoonist (b. Burlington, N. J., circa 1867 - d. Philadelphia, May 5, 1896). Worked for National Bureau of Engraving in Burlington and several Chicago newspapers. Worked for *World's Fair Puck* (1893) and *Puck* (1893–96).

Keppler, Udo (Joseph, Jr.), cartoonist (b. St. Louis, April 4, 1872 - d. La Jolla, Calif., July 4, 1956). Educated at German-American School of New York and New York City Grammar School. Graduated from Columbia Institute in 1888. Studied under Wilhelm Dietz at Academy of Arts in Munich (1890). Worked for *Puck* (Nov. 1890–March 1891). Studied in Heilbronn, Germany (1891). Rejoined *Puck* in November 1891. Changed name to Joseph Keppler, Jr. on Feb. 28, 1894, nine days after father's death. Became chief cartoonist in 1901. Sold *Puck* in December 1913 to Nathan Straus, Jr. Remained art editor for four months. Contributed cartoons to *Puck* until July and then to *Judge* and *Leslie's Weekly* until April 1915. Retired to Woodland, New York and then moved to California in 1946. Devoted more than fifty years of his life to the study and preservation of Indian culture. Declined President Theodore Roosevelt's offer to become Commissioner of Indian Affairs.

Knotser, Emil, lawyer, editor (b. Vienna, 1830 - d. New York City, April 28, 1888). Attended law school in Vienna. Came to United States in 1873. Worked for daily *Milwaukee Seebote* (editor, 1874–87), and *Puck Illustrirtes Humoristisches-Wochenblatt!* (editor, July 1887–March 1888). Wrote several plays.

McCardell, Roy L., editor (b. Hagerstown, Md., June 30, 1870 - d.?). Worked for Birmingham, Alabama *Age-Herald*, *New York Evening Sun* (1890–91), New York *World* (1891–93), *World's Fair Puck* (associate editor, 1893), *Puck* (associate editor, 1893–98), *Vim* (editor, 1898), *Sunday Telegraph* (editor, 1898–1900), *Metropolitan* magazine (editor, 1901), and New York *World* (1902–16). Wrote several juveniles.

Morgan, Matt, cartoonist (b. London, April 27, 1839 - d. New York City, June 2, 1890). War artist for *Illustrated London News* (1859) and cartoonist for

London *Fun* (1862–67) before founding comic weekly, *Tomahawk* (May 11, 1867–Aug. 27, 1870). Came to U.S. in October 1870 to be chief cartoonist for *Frank Leslie's Illustrated Newspaper*. Left *Newspaper* in November 1874. Founded Morgan Art Pottery Company. Managed Strobridge Lithographic Company of Cincinnati. Named art director of *Collier's Once a Week* magazine in 1888 and served in that post until his death.

 Collections: *American Civil War Cartoons* (1874).

MÜLLER, WILHELM, editor (b. Heppenheim, Germany, 1845 - d.?). Came to U.S. in 1866. Taught in Indianapolis and Cincinnati. Worked for *Puck Illustrirtes Humoristisches-Wochenblatt!* (associate editor, 1878?–March 1886; editor, March 1886–July 1887 and March 1889–Aug. 24, 1898 [interrupted tenure due to poor health]).

MUNKITTRICK, RICHARD KENDALL, editor (b. Manchester, England, March 5, 1853 - d. Stamford, Conn., Oct. 17, 1911). Worked for *Puck* (contributor, 1877–81 and 1889–1901; associate editor 1881–89), and *Judge* (editor, September, 1901–5).

 Works: *Some New Jersey Arabian Nights* (1893), *Farming* (1896), *Bugville Nights* (1902).

OPPER, FREDERICK BURR, cartoonist (b. Madison, Ohio, Jan. 2, 1857 - d. New Rochelle, N. Y., Aug. 27, 1937). Educated in the Madison public school system. Worked in *Madison Gazette* printing office (1871). Moved to New York and worked in a dry goods store while contributing drawings to *Wild Oats* (1873–77). Worked for *Frank Leslie's Budget of Fun* (1877–78), *Frank Leslie's Illustrated Newspaper* (1878–80), *Puck* (Feb. 1880–May 1899). Hired away by William Randolph Hearst to draw political cartoons and comic strips for *New York Journal* (later *Journal-American*). During his thirty-three years with that paper, he created the political series "Willie and His Papa" and "The Alphabet Trusts," as well as the comic strips "Happy Hooligan," "Alphonse and Gaston," "Maude the Mule," and others.

 Collections: *A Museum of Wonders* (1884), *The Opper Book* (1888), *This Funny World as Puck Sees It* (1890), *Just for Fun* (1896), *Willie and His Papa* (1901), plus many comic strip collections.

PAINE, HENRY GALLUP, editor (b. Albany, N. Y., April 24, 1859 - d. May 30, 1929). Graduated from Columbia University (1880). Worked for *St. Nicholas* magazine (1882–87); *Puck* (associate editor, 1887–93); *World's Fair Puck* (editor,

1893); *Harper's Weekly* (assistant editor, 1893–94; managing editor, 1894-1900); *New York Daily News* (1901–3); *New York Tribune Literary Review* (editor, 1904–7): and *National Sunday Magazine* (editor, 1911–13).

Rogers, WILLIAM ALLEN, cartoonist (b. Springfield, Ohio, May 23, 1854 - d. Washington, D.C., Oct. 20, 1931). Studied at Worcester Polytechnic Institute. Worked for *New York Daily Graphic* (1873–77), *Harper's Weekly (1877–92; 1893–1902), Puck* (1892–93), and *New York Herald* (chief editorial cartoonist, 1902–22).

Rosenfeld, SYDNEY, writer (b. Richmond, Va., 1855 - d. New York City, June 13, 1931). Educated in New York City. Produced his first play in 1874. Worked for *Frank Leslie's Illustrated Newspaper* (circa 1873). Founded a dramatic weekly, named *Figaro*, then *Hornet*, that lasted only a few months (1874). Worked for *New York Sun* and *New York World*. Co-founded and edited English-language *Puck* (March 14, 1877–April 24, 1878). Founded and edited *The Rambler and Dramatic Weekly* (Jan. 25, 1879–Aug. 30, 1879). Worked as a playwright and drama critic until his retirement in 1923.

Schenck, LEOPOLD, editor (b. Heidelberg, Nov. 15, 1843 - d. Aiken, S. C., April 13, 1886). Educated in Bonn, Heidelberg, and Freiborg. Immigrated to the United States in 1868. Worked for Newark *New Jersey Freie Zeitung*, *St. Charles Demokrat*, St. Louis *Westliche Post*, and *Chicagoer Freie Presse* (associate editor, 1871–76). Served as first editor of *Puck Illustrirtes Humoristisches-Wochenblatt!* (Sept. 23, 1876– March, 1886).

Schwarzmann, ADOLPH, businessman (b. Konigsburg, Germany, 1838 - d. New York City, Feb. 4, 1904). Trained as a printer. Came to U.S. in 1858. Worked in Frank Leslie Publishing House print shop (circa 1862–75), eventually becoming foreman. Became co-owner of *New Yorker Musik-Zeitung* in 1875 and sole owner in June 1876. Co-founded and co-owned (with Joseph Keppler) and managed *Puck Illustrirtes Humoristisches-Wochenblatt!* (Sept. 26, 1876–Aug. 24, 1898), English-language *Puck* (March 14, 1877–Feb. 4, 1904), and *Um Die Welt* (Sept. 10, 1881–Feb. 28, 1885). Supervised publication of other Keppler and Schwarzmann, Inc. periodicals. Elected president of J. Ottmann Lithography Company in 1889, following Jacob Ottmann's death. Became editor-in-chief of *Puck* in 1896, following H. C. Bunner's death.

SHULTS, A. B., cartoonist. Worked on *New York Daily Graphic* (1885), *Tidbits* (1886), and *Puck* (April 1886–April 1888).

STUR, CARL EDLER von, cartoonist (b. Wolfsberg, Germany, Feb. 10, 1840 - d. Lainz, Germany, June 2, 1905). Educated at Vienna Academy of Fine Arts (1857–58). Worked for comic weeklies *Kikeriki!* (1861–72), *Floh* (1873–75), *Wiener Luft* (1875–80), *Puck* (Dec. 1880–June 1881), and *Floh* (1881–1905; except for one year on Berlin's *Lustige Blätter* [1887–88]).

TAYLOR, CHARLES JAY, cartoonist (b. New York City, Aug. 11, 1855 - d. Pittsburgh, Jan. 19, 1929). Studied at National Academy of Design, Art Students' League, and at schools in Paris and London. Received an LL.B. degree from Columbia University (1874). Worked for *New York Daily Graphic*, *Puck* (April 1886–Jan. 1900), *Judge* (Nov. 1901–Aug. 1902). Became professor of the arts at Carnegie Institute of Technology (1911); later, head of department of painting and illustration, the post he held at the time of his death.

Collections: *The Tailor-Made Girl* (with Philip Welch, 1888); *In the "400" and Out* (1889); *England* (1899); also illustrated seven short-story collections by *Puck* writers published by Keppler and Schwarzmann in the 1890s.

VALLENTINE, BENJAMIN BENTON, writer (b. London, Sept. 7, 1843 - d. New York City, March 30, 1926). Educated in England. Came to U.S. in 1871. Worked for *Puck* (associate editor, May 1878–Oct. 1884). Worked for Chicago weeklies *The Newsletter* (editor, Nov.–Dec. 1884) and *Chicago Rambler* (editor, Jan.–Feb. 1885). Founded and edited comic weekly *Snap* (March 14, 1885–April 25, 1885). Worked for Irving Bacheller's Newspaper Syndicate (managing editor, 1886–87), *New York Herald* (1891–98), and *New York American* (1902–3). Wrote and translated a score of plays.

WALES, JAMES ALBERT, cartoonist (b. Clyde, Ohio, Aug. 30, 1852 - d. New York City, Dec. 6, 1886). Educated in Sandusky, Ohio public school system. Worked for engraving firms in Toledo and Cincinnati (House of Bogart and Stillman). Served as political cartoonist for the *Cleveland Leader* during the 1872 presidential campaign. Contributed to *Wild Oats* (1873–75), *Harper's Weekly* (1874). Went to London to study art and trained under sculptor Ernest Pardessons. Contributed to *Judy* and the *Illustrated London News*. Studied at the Louvre in Paris. Worked for *Frank Leslie's Illustrated Newspaper* and other Frank Leslie

publications (Oct. 1876 to Jan. 1879), and for *Puck* (Feb. 12, 1879–Oct. 5, 1881). Co-founded and served as art director for *The Judge* (Oct. 29, 1881–March 8, 1884). Free-lanced for *The World*, *The Morning Journal*, *The Journalist*, *Jingo* (1884), and *Snap* (1885). Rejoined *Puck* (Dec. 1885–Aug. 1886). Died of an accidental drug overdose.

WELCKER, FRITZ, cartoonist. Worked for St. Louis *Puck* (Nov. 25, 1871–Aug. 24, 1872) and family weekly *Unser Blatt* (Jan. 1873–Feb. 1873). Worked for comic weekly *Die Laterne* (1877–96?).

WILLICH, LOUIS, writer (b. Darmstadt, Germany, May 27, 1840 - d. St. Louis, 1896?). Came to United States in 1863. Served in Union Army. Worked for *Illinois Staats-Zeitung* (1865–67) and St. Louis *Westliche Post* (associate editor, 1867–71). Owned and edited St. Louis *Puck* (Nov. 1871–Aug. 24, 1872). Founded and edited St. Louis comic weekly *Die Laterne* (1877–96; publisher 1883–96). Began an English-language edition, *The Lantern*, on June 24, 1882, which had a short life. Also edited *Deutsch-Amerikanische Krieger-Zeitung* (1892–96), organ of a German-American Civil War veterans society, published as a weekly in St. Louis during his editorship.

WILSON, HARRY LEON, writer (b. Oregon, Ill., May 1, 1867 - d. Carmel, Calif., June 28, 1939). Worked for *Puck* (assistant editor, 1892–96; literary editor, 1896–1902). Became novelist and regular contributor to *Saturday Evening Post*. Married for five years (1902–7) to cartoonist Rose O'Neill.

Books: *Zig-Zag Tales* (1894), *The Man from Home* (with Booth Tarkington, 1908), *Ruggles of Red Gap* (1915), *Merton of the Movies* (1922), and twenty-two other novels and plays.

ZIMMERMAN, EUGENE, cartoonist (b. Basel, Switzerland, May 25, 1862 - d. Horseheads, N. Y., March 26, 1935). Came to the U.S. in 1869. Educated in Paterson, N. J. public schools. Worked in many odd jobs before becoming a sign painter and moving to Elmira, N. Y. in 1879. Worked for *Puck* (May 1883–Dec. 1885) and *Judge* (Dec. 1885–1913). Started Zim's Correspondence School of Cartooning, Comic Art and Caricature in 1912. Contributed regularly to *Cartoons* magazine (1913–24).

Books: *Zim's Sketches from Judge* (1888), *Zim's Characters in Pen and Ink* (1900), *This and That About Caricature* (1905), *Cartoons and Caricatures* (1910), and several comic histories of his adopted home of Horseheads, N. Y.

Acknowledgments
and Selected Bibliography

FEW BIOGRAPHERS have the opportunity to meet their subjects face to face.
I have had that opportunity, in a manner of speaking. Soon after Keppler's death,
his family commissioned the sculpting of a death mask. Today that mask is kept
deep in the recesses of the New-York Historical Society Museum collection. What
an odd experience to hold up Keppler's face in front of my own. His features were
smaller than I imagined them to be, his face as gaunt and tired-looking as would
be expected of a man who had struggled through six months of a fatal illness. A
few of his lashes were still imbedded in the plaster, an eerie reminder that this
likeness was not an abstraction.

To my regret, this face-to-face encounter with Keppler did not yield any
answers to the mysteries of his life. For a man who thrived on celebrity, Keppler
left surprisingly little behind to remember him by. He did leave, of course, his
work, and nearly all of it, excepting his oil paintings, has survived to this day.
My task was made easier because the works in question are political cartoons,
an art in which the artist reveals much more of his or her day-to-day thoughts
and opinions than one does in conventional fine art. Some might argue that if
you have access to an artist's work, you have all that you need to know about
the person. I disagree with this, believing motivation and means are as important
as ends.

It is that belief, however, and the pausity of personal memorabilia left behind
by Keppler that have made this biography such a challenge. In a sense, Keppler
has been my co-author. His work brightens the pages of this work in ways none
of my words could have conveyed. But from his days in the latter half of the
nineteenth century to my days in the latter half of the twentieth, he has not been

communicative. The critical reader will discover that I have woven some swatches of Keppler's life with very few threads indeed. I am not revealing this to excuse lapses in the text so much as to assure the frustrated reader that precious little information has been withheld; it simply isn't extant.

If Keppler has not been particularly cooperative, others who are counted among the living have. Many friends and acquaintances gave of their talents and time to help me reconstruct Keppler's life.

In writing this book, I followed in the path of Draper Hill, scholar, cartoonist, and friend. His 1957 Harvard College undergraduate thesis on Keppler is a model of its kind, erudite and mature beyond the age of its young author. Hill, today at work on a biography of Nast, took time out of his busy schedule to read the manuscript and provide meticulous and helpful criticism.

Martin DiCarlantonio read the manuscript several times. I am grateful to him for his unflagging support, enthusiasm, and solid editorial guidance. Katherine Carey applied her expert and rigorous editor's pen to the manuscript as well, much to its benefit. Bruce Wheltle did likewise, supplying me with a sheaf of thoughtful and pointed criticism.

Roger Fischer, professor of American culture and a fan of cartoons, provided valuable advice for strengthening the manuscript. He also served as a worthy debating opponent on the merits and demerits of Keppler's work.

Dieter Engelbrecht, translator, served as my eyes into Keppler's German world. No author could hope for a more fruitful and warm collaboration.

I would also like to tender thanks to the following people who helped me in various ways: John Maass, Peter Havas, Katherine O. West, Kendall Mattern, Jr., and Ray Kaser.

Thanks must be paid to the staffs of the following libraries and collections: University of Massachusetts-Amherst (Special Collections and Rare Books, John D. Kendall, curator); Forbes Library, Northhampton, Massachusetts; New-York Historical Society (Prints Department, Manuscript Department, museum collection); New York Public Library (Prints Department, Manuscript Department, general collection); Firestone Library, Princeton University, Princeton, New Jersey; Free Library of Philadelphia; German Society of Pennsylvania Library (Dieter Engelbrecht, librarian), Philadelphia; Magill Library, Haverford College, Haverford, Pennsylvania; Library of Congress (Rare Book Room, general collection), Washington; Missouri Historical Society (Janice L. Fox, researcher in residence), St. Louis; National Archives (Microfilm), Washington; St. Louis Public Library (Anne Watts, readers' services); Huntington Library, San Marino, California; New Orleans Historical Society.

I am grateful to my agent, Toni Mendez, and her staff, particularly Joy Sikorski. Thanks too to the University of Illinois Press, senior editor Judith McCulloh, and copy editor Mary Giles for their enthusiastic support and diligence in shepherding *Satire on Stone* through to completion.

Primary material

Only a handful of Keppler's personal letters are in public collections. Nearly all of them are in the Manuscript Room of the New-York Historical Society. This cachet, along with other important Keppler documents and memorabilia, was donated to the society in the 1950s by Mrs. Joseph Keppler, Jr. She gave most of the family's other personal affects to Draper Hill, now of Detroit, who has them still. Original Keppler artwork is almost as scarce. What is extant can be found also at the society and at the New York Public Library, Print Room, as well as in private hands, such as the distinguished collection of Art Wood of Rockville, Maryland.

Evidence of Keppler's life is most plentiful in his published work. A complete run of *Kikeriki!* can be found at the University of Massachusetts-Amherst. A complete run of Keppler's first magazine, *Die Vehme* of St. Louis, is in the New York Public Library, a gift from Joseph Keppler, Jr., to his friend and the longtime curator of prints at that institution, Frank Weitenkampf. No copies of *Frank und Frei*, for which Keppler was chief cartoonist, survive. No complete run of Keppler's second magazine, the St. Louis *Puck*, survives, either. The New York Public Library, the Widener Library at Harvard University, the Missouri Historical Society, and the St. Louis Public Library all have complete sets of the magazine's first year. The St. Louis Public Library had a complete set of volume two when I began my research, but the volume has since disappeared from their collection. Only the Missouri Historical Society has a large sampling (nine of twenty issues) of the English-language edition of the St. Louis *Puck*. That society also has a complete run of the family paper *Unser Blatt*, to which Keppler contributed in 1872.

The Library of Congress has the only complete run of *Frank Leslie's Budget of Fun* during the time Keppler contributed to it. No copies of Frank Leslie's *The Jolly Joker* are in public collections. *Frank Leslie's Illustrated Newspaper* is common and can be found in most major libraries, including the New York Public Library and the Library of Congress.

Adolph Schwarzmann's *New-Yorker Muzik-Zeitung* survives in the Music Collection at the Lennox Avenue branch of the New York Public Library system. *Puck-Illustrirtes Humoristisches-Wochenblatt!* can also be found at the New York

Public Library and in other major collections. A full run of the English-language edition of *Puck* is becoming increasingly difficult to locate. The New York Public Library has a set. The Library of Congress has microfilmed its run and turned the crumbling remains over to their Prints and Photographs Division. Both the New York Public Library and the Library of Congress have complete runs of Keppler and Schwarzmann's auxillary publications, including *Puck's Volks-Kalender*, *Puck's Annual*, *Puck on Wheels*, *Um Die Welt*, *Pickings from Puck*, *Puck's Library*, and *Puck's Quarterly*.

Other valuable primary sources include published interviews and biographical sketches, the most important being "Keppler Tells How to Make Cartoons," from the *New York Herald*, Sept. 18, 1892. Of secondary importance are as follows: the informal interview with Keppler that appeared in *The Epoch's* (New York) "Highways and By-ways" column in the July 25, 1890, issue; two profiles of the artist that appeared in the volatile *Journalist* entitled, "America's German Caricaturist" (Oct. 2, 1886) and "Some American Caricaturists" (Nov. 19, 1887); and obituaries that appeared in New York's English-language and German-language press, February 20, 1894. The fact that nearly all of these sources contradict one another, and nearly all are wrong on one point or another, should give future researchers pause.

Of contemporaries who wrote about Keppler, the richest source by far is the writings of Eugene Zimmerman, particularly his autobiography. (The first seven chapters of Zim's autobiography were published in *Cartoonist Profiles* from December 1980 to June 1982. When citing material from these chapters, I have referred to the *Cartoonist Profiles* page numbers. When citing material from subsequent, unpublished chapters, I have referred to the typescript in the possession of the Horseheads, New York, Historical Society.) Also helpful were Zim's series of articles "Rambles in Cartoondom," which appeared in *Cartoons Magazine* in 1914 and 1915; and the twenty booklets that comprise *Zim's Correspondence School of Cartooning Comic Art and Caricature*, published by the author in 1912. Zim had reason to dislike Keppler for his politics and for the way in which his company treated its employees, but he clearly revered the man, professionally and personally. No more heartfelt or revealing tributes to Keppler's life and work survive.

Information about Keppler's colleagues is scarce. The total of what is known about Keppler's partner, Adolph Schwarzmann, is contained in New York newspaper obituaries, which appeared February 5, 1904. *Puck's* editor, Bunner, is treated in Gerald Jensen's undisciplined and uninspired work *The Life and Letters of H. C. Bunner* (Durham, N.C.: Duke University Press, 1939). A far more interesting and evocative portrait emerges from the writings of Bunner's associate,

Henry Gallup Paine, particularly in his "H. C. Bunner and His Circle" (*The Bookman*, June 1912).

Secondary material

The only important secondary source of Keppler biographical data is the writings of Draper Hill. After completing his useful and reliable Harvard College A.B. thesis, "What Fools These Mortals Be!" in 1957, he traveled to Vienna and produced an equally useful addendum to that biography, "The Early Life of Joseph Keppler and His Family."

Keppler's place in the pantheon of American cartooning is adequately emphasized in *A Century of American Political Cartoons* by Allan Nevins and Frank Weitenkampf (New York: Scribners, 1944), in *A History of American Graphic Humor* by William Murrell (New York: Whitney Museum of American Art, 1933, 1937), and in the definitive history of political cartoons, *The Ungentlemanly Art* by Stephen Hess and Milton Kaplan (New York: Macmillan, 1968). Dozens of Keppler cartoons are beautifully reproduced in Gordon Campbell's *The Pen, Not the Sword* (Nashville: Aurora Press, 1971), a hastily compiled and edited anthology of cartoons from *Puck* and *Judge*.

In recent years, several challenging and important monographs on ethnicity and religion in Keppler's work, or the work of the *Puck* staff in general, have been published. Foremost among them are Gary L. Bunker and Davis Bitton's *The Mormon Graphic Image, 1834–1914* (Salt Lake City: University of Utah Press, 1983); Samuel J. Thomas's "Portraits of a 'Rebel' Priest: Edward McGlynn in Caricature, 1886–1893" *Journal of American Culture* (Winter 1984); and the writings of John J. Appel, including "From Shanties to Lace Curtains: The Irish Image in *Puck*, 1876–1910," *Comparative Studies in Society and History* (Oct. 1971); "Jews in American Caricature: 1820–1914," *American Jewish History* (Sept. 1981); and *Jews in American Graphic Satire and Humor* (Cincinnati: American Jewish Archives, 1984).

Photo Credits

Fuhrman Photography: Figures A, B, D-Q
Theodore Gladwell: Figure 6
Hutchins Photography: Figure 60
Dolores Neuman: Figures 1 (inset), 8–11, 16–20, 22–23, 30–38, 40–43, 47–49, 51–56, 58–59, 62, 65, 66–88, 91–119, 121, 123–48; Figure C.

Notes

Periodicals

BoF: *Frank Leslie's Budget of Fun* (New York: 1859–78)

DV: *Die Vehme* (St. Louis: 1869–70)

FLIN: *Frank Leslie's Illustrated Newspaper* (New York: 1855–1922)

GP: *Puck-Illustrirtes Humoristisches, Wochenblatt!* (New York: 1876–98)

P: *Puck* (New York: 1877–1918)

SLP: *Puck* (St. Louis: 1871–72)

UB: *Unser Blatt* (St. Louis: 1872–73)

Collections

NYHSM: New-York Historical Society, Manuscript Room.

NYHSP: New-York Historical Society, Print Room.

NYPL: New York Public Library, General Stacks.

NYPLM: New York Public Library, Manuscript Room.

NYPLP: New York Public Library, Print Room.

DSH: Draper and Sarah Hill Collection, Grosse Pointe, Mich.

ONE. The Brilliant Thread

1. Tudor Jenks, *The Century World's Fair Book* (New York: Century, 1893), flyleaf map, pp. 112–26; "World's Columbian Exposition," *Encyclopedia Americana*, vol. 29 (Danbury, Conn.: Grolier, 1976), p. 533.

2. *P*, Oct. 12, 1892, p. 126.

3. "World's Columbian Exposition."

4. Julian Ralph, "Solemn Funny People," *Des Moines Leader*, April 15, 1887, in the Zim scrapbook, Zim House, Horseheads, N.Y.; "Joseph Keppler," [*New York World*, 1886] in the Keppler scrapbook, vol. 1, NYPLP; Frank Linstow White, "Some American Caricaturists," *The Journalist*, Nov. 19, 1887, p. 6; "Death of Joseph Keppler," *New York Times*, Feb. 20, 1894.

5. Joseph Victor von Scheffel, *Ekkehard* (New York: T. Y. Crowell, 1895).

6. William Allen Rogers, *A World Worth While* (New York: Harper and Brothers, 1922), pp. 217–18.

7. Rogers, *A World Worth While*, p. 218.

8. "World's Columbian Exposition."

9. Draper Hill, "The Early Life of Joseph Keppler and His Family," typescript in author's possession dated Oct. 18, 1957, p. 1; "Joseph Keppler," *New Yorker Staats Zeitung*, Feb. 20, 1894, incorrectly records his birthplace as the Lerchenfeld district of Vienna. This is where he lived in the 1860s when he was employed by the Josefstadt Theater.

10. "Artist Keppler Is Dead," *New York Herald*, Feb. 20, 1894; "Joseph Keppler."

11. Hill, "The Early Life of Joseph Keppler and His Family," p. 1. The Keppler children were born as follows: Franz, Sept. 19, 1836; Joseph, Feb. 1, 1838; John, Feb. 20, 1840; Karl, July 15, 1841; Rudolph, April 12, 1844; Aloysia, June 10, 1847.

12. Ibid., p. 2. Certificates of graduation are part of the Keppler collection, NYHSM.

13. Draper Hill, "What Fools These Mortals Be!" A. B. thesis, Harvard College, 1957, pp. 3–4.

14. Ulrich Thieme and Felix Becker, *Allgemeines Lexikon Der Bildenden Künstler*, vol. 13 (Leipzig: Verlag von E. A. Seemann, 1920), pp. 344–45.

15. James White, "Joseph Keppler," *National Cyclopedia of American Biography*, vol. 2 (New York: James T. White, 1899), p. 225; Thomas Evans, "Joseph Keppler," *Men of Affairs of the Empire State* (New York: T. H. Evans Publishing, 1895), p. 201.

16. "Highways and By-ways" [informal Keppler interview], *The Epoch*, July 25, 1890, p. 391; Evans, "Joseph Keppler," p. 201; "America's German Caricaturist," *The Journalist*, Oct. 2, 1886, p. 3.

17. Evans, "Joseph Keppler," p. 201.

18. H. C. Bunner, ed., *A Selection of Cartoons from Puck by Joseph Keppler* (New York: Keppler and Schwarzmann, 1893), pp. vi–vii.

19. "Highways and By-ways."

20. Ibid.; Hill, "Early Life of Joseph Keppler and His Family," p. 2.

21. Information about Minna Rubens Keppler was pieced together from the following sources: theater poster advertising "Benefize Des Komikers" (Bozen, Italy; 1866), Keppler collection, NYHSP; "Aus Joseph Keppler's Leben Der St. Louiser Ausenthalt . . ." (Keppler's Life in St. Louis), *New Yorker Staats Zeitung*, Feb. 21, 1984; "Minna Keppler," certified copy of death, Bureau of Vital Statistics, City of St. Louis, Dec. 16, 1870; Keppler's memorial painting to his wife, DSH collection; geneologic notes in longhand by Joseph Keppler, Jr., DSH collection.

22. The contract Keppler signed with the Josefstadt is in the Keppler collection, NYHSM; Hill, "Early Life of Joseph Keppler," pp. 2–3, traces Keppler's performances in Vienna and the Tyrol; The Josefstadt's financial troubles revealed in the Keppler cartoon, "Der Systemwechsel in der Josefstadt" (Change of Management in the Josefstadt), *Kikeriki!* July 13, 1865, cover.

23. Hill, "Early Life of Joseph Keppler and His Family," p. 2; theater poster in Keppler collection, NYHSP.

24. Hill, "Early Life of Joseph Keppler and His Family," p. 3; "Highways and By-ways."

25. The University of Massachusetts, Amherst, has a complete run of *Kikeriki!*. Keppler's cartoons appeared in the following issues:

 1863: April 30, p. 8 and May 28, p. 8 (unsigned; attributed by Hill); Dec. 10, p. 8.

 1864: May 12, cover; May 26, p. 3; June 16, cover and p. 8; June 23, p. 4; June 30, p. 8; Aug. 11, p. 8; Aug. 25, p. 7; Sept. 15, p. 4; Nov. 10, cover.

 1865: July 13, cover; July 20, p. 3; Aug. 3, pp. 2 and 3; Aug. 17, cover and p. 8; Sept. 7, p. 7.

1866: July 19, p. 3; Aug. 2, cover; Aug. 9, p. 2.

1867: May 9, p. 3; May 23, p. 2; Aug. 29, p. 3; Oct. 3, p. 2.

26. Information about the Keppler children is pieced together from geneologic notes, DSH collection. Keppler, Jr., records that his father's first wife had twins. A photograph in the DSH collection shows a woman (presumably Minna Keppler) holding one child about six weeks old. Inexplicably, the upper part of the photo, featuring the woman's head, has been chopped off. Keppler, Jr., wrote on the back, "Father's first child (died)."

27. Hill, "Early Life of Joseph Keppler and His Family," p. 2; untitled Joseph Keppler biographical fragment, written in 1893 or 1894 in German on "Puck Art Rooms" stationery. The author (the fragment is not in Schwarzmann's hand) may have been Keppler's father, John, or brother, Karl, both of whom were working for *Puck* at this time; "Keppler's Life in St. Louis"; "Puck's Editor Dead," *New York World*, Feb. 20, 1894; "Artist Keppler Is Dead."

28. Biographical fragment, "Puck Art Rooms" stationery; "Artist Keppler Is Dead,"; "Joseph Keppler," *New Yorker Staats Zeitung*, Feb. 20, 1894, sets his day of arrival in New Orleans as Dec. 25, 1868. But in its follow-up story on Keppler's life in St. Louis, (Feb. 21, 1894), the paper states that Keppler and entourage arrived in 1867. Several other sources quote 1869. *The Epoch* interview sets his arrival in 1868. A search of the passenger lists for ships docking in the port of New Orleans from November 1867 to April 1869 did not turn up Keppler's name.

29. Population statistics from Treasury Department, *Immigration into the United States from 1820 to 1903* (Washington: Government Printing Office, 1903), pp.

4344, 4399–400; discussion of St. Louis as nation's capital found in *Atlantic Monthly* (April 1869), p. 444; *The Nation* (Sept. 2, 1869), p. 183. The man behind this campaign, L. U. Reavis, appears in two Keppler *Die Vehme* cartoons on the subject: *DV*, Oct. 23, 1869, p. 8, and Jan. 15, 1870, p. 4.

30. Claude Fuess, *Carl Schurz, Reformer* (New York: Dodd, Mead, 1933), pp. 143–201.

31. W. A. Swanberg, *Pulitzer* (New York: Charles Scribner's Sons, 1967), pp. 11–13.

32. "Highways and By-ways"; "Joseph Keppler," *New Yorker Staats Zeitung*.

33. Ibid.; "Keppler's Life in St. Louis"; "Highways and By-ways"; W. A. Kelsoe, *St. Louis Reference Record* (St. Louis: Published Privately, n.d.), p. 270; Joseph Bishop, *Our Political Drama* (New York: Scott-Thaw, 1904), p. 143.

34. Pulitzer anecdote in Don Seitz, *Life and Letters of Joseph Pulitzer* (New York: Simon and Schuster, 1924), p. 2; information on Keppler and his circle in "The Cover," *Bulletin of the Missouri Historical Society* 2 (July 1946), p. 43. Brachvogel and Pulitzer appeared frequently in Keppler's St. Louis cartoons.

For cartoons featuring Brachvogel, see *DV*, Oct. 16, 1869, p. 4, and Aug. 20, 1870, pp. 4–5 (the figure lying down); and *SLP* June 24, 1871, p. 12, July 15, 1871, pp. 6–7, and Oct. 14, 1871, pp. 8–9.

For cartoons featuring Pulitzer, see *DV*, Sept. 11, 1869, pp. 4–5, Dec. 4, 1869, p. 8, Feb. 5, 1870, p. 8, and March 26, 1870, p. 4; and *SLP* April. 1, 1871, p. 7, July 15, 1871, pp. 6–7, Jan. 20, 1872, pp. 4–5, Feb. 24, 1872, p. 8, and March 30, 1872, pp. 4–5; and *UB* Aug. 17, 1872, p. 52.

35. Frederic Hudson, *History of Journalism in the United States* (New York: Harper and Brothers, 1873), p. 690.

36. Frank Luther Mott calculates that in 1870 there were 4,500 newspapers (*American Journalism* [New York: Macmillan, 1941], p. 404) and 1,200 periodicals (*History of American Magazines 1865–1885* [Cambridge, Mass: Belknap Press, 1938], p. 5). Karl Arndt states that in 1873, 290 of them, 15 in St. Louis, were published in German (*The German Language Press of the Americas*, vol. 3 [Munich: Verlag Dokumentation, 1976], pp. 805–6).

37. G. A. Zimmermann, *Deutsch in Amerika* (Chicago: Eyller, 1894), p. 96; Adolph Zucker, *The Forty-Eighters* (New York: Columbia University Press, 1950), p. 279; Arndt, *German Language Press of the Americas*, vol. 1, pp. 248, 250, 265, 274–75.

38. (Aug. 28, 1869-Aug. 20, 1870). A complete run of *Die Vehme* is available at the NYPL.

39. Mott, *History of American Magazines 1865–1885*, p. 191. *Die Vehme* may have been the *first* to be printed entirely on lithographic presses, but this claim is difficult to substantiate.

40. Arndt, *German Language Press of the Americas*, vol. 1, p. 272.

41. No copies of *Frank und Frei* survive. The Missouri Historical Society has a broadside by Keppler advertising the publication. Keppler mentioned his involvement with the magazine in the "Highways and By-ways" interview. Alexander Schem, in his *Deutsch-Amerikanisches Conversations-Lexicon*, vol. 7 (New York: E. Steiger, 1869–74), p. 48, describes *Frank und Frei* as "a continuation of *Die Vehme*."

42. "The Cover."

43. Eugene Zimmerman, *Autobiography* (typescript in the possession of Horseheads, N. Y., Historical Society) as published in *Cartoonist Profiles* (Dec. 1981), p. 68.

44. "Minna Keppler."

45. Tempera painting in DSH collection.

46. A complete run of *Puck* (German) is in the collection of the St. Louis Public Library. The Missouri Historical Society has six of the twenty issues that were published in English.

47. *SLP*, Aug. 26, 1871, p. 2.

48. Fertile Germans: *SLP*, May 20, 1871, p. 1; ladies' bustles: *SLP*, April 15, 1871, p. 4; Agricultural and Mechanical Association Fair: *SLP*, Oct. 7, 1871, pp. 8–9; peace accord: *SLP*, June 24, 1871, pp. 6–7.

49. See Keppler's *Kikeriki!* cartoon of Aug. 2, 1866 reproduced on page 27.

50. See *DV*, Aug. 28, 1869, p. 8; *DV*, Oct. 30, 1869, p. 5; *DV*, March 5, 1870, pp. 4–5; *DV*, June 11, 1870, pp. 4–5; *DV*, June 18, 1870, pp. 4–5; *DV*, July 9, 1870, p. 8; and *DV*, July 23, 1870, pp. 4–5.

51. See *DV*, Dec. 18, 1869, p. 8; and *DV*, Feb. 19, 1870, p. 8.

52. *DV*, Aug. 20, 1870, p. 8.

53. *SLP*, March 18, 1871, p. 2.

54. *SLP*, March 18, 1871, pp. 6–7; *SLP*, March 25, 1871, cover.

55. *SLP*, April 29, 1871, p. 4; *SLP*, May 6, 1871, p. 4; *SLP*, April 1, 1871, p. 12; *SLP*, April 29, 1871, pp. 8–9; *SLP*, June 3, 1871, pp. 6–7; *SLP*, June 17, 1871, pp. 6–7.

56. *SLP*, June 10, 1871, pp. 6–7.

57. Morton Keller, *The Art and Politics of Thomas Nast* (New York: Oxford University Press, 1968), p. 160; *DV*, Dec. 11, 1869, pp. 4–5; *DV*, April 9, 1870, pp. 4–5.

58. *SLP*, May 20, 1870, pp. 6–7. In his centerspread cartoon for *SLP*, Aug. 12, 1871, pp. 6–7, Keppler featured Doellinger teaching at the University of Munich to the applause of his students, while the pope is featured adrift off the island of Corsica.

59. *SLP*, April 1, 1870, p. 6; *SLP*, April 1, 1870, p. 9; *SLP*, April 15, 1870, p. 12.

60. *DV*, April 2, 1870, pp. 4–5.

61. *SLP*, Aug. 26, 1871, pp. 8–9.

62. *SLP*, May 13, 1871, pp. 4, 6–7.

63. *SLP*, June 10, 1871, p. 9; *SLP*, June 17, 1871, p. 4; *SLP*, Nov. 4, 1871, pp. 8–9.

64. *SLP*, Sept. 9, 1871, p. 10; *SLP*, Oct. 7, 1871, p. 5.

65. *SLP*, Oct. 21, 1871, pp. 8–9; Nast's cartoon appeared in *Harper's Weekly*, Nov. 11, 1871, pp. 1056–57.

66. *SLP*, Aug. 19, 1871, pp. 6–7.

67. *St. Louis Marriages*, book 15 (St. Louis: Recorder of Deeds office), pp. 89 and 108. Joseph Keppler, Jr., records the date of marriage as July 10, 1871, in Geneological Notes, DSH collection. It is difficult to accept the possibility that the historically minded Keppler, Jr., misremembered his parents' date of marriage. The Kepplers may have celebrated their anniversary on July 10 in order to avoid insinuations that Keppler, Jr., who by all estimations was conceived before the Christian ceremony of August 3, 1871, was conceived out of wedlock. Why they didn't celebrate their anniversary on June 28, the date of the civil ceremony, is mysterious.

68. *SLP*, Aug. 26, 1871, p. 2.

69. "Keppler's Life in St. Louis."

70. *SLP*, Dec. 2, 1871, p. 2; Dec. 16, 1871, p. 2.

71. Zimmermann, *Deutsch in Amerika*, supplement, p. 55.; Kelsoe, *St. Louis Reference Record*, pp. 46–47.

72. The English *Puck* was first announced in the Dec. 9, 1871 issue (p. 2). Keppler rejoined the weekly with the Jan. 13, 1872 issue. Willich reannounced the coming of the English *Puck* in the March 9, 1872 issue, p. 2.

73. *SLP*, March 9, 1872, p. 2.

74. *SLP*, April 13, 1872, pp. 4–5; *SLP*, April 20, 1872, pp. 4–5.

75. *SLP*, May 25, 1872, pp. 4–5.

76. *SLP*, June 15, 1872, pp.4–5.

77. Arndt, *German Language Press of the Americas*, vol. 1, p. 268.

78. *FLIN*, July 6, 1872, p. 268.

79. *UB*, Sept. 14, 1872, p. 106; *UB*, July 20, 1872, p. 5. In total, Keppler drew seventeen signed pieces for *Unser Blatt* and at least five unsigned pieces. Of these, ten were general illustrations, not political cartoons.

80. *UB*, Aug. 3, 1872, p. 33.

81. *UB*, Aug. 17, 1872, p. 52.

82. *UB*, Oct. 26, 1872, p. 209.

TWO. "A Stir in the Roost"

1. For the best discussion of Nast's 1872 campaign work, see Morton Keller, *The Art and Politics of Thomas Nast*, (New York: Oxford University Press, 1968), pp. 73–78.

2. For biographical information, see Maurice Horn, "Matthew Morgan," *World Encyclopedia of Cartoons*, vol. 1 (New York: Chelsea House, 1980), p. 400; and Madeleine Stern, *Purple Passage: The Life of Mrs. Frank Leslie* (Norman: University of Oklahoma Press, 1953), pp. 63–64.

3. Keppler's starting salary is quoted as $15 in Julian Ralph, "Solemn Funny People," *Des Moines Leader*, April 15, 1887, and $30 in "America's German Caricaturist," *The Journalist*, Oct. 2, 1886. The second source is somewhat more reliable.

 The Budget of Fun was founded by Leslie in January 1859. The *Jolly Joker* was founded in March 1863 (publisher not identified) and sold to Leslie around 1872. He merged the two publications in May 1878 to create *Frank Leslie's Budget*, an apolitical humor and adventure monthly that ran until April 1896.

4. Treasury Department, *Immigration into the United States from 1820 to 1903*

(Washington: Government Printing Office, 1903), pp. 4399–4000.

5. Lloyd Morris, *Incredible New York* (New York: Random House, 1951), pp. 101–15, 181–93.

6. Bolton Road is referred to in legal documents in the Keppler collection, NYHSM.

7. Playbills advertising Keppler's New York City performances are in the Keppler collection, NYHSP.

8. For biographical information on Leslie, see Stern, *Purple Passage*. For information on *Frank Leslie's Illustrated Newspaper* and *Harper's Weekly*, see Frank Luther Mott, *History of American Magazines, 1850–1865* (Cambridge Mass., Belknap Press, 1938), pp. 452–65, 469–87.

9. The Crédit Mobilier scandal is discussed in David Muzzey's *James G. Blaine* (New York: Dodd, Mead, 1934), pp. 66–70, and in Alan Peskin's *Garfield* (Kent, Ohio: Kent State University Press, 1978), pp. 354–56.

10. *FLIN*, Feb. 1, 1873, p. 336.

11. *FLIN*, May 3, 1873, p. 125; *BoF*, June 1873, p. 5.

12. War with Spain: *BoF*, Feb. 1874, cover; Washington pig-sty: *BoF*, Feb. 1874, p. 9; Prudery: *BoF*, Oct. 1873, p.9; Cremation: *BoF*, June 1874, pp. 8–9.

13. *DV*, Oct. 30, 1869, p. 8.

14. *BoF*, Nov. 1874, p. 8.

15. *BoF*, April 1875, cover.

16. *BoF*, May 1875, p. 9.

17. *BoF*, June 1875, cover.

18. Stern, *Purple Passage*, pp. 54–67.

19. William McFeely, *Grant* (New York: W. W. Norton, 1981), p. 440.

20. *FLIN*, Nov. 21, 1874, cover.

21. *BoF*, May 1873, cover; *BoF*, Feb. 1875, cover.

22. *FLIN*, Jan. 1, 1876, cover.

23. McFeely, *Grant*, pp. 404–16.

24. *FLIN*, Dec. 5, 1875, cover; *FLIN*, Jan. 8, 1876, cover; *FLIN*, Feb. 26, 1876, p. 408.

25. *FLIN*, April 1, 1876, cover.

26. Alexander Flick, *Samuel J. Tilden* (New York: Dodd, Mead, 1939), pp. 265–73; *FLIN*, April 17, 1875, cover.

27. *FLIN*, Sept. 16, 1876, cover.

28. Information on Schwarzmann is scarce. See "Editor of Puck Dead," *New York Times*, Feb. 5, 1904 and "Adolph Schwarzmann Dead," *New York Herald*, Feb. 5, 1904. Eugene Zimmerman gives us virtually the only descriptions of Schwarzmann the man in his *Autobiography*, as published in *Cartoonist Profiles* (Dec. 1981), p. 65, (June 1982), pp. 74–75. Adolph Schwarzmann, Jr., Schwarzmann's only child, was born in 1880. His brief obituary can be found in the *New York Times*, Nov. 26, 1935.

29. Karl Arndt, *The German Language Press of the Americas*, vol. 1 (Munich: Verlag Dokumentation, 1976), p. 383.

30. Salary quoted in *The Critic*, circa 1898, Nast Scrapbook, Rare Book Room, Firestone Library, Princeton, N.J.

31. Copyright information from Draper Hill, "What Fools These Mortals Be!" A. B. thesis, Harvard College, 1957, p. 28. Schwarzmann buyout from Arndt, German Language Press of the Americas, vol. 1, p. 383.

32. For biographical information on Schenck, see G. A. Zimmermann, *Deutsch in Amerika* (Chicago: Eyller, 1894), p. 172; *P*, April 21, 1886, p. 119.

33. *Puck, Illustrirtes Humoristisches-Wochenblatt!* (Puck, Illustrated Humorous Weekly Paper!) Sept. [27], 1876, cover.

34. Story quoted in *The Critic*, Nast Scrapbook.

35. Contract is part of the Keppler collection, NYHSM.

36. Arndt, *German Language Press of the Americas*, vol. 1, p. 389.

37. Henry Gallup Paine, "H. C. Bunner and His Circle," *The Bookman* 35 (June 1912), p. 462.

38. Most of the front and back covers from *Puck*'s first year were printed in one hue. Most of the double-spreads were printed in two.

39. Examples of this treatment include: *P*, April [25], 1877, pp. 8–9; *P*, July 11, 1877, pp. 8–9; *P*, Aug. 1, 1877, pp. 8–9; *P*, Oct. 31, 1877, pp. 8–9; *P*, Nov. 28, 1877, pp. 8–9; *P*, Feb. 20, 1878, pp. 8–9. Occasionally the treatment worked. See *P*, July 11, 1877 cover and *P*, Jan. 2, 1878, pp. 8–9.

40. Although many sources credit Rosenfeld with the idea of starting an English-language edition of *Puck*, he himself offered testimony to the contrary. In Gerald Jensen's *The Life and Letters of H. C. Bunner* (Durham, N.C.: Duke University Press, 1939), a letter by Rosenfeld to the author is quoted (p. 30): "Keppler and Schwarzmann sent for me after they had got *Puck* going in German, and offered me the editorship of *Puck*, in English."

41. Richard Samuel West, "A Yankee Doodle Dirge," *The Puck Papers* 3 (Spring 1981), pp. 1–7; Stephen Hess and Milton Kaplan, *The Ungentlemanly Art* (New York: Macmillan, 1968), p. 82.

42. The last of the breed was *American Punch* (Jan. 1879–March 1881), established even after *Puck* had effectively supplanted the *Punch* model. A complete run of *Punchinello* (April 2, 1870–Dec. 24, 1870) is in the NYPL collection.

43. For biographical information on Rosenfeld, see Jensen, *Life and Letters of H. C. Bunner*, pp. 30–34, and "Sydney Rosenfeld," *New York Times*, June 15, 1931.

44. *P*, March [14], 1877, cover.

45. *P*, March [14], 1877, p. 2.

46. *P*, March 2, 1887, supplement p. 2.

47. Circular can be found in the Keppler collection, NYHSM.

48. Jensen, *Life and Letters of H. C. Bunner*, pp. 30–31.

49. Ibid., pp. 32–33.

50. Rosenfeld's relationships with Keppler and Schwarzmann are obscured by his *Rambler and Dramatic Weekly* attacks. He advances little of substance against the two men in these bigoted rantings. Fifty years later, Rosenfeld was able to discuss Keppler and Schwarzmann dispassionately. He could not, however, resist commenting wryly on the financial restraints he labored under as editor of *Puck*. He told Jensen (*Life and Letters of H. C. Bunner*, p. 30) that Keppler and Schwarzmann "allowed me, besides a modest salary, a sum equally modest for outside contributions."

51. Gains and loss statement is in the Keppler collection, NYHSM.

52. James L. Ford, *Forty-Odd Years in the Literary Shop* (New York: Harper and Brothers, 1921), p. 113; *P*, Oct. 23, 1878, p. 85.

53. The "General Design Office" functioned from October 1877 through December 1878.

THREE. "Going for It"

1. For examples of the large caricatures, see *GP*, Jan. [27], 1877, pp. 8–9; *GP*, Feb. [24], 1877, pp. 8–9; *P*, Aug. 8, 1877, pp. 8–9; *P*, Dec. 12, 1877, cover. For examples of the animal and inanimate object portrayals, see *P*, March [28], 1877, pp. 8–9; *P*, June 27, 1877, cover; *P*, July 18, 1877, pp. 8–9.

2. *GP*, Nov. [24], 1876, pp. 8–9.

3. For cartoons critical of Tilden, see *GP*, Nov. [1], 1876; *P*, Aug. 8, 1877, pp. 8–9; *P*, June 5, 1878, cover; *P*, Sept. 4, 1878,

cover; *P*, April 23, 1879, pp. 104–5 (and small cut by James A. Wales on p. 103); *P*, June 11, 1879, cover (by Wales); *P*, Aug. 27, 1879, cover (by Wales). For memorial cartoon, see *P*, Aug. 11, 1886, pp. 376–77.

4. *GP*, Nov. [22], 1876, pp. 8–9; *GP*, Jan. [24], 1877, pp. 8–9; *GP*, Feb. [7], 1877, pp. 8–9.

5. *GP*, Feb. [24], 1877, pp. 8–9.

6. *P*, Aug. 27, 1877, p. 16; as advertised in *Puck* from Sept. 26, 1877 (p. 15) until April 16, 1879 (p. 13).

7. *P*, Sept. 5, 1877, cover; *P*, Aug. 8, 1877, cover.

8. Talmage first appeared in *Puck* on February 6, 1878, p. 8 in a cameo. The first cartoon devoted exclusively to him and his "antics" appeared April 10, 1878, p. 16. He didn't become a regular cartoon subject until October 1878, after which he appeared several times a month for fifteen months, at which time the 1880 presidential campaign began dominating *Puck*'s cartoons.

9. *P*, Nov. 21, 1877, pp. 8–9; *P*, Feb. 20, 1878, pp. 8–9.

10. *P*, April 24, 1878, pp. 8–9.

11. *P*, June 27, 1877, pp. 8–9; *P*, July 30, 1879, pp. 328–29.

12. *P*, March 6, 1878, p. 2.

13. On the avarice of organized religion, *P*, Dec. 1, 1880, pp. 210–11; *P*, April 14, 1880, cover. On the achievement of Darwin (by Graetz), *P*, May 3, 1882. On the stature of Herbert Spencer, *P*, Nov. 1, 1882. On science as the religion of the future, *P*, Jan. 10, 1883.

14. *P*, April [25], 1877, pp. 8–9; *P*, May [2], 1877, p. 16; *P*, May [9], 1877, pp. 8–9, 16; *P*, May [30], 1877, cover; *P*, March 13, 1878, cover; *P*, May 1, 1878, pp. 8–9.

15. *P*, May [30], 1877, pp. 8–9; *P*, July 4, 1877, cover; *P*, Aug. 29, 1877, pp. 2, 8–9; *P*, Oct. 24, 1877, pp. 8–9; *P*, Nov. 14, 1877, p 2; *P*, Nov. 21, 1877, cover, p. 2.

16. *P*, May [2], 1877, pp. 8–9.

17. *P*, March 6, 1878, cover; *P*, Dec. 5, 1877, cover; *P*, Jan. 30, 1878, cover; *P*, Feb. 27, 1878, pp. 8–9.

18. H. Wayne Morgan, *From Hayes to McKinley: National Party Politics 1877–1896* (Syracuse, N.Y.: Syracuse University Press, 1969), pp. 31–39; H. J. Eckenrode, *Rutherford B. Hayes: Statesman of Reunion* (New York: Dodd, Mead, 1930), pp. 269–77); *P*, July 25, 1877, pp. 8–9; *P*, Oct. 31, 1877, pp. 8–9.

19. *P*, Jan. 29, 1879, p. 16; *P*, Feb. 12, 1879, p. 16.

20. *P*, Oct. 2, 1878, p. 16; *P*, Oct. 30, 1878, cover; *P*, April [25], 1877, cover.

21. *P*, Sept. 12, 1877, cover; *P*, Oct. 17, 1877, cover; *P*, Jan. 8, 1879, pp. 2, 8–9; *P*, Aug. 3, 1879, p. 16.

22. Theater cartoons: *GP*, Sept. [27], 1876, p. 16; *GP*, Oct. [25], 1876, p. 16; *GP*, Jan. [31], 1877, p. 16; *GP*, Feb. [23], 1877, p. 16; *P*, March [21], 1877, p. 16; *P*, Nov. 7, 1877, p. 7; *P*, Sept. 18, 1878, p. 16; *P*, Oct. 30, 1878, pp. 8–9; *P*, Dec. 4, 1878, cover.
 Juries: *P*, July 2, 1879, pp. 264–65; plumbers: *P*, Dec. 17, 1879, pp. 668–69; abortionist: *P*, April 12, 1878, p. 16; insurance: *P*, March 12, 1879, pp. 8–9; death: *P*, Oct. 15, 1879, pp. 508–9; suffrage : *P*, July 14, 1880, pp. 342–43; schools: *P*, Jan. 8, 1879, p. 16; psychics: *P*, May 24, 1879, pp. 152–53; additives: *P*, Feb. 19, 1879, pp. 8–9; divorce: *P*, Nov. 12, 1879, pp. 578–79.

23. *P*, March 6, 1878, p. 2.

24. *P*, Sept. 19, 1877, pp. 8–9; *P*, May 28, 1879, p. 178.

25. *Rambler and Dramatic Weekly*, June 4, 1879, p. 2.

26. Ibid.

27. Ibid., April 5, 1879, p. 2.

28. S. M. Pettengill, in his 1878 edition of *Pettengill's Newspaper Directory* (New York: S. M. Pettengill, 1878), p. 44, quotes the

German *Puck*'s circulation as 9,050 and the English *Puck*'s circulation as 5,340. Reliable 1879 circulation figures for the two journals are not available. However, George P. Rowell, in the 1880 edition of his *American Newspaper Directory* (New York: George P. Rowell, 1880), p. 261, quotes the German *Puck*'s circulation as "less than 10,000" and the English *Puck*'s circulation as "greater than 15,000," indicating impressive growth of the English *Puck* during 1879. *P*, Feb. 5, 1879, p. 13; *P*, March 19, 1879, p. 30; *P*, May 7, 1879, p. 141.

29. The contract is in the Keppler collection, NYHSM; financial notes, Keppler collection, NYHSM.

30. *P*, Aug. 2, 1886, p. 330.

31. *P*, April 9, 1879, p. 66.

32. Last issue of the *New-Yorker Musik Zeitung*, April 26, 1879.

33. Draper Hill, "What Fools These Mortals Be!" A. B. thesis, Harvard College, 1957, p. 110; genealogical notes, DSH collection; author's interview with Major Kenneth Miller, brother-in-law of Joseph Keppler, Jr., April 5, 1973, Philadelphia.

34. Anti-prohibition cartoons: *DV*, Jan. 22, 1870, p. 4; *GP*, Oct. [14] 1876, pp. 6–7; *P*, Aug. 4, 1886, pp. 306–61; *P*, July 3, 1889, pp. 312–13. Quote from Frank Weitenkampf, *Manhattan Kaleidoscope* (New York: Charles Scribner's Sons, 1947), pp. 123–24.

35. Keppler dreaming of ball: *P*, Feb. 13, 1878, p. 16. Ball invitations by Keppler in Keppler scrapbook, vol. 1, NYPLP.

36. *P*, Feb. 17, 1879, p. 2.

37. *Rambler and Dramatic Weekly*, March 1, 1879, p. 2.

38. Albert Bigelow Paine, *Th. Nast: His Period and His Pictures* (New York: Harper and Brothers, 1904), pp. 122–23.

39. Paine, *Th. Nast*; the Feb. 3, 1875, cover cartoon of the the *New York Daily*

Graphic was devoted to the debate. Under the headline, "*Harper's Weekly*—On Both Sides of the Fence," Curtis is pictured admiring an angelic representation of a white-leaguer, while Nast is putting the finishing touches on a demonic depiction of the same group.

40. Ibid., pp. 297, 303–5, 321–31, 352–54.

41. Ibid., pp. 222, 352–53, 354–57, 361–66.

42. "The Creator of Tattooed Blaine," *The Journalist*, July 3, 1886, p. 1. The charge: "[Gillam] has more ideas to the square inch than Keppler has to the square mile, for Keppler uses other men's ideas, Gillam always his own"; William Allen Rogers, *A World Worth While* (New York: Harper and Brothers, 1922), p. 284; Eugene Zimmerman, *Autobiography*, as published in *Cartoonist Profiles* (June 1982), p. 75,

43. "America's German Caricaturist," *The Journalist*, Oct. 2, 1886; Paine, *Th. Nast,*, p. 356; *The Journalist*, Oct. 13, 1886, p. 9.

44. Ibid. The charge: "[*Puck*] was Republican and Democratic by turns, as it paid *Puck* to be so."

45. Paine, *Th. Nast*, pp. 370, 418, 538–40.

46. Ibid., pp. 356–57.

47. "Keppler Tells How to Make Cartoons," *New York Herald*, Sept. 18, 1892.

48. For caricatures of Conkling, see *P*, Sept. 18, 1878, pp. 8–9; *P*, March 31, 1880, pp. 58–59; *P*, Oct. 13, 1880, pp. 90–91; *P*, May 25, 1881, pp. 204–5; *P*, Oct. 5, 1881, pp. 71–72.

 For caricatures of Butler, see *P*, Sept. 25, 1878, pp. 8–9; *P*, Aug. 13, 1879, cover.

49. Stern, *Purple Passage*, pp. 89, 95–101, 163.

50. For biographical information on Wales, see "James Albert Wales," *Dictionary of American Biography*, vol. 10 (New York: Charles Scribner's Sons, 1936), p. 335; "A Caricaturist's Career," *New York Herald*, Dec. 7, 1886; "James A. Wales—Death,"

New York Tribune, Dec. 7, 1886; "James Albert Wales Found Dead," *New York Times*, Dec. 7, 1886.

51. *P*, June 4, 1879, p. 208.

52. For biographical information on Opper, see "Frederick Burr Opper," *Dictionary of American Biography*, supplement 2 (New York: Charles Scribner's Sons, 1958), pp. 504–5.

FOUR. "Forbidding the Banns"

1. *P*, April 23, 1879, pp. 104–5.
2. Alexander Flick, *Samuel J. Tilden* (New York: Dodd, Mead, 1939), pp. 438–41.
3. Flick, *Samuel J. Tilden*, pp. 427–37.
4. *P*, May 12, 1880, cover.
5. *P*, Sept. 3, 1879, cover; *P*, Sept. 17, 1879, p. 440–41
6. William McFeely, *Grant* (New York: W. W. Norton, 1981), pp. 451–79.
7. *P*, July 17, 1878, pp. 8–9.
8. *P*, Feb. 4, 1880, pp. 782–82.
9. *P*, March 10, 1880, pp. 8–9.
10. *P*, March 31, 1880, pp. 58–59.
11. *P*, April 21, 1880, pp. 112–13.
12. *P*, May 19, 1880, pp. 188–89.
13. *P*, March 17, 1880, p. 32; *P*, May 12, 1880, pp. 168–69.
14. Quoted in *P*, April 18, 1880, p. 141.
15. Quoted in *P*, March 31, 1880, p. 63.
16. Certificate of naturalization in Keppler collection, NYHSM.
17. *P*, May 26, 1880, pp. 208–9; *P*, June 2, 1880, pp. 226–27.
18. *P*, June 9, 1880, cover.
19. *P*, June 16, 1880, pp. 266–67.
20. Ibid., cover, p. 2.
21. *P*, June 30, 1880, p. 298.
22. *P*, July 28, 1880, pp. 376–77; *P*, Sept. 1, 1880, pp. 456–57.
23. *P*, June 30, 1880, cover.
24. *P*, Aug. 25, 1880, p. 448.
25. *P*, Oct. 6, 1880, pp. 75–76.
26. *P*, Aug. 25, 1880, pp. 440–41.
27. Supporting cartoon: *P*, Aug. 25, 1880, cover (by Wales); primary cartoon: *P*, Oct. 13, 1880, pp. 90–91.
28. *P*, Sept. 15, 1880, pp. 24–25; *P*, Sept. 22, 1880, pp. 40–41; *P*, Nov. 10, 1880, p. 168.
29. *P*, Nov. 3, 1880, pp. 142–43.
30. *P*, Oct. 27, 1880, pp. 124–25.
31. *P*, Nov. 10, 1880, pp. 158–159.
32. Frank Luther Mott, *History of American Magazines, 1865–1885*, p. 522; *P*, Sept. 17, 1879, p. 434; *P*, Sept. 29, 1880, p. 50.
33. *Puck's Annual* was modeled after *Puck's Volks-Kalender*, a German-language almanac, which was published from 1878 to 1898. In 1878, an independent publisher had issued, with Keppler and Schwarzmann's permission, an English-language *Puck's Almanac* to little fanfare and less success. Keppler and Schwarzmann tried it themselves two years later, and then yearly through 1886. After that, it was rechristened the *Christmas Puck*, enlarged to *Puck* size, and made a special issue of the magazine. *Puck on Wheels* was published yearly through 1885, after which it was also enlarged and retitled the *Mid-Summer Puck*. In 1883, Keppler and Schwarzmann came out with the first *Pickings from Puck*, which unlike the *Annual* and *Puck on Wheels*, simply collected material that had already appeared in *Puck*. The concept was so successful that Keppler and Schwarzmann abandoned auxilliary publications that depended on original material. *Pickings from Puck* appeared annually until 1891, when it became a quarterly and continued until 1914. *Puck's Library*, a monthly, began in 1887 and was published until 1914. *Puck's Quarterly*, nearly identical in concept to *Pickings*, was begun in 1896 and also published until 1914.
34. Agreement of partnership in Keppler collection, NYHSM; press accolades quoted in *P*, Oct, 12, 1881, p. 95; fire reported in *P*, March 22, 1882, p. 34.
35. Karl Arndt, *German Language Press of*

the Americas, vol. 3, p. 403; *Um Die Welt* closing message Feb. 28, 1885, p. 402.

36. Letter from Amy Gertrude Lukens, *New York Times* March 10, 1901.

37. Some of the *Puck* look-alikes tried evoking the original in their own names. *Pluck* began in Chicago June 5, 1880, lasting only a few months. *Shucks* bowed in Buffalo on September 13, 1884. It also had a short life. Some other entries included:

 Hornet (St. Louis, Sept. 11, 1880–Sept. 10, 1881)

 Chic (New York, Sept. 15, 1880–June 1, 1881)

 Freaks (Philadelphia, Jan. 8, 1881–Apr.? 1881)

 Lantern (St. Louis, June 24, 1882–?)

 Figaro (New Orleans, Dec. 22, 1883–?)

 Jingo (Boston, Sept. 10, 1884–Nov. 18, 1884)

 Portrayer (St. Paul, Nov. 29, 1884–?)

 Whip (St. Louis, Feb. 14, 1885–?)

 Light (Columbus, Ohio/Chicago, Oct. 23, 1889–? 1891)

 Bee (New York, May 16, 1898–Aug. 2, 1898)

 Vim (New York, June 22, 1898–Aug. 24, 1898)

 The Verdict (New York, Dec. 9, 1898–Nov. 22, 1900).

FIVE. "Through Night to Light!"

1. Primary cartoon: *P*, April 6, 1881, cover, p. 72. Supporting cartoons: *P*, Apr. 13, 1881, pp. 96–97; *P*, April 20, 1881, cover.

2. *P*, May 11, 1881, p. 162.

3. *P*, May 18, 1881, pp. 180–81.

4. *P*, May 25, 1881, pp. 204–5.

5. Alan Peskin, *James A. Garfield* (Kent Ohio: Kent State University Press, 1978), pp. 578–80.

6. *P*, May 4, 1881, p. 144.

7. *P*, Sept. 6, 1881, supplement back cover.

8. *P*, July 13, 1881, pp. 324–25.

9. *P*, April 19, 1882, pp. 106–7; *P*, Aug. 23, 1882, p. 390.

10. Eugene Zimmerman, "Rambles in Cartoondom," *Cartoons Magazine* (Nov. 1915), p. 704.

11. *P*, Aug. 23, 1882, pp. 396–97.

12. Ibid., p. 390.

13. *P*, Nov. 2, 1882, p. 130; *P*, Oct. 25, 1882, pp. 120–21.

14. *P*, Nov. 22, 1882, pp. 184–85.

15. *P*, Dec. 27, 1882, p. 258.

16. *P*, May 2, 1883, pp. 130, 136–37.

17. *P*, Feb. 23, 1881, pp. 414, 420–21.

18. Quote: *P*, Jan. 25, 1882, p. 376; cartoon: *P*, Sept. 20, 1882, pp. 40–41.

19. *P*, Feb. 14, 1883, p. 370; *P*, March 14, 1883, p. 18.

20. For biographical information on Gillam, see "The Creator of Tattooed Blaine," *The Journalist*, July 13, 1886 (as much a vicious attack on Keppler as a biographical portrait of Gillam); "Bernard (*sic*) Gillam Dead," *New York Tribune*, Jan. 20, 1896 (in which Gillam associate John Sleicher relates the true story of how the Rev. Henry Ward Beecher helped Gillam get started, not the apocryphal one often quoted); "Bernard (*sic*) Gillam Dies of Fever," *New York Herald*, Jan. 20, 1896; "Death of Bernhard Gillam," *New York Times*, Jan. 21, 1896.

21. "Bernard Gillam Dead."

22. Virtually nothing is known of Graetz. Eugene Zimmerman, in his *Autobiography* (*Cartoonists Profile* [date?], pp.) leaves us with a bit of personal information. Keppler saved some of Graetz's later cartoons for the Berlin paper *Lustige Blatter* because he considered them plagiarisms of *Puck* cartoons (see Keppler collection, NYHSP). Graetz turns up again after the turn of the century as owner and chief cartoonist for the Viennese humor magazine *Der Floh* (see Albert Shaw, *A Cartoon History of Roosevelt's Career* [New York: Review of Reviews, 1910], p. 217, and Raymond Gros, *T. R. in Cartoon* [Akron: Saalfield Publishing, 1910], pp. 97, 168).

23. For biographical information on von Stur,

see Ulrich Thieme and Felix Becker, *Allgemeines Lexikon Der Bildenden Künstler*, vol. 32 (Leipzig: Verlag von E. A. Seemann, 1920), p. 250.

24. R. K. Munkittrick, "Cartoons and Their Makers," *Munsey's Magazine*, Aug. 1904, pp. 742–43.

25. "Death of Joseph Keppler," *New York Times*, Feb. 20, 1894.

26. Eugene Zimmerman, *Autobiography*, as published in *Cartoonist Profiles* (Sept. 1981), p. 85, and (Dec. 1981), p. 65.

27. Keppler's itinerary revealed in his "Prodigal Son" cartoon, *P*, Oct. 10, 1883, pp. 88–89.

28. Ibid.; "Death of Joseph Keppler."

29. *The Judge*, March 22, 1884, p. 3.

30. *P*, Aug. 25, 1886, p. 416.

31. Eugene Zimmerman, "Giants of Another Day," *Cartoons and College Fun* (n.d.), p. 40, DSH collection.

32. *P*, March 2, 1887, supplement, p. 3.

33. "Keppler Tells How to Make Cartoons," *New York Herald*, Sept. 18, 1892.

34. Zimmerman, *Autobiography*, as published in *Cartoonist Profiles* (Dec. 1981) p. 69.

35. Zimmerman, "Giants of Another Day,"; Eugene Zimmerman, *Zim's Correspondence School of Cartooning Comic Art and Caricature*, book 12 (Horseheads, N.Y.: Privately printed, 1912), p. 5.

36. Zimmerman, *Zim's Correspondence School*, book 13, p. 7; Zimmerman, *Autobiography*, as published in *Cartoonist Profiles* (Dec. 1981), p. 69.

37. Zimmerman, "Giants of Another Day," pp. 40–41.

SIX. "A Sail! A Sail!"

1. H. Wayne Morgan, *From Hayes to McKinley: National Party Politics 1877–1896* (Syracuse, N. Y.: Syracuse University Press, 1969), pp. 65–71, 177–81.

2. *P*, Sept. 6, 1882, pp. 8–9.

3. *P*, April 16, 1884, pp. 104–5.

4. Eugene Zimmerman, "Rambles in Cartoondom," *Cartoons Magazine* (April 1916), pp. 581–82.

5. "The Royal Tattoo," *BoF*, Feb. 1875, cover, "Auch eine Tatowirte," *GP*, Nov. [18], 1876, cover.

6. Zimmerman, "Rambles in Cartoondom," p. 582; Albert Bigelow Paine, *Th. Nast: His Period and His Pictures*, (New York: Harper and Brothers, 1904), p. 502; A. B. Maurice and Frederick Cooper, *A History of the Nineteenth Century in Caricature* (New York: Dodd, Mead, 1904), p. 277; Munkittrick, "Cartoons and Their Makers," *Munsey's Magazine*, Aug. 1904, p. 740; W. J. Arkell, *Old Friends and Some Acquaintances* (Los Angeles: Privately printed, 1927), p. 75.

7. *P*, May 14, 1884, pp. 168–69.

8. *P*, June 4, 1884, pp. 216–17.

9. *P*, June 25, 1884, p. 258.

10. Ibid.

11. *The Judge*, June 14, 1884, cover, p. 2.

12. *P*, June 11, 1884, p. 276.

13. *P*, June 25, 1884, pp. 248–49. Keppler drew a similar cartoon nine years earlier on the futility of Grant's third-term bid (*FLIN*, Nov. 6, 1875, cover).

14. Supporting cartoons: *P*, June 25, 1884, cover; *P*, July 9, 1884, p. 304; primary cartoon: *P*, July 7, 1884, pp. 280–81.

15. Carlisle cartoon: *P*, Mar. 5, 1884, pp. 8–9; Lent cartoon: *P*, Mar. 12, 1884, pp. 24–25.

16. *P*, June 4, 1884, p. 224.

17. *P*, July 16, 1884, pp. 312–13.

18. *P*, July 30, 1884, pp. 344–45.

19. *P*, Aug. 27, 1884, pp. 408–9.

20. Frank Weitenkampf, *Manhattan Kaleidoscope* (New York: Charles Scribner's Sons, 1947), p. 16.

21. *P*, Aug. 12, 1884, p. 370.

22. *P*, Aug. 27, 1884, cover; *P*, Oct. 22, 1884, pp. 120–21.

23. *P*, Oct. 29, 1884, p. 144.

24. Announcement appeared in *P*, from June 18, 1884 (p. 242) until Nov. 5, 1884 (p. 146).

25. Zimmerman, "Rambles in Cartoondom."

26. H. G. Paine, "H. C. Bunner as Editor and Critic," *The Critic* May 23, 1896, p. 363.

27. Quoted in *Echo* Sept. 12, 1896, p. 161.

28. *P*, Nov. 5, 1884, p. 152–53.

29. Draper Hill, "What Fools These Mortals Be!" A. B. thesis, Harvard College, 1957, p. 14n; letters to Keppler from Pulitzer in Keppler collection, NYHSM.

30. Walt McDougall, *This Is the Life!* (New York: Alfred A. Knopf, 1926), pp. 95–97.

31. *P*, Dec. 9, 1884, pp. 216–17.

32. Stephen Hess and Milton Kaplan. *The Ungentlemanly Art* (New York: Macmillan, 1968), p. 46.

SEVEN. "Two Roads for the Workingman"

1. W. A. Swanberg, *Pulitzer* (New York: Charles Schribner's Sons, 1967), pp. 120–21, 126–28.

2. *P*, July 22 1885, pp. 328–29.

3. *P*, Nov. 18, 1885, pp. 184–85.

4. Entire correspondence printed in *P*, Dec. 30, 1885, p. 275.

5. *P*, June 21, 1882, pp. 246, 252–53; *P*, March 17, 1886, pp. 40–41.

6. H. C. Bunner, ed., *A Selection of Cartoons from Puck by Joseph Keppler* (New York: Keppler and Schwarzmann, 1883), p. 178.

7. *P*, April 14, 1886, pp. 104–5

8. *P*, April 28, 1886, pp. 136–37.

9. *P*, May 19, 1886, pp. 184–85.

10. *P*, Aug. 25, 1886, pp. 408–9.

11. *P*, Oct. 20, 1886, pp. 122–23. Election discussed in Edmund Morris's *The Rise of Theodore Roosevelt* (New York: Coward, McCann and Geoghagan, 1979), pp. 341–60.

12. Cartoons attacking George and McGlynn by Keppler: *P*, Jan. 26, 1887, cover; *P*, May 18, 1887, pp. 196–97; *P*, June 1, 1887, pp. 228–29; *P*, June 15, 1887, pp. 260–61; *P*, June 22, 1887, pp. 276–77.

By Louis Dalrymple: *P*, April 6, 1887, p. 106; *P*, June 29, 1887, p. 300; *P*, July 27, 1887, cover.

By Charles Jay Taylor: *P*, Dec. 29, 1886, cover; *P*, Jan. 19, 1887, p. 356; *P*, June 8, 1887, pp. 244–45; *P*, July 6, 1887, cover; *P*, July 20, 1887, cover.

By E. N. Blue: *P*, Feb. 9, 1887, pp. 398–99.

Bunner's comment: *P*, July 13, 1887, p. 318.

13. *The Journalist*, Jan. 14, 1888, p. 2.

14. Ibid., May 28, 1887, p. 3; Jan. 14, 1888, p. 2.

15. Ibid., Oct. 1, 1887, p. 3.

16. Ibid., Jan. 14, 1888, p. 2.

17. Ibid., March 23, 1889. p. 2.

18. Eugene Zimmerman, *Autobiography*, as published in *Cartoonist Profiles*, (April 1882), p. 74.

19. Zimmerman, *Autobiography*, unpublished chapter 10, p. 64.

20. Ibid., pp. 64, 66.

21. Ibid., p. 65.

22. Eugene Zimmerman, *Zim's Correspondence School of Cartooning Comic Art and Caricature*, book 5, (Horseheads, N. Y.: Privately printed, 1912); Zimmerman, *Autobiography*, pp. 65–66.

23. "James Albert Wales Found Dead," *New York Times*, Dec. 7, 1886.

24. Fairfax Downey, *Prortrait of an Era* (New York: Charles Scribner's Sons, l936), p. 54.

25. For biographical information on Charles Jay Taylor, see: *Who's Who in America*, vol. 8, *1914–1915* (Chicago: A. N. Marquis, 1914), p. 2306; "Charles J. Taylor, Artist, Dies," *New York Herald Tribune*, Jan. 20, 1929.

26. For biographical information on Louis Dalrymple, see: "Louis Dalrymple," *New York Times*, Dec. 29, 1905; "Louis Dalrymple," *New York Tribune*, Dec. 29, 1905; "L. Dalrymple, Artist, Dead," *New York Herald*, Dec. 29, 1905.

27. For biographical information on S. D. Ehrhart, see: Harold Payne, "Our Caricaturists and Cartoonists," *Munsey's Magazine*, Feb. 1894, p. 548.

28. *P*, March 2, 1887, supplement, pp. 2, 8.

29. Ibid., pp. 3–4.

30. Joseph Keppler, Jr., to Frank Weitenkampf, Dec. 9, 1945, in the Weitenkampf collection, NYPLM.

31. *P*, March 2, 1887, supplement, p. 8.

32. Zimmerman, *Autobiography*, 65.

33. "Keppler Tells how to Make Cartoons," *New York Herald*, Sept. 18, 1892.

EIGHT. "A Hydra That Must Be Crushed!"

1. *P*, June 7, 1882, pp. 230–31.

2. *P*, June [13], 1877, pp. 8–9 (note that issue is incorrectly labeled May).

3. *P*, April 22, 1885, pp. 120–21.

4. *P*, Nov. 30, 1881, pp. 200–1; *P*, Dec. 14, 1881, p. 227.

5. *P*, July 29, 1891, pp. 368–69.

6. *DV*, Sept. 18, 1869, p. 4; *DV*, Oct. 9, 1869, pp. 6–7; *P*, April 16, 1879, cover.

7. *P*, Jan. 11, 1893, pp. 334–35.

8. *P*, Oct. 14, 1891, pp. 120–21.

9. *P*, Oct. 14, 1888, pp. 184–85.

10. *P*, April 11, 1888, pp. 112–13. See also *P*, Sept. 22, 1886, pp. 56–57, and *P*, Nov. 24, 1886, pp. 208–9.

 In 1889, Keppler and Schwarzmann published a collection of Taylor's society cartoons under the title, *In the '400' and Out*.

 The firm of Keppler and Schwarzmann published the following collections of short stories:

 Bunner, H. C. *Short Sixes* (1890)
 Ford, James L. *Hypnotic Tales* (1891)
 Augur, C. H. (Morris Waite) *Half-True Tales* (1891)
 Puck's authors. *Mavericks* (1892)
 Bunner, H. C. *The Runaway Browns* (1892)
 Munkittrick, R. K. *Some New Jersey Arabian Nights* (1892)
 Bunner, H. C. *Made in France* (1893)
 Puck's authors. *Hanks* (1893)
 Wilson, H. L. *Zig-Zag Tales* (1894)
 Bunner, H. C. *More Short Sixes* (1894)
 Bunner, H. C. *The Suburban Sage* (1896)
 Folwell, A. H. et al. *Monsieur D'en Brochette* (1905)

11. *P*, May 15, 1889, pp. 200–1.

12. *P*, July 14, 1886, pp. 312–13.

13. *P*, Dec. 21, 1887, p. 252; *P*, Dec. 28, 1887, pp. 276–77.

14. *P*, July 7, 1886, pp. 296–97; see also Taylor's *P*, Aug. 3, 1887 cover and Opper's *P*, Nov. 16, 1887 cover.

15. *P*, Feb. 22, 1888, cover.

16. *P*, April 18, 1888, pp. 128–29.

17. *P*, May 16, 1888, pp. 198–99.

18. *P*, June 20, 1888, pp. 282–83.

19. *P*, July 4, 1888, pp. 316–17.

20. See *P*, Aug. 8, 1888, pp. 412–13; *P*, Sept. 12, 1888, p. 48; *P*, Oct. 10, 1888, p. 112.

21. *P*, March 7, 1888, pp. 26–27.

22. Quoted in *P*, Aug. 29, 1888, p. 11.

23. *P*, Aug. 22, 1888, pp. 444–45.

24. *P*, Sept. 5, 1888, pp. 18, 24–25.

25. See *P*, Sept. 19, 1888, cover; *P*, Oct. 3, 1888, cover; *P*, Oct. 24, 1888, pp. 120–21; *P*, Oct. 31, 1888, pp. 152–53.

26. *P*, Nov. 7, 1888, p. 162.

27. *P*, Nov. 14, 1888, p. 178; *P*, Dec. 26, 1888, pp. 298–99.

28. Eugene Zimmerman, *Autobiography*, as published in *Cartoonist Profiles* (Dec. 1981), p. 69.

29. *P*, March 30, 1887, pp. 78–79.

30. *P*, June 27, 1888, pp. 288, 300–1.

31. *P*, April 29, 1891, pp. 152–53.

32. Keppler, Jr., watercolor in the DSH collection. "Highways and By-ways," *The Epoch*, July 25, 1890.

33. Joseph Keppler to Udo Keppler, Aug. 12, 1890, in the Keppler collection, NYHSM.

34. Letter fragment from Joseph Keppler to Udo Keppler, Sept. 3, 1891, in the Keppler. collection, NYHSM.

NINE. The Festooned Sarcophagus

1. *P*, Jan. 23, 1889, pp. 362–63. See also Opper's similar treatment of the wealth of senators two years earlier, *P*, Jan. 19, 1887, cover.

2. *P*, Sept. 3, 1890, pp. 24–25.

3. *P*, Nov. 19, 1890, pp. 200–1; *P*, Nov. 18, 1891, pp. 200–1.

4. *P*, March 6, 1889, cover.

5. *P*, Aug. 13, 1890, pp. 400–1.

6. *P*, Sept. 2, 1891, pp. 24–25.

7. *P*, July 22, 1891, pp. 352–53.

8. *P*, April 20, 1892, pp. 136–37.

9. *P*, Feb. 3, 1892, pp. 404–5.

10. *P*, June 22, 1892, pp. 280–81; *P*, Aug. 17, 1892, pp. 412–13.

11. *P*, Aug. 31, 1892, pp. 24–25

12. *P*, Sept. 28, 1892, pp. 88–89.

13. *P*, Nov. 16, 1892, pp. 192–93.

14. *P*, Nov. 16, 1892, p. 186.

15. Notes of withdrawal on Keppler and Schwarzmann company account in Keppler collection, NYHSM.

16. First advertised in *P*, June 22, 1892, p. 295; last advertised in *P*, Oct. 19, 1892, p. 147.

17. *P*, Aug. 7, 1889, p. 394; *P*, March 5, 1890, cover; *P*, March 12, 1890, cover, p. 34; *P*, March 3, 1892, p. 23; *P*, Oct. 12, 1892, pp. 126–29.

18. *P*, Oct. 12, 1892, p. 126.

19. Ibid., pp. 124–25, 126.

20. Excerpt of an article from *The Critic* quoted in *World's Fair Puck*, Aug. 28, 1893, p. 204.

21. For biographical information on Frank Hutchins, see "Frank M. Hutchins," *New York Tribune*, May 7, 1896. For biographical information on W. A. Rogers, see his autobiography, *A World Worth While* (New York: Harper and Brothers, 1922); "Rogers, William Allen," *World Encyclopedia of Cartoons*, vol. 2 (New York: Chelsea House, 1980), pp. 479–80.

22. *World's Fair Puck* May 22, 1893, pp. 30–31; June 19, 1983, pp. 78–79.

23. Keppler recorded his colleagues' disappointment in an undated letter fragment to his son, Udo, in the Keppler collection, NYHSM, and in a four-page diary fragment in the DSH collection.

24. Henry Gallup Paine letter to the editor in the Keppler collection, NYHSM.

25. Joseph Keppler, Jr. to Frank Weitenkampf, Feb. 19, 1944, NYPLM.

26. Henry Gallup Paine letter to the editor in the Keppler collection, NYHSM.

27. "Death of Joseph Keppler," *New York Times*, Feb. 20, 1894.

28. *New York Recorder* clipping in the Keppler collection, NYHSM.

29. *Chicago Herald* clipping in the Keppler collection, NYHSM.

30. *Louisville Courier-Journal* clipping in the Keppler collection, NYHSM.

31. Carl Schurz to Udo Keppler, Feb. 22, 1894, in the Keppler collection, NYHSM.

32. Bernhard Gillam to Pauline Keppler, Feb. 24, 1894, in the Keppler collection, NYHSM.

33. "Death of Joseph Keppler."

Index

Cartoon Index

A Note on the Author

Richard Samuel West was born in Washington, D.C., in 1955. He was graduated from Kenyon College, Ohio, with a B.A. in political science. He has edited political cartoon publications for the last ten years, beginning with *The Puck Papers* (1978–81), a newsletter of political cartoon history, and then *Target, the Political Cartoon Quarterly* (1981–87), the trade magazine for political cartoonists. He has also edited a collection of the work of *Philadelphia Inquirer* political cartoonist Tony Auth, which was published in the spring of 1988. Currently he is at work on a biography of William Randolph Hearst's political cartoonist Homer Davenport. Professionally, West is director of publications for SANE/FREEZE, America's largest peace and social justice organization. He lives in Washington, D.C.